Looking North

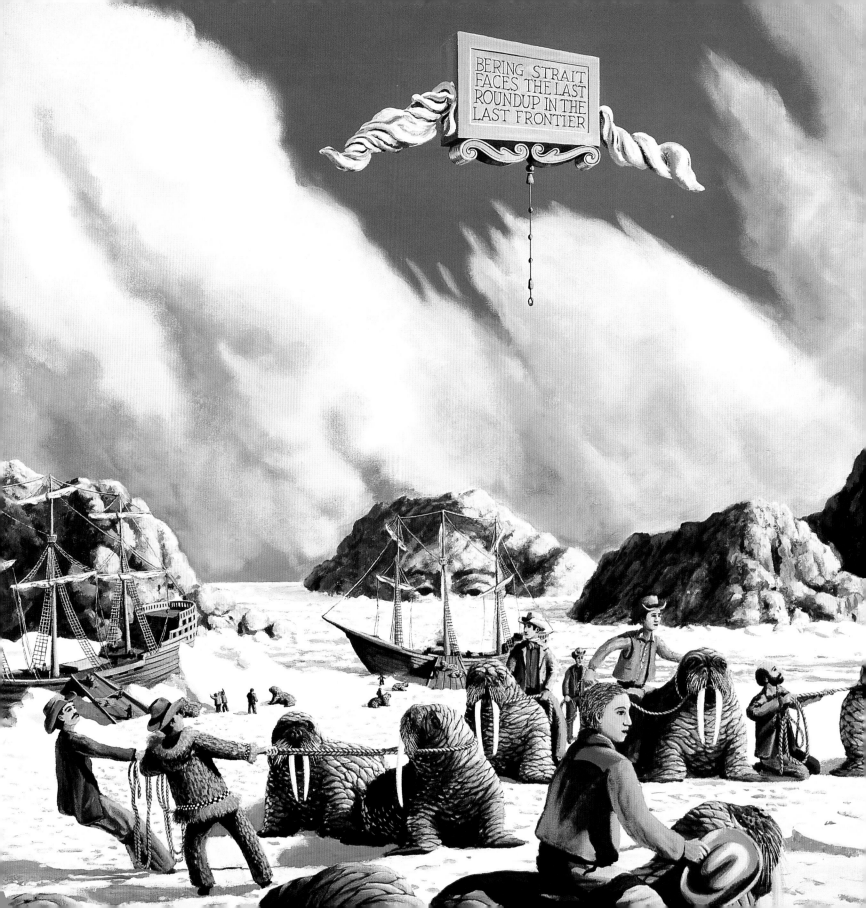

Looking North

Art from the University of Alaska Museum

Edited by Aldona Jonaitis

With conversations edited by
Susan McInnis

Contributions by
Alvin Amason
Wanda Chin
Terry Dickey
Molly Lee
Barry McWayne
Peggy Shumaker
Glen Simpson
Kesler Woodward

Photographs by
Barry McWayne

Published for the University of Alaska Museum
by the University of Washington Press
Seattle and London

This publication has been generously supported by Alaska Airlines, H. Willard Nagley II, the Alaska Humanities Forum, and the National Endowment for the Humanities, a federal agency that supports research, education, and public programming in the humanities.

Peggy Shumaker's poems "Braided River," "The Day the Leaves Came," and "Exit Glacier" are from *Wings Moist from the Other World* by Peggy Shumaker, © 1994 (reprinted by permission of the University of Pittsburgh Press); "Where Mountains Have No Names" and "The Inupiat Christmas Pageant" are from *The Circle of Totems* by Peggy Shumaker, © 1988 (reprinted by permission of the University of Pittsburgh Press); "What to Count On" is reprinted by permission of *Third Coast*; "Wingspan of Sand" appeared in *Nimrod: International Journal*, vol. 2, no. 2 (reprinted by permission of the University of Tulsa). The unpublished poems "The Story of Light," "Avalanche Lily," and "Wild Lake" are included by permission of Peggy Shumaker.

Illustration facing title page: detail from figure 50

Designed by John Hubbard
Produced by Marquand Books, Inc., Seattle
Printed in Hong Kong

Library of Congress Cataloging-in-Publication Data
University of Alaska Museum.
 Looking north : art from the University of Alaska Museum / edited by Aldona Jonaitis ; with conversations edited by Susan McInnis ; contributions by Alvin Amason . . . [et al.] ; photographs by Barry McWayne.
 p. cm.
 Includes bibliographical references and index.
 ISBN 0-295-97693-4 (cloth : alk. paper). —
ISBN 0-295-97694-2 (paper : alk. paper)
 1. Art, American—Alaska—Catalogs. 2. Indian art—Alaska—Catalogs. 3. Eskimo art—Alaska—Catalogs. 4. Alaska—In art—Catalogs. 5. Art—Alaska—Fairbanks—Catalogs. 6. University of Alaska Museum—Catalogs. I. Jonaitis, Aldona, 1948– . II. McInnis, Susan. III. Amason, Alvin. IV. Title.
N6530.A4U54 1998
709'.798'0747986—dc21 97-35363
 CIP

Contents

Preface and Acknowledgments 9
Aldona Jonaitis

1 Looking North 13
Aldona Jonaitis

2 Resonance of Memory 45

3 Making Authentic Art for Sale 63

4 Categories 81

5 Images of Natives 97

6 Landscape 117

7 A Sense of Place 133

8 Conversations among Alaskan Artists 147

9 Final Thoughts 163

10 A Sense of Wonder 171
Kesler Woodward

Bibliography 192
Contributors 203
Index 204

Maps

Alaska	26
Alaska Native groups	32

Poems

Where Mountains Have No Names	13
Braided River	45
Wingspan of Sand	63
What to Count On	81
Avalanche Lily	97
The Story of Light	117
The Day the Leaves Came	133
Wild Lake	147
The Inupiat Christmas Pageant	163
Exit Glacier	171

Illustrations

1. Fur clothing
2. Okvik Eskimo animal head
3. Brett Weston, *Mendenhall Glacier, Alaska*
4. Susan McInnis, Terry Dickey, Kesler Woodward, Barry McWayne, Alvin Amason
5. Terrence Choy, *Alaska Go Pan*
6. Helen Seveck, Inupiaq fur parka
7. Yupik fox mask
8. Simon Paneak, Nunamiut dipper
9. Frederick S. Dellenbaugh, *Pier at Orca*
10. Fred Machetanz, *Off to the Trapline*
11. Brian Allen, *Pizza Hut*
12. Happy Jack, Inupiaq incised tusk
13. Henry Wood Elliott, *Seal Drive Crossing*
14. Theodore Roosevelt Lambert, *A Tundra Town at Breakup*
15. Robby Mohatt, *Traces VI*
16. Yupik tusk
17. Henry Varnum Poor, *American Soldiers Pulling a Dead Russian from Chena Slough*
18. Cheryl A. Bailey, *Fusion Pattern #1*
19. Central Alaskan Yupik coiled grass baskets
20. Aleut grass baskets
21. Old Bering Sea toggle harpoon head with inset blades
22. Inupiaq baleen baskets
23. Susan McInnis
24. Robert Bateman, *Polar Bear Profile*
25. Okvik Eskimo human figure
26. Charles Janda, *Alluvial Fan, Adams Inlet*
27. Margie Root, *My Mother Always Ran the Show*
28. Tlingit spruce root baskets
29. Bedusa Derendy, Athabaskan or Yupik beaded collar
30. Wanda Chin, Molly Lee, Glen Simpson
31. Julia Nevak, Yupik cloth and fur parka
32. Hannah Netro, Athabaskan baby belt
33. Eustace Paul Ziegler, *Tanana Woman and Dog*
34. Sydney Mortimer Laurence, *Mt. McKinley* (1919)
35. Edmond James FitzGerald, *Lining through the Riffle*
36. Shelley Schneider, *Construction Laborers in Clearwell, Eklutna Water Project*
37. Susan McInnis, Terry Dickey, Aldona Jonaitis
38. Aleut grass wallet
39. Haida argillite carvings
40. Tlingit spruce root basket
41. Kesler Woodward, *Woods at Creamers*
42. Jacob Simeonoff, full-crowned hunting hat
43. Tlingit dish
44. Inupiaq male and female masks
45. Yupik dance headdress
46. Tlingit dagger
47. Alvin Eli Amason, *Oscar Scared Him with His Icon*
48. Lawrence Ullaq Aviaq Ahvakana, *Walrus Mask*
49. Inupiaq walrus skull with carved tusks
50. Daniel DeRoux, *Bering Strait Faces the Last Roundup in the Last Frontier*
51. Yupik gathering bags
52. Jane Meyer, sculpture
53. Ethel Washington, Inupiaq doll
54. Siberian Yupik human figure
55. Dolly Spencer, Inupiaq doll
56. Joseph John Jones, *Muktuk Marston Signing Eskimos into the Alaska Territorial Guard*
57. Yupik feast bowl
58. Yupik grass basket
59. Ipiutak-style "rake"
60. Denise Wallace, jewelry
61. Robert Swain Gifford, *Icy Bay, Alaska*

62. Tlingit spruce root basket

63. James H. Barker, *4th of July at Black River Fishcamp*

64. Alex Harris, *Newtok, July 1977*

65. Don Doll, S.J., *Ben Chugaluk Moves a House to Toksook Bay*

66. James Everett Stuart, *Indian Town near Sitka*

67. Chilkat blanket

68. Tanis Hinsley, *Self Portrait*

69. George Aden Ahgupuk, drawing

70. Inupiaq snow beater

71. Okvik Eskimo human figure

72. Ronald W. Senungetuk, *Two Spirits*

73. Eustace Paul Ziegler, *Native Woman*

74. Theodore Roosevelt Lambert, *Eskimo Dance in the Kashige*

75. Gwich'in Athabaskan sled bag

76. Mark Daughhetee, *The Shaman*

77. James Kivetoruk Moses, *Shaman*

78. Sydney Mortimer Laurence, *Pulling for Port*

79. Eustace Paul Ziegler, *Up the Susitna River*

80. Rockwell Kent, *Voyagers*

81. Ansel Adams, *Mount McKinley and Wonder Lake*

82. Kesler Woodward, Wanda Chin, Glen Simpson, Molly Lee, Alvin Amason, Susan McInnis, Aldona Jonaitis, Terry Dickey

83. Arthur William (Bill) Brody, *Guardians of the Valley*

84. David Mollett, *Tanana River*

85. Gary L. Freeburg, *Tidal Pool*

86. Nathan Jackson, Tlingit eagle Kaag Waan Taan totem pole

87. Yupik grass basket

88. Florence Nupok Malewotkuk, *Polar Bears*

89. Yupik masks representing plants

90. Charles Mason, *American Gothic, 1985*

91. Stephanie Harlan, *Two-Headed Dog*

92. Aleut model boat

93. Pacific Eskimo (Alutiiq) spruce root basket

94. Alvin Eli Amason, *I Could Watch You Until the Stars Come Out and I Can't See No More*

95. Kesler Woodward, *Spring Green*

96. Joseph W. Kehoe, *Seward Skyline*

97. Glen Simpson, *Thule Bird*

98. Yupik game pieces

99. Aldona Jonaitis, Terry Dickey, Kesler Woodward, Glen Simpson

100. Myron Wright, *Lake George, Chugach Mountains*

101. Punuk Eskimo wrist guard

102. Tony Rubey, *The Sporting Life of Nome*

103. Athabaskan willow basket

104. James Schoppert, *Raven: In the Pink*

105. Glen Simpson, *Tunghak* (Spirit Hand)

106. Athabaskan moccasins

107. Malcolm Lockwood, *Ice Fractures*

108. Yupik grass basket

109. Old Bering Sea winged object

110. Fran Reed, *Gulkana basket*

111. Leah Roberts, Gwich'in Athabaskan fish-skin bag

112. Nathan Jackson, Tlingit raven headdress

113. Kathleen Carlo, *Nokinmaa yiłmaa* (Snowy Owl)

114. Yupik bird mask

115. Lawrence Beck, *Tunghak Inua* (Spirit Mask)

116. Harry Shavings, Yupik miniature mask

117. Deg Hit'an (Ingalik Athabaskan) mask

118. Inupiaq *kikituk*

119. Siberian Yupik charm belt

120. Inupiaq umiak seat

121. Andrew Tooyak, Sr., Inupiaq *kikituk*

122. Glen Simpson and Alvin Amason

123. Siberian Yupik pipes

124. Punuk Eskimo turreted object

125. John Hoover, *Salmon Woman*

126. Theodore J. Richardson, *Southeastern Scene*

127. Theodore Roosevelt Lambert, *The Native Camp at Anvik, Alaska*

128. Claire Fejes, *Source of Life*

129. Siberian Yupik gut parka

130. Magnus Colcord ("Rusty") Heurlin, *Eskimo Hunter*

131. Nina Crumrine, *Chief Andrew*

132. Henry Wood Elliott, *Village Cove and Hill*

133. Sydney Mortimer Laurence, *Mt. McKinley* (1924)

134. Jules Dahlager, *Alaskan Scene*

135. David Rosenthal, *Danger Point*

136. Kesler Woodward and Barry McWayne

137. Paul Gardinier, *Sounding Board for Joseph Beuys*

138. Sydney Mortimer Laurence, *Mount Susitna, Cook Inlet, Alaska*

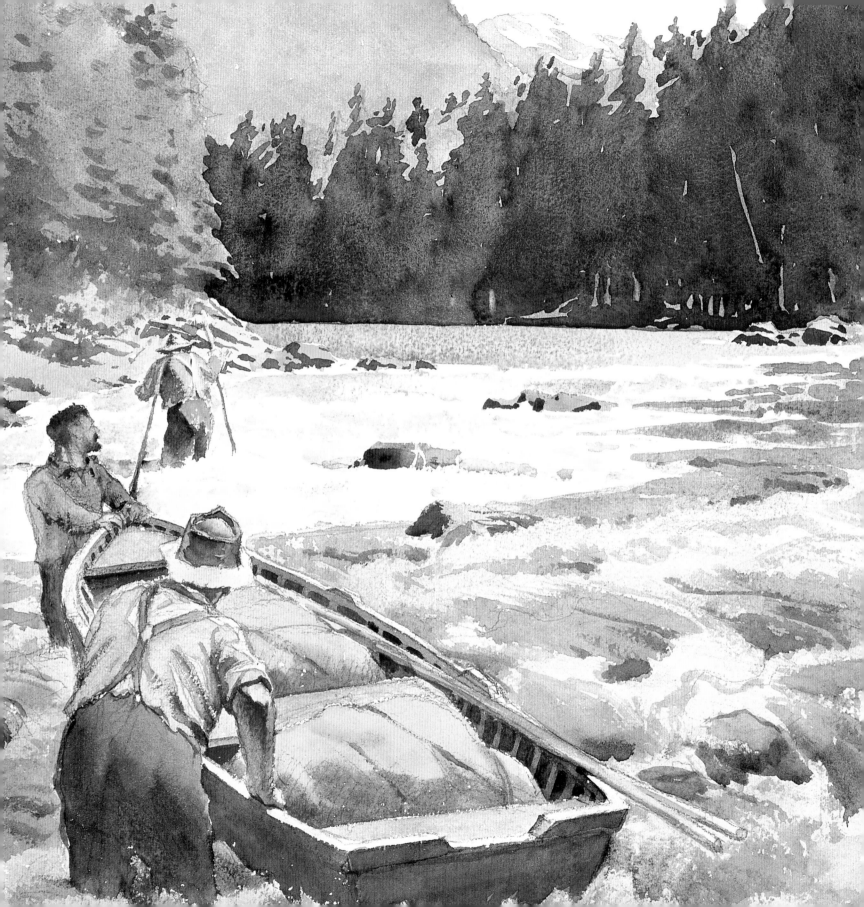

Preface and Acknowledgments

Aldona Jonaitis

In the late winter of 1996, I traveled down to Seattle for a meeting of the Puget Sound Committee of our museum expansion campaign and had a most enjoyable lunch with my friends at the University of Washington Press. After I described to the group our plans for building a gallery that would display the University of Alaska Museum's (UAM) outstanding art collection, Don Ellegood, the recently retired director of the Press, urged us to publish a book celebrating that collection. It seemed like such a good idea that immediately on returning to Fairbanks I brought together a group of UAM staff—including Wanda Chin, exhibits coordinator; Terry Dickey, education coordinator; Molly Lee, ethnology curator; Barry McWayne, fine arts coordinator; and Gary Selinger, special projects manager; as well as Kesler Woodward, fine arts affiliate and chair of the University of Alaska Fairbanks (UAF) Art Department—all of whom liked the idea immensely.

This group then met periodically throughout the spring to select objects that would best represent our extensive art holdings. Wanda, Molly, Barry, Kes, and I assumed the responsibility for writing captions for these artworks. We asked Glen Simpson, a Tahltan metalworker and professor in the Art Department, and Alvin Amason, Alutiiq director of the Native Arts Program and assistant professor in that same department, to join us in a conversation about art. Susan McInnis, an award-winning journalist and experienced radio and television interviewer, led these discussions. She and I then edited the five and one-half hours of conversation that form the text of this book. Barry McWayne, whose work has appeared in two outstanding art books, Dorothy Jean Ray's *A Legacy of Arctic Art* and Ann Fienup-Riordan's *The Living Tradition of Yup'ik Masks*, took the photographs for this publication. And Peggy Shumaker, award-winning poet and professor of English at UAF, generously agreed to let us publish some of her poems that complement the artworks especially well.

Art at the University of Alaska Museum

The artworks in this book have been selected from the University of Alaska Museum's collection of Alaskan art, which ranges from two-thousand-year-old ivory carvings to paintings done in the 1990s. The first pieces in our collection were transferred from the University's art collection when the Museum first opened its doors in 1929. Otto Geist, a local amateur paleontologist/archaeologist who traveled widely along the Bering Sea coast and on St. Lawrence Island between 1926 and 1939, collected a good many of the archaeological and ethnological artifacts. Over the years, UAM expanded its art holdings by means of purchases, donations, and field collections. This book presents a selection of works by both Native and non-Native artists from the fine arts, ethnology, and archaeology departments.

The Museum's single largest collection is in archaeology, with its special strength in Bering Sea materials. Approximately one thousand of our 750,000 archaeological artifacts have considerable artistic merit; some, such as the "Okvik Madonna" figurine (fig. 25), are especially masterful works. Our nine-thousand-object ethnographic collection contains

approximately four thousand nineteenth- and twentieth-century artworks by Tlingit, Tsimshian, and Haida from the southeast; Athabaskan of the interior; Aleut and Alutiiq from the Aleutians, Kodiak, and the Alaska Peninsula; Yupik of western Alaska; Siberian Yupiit (plural of "Yupik") of St. Lawrence Island; and Inupiat (plural of "Inupiaq") from northern Alaska. Especially noteworthy objects from this collection include an outstanding array of Alaska Native baskets, one of the largest collections anywhere of Eskimo ivories, historical and contemporary Athabaskan beadwork, a small but fine assortment of Haida argillite, several unique and exquisite Yupik masks, and an outstanding Chilkat blanket.

In 1990 the U.S. Congress passed the Native American Grave Protection and Repatriation Act (NAGPRA), which identified certain categories of museum holdings as repatriatable: skeletal material, artifacts interred with skeletal material, certain types of sacred objects, as well as objects of great value to the people. Museums had to provide all Native groups in the United States with summaries of all their collections by November 1993 and with detailed accounts of human remains and related grave goods by November 1995.

One of the many fortuitous consequences of the NAGPRA legislation for UAM was the development of a database of our ethnographic and archaeological collections, computerization of the entire ethnographic collection and part of the archaeology collection, and the strengthening of our relationships with groups of Alaska Native peoples. In 1995 and 1996 we worked with delegations of elders from the villages of Gambell and Savoonga on St. Lawrence Island as well as from Hooper Bay, a village on the Bering Sea, who each visited the museum for a week to study collections from their communities.

Our fine arts collection of 2,900 paintings, sculptures, photographs, prints, and items commonly labeled as "craft" is also of excellent quality. In his 1992 analysis of our painting collection, art professor Kesler Woodward stated, "Both its historical and its artistic value are significant, in that [the art collection] contains outstanding examples of work by (1) most of the state's best-known historical artists, and a number of lesser-known figures, and (2) many of the state's best-known contemporary artists, along with many lesser-known contemporary figures" (Woodward 1992).

As Woodward points out, the strength of our collection is the breadth and quality of its historical holdings, which include twenty-six paintings by Sydney Laurence, fifty-six by Rusty Heurlin, fifty by Ted Lambert, and twenty-seven by Eustace Ziegler. According to Woodward, "The canvases by Rockwell Kent, R. Swain Gifford, and Robert Bateman are highlights of the collection, and are the kinds of paintings many major museums would be pleased to acquire and exhibit. The collection of twenty-four E. J. FitzGerald watercolors is, in my opinion, the finest group of Alaskan watercolors in the state." Woodward also mentions the significance of our Eskimo drawings and watercolors by George Aghupuk, Florence Malewotkuk, and Kivetoruk Moses, among others, and our extensive print and photograph collection.

Since the time of Woodward's report, these art collections have been strengthened by a series of excellent purchases and donations. Particularly noteworthy are the purchase of a large group of Henry Wood Elliott watercolors and the donation by Dorothy Jean Ray of her Eskimo art collection (Ray 1996). Within recent years we have made a special effort to collect works by contemporary artists and have enhanced our collections enormously by the addition of major works by Sylvester Ayek, Bill Brody, Robby Mohatt, Kay Marshall, Melvin Olanna, David Rosenthal, and Ron Senungetuk (Woodward 1995).

Acknowledgments

First, of course, I must express my deepest and most sincere thanks to all of the contributors for their cooperation and help in making this book a reality. Other UAM staff who made major contributions include Tanya Barnebey, Suzanne Bishop, Hazel E. Daro, Amy Geiger, Craig Gerlach, Michael Lewis, Gary Selinger, Roland Tapper, and Marie Ward. Lawrence Kaplan provided valuable information on names. Several student assistants helped in the research: Heidi Heidt, Christopher Hyrcko, and Allison Young. Allison also wrote the initial draft of the archaeology captions. Thanks to Leonard Kamerling, who thought of the title *Looking North* for his video about the University of Alaska Museum. We thought that title was also most appropriate for this book.

As always, the staff at the University of Washington Press have been exceptional. As I stated earlier, the original idea for this book came from Don Ellegood, to whom I am especially thankful. I also acknowledge the help of editor Lorri Hagman.

This book was made possible by the wonderful generosity of Alaska Airlines, H. Willard Nagley II, the Alaska Humanities Forum, and the National Endowment for the Humanities. Special thanks for their help in obtaining funding for this publication go to Bill McKay, Joseph Crusey, Steven Lindbeck, Suzanne Bishop, and Pamela Davis.

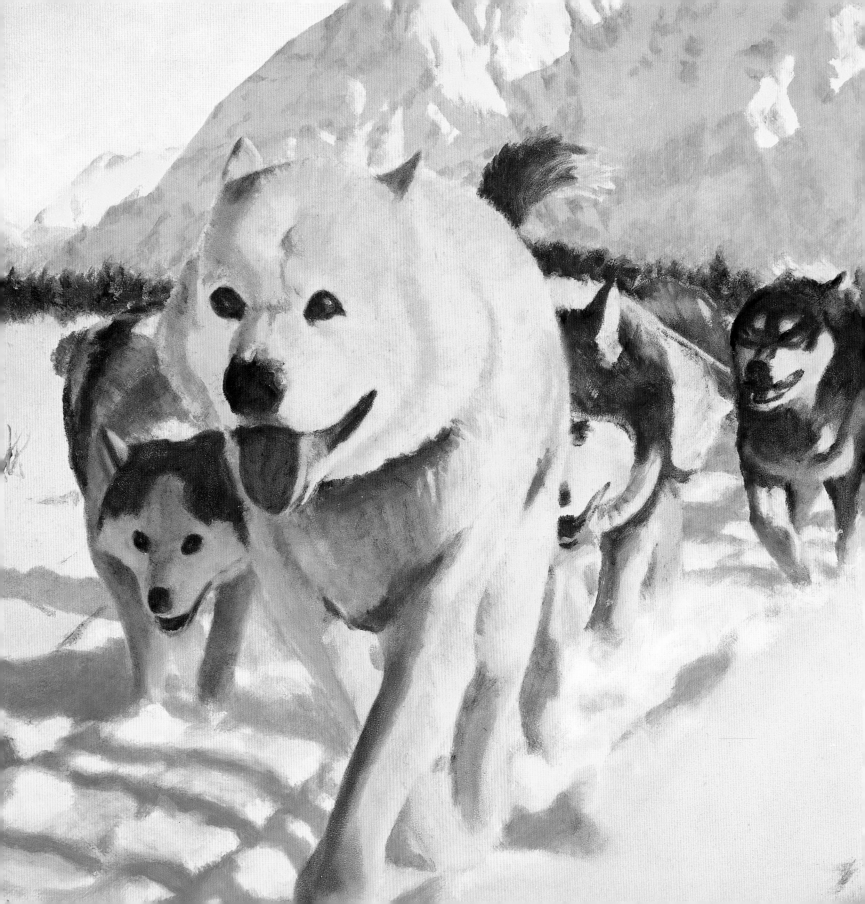

Looking North *Aldona Jonaitis*

Where Mountains Have No Names

Moving water melts the glacier
from the inside out. We listen,
trace its widening along the flatland.

A yearling moose strips new bark
off low-hanging birch, thrashes
and stomps knee-deep in the stream.

Vast, bountiful, unforgiving—
the ways of water's being.

Peggy Shumaker
The Circle of Totems

Detail of figure 10

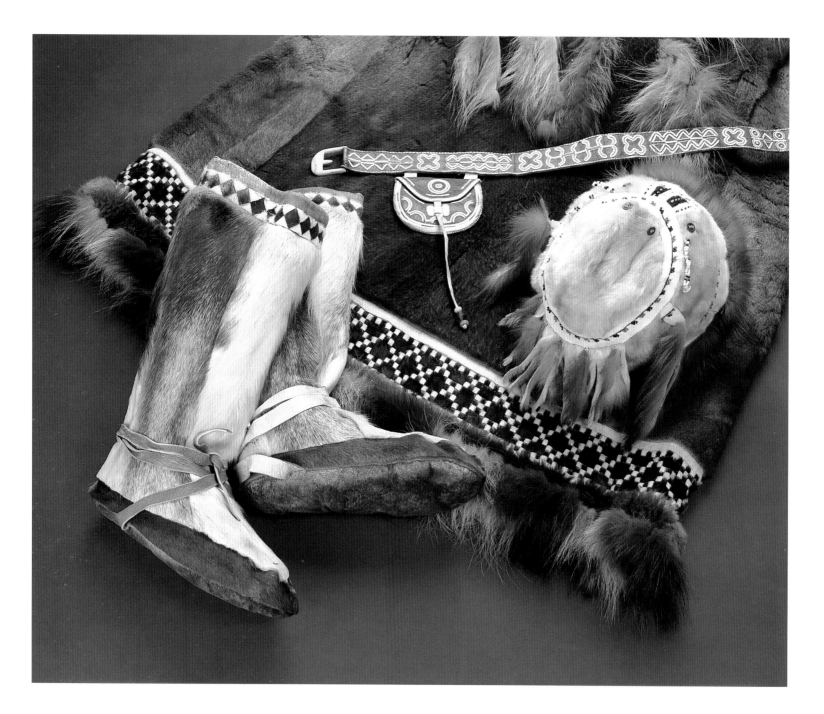

1

Fur clothing

Alaska is a land of extremes. It is the largest state by far. Its interior sees temperature fluctuations from -40° to above 90°. In the Arctic, endless light in June and July contrasts with short, pale, sunless days in December and January. Unrelenting rains drench the southeast region. The tallest mountain in North America, Mount McKinley, can be seen from both Anchorage and Fairbanks. Large populations of bears, wolves, moose and caribou, uncountable birds, millions of salmon, and sea mammals such as otters, walrus, and whales inhabit this land's mountains, tundras, and shores. It is an impressive land that has long fascinated its visitors.

As early as the seventeenth century, people of means assembled fossils, minerals, stuffed animals, artifacts of "primitive" or exotic cultures—scientific oddities that they housed in specially built cabinets that came to be called "cabinets of curiosities." Inspired by the growth of scientific pursuits initiated during the European Renaissance and acquired during the Age of Exploration, which exposed the Old World to the wonders of mysterious regions heretofore never known, the contents of these cabinets served as specimens that gentlemen scholars analyzed, cataloged, and named. Although one often associates cabinets of curiosities with jumbles of items from Africa, Asia, and the Pacific, the northern reaches of North America held treasures as exotic and mysterious as those from warmer regions. Things from the north often made their way into these collections, with narwhal tusks being particularly favored as proof of the existence of unicorns. Such cabinets of curiosities containing a wealth of natural and cultural history became the precursors of the modern museum.

The metaphor of such a cabinet seems apt for the University of Alaska Museum, which shares with its public the abundant products of an extravagant nature and the highly refined artifacts of various Native groups. Emerging from Alaska's often-frozen soil are wonders such as a mummified steppe bison killed thirty-six thousand years ago by a now-extinct lion, a herd of infant dinosaurs killed millions of years ago by a flash flood, and seemingly limitless gold nuggets. Two-thousand-year-old ivory carvings provide tantalizing insights into the worlds of ancient Eskimo communities. Even specimens and artifacts of recent creation embody Alaska's singular wilderness and wildness, its climatic extremes, its awesome

Cap
Lilly Paul
Caribou fur, beads, buttons, yarn. Central Alaskan Yupik. Kipnuk. Modern Alaskan Native Culture Project, 1972. Purchased, 1972. UAM72-18-2

Mukluks
Anonymous
Reindeer fur. 38.1 cm. Inupiaq. Nome. Collected by Leonhard Seppala. Donated in 1968 by Mrs. Leonhard Seppala. UAM68-41-1AB

Parka
Mrs. Jackson (first name unknown)
Reindeer, wolverine, and wolf fur; yarn; beads. 101.5 cm × 33 cm (without hood). Central Alaskan Yupik. Akiak, 1929. Collected by Agnes Schlosser. Donated by Agnes Schlosser, 1967. UAM67-132-1

Belt and pouch
Anonymous
Sealskin, reindeer hair, beads, ivory. 109.2 cm. Siberian Yupik. St. Lawrence Island, 1920s. Collected by Otto W. Geist. UAM64-21-137

Skinsewing is surely one of the greatest accomplishments of Eskimo women. Anyone who has ever looked at a parka, for example, recognizes that it is a highly sophisticated garment, requiring tailoring as complex as any French dress. More remarkable still, until recently the intricate pieces needed for fur clothing such as that illustrated here were cut out by eye, without benefit of a pattern. In addition to warmth, beautifully made parkas and boots provided their wearer with prestige and distinguished the residents of different communities when they gathered. Because Eskimo parkas traditionally lacked pockets, belts of fur or leather were needed for the attachment of small tools. Valuables could be stored in small pouches hung from a belt. (LEE)

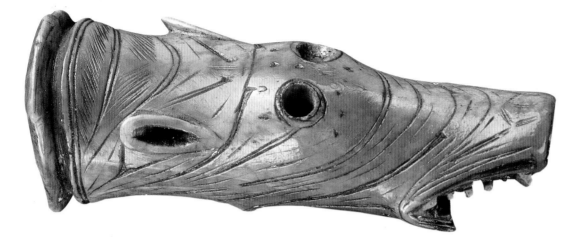

2

Okvik Eskimo animal head
Anonymous
Ivory. 11 cm. Okvik site, Punuk
Island, Okvik period (C.E. 100–550).
Excavated by Otto Geist, 1934;
cataloged, 1966. UA66-002-0089

During his 1934 field season on Punuk Island, Otto Geist exca-
vated this head of a long-nosed, open-mouthed dog, polar bear,
or mythical beast. A broad, deep slot runs underneath from the
mouth to the base of the throat and a groove encircles the base
of the neck, suggesting that the piece might have been attached
or lashed to some implement. Its sketchy, irregular, curved
double lines alternating with broken parallel lines and converg-
ing lines at the eyes and ears suggest the Okvik style. Although
the function of this piece is unknown, Fitzhugh and Kaplan
(1982) point out that the use of polar bear or beast images on
sea-hunting weapons lasted into nineteenth-century Bering Sea
Eskimo culture. (Fitzhugh and Kaplan 1982:60–85, 244, 250;
Rainey 1941:463–68, 519 [illus.], 551–53) (JONAITIS)

3

Mendenhall Glacier, Alaska
Brett Weston
Photograph, gelatin silver print.
40 cm × 46.5 cm. 1973. Purchased,
1986. UAP86:022:001

Brett Weston's first visit to Alaska, in 1973, was the result of a
National Endowment for the Humanities grant to photograph
in the forty-ninth state. His initial impression was so strong that
he returned to the north three more times. The photographs he
made during his Alaska sojourns were "not meant as a portrayal
but rather as an intimate revelation of that magnificent land."
Weston's reputation as one of this century's most important and
individualistic photographers stems from his keen awareness of
visual drama, bold use of graphical forms, impeccable craftsman-
ship, and profound commitment to the medium of photography.
Weston was a man of few words and rarely talked about his work.
In the introduction to his *Alaska* portfolio (1978), from which this
image comes, he says, "It is my hope that these prints will survive
without the usual verbiage and futile explanations that so often
are used in an attempt to reinforce and clarify. I feel strongly that
photographs should be *seen;* the less said the better." (MCWAYNE)

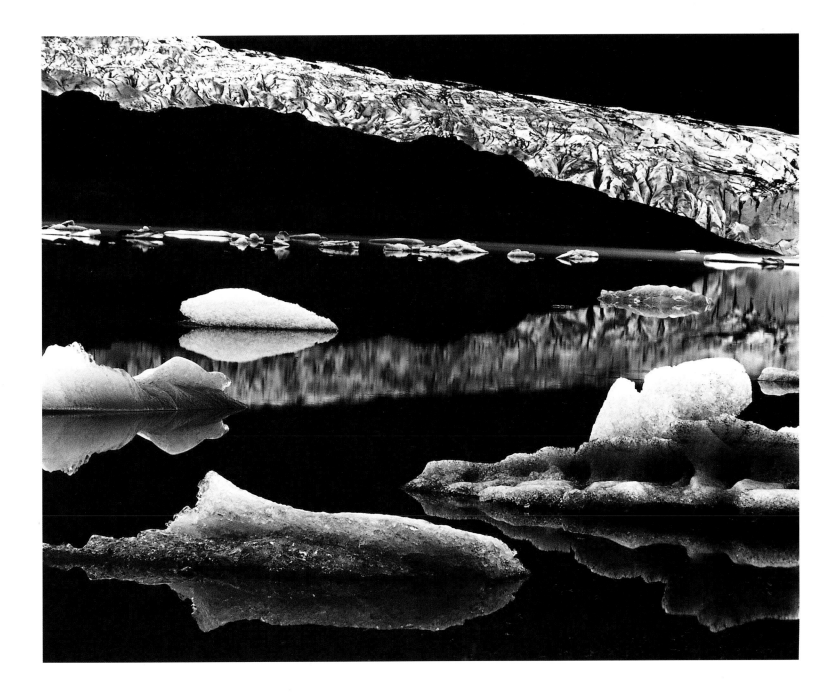

4

From left: **Susan McInnis, Terry Dickey, Kesler Woodward, Barry McWayne, Alvin Amason**
Photograph by Aldona Jonaitis

natural abundance. More than any other state, Alaska produces those things which so intrigued the first modern investigators of the natural world, the people who, for reasons of personal or scientific interest, made the first cabinets of curiosities.

The function of this museum is to continue the sort of study and classification begun by early scientists and to collect and display the natural and human products of Alaska. It has been our intention to retain in the exhibition spaces some of the sense of wonder and mystery that informed early collections and collectors. Artistic responses to this world constitute profound statements of respect for the majesty, complexity, and diversity of the north. Indeed, for two thousand years artists have drawn their inspiration from this dazzling land. Native artists have depicted its abundant wildlife—from the seals, birds, and bears carved on ivory implements from the Okvik culture, and the dreamlike presences of spirits that transform magically from animal to human form on Yupik masks, to the wolves, ravens, eagles, and orcas that embody clan legends on Tlingit totem poles. As Westerners explored and then settled this northern region, Euro-American artists added endless variations on its spectacular landscapes to Alaska's artistic reper-

toire. Stretches of wilderness with mountain ranges, glaciers, volcanoes, fjords, broad river valleys, frigid tundra, and temperate rain forests inspired generations of landscape painters as well as photographers. Today Native and non-Native artists alike continue exploring new ways of looking at this world and drawing from it their unique northern visions.

This book illustrates the impressive range of Alaskan art from the UAM collections. Poems by Peggy Shumaker resonate with some of these images. For the text we have transcribed conversations—conducted by Susan McInnis—about Alaskan art between faculty from the University's art department (Alvin Amason, Glen Simpson, and Kesler Woodward) and Museum staff (Wanda Chin, Terry Dickey, Molly Lee, Barry McWayne, and myself).

The inspiration for this format is *Form and Freedom,* a book of conversations about Northwest Coast Native art between Bill Holm, the most distinguished scholar of that art, and Bill Reid, an accomplished artist of Haida descent (Holm and Reid 1975). Unlike the often dry, academic treatment to which art is so often subjected, Holm and Reid's work literally sparkles, their words enlivening the carvings illustrated and offering penetrating insights into their manufacture,

5

Alaska Go Pan
Terrence Choy
Commercial metal gold-mining pan, acrylic paint, mannequin leg, casters. 75 cm × 42 cm. 1985. Purchased from artist. UA85-3-2

Goldpan painting, a popular form of Alaskan art, typically shows romantic scenes of cabins, caches nestled in summery woods, sunsets, or winter's dazzling aurora. *Go Pan* breaks out of the two-dimensionality of this tradition in its assemblage of commercial caster wheels, hardware, and found objects. By using a variety of items that rarely find their way into artworks, Choy pokes fun at the saccharine nostalgia of goldpan painting. The disembodied mannequin leg expresses his views on society's commodification of female beauty; the casters allude to the slippery wheeled rush of technology. Choy's frigid blues, similar to those of a Sydney Laurence landscape, become in this piece cool, hip, and modern. This intentionally unbalanced sculpture teases us to relinquish some old-fashioned ideas about Alaska and its art. (CHIN)

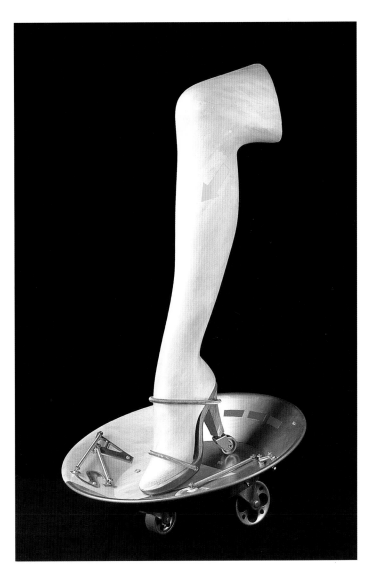

style, and meaning. *Looking North* takes the idea of conversations about art and applies it to Alaskan art made over two millennia and by diverse artists, including in the process multiple voices—men and women, artists and scholars, art professionals and anthropologists, Natives and non-Natives. We hope that this unique combination of art, poetry, and dialogue presents to our readers an experience that enhances their understanding not only of Alaskan art but the art of all people.

New ideas on art and museums inform this publication. Art history, the discipline that classifies, analyzes, and interprets art, has changed over the past several decades. So have museums, institutions that play a critical role in educating the public about art. As Reesa Greenberg, Bruce Ferguson, and Sandy Nairne assert in the introduction to their anthology about museums (1994:2), "Exhibitions have become *the* medium through which most art becomes known." A

"new art history," along with a "new museology," have reassessed how we look at, research, exhibit, understand, evaluate—and even define—art. The arrangement of artworks on these pages, the themes of our conversations, and, indeed, the initial inspiration behind this volume owe a debt to contemporary critical theorists who, as part of a larger intellectual movement, analyze the world's cultural products and history from fresh, global perspectives.

Art History

Until quite recently, the space that "art" inhabited in the cultural landscape held paintings and sculptures made mostly in the Western tradition. Scholars presented art's history as a sequence of works progressing from one style to the next; virtually all of these works were by men, virtually all of their patrons and appreciators came from the dominant classes, and virtually all were presented as intrinsically worthy of aesthetic accolades. Based on the twin assumptions that there exists a universally accepted canon that defines "great art" and that art emerges during the progressive movement of ever-inventive traditions, such art history represented a neat, tidy, and universally valid description and analysis of cultural history. Excluded from this art historical narrative were traditions that eluded its classic canons—aboriginal art, art by women, "craft," and work considered "popular" or "folk."

Contemporary scholars of the "new art history" analyze those excluded traditions, without ranking any one tradition above another.[1] Some study art from a feminist perspective, interpreting both the absence of female artists in the narrative of art history and the abundance of female images in art as signifiers of male hegemony.[2] For others, the exclusion of Native or aboriginal art from the canon offers opportunities for scrutinizing often unstated hierarchies and colonialist or neocolonialist perspectives.[3] The opposition between "art" and "craft," as well as that between fine art and popular art, has been reevaluated by scholars who

critique the explicit elitism that positions one type of art as superior to another.[4] As a broader variety of works presses resolutely into the space once reserved for the great Western tradition, it challenges the art historical canon. Moreover, art history's narrative no longer appears as a straight ribbon set with singular images of great works made in a finite number of styles validated by the academy; rather, it now is seen to consist of many threads, some connecting to others, some ending abruptly, some emerging from nowhere, some extending from beginning to end, some remaining fragments.

Past art scholarship often focused on a work's style or iconography, not always contextualizing it within its cultural, political, or economic milieu. Unlike their predecessors, many "new art historians" do address the social conditions under which art styles developed to understand how patronage, marketing and selling, collecting, the role of artist, and the function of his/her art in society all influence the nature of the artwork.[5] The stereotype of artist as passionate creator, living an intentionally unconventional life of aesthetic poverty in a garret, making artistic decisions based solely on what his or her soul demands, is a largely romantic fiction. As Kes Woodward says, "We have this mystical idea of art as being something that's totally different from everything else in life. But as much as I might like to pretend that's true, it's really not."

No artwork exists in isolation from its context, which, neither static nor finite, changes throughout its life. The cultural biographies of objects do not end with their creation, but incorporate the events surrounding their circulation and consumption, where they travel, and who exhibits, writes about, studies, copies, or appropriates them.[6] What viewers bring to the artwork and what they take from it become part of the artwork, as do institutions—the museum, the discipline of art history, and the art market (Leppert 1996:12). These elements of an artwork's life history

6

Inupiaq fur parka *(front and back)*
Helen Seveck
Arctic-ground-squirrel, wolf, and wolverine fur; domestic calfskin. 144 cm × 73 cm. Point Hope, 1961. Purchased from Chester Seveck, 1968. UAM68-003-0001

Though Helen Seveck came from Point Hope, she and her husband, Chester, lived for many years in Kotzebue, which may explain why a few knowledgeable visitors have told us that the parka is Kotzebue style despite the Point Hope origin listed on its label. (LEE)

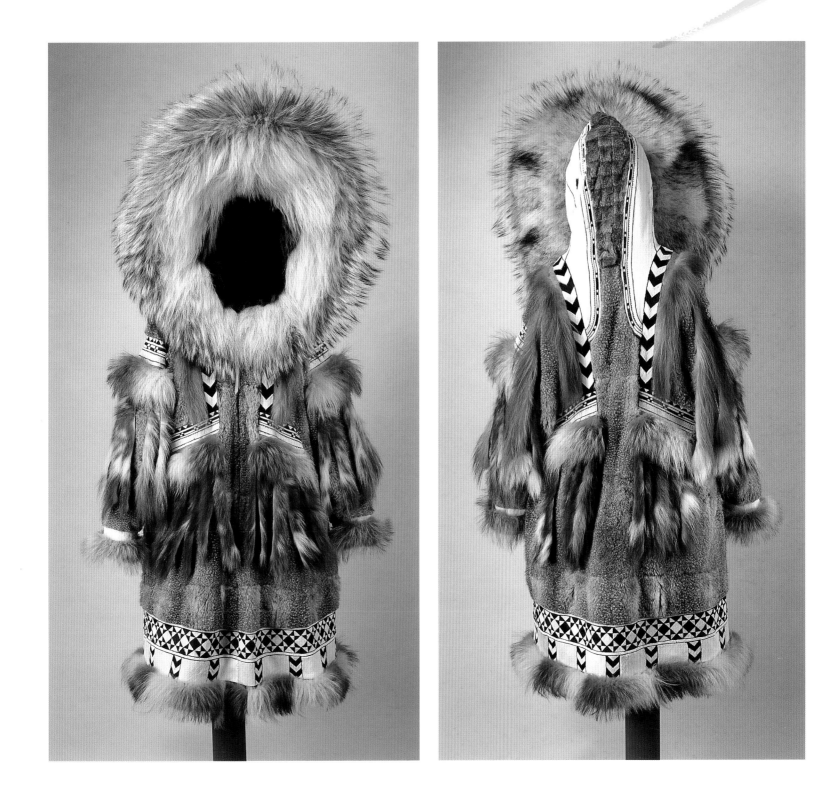

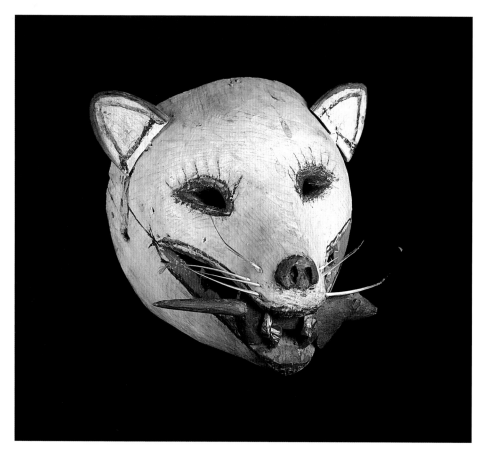

become "wrappings," surrounding it with layer upon layer of events and representations, each of which resonates with the others, creating an entity of ever-changing dimension, which nevertheless remains solidly attached to the actual work at its heart.

Even designating an object as "art" can become such a wrapping. For Woodward, "art" elevates an item and positions it upon a cultural pedestal. For anthropologist Molly Lee, the very same word can deprive a work of its cultural context. Lee has, on numerous occasions, pointed out that "art" often needs a qualifier. Some items, mostly those in the fine art collection, are "art by destination," made by artists who intend their creations to circulate in the art culture of museums, galleries, collectors, critics, and scholars (Maquet 1983). "Art" from the archaeology and ethnology collections—produced by those whose language offers no exact word for "art," and for whom the placement of their artifacts on the wall of a museum or in an art book would have been quite remarkable—is, in contrast, "art by metamorphosis."[7] An elegant Chilkat blanket used to convey to all the status of its wearer, a Yupik mask embodying the spiritual world, or an Inupiat fur parka becomes "art" when presented as such in a museum—or in an art book. Thus, at times, a chapter in the cultural biography of an ethnographic or archaeological artifact, such as those illustrated here, includes its metamorphosis into an artwork.

In its categorization of things, language can add to—or subtract from—an object's significance, as in identifying an object as "art" or in calling a two-thousand-year-old ivory carving from the Bering Strait region—arguably the most exceptional work in the UAM collection—the "Okvik Madonna" (fig. 25). This delicate sculpture of a long-faced woman, who probably represents a mythic "mother of the animals," from whose abdomen a mammal emerges, has nothing to do with the Christian Madonna. Although the designation was intended as a compliment, identifying an

7

Yupik fox mask
Anonymous
Wood, sinew, quill. 15.2 cm × 14 cm.
Qissunaq (Kashunuk), 1946.
Purchased from Frank Waskey, 1947.
UAM314-4353

Frank Waskey, whose Yupik name was Neqyacagaq (Little Fishy One), was an American trader with a long-standing interest in Yupik artifacts who lived intermittently on the Bering Sea coast during the first half of this century. In 1946 he collected ten masks in the old village of Qissunaq, twenty miles inland from Hooper Bay, at the Inviting-In Festival (Agayuyaraq), the most sacred Yupik annual event, held at the end of winter. The masked dances reinforced relations between the human and animal worlds (Fienup-Riordan 1996:40). According to one Yupik informant, unadorned animal masks such as this one, which contrast dramatically with the larger, more complex masks of nearby Hooper Bay, were characteristic of Qissunaq. Songs about white foxes are still sung in Chevak, where many former Qissunaq residents now live. This mask, reportedly made by the shaman Ingluilnguq, has a mouthgrip on the reverse rim, pegged teeth and ears, and bird-quill whiskers (Fienup-Riordan 1996:298). The animal in the fox's mouth is probably a lemming. (LEE)

Eskimo archaeological ivory with an icon from the Western tradition represents a kind of Eurocentrism inappropriate in this age.[8] At times, it is necessary to "unwrap" such "naming" to understand how an artwork's meaning has been constructed.

Museums

Museums have always wielded considerable power as agents of classification, determining what is and what is not art, crafting their version of the art historical narrative, validating certain works as canonical, and, by omission from that narrative, invalidating others.[9] As part of a larger movement to reassess how they do and do not accomplish their goals, museums are becoming more inclusive, as their classifications, which remain powerful instruments of definition, accommodate more and more varieties of art.[10]

Museums have, for some, a capacity to bore and make lifeless the most extraordinary things. Objectivity has played some role in this, as the remote curatorial voice speaking with authority and anonymity wraps the objects it interprets in a forbidding sheet of gray. Many museum visitors desire some sort of connection with what they see, but too often become disappointed or even alienated when museums make no effort to foster such connection. As Terry Dickey describes it, "The objects in our collection have a certain knowledge and information and perspective about the history of our state. Our visitors also have their own sets of knowledge and experiences. If they don't intersect, the museum visitor walks in the door and walks out again without any impact whatsoever. Like two ships passing in the night. What needs to happen is that these sets of knowledge and experiences find some ways to overlap. If they do, then we have something to talk about." Our goal is to enliven our artworks and enrich our visitors' museum experiences.

What museums select to exhibit, how their programs interpret those items, who visits them, and what they see there all contribute to and reflect the institution's entrenchment in the social fabric of culture. During the past decade, a large number of publications analyzing museums from perspectives ranging from sympathetic to highly critical have brought attention to their roles and functions in society.[11]

Art and ethnographic museums have been subjected to particularly critical judgment. Some critics charge that ethnographic displays, and the natural history museums in which such displays can commonly be found, are instruments of imperialism and challenge the presence of objects made by people not members of the dominant culture.[12] Other critics accuse art museums of having been elitist institutions that responded neither adequately nor quickly enough to the needs of America's diverse populations. Although art museums, like almost all other types of museums, include public education as part of their mission, some say they have defined their publics rather narrowly.[13] French philosopher Pierre Bourdieu (Bourdieu and Darbel 1990) has undertaken some interesting studies of how different classes of visitors react to art museums; although his examples are European, his conclusions are suggestive for American museums as well.[14] According to Bourdieu, since upbringing and schooling provide an individual with the tools to appreciate art, well-educated museum goers have no need for lengthy interpretive labels and thus feel comfortable in the art museum. In contrast, those less-educated visitors who have not learned how to look at, understand, and evaluate these artworks' importance often feel alienated, daunted, and, ultimately, ignorant.[15]

History can explain in part the art museum's particular stance on public education. In the late nineteenth century, art museums began to distinguish their educational programs from those of natural history museums. The natural history museums, which exhibited things acquired from the "natural" world—including not only plants, animals, and rocks, but also

from the "natural" peoples who lived in recently colonized lands—saw as their mission the education and socialization of the masses, particularly the hordes of immigrants flooding into the country from southern and eastern Europe. To achieve these goals, such museums gave considerable energies to explaining the content of displays, so that literate visitors would learn something of value.[16] In contrast, the art museums that owned and displayed the finest cultural products of the West welcomed the more elite and well-educated visitors.[17] Instead of providing explanatory texts like those at natural history museums, art galleries typically offered little more information about a painting than its maker's name, its date, and perhaps its donor, since an artwork worthy of display in a gallery needed no interpretation; it was, simply, intuitively obvious why this work deserved to have so privileged a position.

In recent years many museums have been working to diversify their exhibits to include art from different quarters and to pay closer attention to the educational needs of a broader cross section of the public. Since the 1980s some museums have devoted considerable effort to bringing Native Americans into the exhibit design and interpretive process;[18] others have become more welcoming to women.[19] Although many museums have become more pluralistic, some critics suggest that more needs to be done. For example, Marcia Tucker (1992:9–16) has coined the phrase "art-apartheid system" for the way some museums marginalize artworks by various ethnic groups, rarely presenting them as of merit *equal* to that of mainstream art.[20] For Irene Winter (1992:42), museums are indeed becoming less firmly wedded to those older foundations of art history—but usually in temporary exhibits, not permanent installations.

Stephen Weil (1995:108) recently proposed several ways art museums can enhance their educational success. He first urges the museum to become a forum for ongoing and open discourse, to balance aesthetic perspectives with approaches that emphasize other qualities in the art and to display not only "great" works of art, but those whose merit lies elsewhere than in their beauty. Weil concludes: "The traditional concept of the art museum as a temple in which to celebrate human genius of the few must be expanded into a view of the art museum as a place in which to celebrate the human accomplishments of the many, a place where the visitor may come to gain a better appreciation of that uniquely human capacity for creative transformation, which, while so clearly embodied in the creation of works of fine art, is by no means confined to that activity alone."

We would like to think that our institution has been creating more inclusive displays for some time. Our Main Gallery presents the art, culture, and natural history of Alaska in an interdisciplinary fashion, demonstrating the connections between the land and its people. Fine art, ethnology, and archaeology collections are treated as equally important indicators of the state's artistic heritage. In designing this gallery in the late 1970s, staff collaborated with Native advisors on the representation of their cultures. To replace the anonymity so often associated with beadworkers, basket makers, and carvers, whenever possible we identified the artists of works, such as the ladle by Inupiaq Simon Paneak (fig. 8). In addition, "traditional" items such as Yupik dance fans made of basketry and feathers appear alongside strikingly innovative works such as the same type of fan made from the plastic lid of a coffee cup.[21] This is intended to dispel the twin notions—still, unfortunately, prevalent among the general public—that Native culture does not have an ongoing history and that any accommodation to modernity deprives an object of its authenticity. Over the years we have continued working collaboratively with Native and non-Native artists as we developed special exhibitions, some that featured Native Alaskan art, some that presented non-Native art, and still others that displayed both kinds together.[22]

The Land

The immensity and striking grandeur of Alaska inspired many artists who have made the landscape synonymous with Alaskan painting.[23] In common with all art, painted and photographed landscapes do not present the *real* world to their viewers; instead, these images represent something the artist sees or imagines. For example, as we discuss further on, contemporaries and artistic colleagues Bill Brody and David Mollett convey decidedly different attitudes about the Alaskan wilderness as well as those about life and art. Brody's nature is alive, almost anthropomorphic, while Mollett's becomes an objectifying study of geometric forms and features (figs. 83 and 84).

Regardless of how wild and pristine the image is, a landscape painting implies both the presence of the human who created it and that artist's culture. The social conditions under which this landscape was made and the cultural uses to which it was put, both at the time of its completion and throughout its existence, wrap this product of the artist's vision, imagination, and intent (Leppert 1996:3). Those studying landscape painting today are turning from analyses of form toward an investigation of how these artworks express the values humans impose upon them, sometimes subtly, sometimes overtly. Thus Dutch seventeenth-century landscapes can be read to symbolize Holland's conquest of the sea, and paintings of the American frontier to indicate victory over the Indians and celebration of expansionist conquest of the wilderness.[24]

Landscape painting as a genre arose in sixteenth-century Europe, when scenes of farmlands and rural countryside were newly deemed worthy of artistic presentation.[25] It was not until the nineteenth century that artists began to paint, and poets to write, of wilderness. For example, the English Romantics represented mountains not as their seventeenth-century predecessors had—ugly, disfigured, malevolently asymmetrical, disharmonic symbols of God's wrath—but as

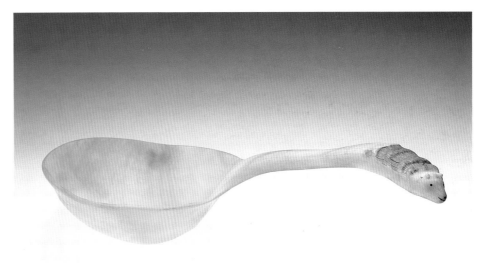

8

Nunamiut dipper
Simon Paneak
Dall sheep horn. 38.1 cm. Inupiaq. Anaktuvuk Pass, 1968. Purchased from artist, 1969. UAM69-068-0001

Water dippers were a necessary Inupiaq household utensil. On the arctic coast most were made of bentwood or whale bone, but some were fashioned out of sheep horn traded from the Nunamiut, or inland Inupiaq (Murdoch 1892:101–2), who inhabited scattered settlements in the river valleys of the mountains east of Point Barrow. Their descendants now live in the village of Anaktuvuk Pass in the Brooks Range. The Dall sheep is a key subsistence animal for the Nunamiut, providing meat as well as horn. Simon Paneak (1901–75), one of the last traditional Nunamiut hunters, served as guide and informant to the many Euro-Americans who traveled to the Brooks Range for research and hunting. The significance of the animal on the dipper handle, probably a fox, is unknown. (LEE)

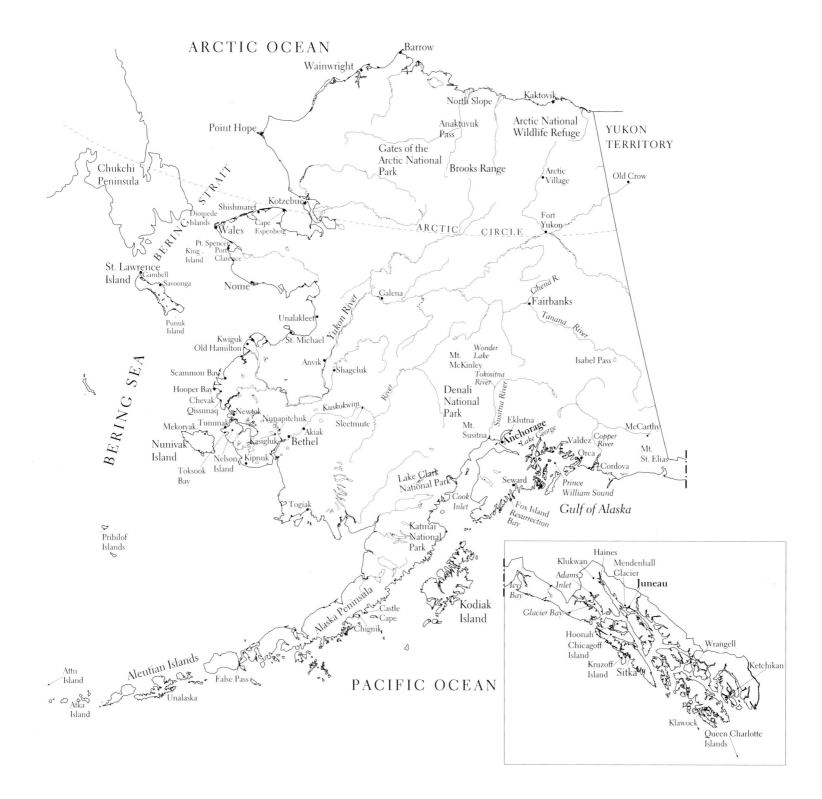

ARCTIC OCEAN

Barrow
Wainwright
Kaktovik
North Slope
Point Hope
Anaktuvuk Pass
Arctic National Wildlife Refuge
YUKON TERRITORY
Chukchi Peninsula
BERING STRAIT
Gates of the Arctic National Park
Brooks Range
Arctic Village
Old Crow
Kotzebue
Shishmaref
Diomede Islands
Wales
Cape Espenberg
ARCTIC CIRCLE
Fort Yukon
Pt. Spencer
King Island
Port Clarence
St. Lawrence Island
Gambell
Savoonga
Nome
Galena
Chena R.
Fairbanks
Tanana River
Isabel Pass
Punuk Island
Unalakleet
Yukon River
Kwiguk
Old Hamilton
St. Michael
Anvik
Shageluk
Mt. McKinley
Wonder Lake
Tokositna River
BERING SEA
Scammon Bay
Hooper Bay
Chevak
Qissunaq
Newtok
Nunapitchuk
Kuskokwim
Sleetmute
Susitna River
Denali National Park
Mekoryak
Tununak
Kasigluk
Akiak
Bethel
Mt. Susitna
Eklutna
Lake George
Anchorage
Valdez
Orca
Copper River
McCarthy
Nunivak Island
Nelson Island
Kipnuk
River
Lake Clark National Park
Seward
Cordova
Mt. St. Elias
Toksook Bay
Pribilof Islands
Togiak
Cook Inlet
Fox Island
Resurrection Bay
Prince William Sound
Gulf of Alaska
Katmai National Park
Alaska Peninsula
Castle Cape
Chignik
Kodiak Island
Attu Island
Aleutian Islands
False Pass
Atka Island
Unalaska
PACIFIC OCEAN

Haines
Klukwan
Mendenhall Glacier
Adams Inlet
Juneau
Icy Bay
Glacier Bay
Hoonah
Chicagoff Island
Kruzoff Island
Sitka
Wrangell
Ketchikan
Klawock
Queen Charlotte Islands

Alaska

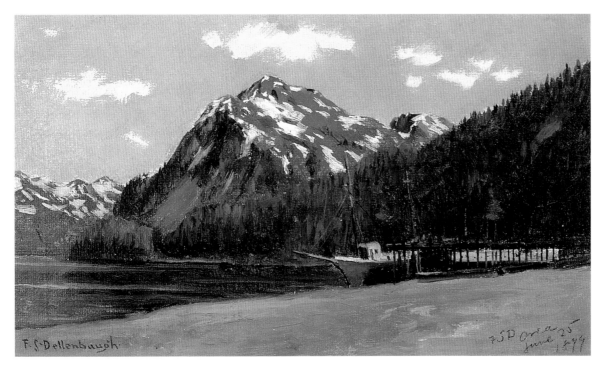

F.S.Dellenbaugh.

9

Pier at Orca
Frederick S. Dellenbaugh
Oil on board. 15.24 cm × 26.67 cm.
1899. Purchased, 1961. UA1030-2

Pier at Orca is one of two oils by the well-known artist Frederick Dellenbaugh (1853–1935) in the museum's collection. Both were painted in his role as one of the official artists on the last great exploring expedition to Alaska, the Harriman Expedition of 1899. This privately financed expedition, sponsored by railroad and mining magnate Edward Harriman, brought to Alaska a panoply of the country's best artists, scientists, and naturalists. Along with Robert Swain Gifford (see fig. 61), bird painter Louis Agassiz Fuertes, and photographer Edward S. Curtis, Dellenbaugh sought both to document and to respond artistically to the wonders of Alaska.

Dellenbaugh traveled widely in the American West, serving as expedition artist to John Wesley Powell in the Grand Canyon and writing and illustrating numerous books. His paintings from the Harriman Expedition are small and unassuming, but they provide a deft visual travelogue of the expedition's route along much of the coast of Alaska and as far north and west as Plover Bay in Siberia. (Goetzmann and Sloan 1982; Merriam 1901–14; K. Woodward 1995:31–35)
(WOODWARD)

glorious embodiments of freedom, irrationality, and spirituality (Nicholson 1997). Artists, including many Hudson River School painters and Albert Bierstadt, produced intense and dramatic paintings conveying similar messages.

If one region embodies the spirit of romanticism, it is Alaska, a land that offers intoxicating tastes of a wilderness to those who find "civilization" impoverishing and crave the inner peace isolation provides. For some, a venture into dangerous lands of life-threatening elements satisfies an urge to push one's limits to the extreme.[26] For others, landscape inspires nostalgic yearnings for a different kind of world. The idea of Alaska as the "last" wilderness suffuses its representations with a melancholic sense of loss for other, already vanished wildernesses, and an almost desperate wish to keep this one pristine. As Woodward explains, Rockwell Kent (fig. 80) sought respite in Alaska from personal problems and, imposing on it a host of literary and artistic allusions to Blake and Nietzsche, portrayed his Alaskan seascape as a pure, unspoiled place devoid of discordant and combative humans.

Images of this landscape's inhabitants also communicate nostalgia for a simpler, more independent life intimately tied to mountains and forests. Since well before statehood, Alaska has prided itself on being a land of determined and individualistic pioneers—some who as miners conquered the environment, some who have lived in harmony with it as trappers, hunters, and fishers, and some who have drawn from the wisdom and knowledge of those whose ancestors have lived on the land for centuries. While some artists choose to depict nature without a human presence, others represent the users of the land. Dog mushers are an especially popular subject for Alaskan art in several media: Fred Machetanz's musher in *Off to the Trapline* (fig. 10), Brian Allen's musher racing past a Pizza Hut (fig. 11), even Eskimo Happy Jack's

10

Off to the Trapline

Fred Machetanz

Oil on canvas. 55.88 cm × 71.12 cm.
1984. Purchased, 1985. UA85-22-1

Fred Machetanz (b. 1908) is perhaps the most popularly ac-
claimed artist to continue the traditional romantic image of
Alaska into the present day. Focusing on Alaskan animals, Native
people, sourdoughs, and the landscape, Machetanz's work is
widely reproduced and highly sought after by individuals and
public collections throughout the United States and abroad.

Born in 1908 in Ohio and trained in art at Ohio State Uni-
versity, Machetanz intended a brief visit to his uncle Charles
Traeger's Unalakleet trading post in 1935, but remained for two
years. After working as an illustrator in New York, sailing with a
coast guard patrol along Alaska's coast, and serving in the Aleu-
tians with the navy in World War II, he returned to Unalakleet,
where he met and married writer Sara Dunn in 1947. The couple

worked together on books, films, and lecture tours for many
years, and they still live near Palmer in the home they began
building in 1950.

Machetanz has become almost as much a legend as Sydney
Laurence and Eustace Ziegler among longtime Alaskans. His oil
paintings on Masonite employ ultramarine blue underpainting
followed by many traditional linseed oil glazes, achieving a
luminosity reminiscent both of Renaissance painters and the
twentieth-century painter Maxfield Parrish, who was an early
influence on the artist. (Diffily 1980; Doherty 1981; Lawton 1965;
Alaska Life 1941; McCollom 1974; Woodward 1993:118–22; Yost
1970) (WOODWARD)

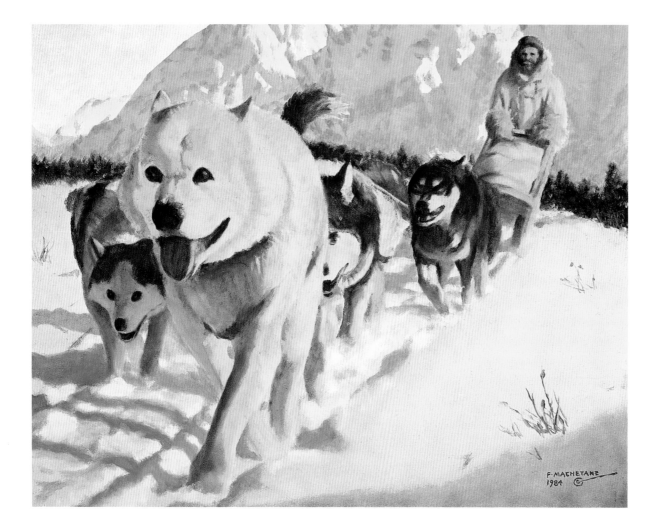

11

Pizza Hut
Brian Allen
Photograph, gelatin silver print.
35 cm × 43 cm. 1984.
Purchased, 1985. UAP85:076:001

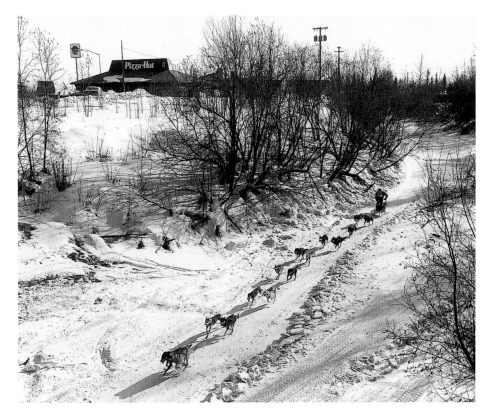

Brian Allen has made some remarkable photographs staying close to home. In fact, he makes every effort to photograph things that are part of his everyday experience. His eye seeks out aspects of northern life that are particular to Interior Alaskans. Sprint dog racing is a northern fascination. As the North American Sled Dog Championship is run through downtown Fairbanks, Allen could enjoy the event by walking only a short distance from his house. He made this image of Eddie Streeper speeding along Noyse Slough on his way to a second-place finish. For Alaskans, this is a perfectly plausible picture, but to many outsiders it is completely baffling. What is going on here? Is the man rushing home with a large pepperoni and cheese? And do many people in Alaska travel by dogsled? In his best works, Allen affords us an opportunity to see ourselves, our families and friends, and our community in a delightfully refreshing way, revealing the incongruities and quirks we rarely notice but which make life in the far north so wonderfully uncommon. (MCWAYNE)

popular dog-team image engraved on a walrus tusk (fig. 12). These independent, ruggedly individualistic Alaskans—usually men—who appear on artworks that city-dwellers display in their homes or curators install in a museum gallery, romantically evoke the lives of the "true" Alaskans, lives that only the few willing and capable of surviving the brutal Alaskan elements can hope to lead. These artworks provide for their owners an appealing fantasy of intimacy with the land, and freedom from society's constraints.

Works depicting this region of unparalleled natural splendor and its captivating people certainly hold great appeal for art buyers who want something clearly identified as Alaskan. But what exactly is the Alaska these works represent? In part, Alaska personifies a land we must preserve and treat with respect. Alaskan landscapes resonate with the message of environmentalism, with its goals of reduced exploitation of the land and preservation of large tracts of wilderness untouched by humans. Concern for the environment, its exploitation, and its preservation has a long history in Alaska. Henry Wood Elliott's outrage over the indiscriminate slaughter of fur seals on the Pribilof Islands in 1872 inspired paintings that served as political statements for limiting the seal harvest (fig. 13). Then, when Ansel Adams came to Alaska in 1947 to document the last great wilderness, he developed a reverence for unspoiled nature, which he communicated with intentionally dramatic photographs.

But Alaska also stands for a unique environment of excess, of extremes, of a nature powerful and dangerous, a world where Native cultures remain strong,

13

Seal Drive Crossing
Henry Wood Elliott
Watercolor. 29.21 cm × 40 cm. 1872.
Donated by Mrs. Harriet Wetmore
Chapell Newcomb, 1948. UA482-2

Henry Wood Elliott (1846–1930), best known in Alaska as the savior of the state's fur seal population, was one of the finest watercolorists to visit in the late nineteenth century. A Cleveland native, Elliott first visited Alaska in 1867 with the Western Union Telegraph Survey, just two years before serving as official artist for F. V. Hayden's U.S. Geological Survey expedition to the western United States. He was sent north again in 1872 as a U.S. Treasury agent supervising the Alaska Commercial Company's management of the fur seal industry in the Pribilof Islands. He visited regularly thereafter and continued to fight in Congress to reverse the practices that had led to disastrous declines in the northern fur seal population.

Elliott traveled more extensively in Alaska than did any other late-nineteenth-century artist, from the southeast to the Arctic Ocean. A prolific artist, he made striking watercolors of landscapes, villages, and animal life wherever he went. Varying widely in scale and level of detail, his work is characterized by clear topographical observation and a light, sure touch.

This piece, one of Elliott's largest works, is among his most dramatic scenes. Light/dark contrasts, stormy sky, and windwhipped foreground plants evoke the grim drama unfolding as much as does the middle-ground scene depicting the fur-seal killing ground itself. It is a testament to Elliott's skill that his means of depiction are at once so tightly harnessed and so evocative.

Never lurid or overdrawn, the painter's technique remains constant, but is sufficient to evoke such disparate moods as those in the two examples reproduced here (see also fig. 132). These are but two of some seventy Alaskan works by Elliott in the UAM collection. (DeRoux 1990:3–5; Elliott 1886; Graburn, Lee, and Rousselot 1996:56–57, 525–42; Shalkop 1982a; Van Nostrand 1963:11–17, 78–80; K. Woodward 1993:26–28) (WOODWARD)

12

Inupiaq incised tusk *(front and back)*
Happy Jack
Ivory. 64.8 cm. Nome, before 1918.
Donated by Dorothy Jean Ray, 1994.
UAM94-9-49

Undoubtedly the most famous of the pictorial engravers of ivory tusks was the Inupiaq artist Angokwazhuk, also known as Happy Jack (1873–1918). Like many other Eskimo artists, Happy Jack took up carving as a result of an accident; crippled by frostbite, he supplemented his income by carving ivory. He was already an accomplished artist when he was taken aboard a whaling ship and learned to incorporate whalers' scrimshaw techniques into his work. After his death in the 1918 influenza epidemic, Happy Jack's fame languished until anthropologist Dorothy Jean Ray's research restored him to his rightful position as "King of the Eskimo Ivory Carvers" (Ray 1961:5–24; 1996:115–17). The University of Alaska Museum was the grateful recipient of Ray's donation of five Happy Jack engraved tusks and cribbage boards. Happy Jack is known for his virtuoso skills as an engraver of realistic scenes. The dog team on this cribbage board was copied from an F. H. Nowell postcard photograph called "Howling Dog Team." (LEE)

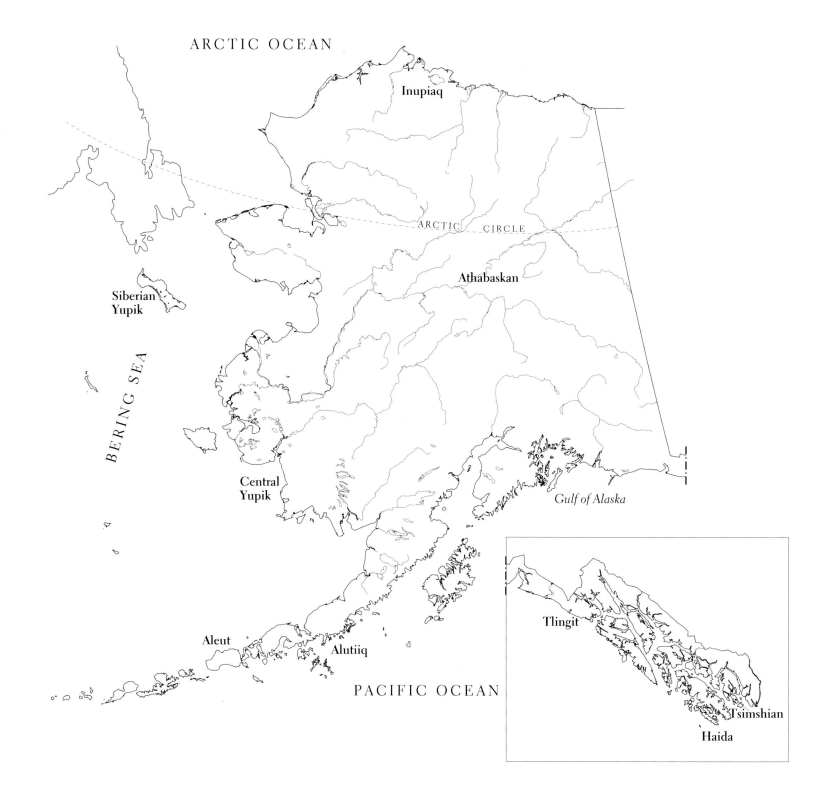

ARCTIC OCEAN

Inupiaq

ARCTIC CIRCLE

Athabaskan

Siberian
Yupik

BERING SEA

Central
Yupik

Gulf of Alaska

Tlingit

Aleut

Alutiiq

PACIFIC OCEAN

Tsimshian

Haida

Alaska Native groups

and, especially, a land where rugged individualists, those unwilling to acquiesce to others' rules or conform to the mores of the larger society, have a place. They care not at all what urbanites from the Lower 48 think; for them, hunting caribou and bear, trapping beaver and fox, and hitching dogs to a sled and mushing a thousand miles are not only permissible, but are the *rights* of Alaskans. And for some, the oil under the Arctic National Wildlife Refuge, the salmon in the rivers and streams, the trees in the forest, the gold in the earth are *theirs*, and woe to those who might wish to interfere with these perceived rights.

These two perspectives—Alaska as wilderness to be preserved and Alaska as the land of independent individualists—sometimes complement each other and sometimes clash. Today environmentalists worry about oil drilling in the Arctic National Wildlife Refuge, fearing that it may do irreparable damage to the caribou herds; they support rules restricting automobile traffic in Denali National Park and limiting the number of cruise ships that enter Glacier Bay; they clash with loggers unconcerned with the survival of various endangered species. Certainly many Alaskans embrace environmental causes. But many do not, and challenge the authority of those from "outside" whose attempts to dictate policy and behavior have been greeted with considerable resistance. The independent spirit of Alaskans in respect to their land might be seen as merely quaint if the stakes were not so high. Alaskan environmental issues affect not just Alaska, but the entire globe, for what happens in one region—clearcutting of forests or excessive burning of fossil fuel—has worldwide consequences. As the biggest, wildest, least-populated state, Alaska, its land, and its diverse people have become players in a complex environmental scenario of international significance. Thus, while landscape images may indeed be beautiful, they cannot shed the wrappings of the politicization—from numerous quarters and in many guises—of Alaska's land and resources.

Alaska Natives and Their Art

Second only to the landscape in popularity as subject matter for Alaskan art is the image of the state's first human inhabitants. It has long been acknowledged that few representations of Native Americans can be considered completely objective as popular stereotypes, positive or negative, entangle and distort most images.[27] Throughout much of the nineteenth century, imperialistic nations appropriated lands inhabited by indigenous people, justifying their actions in part by ascribing genetic inferiority to darker races. Missionaries, with the best of intentions toward their converts, rarely believed them equal to whites. And segregation in Alaska—which legally prevented Natives from sitting next to whites in restaurants and on busses—lasted well into the twentieth century. The painter James Everett Stuart's faceless Tlingit inhabitants of Sitka, barely distinguished from the land and sea surrounding them, seem closer to the "natural" world than do whites, and so inhabit a lower rung on the evolutionary ladder (fig. 66). Stuart himself may or may not have consciously embraced such judgments; they were nonetheless pervasive during his time.

Changing attitudes inspired more positive images of Alaska's Natives, many of which hover around those often indistinct boundaries separating affectionate admiration from romanticized stereotyping. Ted Lambert, clearly captivated by Yupik dramatic song and dance, portrays his subjects as nonindividualized actors in a celebratory drama. *Native Woman* by Eustace Ziegler (fig. 73), who lived in Cordova and enjoyed warm relationships with the Indians there, can be read either as an intimate, fully humanizing portrait of an individual or, as Glen Simpson suggests, as a "generic Indian," replete with clothes colored the brilliant turquoise blue of the American Southwest. Some artists who live in proximity to Natives for many years can successfully divest themselves of romanticizing tendencies, as has James H. Barker, who lived in Bethel

14

A Tundra Town at Breakup
Theodore Roosevelt Lambert
Oil on board. 34.29 cm × 51.44 cm.
1937. Donated by Charles M. Binkley,
1981. UA81-27-4

One of Alaska's most admired histori-
cal painters, Ted Lambert (1905–60)
traveled more widely throughout
Alaska than any other artist of his day,
working for lengthy periods from
McCarthy and Kennicott to Bethel,
Lake Clark, and Alaska's North Slope.
He spent almost twenty years in
Fairbanks.

A onetime pupil and friend of and
fellow traveler and artistic collabora-
tor with Eustace Ziegler, Lambert
was also highly regarded by Sydney
Laurence, who told an Anchorage
reporter in 1937 that Lambert was a
great artist and might someday be
Alaska's greatest painter (McCollom
1976:189). Unlike Laurence and
Ziegler, Lambert never abandoned
the rough life of the Alaskan sour-
dough, and his paintings are widely
sought after in part because they
reflect his ongoing personal involve-
ment with the details of pioneer life.
A Tundra Town at Breakup is among
the finest of the more than forty-five
paintings by Lambert in the UAM
collection. (*Alaska Life* 1942; First
National Bank of Fairbanks 1986;
K. Kennedy 1939; McCollom 1976;
K. Woodward 1995) (WOODWARD)

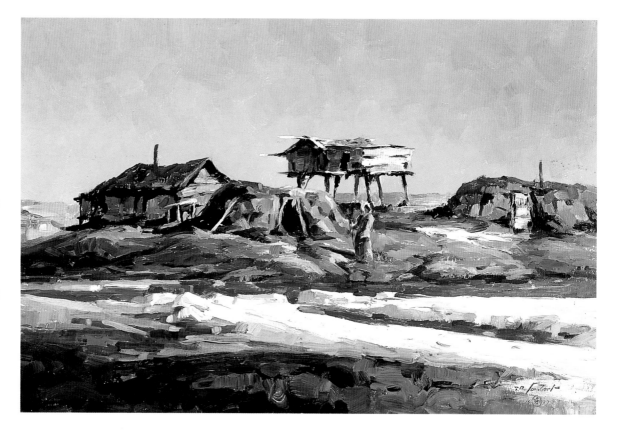

for thirteen years, creating strikingly honest photo-
graphs of the Yupik people there (fig. 63).

Non-Natives have for years represented Native
cultures in their museums. The typical ethnographic
exhibit of the past displayed masks, feast bowls,
and decorated clothing as components of a Native
culture as it existed prior to Euro-American accultura-
tion. A subtext of this kind of display was that it repre-
sented "authentic" Native cultures as untainted by
Western influence, thus perpetuating the myth of the
"disappearing primitive" who would be soon over-
whelmed by the forces of progress. "Traditional" cul-
ture was thought to be pure and unacculturated;
objects embodying accommodations to the colonial
forces were deemed inauthentic and thus not worthy
of display.

The designation of tradition as authentic and
acculturation as inauthentic emerges from the appli-
cation of a colonialist paradigm that inscribes clear
divisions between colonized and colonizers. Some
words used to characterize these supposed polar oppo-
sites—such as "underdeveloped" and "developed,"
and "uncivilized" and "civilized"—express disrespect
for aboriginal peoples. Others, such as "spiritual" and
"secular," promote the "noble savage" stereotype of
Indian as shaman, a notion that holds enormous
popular appeal, as television, movies, New Age books,
and advertisements make quite evident.[28] Even some
Natives embrace this cliché, as in Molly Lee's ac-
count of Poldine Carlo, an Athabaskan elder who, on
visiting the collections to see an old chief's jacket,
said, "It's so nice to see this old stuff where beadwork

is just beadwork. All these new artists are making things and they put the circle here and the dot here and they say, 'This represents God.'"

Alaskan Native art confronts and shatters the equation of authenticity with purity. Native Alaskans—Eskimo, Aleut, Athabaskan, Tlingit, Haida, and Tsimshian—have never existed in pristine isolation from one another, nor from more recent immigrants to their lands. As always happens when different people meet, the various cultures of Alaska interacted, the borders between their respective domains becoming increasingly obscure.[29] Artistic hybridity was one result of this interaction. Perhaps the most ancient Alaskan example of such hybridity appears in the Ipiutak carvings from Point Hope, which some scholars suggest were influenced by Siberian art. More recently, according to Molly Lee, the coiling technique used for Yupik baskets diffused, along with the culture of tea, from China to Siberia to Alaska. Colorful beads obtained in trade from Russians, Europeans, and Americans were used by Athabaskan women to create floral decorations on such items as baby carriers, clothing, and sled bags, replacing the colored porcupine quills used earlier. Ingenious transformations of new media continue; Alvin Amason describes earrings fashioned from carved transparent toothbrush handles.

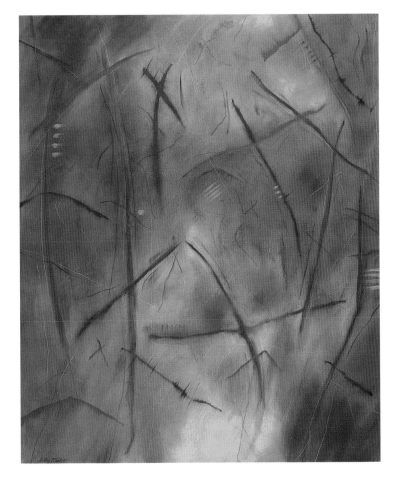

15

Traces VI
Robby Mohatt
Oil and alkyd on canvas. 182.88 cm × 152.4 cm. 1993. Donated by the Friends of the University of Alaska Museum, 1995. UA95:060:001

One of Alaska's best-known abstract painters, Robby Mohatt was educated at Beloit College, Black Hills State University, and the University of Alaska Fairbanks. She has worked as a professional artist and teacher in Fairbanks since 1983. Her work is included in the collections of the Anchorage Museum of History and Art and the Alaska State Museum, both of which have featured solo exhibitions of her paintings. She received an Individual Artist Fellowship from the Alaska State Council on the Arts in 1992.

Mohatt's work features dense, mysterious grounds on which float forms and symbols often reminiscent of signs from various Native American cultures. According to the artist, "*Traces* are signs of life—tracks and furrows etched into the earth, markings on rocks, broken branches. This evidence of life points to our origins. The human search for our beginnings leads us to our destiny" (K. Woodward 1995:53). (Luevano 1995; K. Woodward 1995) (WOODWARD)

They were a gift to Yupik Theresa John from her mother, who was too poor to buy beads.

The tradition of hybridity has remained strong throughout the twentieth century. George Ahgupuk mixed a long-time Eskimo graphic tradition with a narrative style influenced by Western art (fig. 69). Glen Simpson draws on his Tahltan heritage, his deep knowledge of other Native artistic traditions, and his fine training in metalwork. Alvin Amason integrates his Alutiiq roots with art school education. Native people today make art for use within their own communities and for sale to outsiders, live in bush communities as well as cities, and learn from their elders and from professors at universities. At the UAF Native Arts Program, Native Alaskans interact, influencing each others' work and in turn are influenced by developments in the contemporary art world. Moreover, in an ongoing circulation of ideas, themes, and styles, the first people of the state inspire and are inspired by non-Natives.

A fine line can be drawn between non-Natives who respectfully draw on Native art for new artistic visions and those who simply imitate it. Examples of the former include Fran Reed, who crafts baskets of fish skin using an old Athabaskan technique (fig. 110), and Robby Mohatt, whose paintings allude subtly to Plains Indian symbolism (fig. 15). But others make what Glen Simpson identifies as "artifakes," things made in a "traditional" style that could easily be mistaken for Native manufacture, and are sometimes sold as such by disreputable dealers. Simpson and Amason agree that such "artifakes" lack a depth of meaning solidly rooted in the past and an intimate connection to community. An imitation might *look* like a Native artwork, but can never *be* one.

New appreciation for the ingenious creations that emerged over years of cultural exchange and, certainly, a new respect for the artistry of such works did not develop in a vacuum. Earlier I mentioned the "new art history" that embraces indigenous art from all over the world. Over the past several decades increasing visibility of cultures other than those of Europe and North America has resulted in a worldwide celebration of pluralism.[30] Shifts from narrow focus to broad, from singular to multiple, from unilineal to multilineal, from restrictive to open, from homogeneity to heterogeneity can be connected to global socioeconomic changes. Cultures other than those of the West can no longer be ignored, in part because of the expanding economic power of what used to be called Third World countries, the opening up of the Second World (once communist), and the increasing vocality and growing empowerment of such minorities as Native Americans. With instantaneous global communication linking previously isolated or unconnected places, we now know far more about the world than at any time in the past and thus have more opportunities to discover, understand, and embrace the artistic creations of many varied cultures.[31]

Visitors to the Land

We also have innumerable opportunities to consume the art of many societies around the world: Benetton clothing ads celebrate diversity, stores in suburban malls sell Andean sweaters and Southeast Asian carvings, and mail-order catalogs offer African jewelry and Guatemalan textiles. Worldwide expansion of tourism has contributed a great deal to such commodification of culture, for tourists want souvenirs of their trips, material mementos that remind them of the places they have been and the people they have encountered.[32] People have been traveling north on holiday trips since the 1880s, when steamships sailed up the Inside Passage from San Francisco and Seattle. Today hundreds of thousands of tourists pour into Alaska each year, arriving on luxury cruise ships or ferries, or driving in cars or recreational vehicles, making tourism one of the largest and most rapidly expanding industries in the state. These visitors constitute a willing and enthusiastic market for Native-made artworks.[33]

Since the end of the last century, women of virtually every Native Alaskan group have produced fine trade baskets of birchbark, willow root, spruce root, and, on the Aleutians, of grass. In Barrow men expertly weave baleen into baskets topped by walrus-ivory carvings. Nunivak Islanders carve walrus tusks (fig. 16); Inupiat women make dolls; and Yupik craft birds, buttons, and cribbage boards from ivory. In the past designating something "tourist art" was enough to brand it forever as "inauthentic"; tourist pieces were thought acceptable for display on a traveler's mantelpiece, but were barred from the domain of fine art.

Some find hybridized art manufactured solely as a commodity for sale to outsiders a disturbing refutation of the myth that the pristine "primitive" functions in a small, isolated world, untouched by civilization. In truth, Native artists do not lose their ethnic identity when they interact with non-Natives in the marketplace any more than Michelangelo did, when his commissions were paid for by popes and Medici princes, or Ghiberti did when his studio's success depended upon the largesse of the Guild of Cloth Refiners (Even 1989). If great works of the Western tradition are made for sale in an art market, why are not Native pieces acceptable? Native artists, like almost all artists everywhere, must worry about the mundane realities of markets, consumers, and museums, and participate in an international market, producing commodities they sell to their particular clients—tourists to their lands.[34] The knowledge these artists have of that market is strikingly accurate, for, as Ruth Phillips (1996:116) points out, Native manufacturers of tourist art were in the past and continue to be today careful anthropologists themselves, studying the aesthetics and material culture of non-Native customers to figure out what they could make that would sell.[35] Simply because artists pay attention to their prospective market does not mean their art is devoid of cultural content; on the contrary, such works often constitute profound statements of Native self-identity intended for consumption by outsiders.

It is within this context of art made for visitors to Alaska that the realms of Native art and landscape painting converge. The landscape, inhabited for brief periods of time by tourists wishing a respite from city life, has itself become a commodity that can be bought and consumed.[36] Souvenirs of that landscape can take the form of a postcard—depicting an icon such as Mount McKinley or a totem pole that almost fetishistically appears over and over—sent by untold numbers of visitors to equally untold numbers of recipients around the world. Or they can take the form of paintings which, by selling well among visitors to the state, qualify as "tourist art." The tourist even becomes a subject of artistic representation, as in the

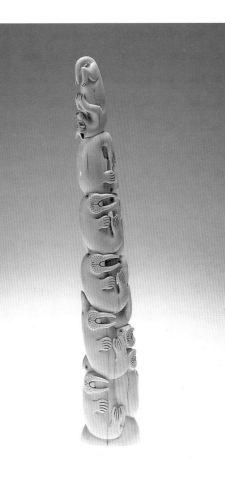

16

Yupik tusk
Anonymous
Ivory, baleen. 42.8 cm × 7 cm × 4 cm. Nunivak Island, 1925–30. Purchased, 1956. UAM717-113

The carving of multiple animals on walrus tusks in two and three dimensions spans the Eskimo/Inuit territory from the Bering Sea coast to Labrador and seems to have evolved after the introduction of cribbage boards by the Yankee whalers. Carvers on Nunivak Island developed a unique version of complex intertwining animals known as the Nunivak tusk. In the 1920s Lomen Brothers, a Nome-based trading and reindeer-herding company, established a herd on Nunivak and brought along ivory to encourage the curio business. The Nunivak tusk can be distinguished by its almost fully three-dimensional carving and the writhing, exuberant depiction of the animals. The fully developed style allows us to date this example (Ray 1981:65–66). (LEE)

case of Charles Mason's grumpy visitors who drove their "WUZIBUS" to Alaska (fig. 90).

One characteristic of Alaska is its large number of transients, some of whom, like tourists, take brief excursions here, and others who remain for extended periods. A significant number of the state's population turns over each year; some leave because their military service is complete, others due to the long, cold, dark winters or the remoteness from family and friends. A good number of the painters represented in this book qualify as visitors, either short- or long-term.

Elliott came to Alaska as an artist on the United States Geological Survey's western expedition from 1869 to 1871. Henry Varnum Poor and Joseph John Jones were stationed in the territory during World War II (fig. 17). And although Sydney Laurence lived in Alaska for two decades, from the mid-1920s until he died in 1940, he came north from the Lower 48 only during the summertime. Though the devotion these artists had *to* the land is not in question, their roots *in* the land did not penetrate as deeply as did those of tenth-generation New Englanders or Midwesterners in their earth. The cultural biography of a work by these artists would include the reasons why each came to Alaska, what the voyage away from home and settling in a remote part of the world meant for him or her, why he or she stayed as long or short as he or she did, and

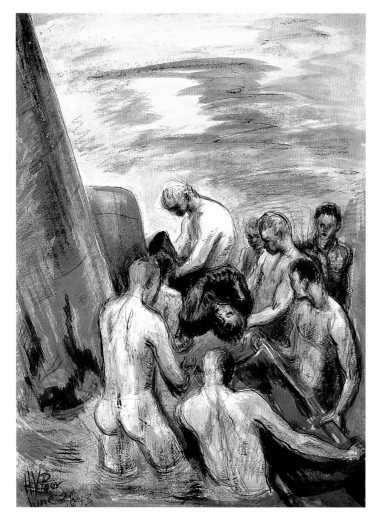

17

American Soldiers Pulling a Dead Russian from Chena Slough
Henry Varnum Poor
Pen and ink, wash, pastel.
46.99 cm × 36.20 cm. June 20, 1943.
Purchased, 1987. UA87-3-26

Henry Varnum Poor (1888–1970) was one of several nationally prominent artists officially involved in chronicling the war effort in Alaska during World War II. Sent north with the Army War Art Unit in 1942, he toured the Alaska Territorial Guard coastline defenses, traveling as far north as Barrow. He also spent some time at Ladd Field, near Fairbanks. Alaska was a major stopover for Russian pilots ferrying planes from the United States to Europe in the Lend-Lease war operation.

This painting documents the retrieval of the body of a Russian pilot who crashed in the Chena River near Fairbanks. As in most of his Alaskan work, Poor has captured here the essence of a dramatic incident in a swift, sure, economical manner. His skills as an incisive observer of fleeting events made him a particularly effective documenter of people and events in the war effort.

Poor wrote two books about his experiences in Alaska, *An Artist Sees Alaska* (1945a) and *The Cruise of the Ada* (1945b). (Binek 1989; Poor 1945a, 1945b; K. Woodward 1993:109–11)
(WOODWARD)

18

Fusion Pattern #1

Cheryl A. Bailey

Mixed-media photograph; type-c
print, glitter, tape. 22 cm × 34 cm.
1983. Purchased, 1983.
UAP83:155:001

Cheryl Bailey created a little dilemma with this work by forcing
our curators to answer the question What is a photograph? Is this
really a work of photographic art, or should it be classified as
something else entirely? Bailey called the image a photograph
and, ultimately, that is what we called it, too. Though a photo-
graph forms the substrate of *Fusion Pattern #1,* the work derives
its strength from the visual and tactile effects of the attached
materials: the tape, the glitter, the colored ribbon. The artist
seems to be addressing the conflict between nature and man,
between the animals that roam the woods and the developer
who divides and fences their habitat. Bailey has brought this
Alaskan issue to light in an artwork that is both thoughtful and
humorous in its visual presentation and creative in its use of
unconventional materials. (MCWAYNE)

what insights—artistic, emotional, even spiritual—
the new land offered.

A Patchwork of the North

This book's organization differs from classification sys-
tems grounded in academic disciplines and from the
organization of our own museum. We store "art" items
in three separate museum departments: archaeology,
ethnology, and fine art. Archaeology contains items
excavated from beneath the ground, whether dated
pre- or post-contact; ethnology the objects made by
Native Alaskans during the nineteenth and twentieth
centuries in what could be called a "traditional" style;
and fine art the paintings, sculptures, graphics, and
photographs mostly—although not exclusively—done
by non-Natives. A book written twenty years ago about
this museum's art collection would probably have in-
cluded only works stored in the fine arts collection,

whereas one written a decade ago might have included
pieces from archaeology and ethnology, but presented
separately from fine art. We have intentionally *not* ar-
ranged the artworks in this book according to their de-
partments of residence, nor have we organized them
by traditional categories—landscape, beadwork, bas-
ketry, sculpture, photography. We have learned in the
past several years a healthy skepticism of classification
systems that exclude as well as include, dismiss as well
as incorporate.

In addition, we interpret materials not from a
single, authoritative point of view, but from numerous
perspectives, none of which purports to render the
"truth" about the object. Our conversations range
widely from object to object, idea to idea, always mov-
ing, never assuming finality and closure, allowing
space for new insights, welcoming new connections.
Our group—Native Alaskan artists, non-Native artists,

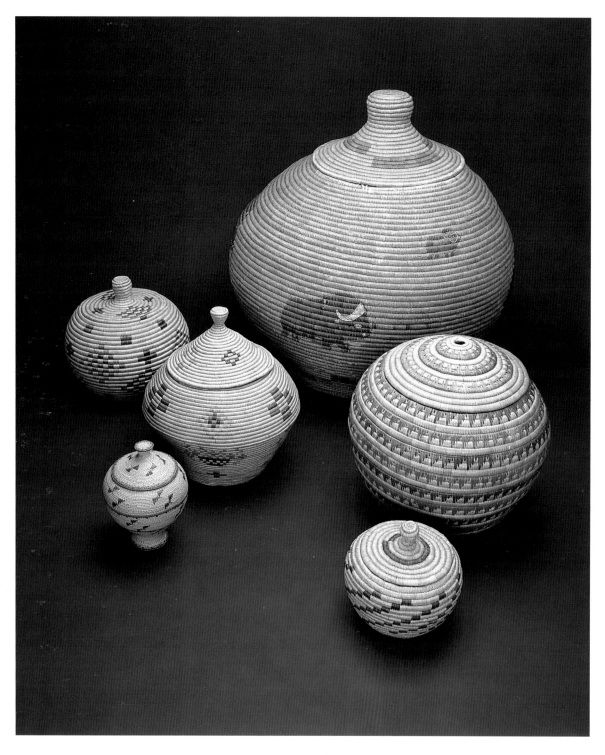

19

Central Alaskan Yupik coiled grass baskets
(clockwise from top right)

A. Musk-ox basket
Attributed to Lola Joshua
56 cm high. Mekoryuk, Nunivak Island.
Purchased, 1996. UAM96-20-1AB

B. Coiled grass basket
Lizzie Chemigak
29.8 cm high. Toksook Bay.
Purchased, 1981. UAM81-3-78AB

C. Coiled grass basket
Anonymous
14.2 cm high. Tununak, Nelson Island.
Collected for UAM by Otto W. Geist,
1927. UAM1-1927-741AB

D. Coiled grass basket
Neva Mathais
17.7 cm high. Chevak.
Purchased, 1981. UAM81-3-170AB

E. Coiled grass basket
Anonymous
31.1 cm high. Kwiguk. Collected by
Henry Wolking, 1905–40. Museum
bequest, 1942. UAM236-4047AB

F. Coiled grass basket
Anonymous
21.6 cm high. Nunivak Island.
Collected by James VanStone, 1952.
Purchased, 1952. UAM554-5451AB

art historians, an anthropologist, an educator, a designer, and a journalist/interviewer—attempts, in the words of Barry McWayne, to identify artworks with a "personal experience [to make] direct links between the object and its history, an individual's experience and a more permeating, universal kind of experience." Poems by Peggy Shumaker enhance those experiences and add to this intentionally heterogeneous, fragmentary, "patchwork" representation of our artistic treasures. The heterogeneity of this approach is described with passion by W. J. T. Mitchell (1994b:419):

> Suppose we thought of representation, not as a homogeneous field or grid of relationships governed by a single principle, but as a multidimensional and heterogeneous terrain, a collage or

The UAM Ethnology Department's outstanding collection of Alaska Native basketry includes over a thousand examples. Almost four hundred are made of grass and are primarily from the Bering Sea region. Coiled grass basket-making, which is not traditional in Alaska, probably spread across the Bering Strait from Siberia during the whaling era of the late nineteenth century. The art is now practiced widely in as many as twenty-five Yupik villages, and numerous substyles have developed, several of which are represented here. Basket B is recognizable as being from Nelson Island (the location of Toksook Bay) because of its coil width, globular shape, and rows of alternating color, whereas the coiling width and knob shape on basket C are typical of Nelson Island. The fine coiling on basket D is characteristic of both Chevak and Hooper Bay.

Perhaps the most appealing example illustrated is basket A, decorated with musk-oxen. (Two large bears appear on the reverse side.) Although the basket was offered for sale at a Fairbanks art gallery earlier this year with no accompanying documentation, I guessed from the decorative style that it had been made during the 1930s, when musk-oxen were introduced on Nunivak Island. Irene and Richard Davis, lifelong Nunivak Islanders, remember that Lola Joshua (d. c. 1950s) was the only Nunivak woman to make such large baskets. An unexpected donation from a generous patron enabled us to add the basket to our collection. (LEE)

patchwork quilt assembled over time out of fragments. Suppose further this quilt was torn, folded, wrinkled, covered with accidental stains, traces of the bodies it has enfolded. This model might help us understand a number of things about representation. It would make materially visible the structure of representation as a trace of temporality and exchange, the fragments as mementos, as "presents" re-presented in the ongoing process of assemblage, of stitching in and tearing out. It might explain why representation seems to "cover" so many diverse things without revealing any image of totality, other than the image of diversity and heterogeneity. It might help us to see why the "wrinkles" and differences in representation, its suturing together of politics, economics, semeiotics, and aesthetics, its ragged, improvised transitions between codes and conventions, between media and genres, between sensory channels and imagined experiences are constitutive of its totality. The theory of representation appropriate to such a model would have to be pragmatic, localized, heterogeneous, and improvisatory totality.

We hope to encourage our readers to think about art, how they feel about art, and why they think art is important, if they do—and if they do not, then why. By assembling material from our archaeological, ethnographic, and fine art collections, by presenting art by women and by men as of equal significance, and by organizing art in a nonhierarchical fashion according to themes that transcend culture, age, and class, we hope to provide the reader with more knowledge of Alaskan art and of how contemporary artists, art historians, anthropologists, and museum professionals understand that art.

But, stepping back from such intellectual analyses, we also acknowledge the profound impression art can make on the individual. Alvin Amason, picking

up an Aleut grass basket (fig. 20) of the type his grandmother used to make, shares a Proustian memory of the beach on which they picked the grass for her baskets, the place where they found the pigments for her dyes, and the ancient artifacts they unearthed nearby. Discovering art with others can be a joy; when Amason shows his Native art class an Old Bering Sea harpoon kit, "the best ivory carver in class picks it up and just goes, 'Damn! How'd they do that?' Just amazed at the tools. Knowing what tools they did and didn't have back then—say, made of squirrel teeth or a piece of iron from a Japanese hull. 'How could he do stuff like that? It's incredible. What vision!'" Even very familiar objects can elicit new delights, as when Wanda Chin discovers new depths in the "Okvik Madonna" and Kes Woodward's birch trees (fig. 95). Or when Molly Lee reveals the passion underlying her academic perspective as she describes "the cultural biographies—the wonderful tales and the sad ones—that fill our files in the collection room, add so much to an object's resonance." The sheer pleasure one receives from seeing, thinking, feeling, and remembering is the most intimate, personally delightful experience an artwork can provide. And that is something that Alaskan art offers everyone.

Notes

I would like to thank Janet Catherine Berlo, Jonathan Holstein, Molly Lee, Ruth Phillips, Peggy Shumaker, and Kesler Woodward for their comments on this chapter.

1. For an excellent study of the new art history's connection to Native American art studies, see Phillips (1989a).

2. Works from a feminist perspective include Broude and Garrard (1982, 1992), Butler (1990), Nochlin (1988), Parker and Pollack (1981, 1987), and Pollack (1988, 1993).

3. For interesting discussions of these issues, see Clifford (1988) and Marcus and Myers (1995).

4. See in particular Varnedoe and Gopnik (1990) and Bright and Bakewell (1995). George Marcus (1995:30) comments that "a core notion in the contemporary debate about postmodernism is the idea that the creative possibilities of modernism are exhausted, assimilated by popular culture, that the distinction between high and popular culture no longer holds." Orvell (1995:xii–xiv) also asserts

that the boundaries between such categories have eroded, "offering a variety of permutation and borrowings at both ends and across the middle." An interesting recent study by Nemerov (1995) reassesses Frederic Remington from the perspective of contemporary historic events, ideas, and values and situates this artist—whom many have judged a second-rate creator of clichés and sentimental images—within the context of his times.

5. A useful summary of the history of art history is provided by Fernie (1995:22): "In terms of content, the history of art can be seen as having moved, broadly speaking, from a concentration on the uniqueness of the work of art in Vasari's time, to the work of art as expression of high culture in Winckelmann's, to its status as a manifestation of spiritual and social forces for the Hegelians, to a multiplicity of aims, including reaffirmation of the centrality of the work of art and the artist, in the middle of the century, and to the made image as a register of broad social, ideological and psychological structures in our own period." Other works that address the "new art history's" social focus include Baxendall (1985, 1995), Belting (1987, 1994), Berger (1992), Clark (1973), Leppert (1996), Lubin (1994), Mitchell (1994a), Preziosi (1989), Staniszewski (1995), and Tagg (1992).

6. Igor Kopytoff provides an excellent framework for investigations of a work's "cultural biography," suggesting that what is important is not the fact that an item was obtained, but "the way [that item is] culturally redefined and put to use" (1986:67).

7. Nestor Garcia Canclini (1995:176) proposes for the definition of art the "space where society carries out its visual production."

8. The term "Eskimo" as a generic word for Eskimoan-speaking people is acceptable in Alaska, even though it is not in Canada, where "Inuit" is the proper term. In Alaska three groups speak Eskimoan languages: the Inupiat in the north, the Yupik in the west, and the Siberian Yupik on St. Lawrence Island.

9. A ground-breaking analysis of this process was done by Duncan and Wallach (1980).

10. The literature critiquing museums and analyzing their modes of representation is extensive and varied. Some more recent publications that deal with museums in general are: Bal (1996), Bennett (1995), Boniface and Fowler (1993), Clifford (1988, 1997), Greenberg et al. (1994), Hooper-Greenhill (1992, 1995), Karp and Lavine (1991), Lumley (1988), MacDonald and Fyfe (1996), Orvell (1995), Pearce (1990, 1992, 1994), Sherman and Rogoff (1994), Stone and Molyneux (1994), Vergo (1989), Walsh (1992), and Weil (1995).

11. MacDonald and Fyfe (1996) have devoted an entire volume to the anthropology and sociology of museums as they both form and reflect social relations.

12. See, for example, Ames (1992), Belk (1995), Bennett (1996), Coombes (1994), Harvey (1996), and Stocking (1985). Deborah Root (1996:107ff.), stridently takes on ethnographic museums: "As we near the millennium, it has become increasingly clear, even to

some of us at the heart of Western culture, that there is something not quite right about large buildings stuffed with the booty of formerly conquered people. . . . If we think the matter through carefully, the concept of museums—particularly ethnographic museums and museums of 'natural history'—quickly dissolves into strangeness and necrophilia. Museums can be truly thought of as cannibal institutions: large edifices containing stuffed animals and the paraphernalia of cultures believed to be dead or dying, all organized according to the current scientific theory. . . . A taxidermal aesthetic suffuses the museum."

13. Recent discussions specifically on art museums include Association of Art Museum Directors (1993), Crimp (1993), Duncan (1995), Fyfe (1996), Pointon (1994), Winter (1993), and Zolberg (1992, 1994).

14. See, for example, Zolberg (1992, 1994). For an interesting study of those who do not go to art museums, see Getty Center for Education in the Arts (1991).

15. See Fyfe (1996) for a discussion criticizing Bourdieu for being deterministic.

16. For a case study of how one large museum in New York City did this, see Jonaitis (1992).

17. For an interesting discussion of this process, see DiMaggio (1991).

18. For example, exhibitions at major art museums that involved Natives in their curation include Jonaitis (1991), Wright (1991), and Fienup-Riordan (1996).

19. For a recent study of the inclusion of women's art in museums, see Glaser and Zenetou (1994) and Higgonet (1994). See also Duncan (1995:102–32) for an interesting discussion of how modern art museums privilege men.

20. See also Berger (1992), who makes a similar argument.

21. For an illustration of these plastic dance fans, see Fienup-Riordan (1996:113).

22. See, for example, Carlo and Fosdick (1988), Fienup-Riordan (1986), Ray (1996), Wallen (1990), and Woodward (1995).

23. See Woodward (1993) for an excellent study of Alaskan painting.

24. As Mitchell (1994a:17) states, "These semiotic features of landscape, and the historical narratives they generate, are tailor-made for the discourse of imperialism, which conceives itself precisely (and simultaneously) as an expansion of landscape understood as an inevitable, progressive development in history, an expansion of 'culture' and 'civilization' into a 'natural' space in a process that is itself narrated as 'natural.'"

25. For recent works on the landscape, see Adams (1994), Barrell (1980, 1986, 1992), A. Bermingham (1986), Gifford (1993), Helsinger (1996), Jackson (1984, 1994), Kemal and Gaskel (1993), and Pugh (1990).

26. For more on the quest for remoteness, see Tuan (1993).

27. The classic book on how stereotypes of Native Americans changed over the centuries to reflect the dominant society's needs is Berkhofer (1979).

28. See, for example, Bird (1996), Morris (1994), and O'Barr (1994) for studies of such stereotypes.

29. The literature on the changing perspectives of anthropology toward its subjects of study is extensive; many pages have been devoted to dispelling the myths of authenticity and purity. Works that deal with material culture studies from this perspective include Clifford (1988), Marcus (1995), and Eric Michaels (1994).

30. Jencks (1996:30) even comments that a commitment to pluralism is "perhaps the only thing that unites every post-modern movement."

31. For a recent publication on colonialism and postcolonialism, see Prakesh (1995). For more on tourism, travel, and culture formation, see Clifford (1990, 1992).

32. An important essay on the process of commoditization of such items is Appadurai (1986:13), which proposes that "the commodity situation in the social life of any 'thing' be defined as the situation in which its exchangeability (past, present and future) for some other thing is its socially relevant feature."

33. The first major work on tourist art was Graburn (1976). For more recent studies of this subject, see Phillips (1995), Steiner and Phillips (1998), Lee (1998), and Jonaitis (1998).

34. Canclini (1995:173–74) challenges the traditional, stereotyped differentiation between art and craft—art traditionally conceived of as spiritual, beautiful, and nonuseful, made by solitary artists of singular vision; craft emerging from the realm of practical objects, made by rustic, collective, and anonymous artisans unaware of the larger world. He also argues (223–27) that museums, which were formed to house collections, now show many kinds of items in their galleries, but the classifications between high and popular art are disappearing, creating serious problems for those who still wish to engage in classification.

35. A great deal of work exists on collecting. See, for example, Belk (1995), Elsner and Cardinal (1994), and Pearce (1992). The relationship between museums and tourism has been the topic of various publications, including MacCannell (1989:77–80) and Boniface and Fowler (1993:102–20).

36. Mitchell (1994a:15) says, "Landscape is a marketable commodity to be presented and re-presented in 'packaged tours,' an object to be purchased, consumed, and even brought home in the form of souvenirs such as postcards and photo albums. In its double role as commodity and potent cultural symbol, landscape is the object of fetishistic practices involving the limitless repetition of identical photographs taken on identical spots by tourists with interchangeable emotions." See also Kemal and Gaskell (1993:15) for more on this.

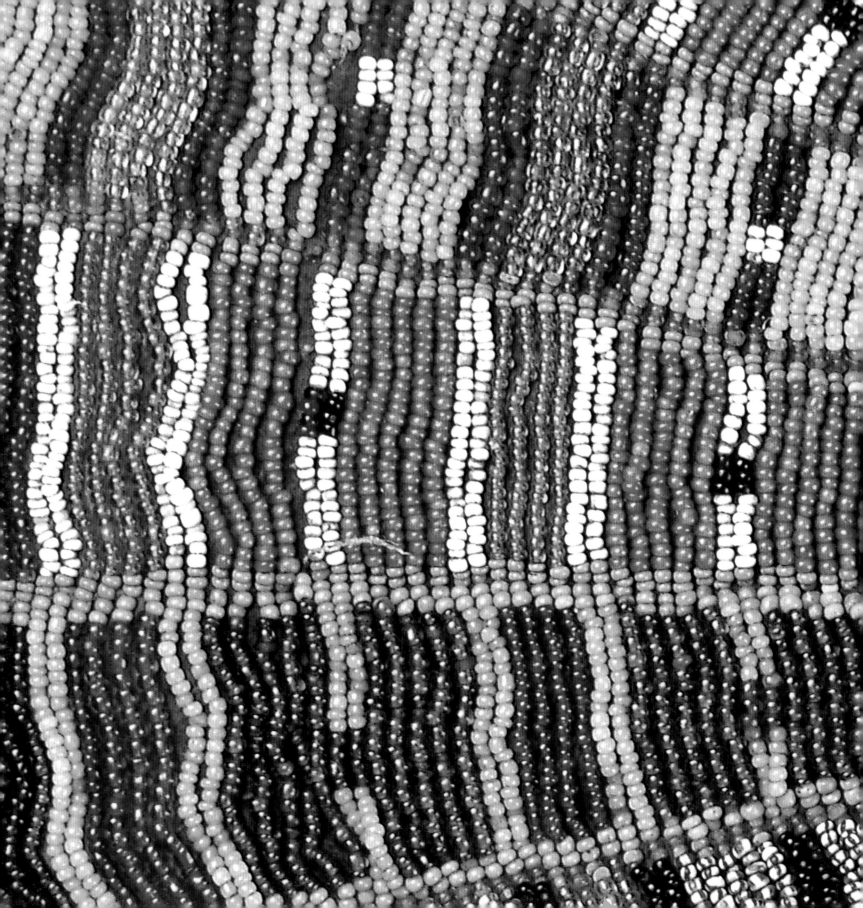

2

Resonance of Memory

Braided River

Under the ice, burbot glide
as if giving birth
to silence.

Someone who held the auger straight
drilled clean through
to moving water,

set gear, then hurried home,
chilled blood pulling back
from the surface, circling deeper

toward the center, the sacred.
As all winter the heartwood
holds the gathered birch sap

still. Ours is only one bend
of a wild, braided river.

Peggy Shumaker
Wings Moist from the Other World

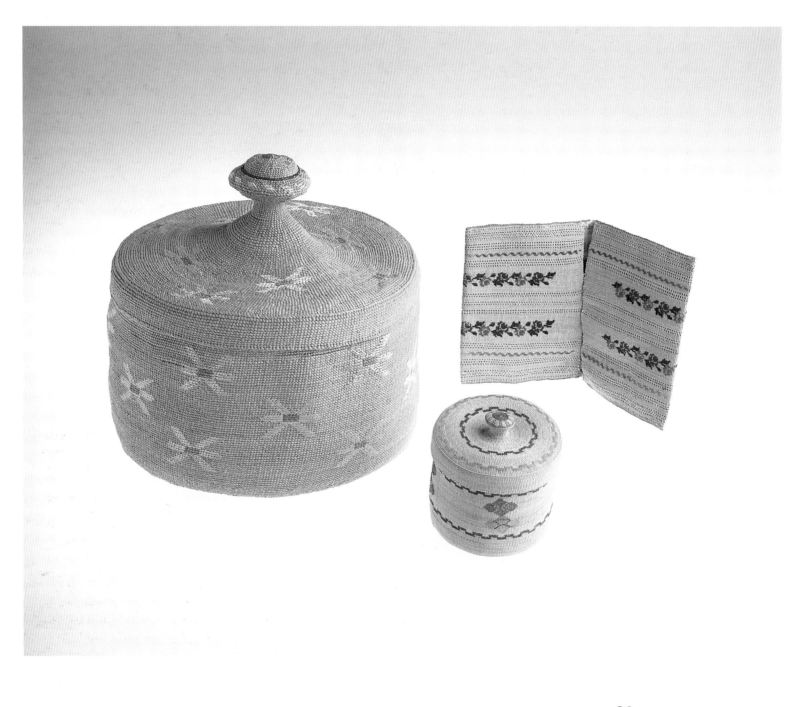

20
Aleut grass baskets

Amason: My level of appreciation changes depending on what I pick up. Like this grass basket (fig. 20). My grandmother used to weave these things, and I helped her harvest the grasses. So with a basket in my hand, I'm almost physically there: I know the exact beach where we picked the grasses, and the time of the year we would have gone there. I know how far I'd have to go for yellow ocher or red ocher. Or where the artifacts are.

If I find a toggle harpoon near the site where we're picking grass, it's really something. Wow, I think, this was a camp! It was a winter camp or a summer camp, or maybe whales went through these narrows here. A bunch of shards or flakes from making, let's say, a stone lamp, tells you people spent a lot of time here. The weapons they used tell you what kind of animals they harvested. You can tell it's an old camp, here for hundreds and hundreds of years. There's something special about it.

On the other hand, if I pick up an object from Barrow, which is way out of my area, it's not the same. I know different things: that men traditionally make baleen baskets there because ivory and baleen are men's materials (fig. 22). Although you would think basket making would be for women.

Lee: Barrow is the only place where men make baskets. It's the only exception in North America, if not the world.

When I chose these I was looking for the two most beautiful baleen baskets in our collection. It was a complete coincidence that both were of polar bears.

Simpson: You weren't seeking physical strength?

Lee: No. But maybe the guys who made them were. I've always thought the way those finials were carved had something to do with how hunters saw things. They carved what they saw—just exactly what a polar

Large basket

Anonymous

Grass, embroidery thread. 9.9 cm high (without lid). Aleutian Islands, before 1918. Donated by Helen D. Brosius, 1947. UAM392-3

Wallet

Xcenia Brown

Rye grass, embroidery thread. 14.7 cm high × 9.5 cm wide. Attu Island, 1903. William Brown Collection. Donated, 1970. UA70-003-012

Small basket

Anonymous

Rye grass, sewing silk, woven twine. 6 cm high (without lid). Attu Island, before 1918. Donated by Emma Lambert, 1964. UAM64-49-7

Of the myriad types of Native North American basketry in general—and Alaska Native basketry in particular—perhaps none is more revered than that practiced by women on the remote, fog-bound Aleutian Islands. During the Nome gold rush of the 1890s prospectors who struck it rich often bought such baskets as souvenirs when their ships refueled in Unalaska en route home. Twined from finely split sea grass, the baskets' delicacy of design and extreme fineness made them as prized among turn-of-the-century basket collectors as they are today. The heyday of Aleut basketry was before the disastrous 1918 influenza epidemic, when most of the older weavers perished. Unfortunately, little is known about most of these baskets because of their early initial collection dates. In recent years there has been a revival of Aleut basket making, an encouraging sign for the perpetuation of this extraordinary art form.

The basket on the left is woven in the Unalaska style. Diagnostic features are its coarser (about 170 stitches per square inch) weave, absence of the added third strand at the basket's corners, thinner knob stem, and rounder knob. The overall pattern of "stars," which appear on a number of Unalaska-style baskets, corresponds to the Russian Cyrillic symbol for *kh*.

The basket on the top right is a small wallet whose shape is inspired by Euro-American prototypes. Its floral embroidery, fineness of weave, and incorporation of a hemstitching pattern all reflect its Attu origin.

The basket on the bottom right is a classic Attu type. The most telling characteristics are the extra strand added to the base, lid, and knob in the row where they turn the corner (Shapsnikoff and Hudson 1974). The isolated medallions repeated several times around the basket's circumference and balanced between running borders of geometric patterns are typical of both Attu and Atka baskets (Hudson 1987:66). One of the most pleasing features of Aleut baskets generally is the knob decoration. Here, the basket makers used the same colors as on the main body of the basket but employed complementary patterns. This basket, which has approximately 750 stitches per square inch, is the most finely woven in the UAM collection. Researchers think that the combination of geometric and floral decorations harkens back to Russian wallpaper and embroidery patterns. (LEE)

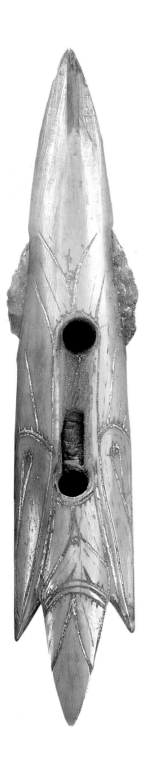

21

Old Bering Sea toggle harpoon head with inset blades
Anonymous
Ivory, chert. 12 cm. St. Lawrence Island, Old Bering Sea period (C.E. 400–750). UA79-053-0105

The toggle harpoon head is a unique adaptation to hunting sea mammals in the arctic pack ice. When thrust beneath the tough hide of the walrus or seal, this harpoon head leaves no part of the tool exposed to be broken off against the sharp edges of ice floes. The design reflects cultural preferences of the maker, physical limitations of the raw material, and functional requirements of the tool. Many harpoon heads made from caribou antler differ in shape from this ivory piece, while retaining necessary functional characteristics.

The elaborate decorative style of this example may reflect the spiritual connection between the human hunter and the intended prey. Ethnographic accounts record the perception that beautifully decorated hunting tools were produced by Yupik and Aleut hunters to please the spirit of the intended prey and thus ensure success in hunting. (Arutiunov and Sergeev 1972:305–11; Collins et al. 1973:3–9, 11 [illus.]; Crowell and Fitzhugh 1988:121–25; Dumond 1977:118–25; Fitzhugh and Kaplan 1982:66–67; Geist and Rainey 1936:200–209) (JONAITIS AND YOUNG)

bear's head would look like poking out of an ice hole. Women would not make baskets like these, and, in the old days, they didn't carve ivory. This form is uniquely male.

Simpson: These charms carry the power to hunt at sea, also very male.

Lee: That's a Robert James from Wainwright (fig. 22). And the decoration is bird quill, not light baleen. Light baleen would be a slightly different color, more yellowish and translucent.

Amason: It has a bird quill in there?

Lee: Yes. They used snowy owl quill if they could get it.

Amason: Wow.

McInnis: So Alvin's life experience lets him "own" those Aleut baskets in ways that are particular and intimate for him. It has to happen to each of us in ways that are unique.

Chin: Sometimes what's on exhibit becomes personal and intimate when you let yourself take the time to really see it. It happens to me. I've worked at this museum for sixteen years, but I never really saw the "Okvik Madonna" until one day when Gary Selinger and I were talking about it (fig. 25). He was gathering caption information for this book and called me over and said, "Why is this art? What do you see here?" It was an honest question. He's a scientist. He wanted facts.

So I looked. I really looked at the figure on the Madonna's abdomen. I had assumed it was weathered, smoothed away by age. But then I saw something quite different—a draped figure, a figure that was pushing out, emerging. I started telling Gary what I was seeing, analyzing it for him. We both gained a renewed appreciation. The facts teach us one thing, but the physicality of the piece—its material essence—has something to teach us, too.

22

Inupiaq baleen baskets

Anonymous
Baleen, ivory. Basket, 3.8 cm high
(without bear's head) × 8.9 cm diam-
eter; lid, 4.4 cm high × 7.6 cm diam-
eter. Barrow, 1943. Purchased from
Claire Fejes, 1981.
UAM81-3-0161

Robert James
Baleen, ivory, bird quill. 6.4 cm high
(with lid) × 10.5 cm long × 9.5 cm
wide. Wainwright, 1950s. Donated by
Dr. Laurence Irving, 1983.
UAM83-25-1AB

Baskets of baleen, the keratinous substance forming the strainer-
like mouthparts of the bowhead whale, have been woven by
Inupiaq men since shortly after the turn of the century. At that
time, baleen was a valuable raw material in Euro-American
culture because it could be heated and re-formed. Its most
common use was in stays for "whalebone" corsets. Thus baleen
was an important trade item for the Inupiat in the whaling
communities of arctic Alaska. With the invention of plastics, the
bottom fell out of the baleen market, leaving the Inupiat, who
were dependent on imported ammunition and foodstuffs, with
a serious trade deficit. At the suggestion of Barrow trader Charles
Brower, Inupiaq men began weaving baleen baskets for the
tourist market. These are perhaps the only type made by men
both because the material is extremely tough to work with and
because traditionally baleen, which does not collect frost, was
closely associated with outdoor, male activities (Lee 1983).

The basket at left is woven in the open-weave technique
invented in the early 1940s by Barrow basket maker Marvin S.
Peter. The shape and weave suggest that it may have been made
by Peter himself. The finial carving, with its minutely articulated
teeth and tongue, is one of the most accomplished examples of
baleen basketry.

The basket at right, by Robert James (1901–78), exemplifies
the classic period of baleen basketry (c. 1935–50). James's baskets
are masterpieces of both weaving and carving. His weaving
abilities are evident in the tightly executed stitches and the
accents of contrasting light bird quill. His control of form can be
seen in his shallow-sided baskets and oval shapes. James's most
characteristic finial is a polar bear's head. Its bared-fang stance
was borrowed from the Alaska Territorial Guard insignia, first
used during World War II (Heinrich 1950). Also typical of James
are the notched corners of his starter pieces and finials. (LEE)

24

Polar Bear Profile
Robert Bateman
Acrylic on canvas. 60.96 cm × 91.44 cm. 1976. Donated by Grace Berg Schaible, 1991. Exhibited in *Portraits of Nature: Paintings by Robert Bateman,* Smithsonian Institution, National Museum of Natural History, 1987. UA91:036:001

Perhaps the most widely acclaimed wildlife painter in the world today, the Canadian artist Robert Bateman (b. 1930) is a fervent conservationist whose work and voice urge both appreciation of and care for our wild natural heritage. Born in Toronto, the artist has traveled in search of wildlife and landscape throughout the world, and his paintings have been the subject of museum exhibitions, television documentaries, and several books.

This major work has been widely reproduced and was included in the 1987 retrospective exhibition of Bateman's work at the Smithsonian Institution's National Museum of Natural History. Noting his fascination with the unique fur of the great arctic carnivore, Bateman has said, "I have treated the fur as landscape" (Derry 1981:128). As is the case with all of his best work, the painting is alive with complete mastery of both gesture and detail. (Bateman 1984, 1985, 1986; Derry 1981 [illus.], 1985; Shetler 1987 [illus.]) (WOODWARD)

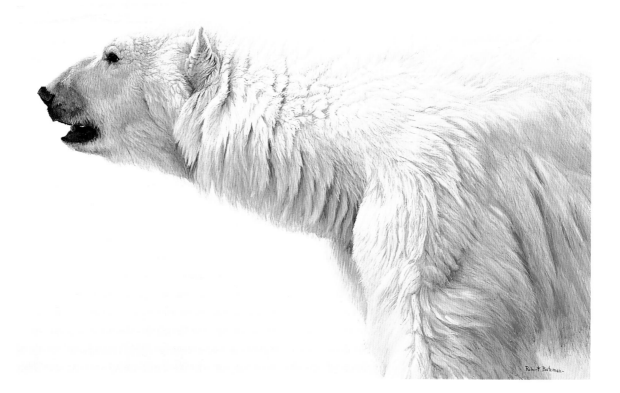

25

Okvik Eskimo human figure
Anonymous
Ivory. 18 cm. Okvik site, Punuk Island. Okvik period. Excavated by Otto Geist, 1934, and deposited in UAM. UA4-1934-0607

This unique piece depicting a figure holding a child or animal was excavated by Otto Geist at the Okvik site, located on the largest, most northerly island of the Punuk group. Although popularly referred to as the "Okvik Madonna," this ivory carving does not portray a figure from the Christian tradition. Very few other figurines from this period have smaller beings on the belly. This piece is decorated with roughly cut parallel lines on the torso and short single spurs above the arms and backside. The long, narrow, oval-shaped face has an elongated ridgelike nose, carved eyebrows, and a twisted smile. Anthropologists have long debated the significance of this piece, and Okvik figurines in general, without reaching consensus. (Bandi 1969:70–71, 72 [illus.]; Collins et al. 1973:8 [illus.], 9; Rainey 1941:63, 465, 551–52, 533 [illus.]; Ray 1961:41 [illus.]; Wardwell 1986:36) (JONAITIS AND YOUNG)

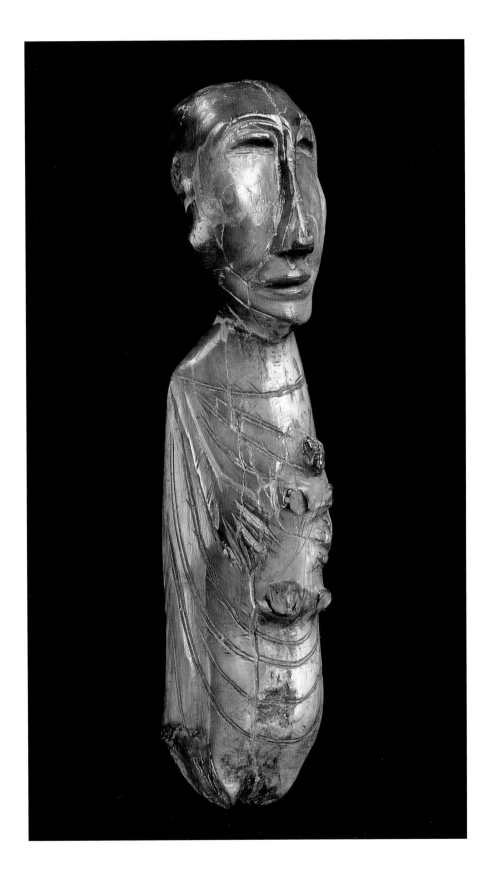

McWayne: You're talking about how looking closely made you see something new. Sometimes it's the artists' ability to see that reaches us—the way they make their own deeply personal experiences universal.

Charles Janda made this beautiful image of an alluvial fan (fig. 26). He was head park ranger at Glacier Bay for a long time, loved the land there, and loved making pictures. He might pick up a shell or something else he found and bring it home as a keepsake, something to speak to him about a particular moment. His photography captures this sense of eternity.

In a different way, Margie Root's intensely personal images become universal (fig. 27). She explores her own life, her particular emotions, her history, her ancestors. It's a unique experience. But her artistic expression of it reaches much further.

Woodward: We're talking about how art moves people. Unfortunately museums too frequently *categorize* things instead of connecting them. Art historians tell us, "This painting was done by *this* person and it's in *this* style," and they think they've said something significant. It's the same with artifacts, when we identify, say, a Tlingit "basket from the postcontact period." It's useful information, but museum visitors need more. Alvin, Wanda, and Barry

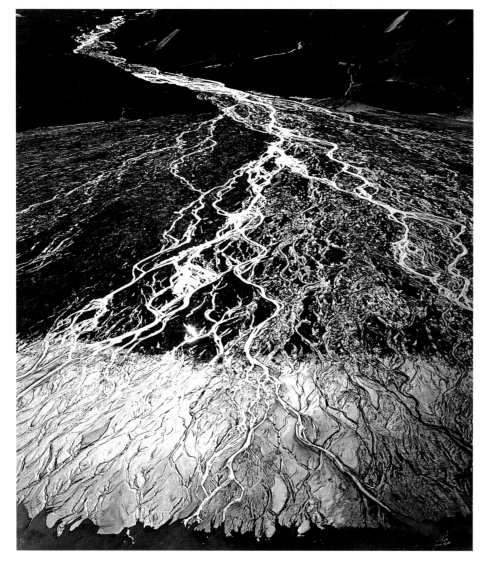

26

Alluvial Fan, Adams Inlet
Charles Janda
Photograph, gelatin silver print.
25 cm × 22 cm. 1968. Purchased,
1984. UAP84:120:001

For many years Charles Janda was chief ranger at Glacier Bay National Park in southeast Alaska. He spent much of his free time photographing the Park's grandeur and tranquillity. With broad access to the Park and the opportunity to return time and time again to favorite places, Janda could capture the right light at the right time of year to do justice to Glacier Bay's spectacular land forms and majestic scenery. His powerful aesthetic vision is underpinned by superb technical skill. His elegant black-and-white landscapes shimmer with intensity and depth. He clearly relishes the land he administered and brings that feeling to his photographs. This work, a dramatically rendered view of water and light, uses the full range of contrast available in black-and-white photography to create a sense of brilliance and drama, elements present in many of Janda's finest images. (MCWAYNE)

are talking about the difference personal experience makes—the artist's and the patron's. There must be ways to encourage equivalent experiences among museum visitors—to get people past "That's an Aleut basket, that's a Sydney Laurence."

McInnis: Well—how do you do that?

Dickey: I approach education within the museum this way: The objects in our collections contain a certain knowledge and information and perspective about the history of our state. Our visitors also have their own sets of knowledge and experiences. If they don't intersect, the museum visitor walks in the door and walks out again without any impact whatsoever. Like two ships passing in the night.

What needs to happen is that these sets of knowledge and experiences find some way to overlap. If they do that, then we have something to talk about. If they don't, it's just a pretty basket, a pretty picture, a pretty artifact, or a pretty charm. We haven't really changed or confirmed the kind of information that the visitor comes in with. We need to expand both the amount of knowledge the museum presents and the amount of knowledge that our visitor takes away.

McInnis: Doesn't the range of experiences people bring to the museum also affect their experience once they get here?

Dickey: That's why we have to vary the educational programs we offer people—at different levels—so we offer everyone the opportunity to broaden their experiences. Some of our visitors bring a college experience. Some of them high school. Others elementary. If we had a single set of experiences that people came in with, we would have a very clearly defined mission for museum education.

Jonaitis: We get a lot of visitors from outside Alaska, from states with small Native populations. Many think all Alaska Natives live in snow houses or that

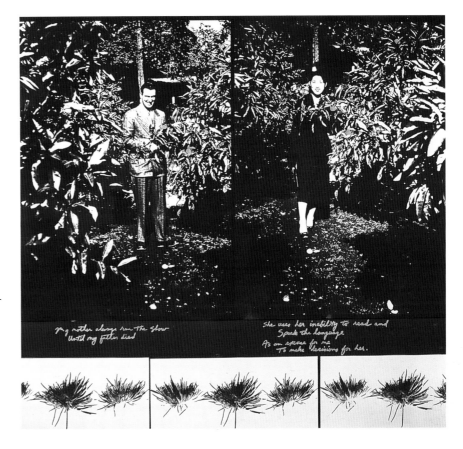

27

My Mother Always Ran the Show
Margie Root
Photograph, hand-colored
cyanotype. 71 cm × 75 cm. 1990.
Purchased, 1992. UAP92:001:001

Margie Root's images derive from childhood memories. The sparse visual and verbal components of her work, especially the monochromatic blue of the cyanotype, enhance the poignancy of her recollections. This piece employs family snapshots to reflect on the relationship between her American father and Japanese mother. The text reads:

> My mother always ran the show
> Until my father died.
> She used her inability to read and speak the language
> As an excuse for me to make decisions for her.

When the University of Alaska Museum offered to purchase the photograph, the artist at first declined. She was torn between showing her art publicly and selectively sharing it with friends and colleagues. But with the sale and subsequent exhibition of the piece, Root was encouraged to continue her exploration of family relationships and has developed an impressive body of work. (MCWAYNE)

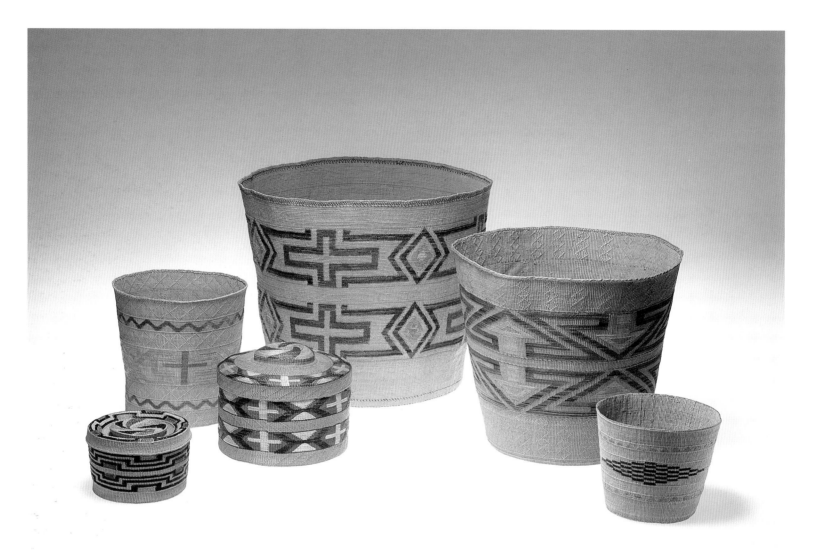

Tlingit spruce root baskets
(left to right)

Rattle top basket

Anonymous

Spruce root, maidenhair fern stem, dyed grass. 6.4 cm high. Southeast Alaska. Collected by Hardy Trefzger, 1915–59; purchased, 1959. UAM840-60AB

The body of this basket has two rows of Wave pattern (Paul 1944:63). The lid has Wave pattern along the outer edge and Fern pattern (Paul 1944:66) on top of the central knob. The knob has pebbles inside.

Basket

Anonymous

Spruce root. 14 cm high. Southeast Alaska. Collected by Hardy Trefzger, 1915–59; purchased, 1959. UAM840-8

The central design is composed of Cross pattern (Paul 1944:61) bordered by Mouth Track of the Woodworm (Paul 1944:47) along top and bottom.

Rattle top basket

Anonymous

Spruce root, maidenhair fern stem, dyed grass. 11.4 cm high. Southeast Alaska. Collected by Rhoda Thomas, 1937–57; bequested to UAM, 1967. UAM67-98-101AB

Both the lid and body incorporate the Cross and Crossing pattern. At the center of the top is the Fern Frond pattern (Paul 1944:1.1).

Berrying basket

Anonymous

Spruce root, maidenhair fern stem, dyed grass. 24 cm high. Southeast Alaska. Collected by Hardy Trefzger, 1915–59; purchased, 1959. UAM840-2

Cross and Tattoo pattern (Paul 1944:61, 63).

Berrying basket

Anonymous

Spruce root, maidenhair fern stem, dyed grass. 20.3 cm high. Southeast Alaska. Collected by Hardy Trefzger, 1915–59; purchased, 1959. UAM840-44

Half the Head of a Salmon Berry pattern (Paul 1944:67).

Basket

Anonymous

Spruce root, maidenhair fern stem. 8.85 cm high. Southeast Alaska. Collected by Hardy Trefzger, 1915–59; purchased, 1959. UAM840-30

The central design is unusual, resembling solid Goose Track pattern (Paul 1944:65) bordered on top and bottom by a row of red Half the Head of a Salmon Berry pattern (Paul 1944:58).

The twined spruce root baskets of the Tlingit (Northwest Coast) Indians are perhaps the best known of the Alaska Native basketry traditions. Compared to Aleut twined beach-grass baskets, Tlingit examples are far more numerous. The weaving is less fine, mainly because of the differences between spruce root and beach grass. Nonetheless, Tlingit baskets are beautifully made—evenly woven, with controlled shapes and well-executed designs. Around the turn of the century hardly a tourist returned from an Inland Passage cruise without at least one example. After about 1950 the art form became moribund, but in the Native art revival of today, a few young Northwest Coast weavers are producing baskets, some of which compare favorably in quality with those of their forebears. (LEE)

29

Athabaskan or Yupik beaded collar

Bedusa Derendy

Seed beads, moosehide, fabric. 38.1 cm × 12.7 cm. Canoe Village, c. 1912. Donated by Elena Derendy Pete, 1964. UAM64-65-5

The ethnic origin of this magnificent beaded collar is uncertain. It was made in about 1912 by Bedusa Derendy from Canoe Village, an early settlement on the western bank of the Kuskokwim about thirty-three miles from the modern-day village of Sleetmute, for her daughter Elena Pete. According to Mrs. Pete, the collar was enlarged as she grew older. Many of the beads date from styles popular in the nineteenth century and some are of Russian origin. Sleetmute and Canoe Village (now abandoned) have been inhabited by both Deg Hit'an Athabaskans and Yupit. Athabaskan beadwork specialist Kate Duncan has examined the collar and is unsure of its ethnicity, since the floral designs normally associated with Athabaskan beadwork are absent. Poldine Carlo and Hannah Solomon, Athabaskan beadworkers from farther upriver, are equally mystified, as is Ann Fienup-Riordan, expert on Yupik material culture. Sleetmute resident Maxie Alexei suggests that Deg Hit'an is the best designation for the piece, although he points out that many families in this area are of mixed Deg Hit'an and Yupik origin (Alexei 1996).
(LEE)

they're extinct. If they have any knowledge of Native art, it's fringed-buckskin quilled shirts from the Plains. We need to deal with such misunderstandings.

Chin: I'd like them to at least see something authentic while they're with us. Terry and I saw a video, *Unzipped*, about the fashion designer Isaac Mizrahi, who created an "Eskimo collection" inspired by Hollywood movies and film clips. We watched in horror, and I said, "Oh, my God, millions of people must think this is authentic Eskimo culture." And to think that Mizrahi could have been inspired by the real source.

McInnis: Hollywood gives us connectedness—to pathos, drama, vitality, life. I believe more in the big-screen version of Cochise than in the real people from Savoonga whose stories are told here by the museum.

Dickey: When we went to the Minnesota Institute of Art, we saw gorgeous collections, but what was displayed was just the object and its label—what it was made of, the date—

Lee: —for the Alaskan material.

Dickey: —for the Alaskan material, and really for a lot of other materials, too. It was just basket after basket, ivory after ivory. There was no interpretation. After I went through the galleries, I was dazed. I was tired of just looking at the works. I wanted the connectedness Alvin told us about. Somehow, the museum needs to share with the visitor that kind of personal connection.

A lot of our visitors don't know how to see. What's the average time people spend in front of our cases? Twenty seconds! And they've got a lot to do in twenty seconds. They've got to read the labels. They've got to read the maps. They've got to figure out what the exhibit is about. By the time they end up looking at a piece, it's time to go.

Lee: They express a lot of frustration about that.

Dickey: Yes, they do. And we live in a very, very busy world. In reality, that time may end up being shorter than twenty seconds.

Jonaitis: Tourists often purchase souvenirs of their trip here—like crudely carved totem poles that say "Alaska." How do we build a bridge between the tacky totem poles, the art, and the artifacts? They'll buy the totem pole to take home—can we get them to really look at the FitzGerald watercolor or Sydney Laurence?

Lee: I've been fascinated by this very thing for years. My parents, who had a Braque drawing on their wall, would come home from trips with absolute schlock. And I couldn't figure out why. In front of my grandparents' beautiful brass opium bowl, they'd put one of those god-awful East Africa carvings-from-a-horn. Every time Skip Cole (my professor of Native art) came to lunch, I had to hide it.

Finally, when I read Beverly Gordon on souvenirs, I understood. She said people buy this stuff as tangible representations of their trips. They are memories. The souvenirs may have nothing whatsoever to do with taste. So it may be that you need both. Travelers may well see one thing and buy another.

Owners of private collections have personal connections with their possessions. After they have bought Alvin's grandmother's basket, *their* granddaughter inherits it and remembers *her* grandmother and how her grandmother bought it on a trip to Alaska—I always have to get the Western consumer in there, who is often forgotten—but the resonance of memory is the same. Individual pieces can have a unique resonance for each of us.

Some of these works have great sadness connected with them, adding a layer, a dimension. This necklace made by Bedusa Derendy comes from

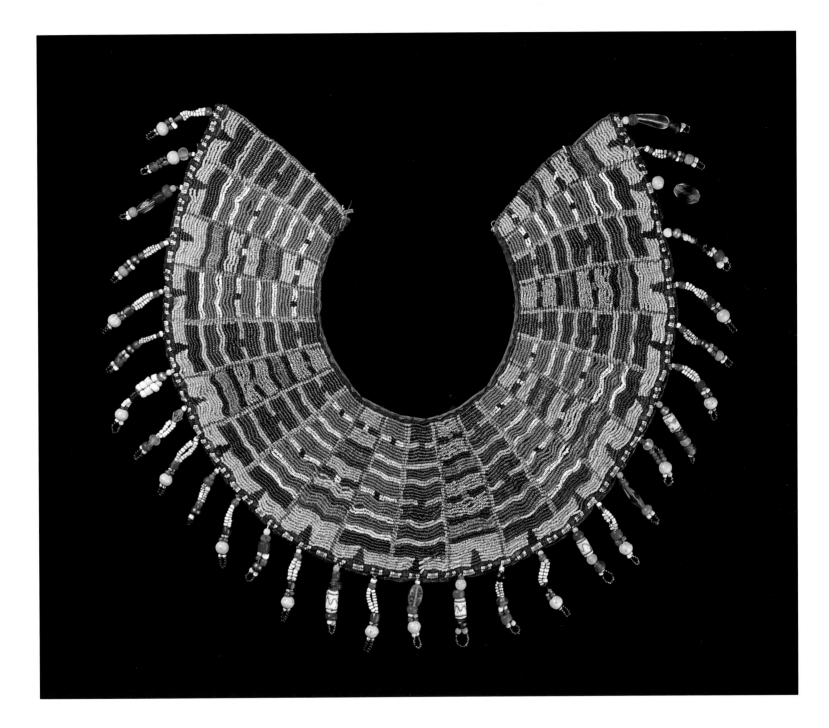

Canoe Village, a community near Sleetmute that no longer exists (fig. 29). Sleetmute, where Canoe Village people moved, has serious social problems, which may be why the owners sold the necklace. It was made for a young girl's coming-of-age ceremony, and she later did some more work on it, but at some point the family needed money and sold it. When I look at this piece, I think how beautiful the beadwork is and how wonderful all the different kinds of Russian trade beads, but I also think how hard life became for the people who owned it. This is why museums make me sad. There's a famous essay by James Boon called just that: "Why Museums Make Me Sad."

The cultural biographies—the wonderful tales, and the sad ones—that fill our files in the Collection Room add so much to their resonance. There are other stories, too. We bought a parka (fig. 31) earlier this year from a woman, and every time I talk to her

on the phone, she wants to make sure that it's all right—"It's going to be there for my grandchildren, isn't it?" We have her story, too.

Woodward: So how old is this beaded necklace?

Lee: Well, the beads are very old, but it was made sometime between 1910 and 1920. It was sold in the 1950s. We have fairly good documentation on it. This is why documentation is so important.

Simpson: And of course Bedusa Derendy's gone.

Lee: Yes. But probably her kids aren't.

Woodward: So, is it the age of the beads that brings in this distinctly different range of color from other beadwork?

Lee: Yes. This is from a part of the Yukon inhabited by Russians—and they might have brought in this wide variety of beads. The biography isn't clear here, in large part because people so often took pieces apart and reworked the beads with others in new designs.

Chin: Artwork reincarnated. Ongoingness. New-naturedness.

Simpson: The beads can be quite ancient.

Amason: They worked with what was available.

Chin: My mother told us about learning to knit and crochet in her village in China. The other women left scraps of yarn here and there. She picked them up, tied them all together, and started her own knitting. Even in Los Angeles, my brother seemed to have the same blue sweater year after year. Once he outgrew it, the whole thing got pulled apart, all the yarn was washed, and my mother sat down to knit again. So my brother always had this "forever" blue sweater.

Amason: When I was looking at Theresa John's earring collection, she was really pleased. She

30
From left: **Wanda Chin, Molly Lee, Glen Simpson**

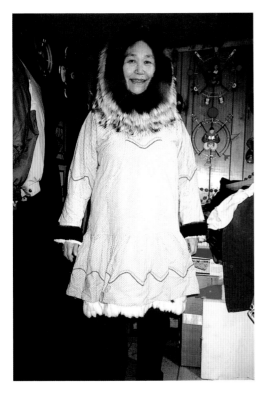

31

Yupik cloth and fur parka
Julia Nevak
Cotton cloth; trimming—wolf, wolverine, sealskin, beaver, commercial rabbit. 116.8 cm × 80 cm. Toksook Bay, 1996. Purchased from Julia Nevak, 1996. Photograph by Molly Lee. UAM96-7-1

When I accompanied the UAM masks to the Toksook Bay dance festival in January 1996, I got to know Julia Nevak, a member of the Toksook Bay dance group, who mentioned shyly that she had a *kuspuk* (woman's parka) to sell. We had no winter *kuspuk*s. This *kuspuk* embodies Yupik women's distinctive mix of external modesty and inner richness. The cloth covering, reminiscent of the flour sacking such garments were originally made of, is demure in the extreme. It belies the soft, rich lining of black and white commercial rabbit fur, only a suggestion of which shows in the little fringe around the hem of the garment. The sunshine ruff, which is backed with sealskin for extra stiffening, uses a combination of wolf, wolverine, and beaver fur with the guard hairs removed. The sleeves also are edged with beaver. The entire garment is hand sewn. Nevak, who was born in Tununak, was pleased by our enthusiasm and even happier at the thought that her *kuspuk* would be safe somewhere for future generations of her family to see. (LEE)

showed me a couple of pairs that were her mother's, very old pieces. Beautiful stuff. But while I'm looking, she's just smiling, and then she says, "We were too poor for beads, so my mother used to get those transparent colored toothbrush handles and she'd make beads out of toothbrush handles."

Jonaitis: Wonderful.

Amason: Just carve them and drill them, and that's what these earrings are made of. And they're gorgeous.

Lee: I never heard that. That's neat.

Simpson: Colgate earrings.

Chin: For us—in terms of assemblage—these are incredibly wonderful. But you could show it to my mom and she'd reject it out of hand—"I don't know why you want that," or "Look at that *old* thing."

I had the same experience with *A Child Is Born*, the exhibit that showed things made in honor of new babies, like a beaded baby carrier. I asked some of the Native ladies, "Gee, what would you give somebody to honor the baby?"

The response was, "Oh, you know, we would go to Penney's and buy them something nice from the store."

I really had to keep asking and asking. Finally Sally Hudson told me about the ptarmigan crop. Except she didn't have a ptarmigan, so Glen got one out of his freezer for her so she could inflate it for me. Do you remember? The dried crop, inflated, to make the rattle?

Simpson: Oh, you make rattles out of—

Chin: Yes, for a baby.

32

Athabaskan baby belt
Hannah Netro
Smoked moosehide, cotton cloth,
glass seed beads, glass trade beads,
pipe beads, yarn. 120.6 cm × 13.1
cm. Kutchin, Athabaskan. Old Crow,
Yukon Territory, c. 1920s. Collected,
1946; donated by Don Peterson,
1966. UAM66-006-0003

Athabaskan women, among the most accomplished bead-
workers in North America, take particular pride in their elabo-
rately decorated baby belts, which are worn across the shoulders
to support the baby carried on one's back. This is one of several
outstanding examples in the UAM beadwork collection. The
solidly beaded white background has been characteristic of
western Kutchin beadwork since the 1920s (Duncan 1989:pl. 20).
(LEE)

Amason: So who makes those rattles? Are they
Athabaskan?

Chin: Right.

Amason: Poldine Carlo said if we were ever out bird
hunting and we were in trouble, that sack in the
ptarmigan would give us instant energy. It's really
powerful stuff. A person could survive eating just
that.

Chin: For me, the interchange—hand-me-downs,
gifts from Penney's, sweaters unraveled—it all goes
back to the economic system of power and what's
valued. My mother grew up poor and had to do cer-
tain things to get us all by. Today she says, "I don't
know why you want that old stuff." She wants things
to match. So do the Native ladies.

McInnis: Things not from a poor time. My grand-
mother, too.

Simpson: There are treasure troves of antiques wher-
ever retirees concentrate. They still have this mental-
ity—"That's old stuff. We're going to buy something
new." They don't have our romantic attachment to
history. They're looking for bigger and better.

Jonaitis: Gloria Webster told me, "I don't mind that
my father sold that mask, because it fed us. We could
always ask somebody to make a new one." The
Kwakiutl didn't lose privilege if they fell on hard
times.

33

Tanana Woman and Dog
Eustace Paul Ziegler
Oil on board. 48.9 cm × 38.74 cm.
1939. Donated by Grace Berg
Schaible, 1991. UA91:017:001

This is a striking example of Ziegler's
(1881–1969) ability to capture both
character and activity in a seemingly
simple composition. The dramatic sky
and hilltop setting, as much as the
dynamic pose of the Athabaskan
woman, her child, and her pack-laden
dog, capture fully the flavor of a cul-
ture, a place, and a moment in time.
 The University of Alaska Museum's
outstanding collection of Ziegler's
work numbers more than two dozen
oils, several excellent watercolors,
and approximately thirty of his fine
etchings. Collections of such range
and depth enable students, faculty,
and visiting scholars to study the
work of Alaska's best-known artists
firsthand. (WOODWARD)

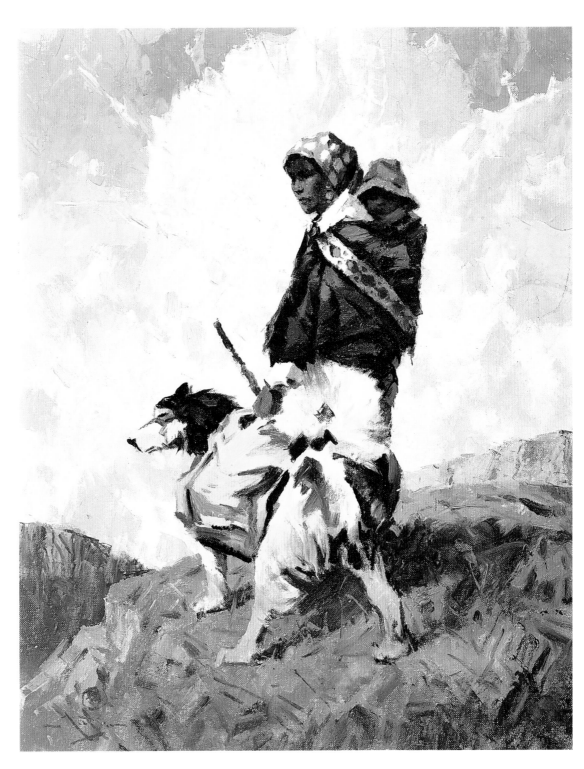

3

Making Authentic
Art for Sale

Wingspan of Sand

Lit from inside, birches
spark, flare,

blaze trails
for travelers

outstretched in air.
Tawny cranes

return to rest
where earth cradles water.

Cranes graze, pace, graze,
flap scuttle jabber scold . . .

This harvest
flashes—wingspan of sand,

hillside of crook-necks
soon to move on.

What will remain
has always remained—

water seized
by ice-driven air,

faith through hard cold
that the languages

of marsh, sky,
sandhill crane

will keep on
with us or without.

Peggy Shumaker

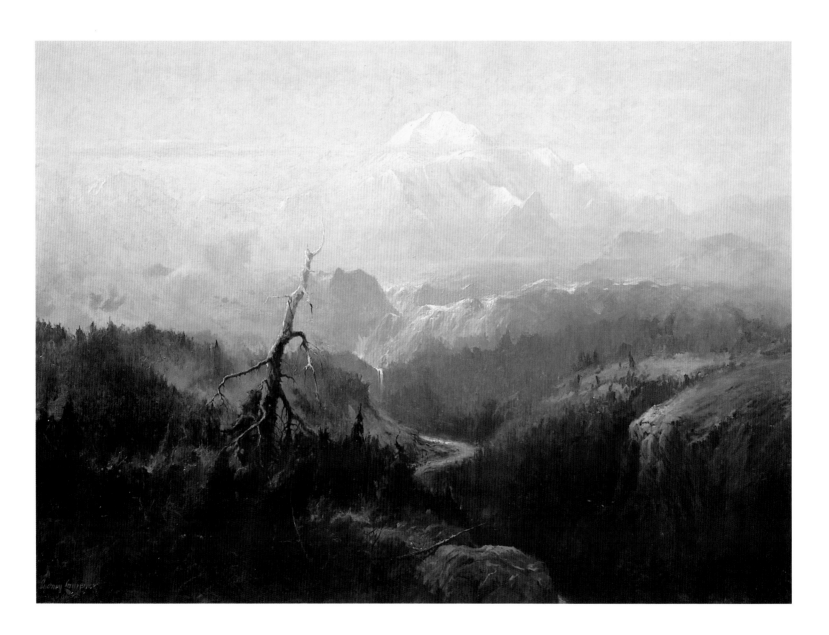

McInnis: I'm interested in the subject of making a living from art—from the tourist trade to Sydney Laurence. For example, Laurence had a couple of very good decades breaking new ground, but then, somewhere around the late twenties, he began painting fairly formulaically. It was partly because there were people lined up saying, "Sydney, I want your next mountain." So, in some ways, he was painting tourist art. People came, bought a Laurence, and took it home to Hartford to put on the wall as their piece of Alaska. Someone else bought a Haida argillite carving and took it home to Kansas City, and that was part of their memory.

We value Sydney Laurence differently from women who wove baskets as fast as they could for the shipboard trade. But they seem to be part of the same spectrum.

Simpson: Are they related in that they're commercial, because they're making things primarily for sale?

McInnis: Well, these artists, or artisans, or souvenir makers were all working for a living, and everybody was doing the best they could, and answering a need. So they are related, at least in that variations on what they were doing became "fine art," whether that was a basket or a Sydney Laurence.

Jonaitis: I think this notion of the sale of art is very problematic. The romantic notion is that art emerges from your soul, that it is not a commodity and ought not to be sold. If it is sold, you should really keep the fact of that sale very quiet. By the same token, Native art is considered authentic if it is made for use within Native society. As soon as a Native person sells something to a tourist, the thing becomes infinitely less valuable, less authentic, less significant. Molly's written on this.

Are Aleut grass baskets, or Yupik baskets, or Athabaskan willow root baskets ever used within the communities? Or are they only made to sell?

Simpson: People do keep baskets, especially within the family, because a family member made it— Grandma made it. Some pieces survive as family heirlooms, but primarily they are made for sale. And willow root is so costly now. A piece like this would cost big bucks.

Lee: But they originally made them to use, didn't they?

Simpson: Yeah, I think they did use them, but I think even if we go way back we still find them being made for sale.

Amason: Or traded.

Lee: We can see the history of Aleut baskets by looking back to the earliest explorers—people like John Webber, Cook's expedition artist, who made wonder-

34

Mt. McKinley
Sydney Mortimer Laurence
Oil on canvas. 129.54 cm × 182.88 cm. 1919. Donated by Austin E. Lathrop, 1936. UA74-70-4

Alaska's most widely beloved historical painter, Sydney Laurence (1865–1940) was the first professionally trained artist to make Alaska his home. Born in Brooklyn in 1865, Laurence studied at the Art Students League in New York and exhibited regularly there by the late 1880s. Settling in 1889 in the artists' colony of St. Ives, Cornwall, England, over the next decade, he exhibited at the Royal Society of British Artists and was included in the Paris Salon in 1890, 1894, and 1895, winning an award in 1894.

Laurence moved to Alaska in 1904 for reasons still unknown. Living the hard life of the pioneer prospector, he painted little in his first years in the territory, but between 1911 and 1914 he

began to focus once again on his art. He moved from Valdez to the budding town of Anchorage in 1915, and by the early 1920s he was Alaska's most prominent painter.

This ambitious, early painting of Mount McKinley is one of the best examples of the artist's work from his strongest period. By 1919 Laurence had found his stride again as a painter. In works such as this one he attained a uniquely personal application of the tonalist technique he had learned in New York and Europe to the majesty of North America's highest peak. (Shalkop 1975, 1982b; K. Woodward 1990a, 1990b, 1993, 1995) (WOODWARD)

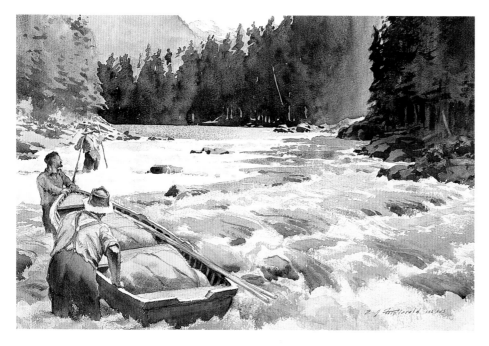

ful drawings that were later reproduced as engravings. Webber's images don't look much like these baskets—most of his drawings show flat bags—but they are made in the same twined technique.

The designs were originally inspired by Russian patterns—from magazines, wallpaper, or textiles that ended up in the Aleutians during the Russian occupation. Basket design changed when the Americans got here in the 1860s. This style of basket evolved to be sold to tourists and prospectors who came through False Pass on their way to the Yukon. They both came up around the 1890s—the Gold Rush and the beginnings of Alaska tourism were roughly simultaneous.

Originally Aleut baskets were woven upside down on wooden molds. Later a lot of them were made on—

Amason: —Darigold cans—

Lee: Right, canned-milk cans. They definitely were made for sale. Between the prospectors and the tourists, they triggered a big basket craze. Buyers prized the basket with the most stitches per square inch. Never mind that the poor lady couldn't see after she finished it. This is what people wanted and this is what they bought.

Simpson: Belle Deacon told me she made baskets to support her children when she was a young lady. She may have been widowed back then, and she sold her baskets to buy groceries. She said she got maybe three or five bucks for a nice birchbark basket. That was her "saleable product."

Jonaitis: The fact is that artists do need to make money. And isn't it much better to make money making art than doing something else that isn't as much fun? We put labels on what's acceptable and what's not acceptable, what's art and what's curio. Thank goodness, these days those labels are really beginning to be demolished. I hope. Michelangelo didn't paint the Sistine Chapel as a gesture of charity

35

Lining through the Riffle

Edmond James FitzGerald
Watercolor. 36.2 cm × 55.25 cm.
Undated. Donated by Gerald
FitzGerald, 1977. UA77-5-3

Perhaps the finest watercolorist to work in Alaska in this century, Seattle artist E. J. FitzGerald (1912–89) was a frequent visitor. He first traveled to Alaska in 1928, probably in response to encouragement from his older brother Gerald, who had worked for the United States Geological Survey (USGS), as well as from the well-known Alaskan artist Eustace Ziegler, with whom FitzGerald had studied in Seattle. On his first visit the artist served as crewman on a telegraph cable repair ship in southeast Alaska. He returned seven times in the 1930s with the USGS. His work for the survey as a boatman, field assistant, cook, and packer allowed him to see many regions of the territory, and he did sketches in oils and watercolors wherever he went.

In 1970 FitzGerald made another trip to Alaska, traveling to the Brooks Range, North Slope, and Interior regions of the state while making illustrations for a Humble Oil Company article on the proposed trans-Alaska pipeline. A president of Allied Artists of America (1960–63), member of the National Academy of Art and the American Watercolor Society, and author of two books on watercolor instruction, FitzGerald produced watercolors that are outstanding examples of both the documentary and the expressive potential of the medium. The University of Alaska Museum's collection of some two dozen watercolors and three oils by the artist is one of its strongest fine art holdings. (Bonnell 1986; Hines 1983; Kollar 1993; K. Woodward 1995:96–97)
(WOODWARD)

36

Construction Laborers in Clearwell,
Eklutna Water Project
Shelley Schneider
Photograph, Cibachrome.
35.5 cm × 28 cm. 1987. Purchased,
1989. UAP89:006:001

Shelley Schneider arrived in Alaska in 1980 and settled at a remote lake in the foothills of the Alaska Range. She had come to experience nature in all its moods and build a photographic portfolio along the way. After three years Schneider and her husband relocated to Anchorage, where she accepted the directorship of the Alaska Photographic Center and continued to photograph and exhibit. Until then most of her work had focused on nature, particularly close-up studies and textural abstracts. But in 1986 Schneider was awarded a municipal "One Percent for Public Art" grant to photograph the construction of the Eklutna water project near Anchorage. For two years she worked at the site, producing an extensive series of images that combine a strong graphical sensibility with a refined eye for color and light. Schneider developed a masterful ability to incorporate the hand of man into her work, as in this dramatic image made underground in a huge water storage tank. The laborers have taken a break from sanding the walls of the tank. Sanding dust hanging in the air, along with the mixture of tungsten illumination and daylight, creates an eerie, mysterious quality that captures the essence of the place. (MCWAYNE)

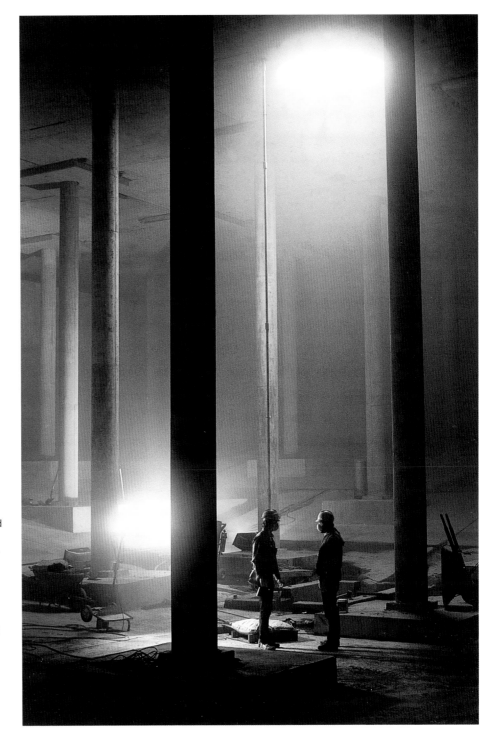

37

From left: **Susan McInnis, Terry Dickey, Aldona Jonaitis**

38

Aleut grass wallet
Anonymous
Elymus mollis, embroidery thread.
14 cm × 7.5 cm. Atka Island, Aleutian Islands. Collected by William N. Beach; donated, 1956. UAM717-69

Commonly known as card, cigarette, or cigar cases, telescoping wallets were popular with outsiders. Objects of this type are probably not aboriginal and may have come about purely as a response to the tourist trade. William Beach, collector of this piece, was a sportsman who made over twenty trips to Alaska in the 1930s and 1940s. The wallet is undoubtedly much older.
(LEE)

to the Catholic Church. He got paid for that. Rembrandt sold his paintings in a seventeenth-century Dutch art market. In the seventeenth century, people specialized—in interiors, in still lifes, in landscapes. If you were a buyer, you'd go to one of them because they had the kind of art you wanted.

Woodward: We have this mystical idea of art as being something that's totally different from everything else in life. But as much as I might like to pretend that's true, it's really not. We all make decisions about how we do the things we do. Whether you're making paintings, or writing grants or books, or designing buildings, or anything else, the truth is we all tend to relax and get lazy and fall into a formula. The commercial market may hasten that along, but one of the hardest things for artists to do is keep from making copies of their own work. You just can't go into your studio, take as a given what you did with your last painting, and start from there. You have to question, each time, how you want to approach the canvas.

But that, it seems to me, is not fundamentally different from what you do when you get ready to make a radio program, Susan. You don't want to fall into the same formula either. It seems to me it's the same in every walk of life when you get down to it. You have to try to do what you do originally and creatively, to answer the needs of the moment, whether they're commercial, or spiritual, or personal—or just how much time you have that day.

Amason: Sounds to me like we're all decompressing from a long winter.

McWayne: I'm thinking that this whole dollar thing has had another kind of impact on art. The fact that people pay millions for some works has elevated the status of art in our culture. Think about the da Vinci in London's National Gallery that shared the wall with lots of other works until someone came along and offered to buy it for some vast sum. All of a

39

Haida argillite carvings

Man on dog's back
Anonymous
9 cm. 19th cent. Collected by
Frederic Remington, c. 1900;
donated by Dr. Harold McCracken,
1975. UA75-047-0005

Model totem pole
Anonymous
36 cm. 19th cent. Donated by
Dr. Harold McCracken, 1975.
UA75-049-0007

Bear and humans
Anonymous
25 cm. 19th cent. Donated by
Dr. Harold McCracken, 1975.
UA75-049-0006

The Haida of the Queen Charlotte Islands learned early in the nineteenth century that travelers to their villages often purchased Native artifacts to bring home as mementos of their voyages, and developed a unique form of "tourist art"—sculptures in argillite, a type of shale found on these islands. The earliest such carvings date to the 1830s; carving in argillite continues to the present. These three carvings represent stages in the development of this art form.

The first argillite carvings depicted Euro-Americans, sometimes upon their ships, and often assumed the shape of pipes. Although many could actually have been smoked, most were treated as objects for display. The carving that depicts a Euro-American on the back of a dog was probably carved before 1880. Later argillite pieces depicted Haida mythological beings, arranged to suggest activity and interaction, such as the depiction of a bear with a man held upside down in his mouth. This more "narrative" presentation, which appealed to Euro-American consumers, was not typical of most art made for use in the Haida community. By the 1890s the most popular form of Haida argillite was the model totem pole. (Macnair and Hoover 1984) (JONAITIS)

sudden that same piece was put in its own room behind bulletproof glass and given a chapel-like ambience, simply because somebody offered to pay a lot of money for it.

Lee: And there's nothing at all static about our evaluations. At the Met things have risen out of the basement and then returned to the basement when the next generation says they're fakes, or has no use for them, or the period eye changes.

McWayne: A lot of people go to a museum that has one of these pieces merely to prove to themselves that they are standing in front of the *real* piece of art. They've seen things reproduced ad nauseam. Which raises the point that a piece of art takes on many different lives as it goes out into different contexts—often very different ones from what the artist intended. I remember standing next to a woman at the Getty, next to van Gogh's *Irises*. Suddenly she said, "Ah, *that's* the piece they paid fifty-three million for. And I'm here. And it's real."

Amason: And it's small!

40

Tlingit spruce root basket
Anonymous
Spruce root, grass. 23.2 cm high.
Southeast Alaska, after 1890. Collected by George and Dora Bunker,
c. 1900; donated by Mrs. Henry L.
Boos, 1972. UAM72-15-11

This basket, which was collected by Mrs. Henry Boos's parents around the turn of the century, is a classic early tourist piece. Its use of aniline dye suggests that it was made after 1890. Thanks to the early research of basket dealer George T. Emmons (1903) and its later refinement by Frances Paul (1944), most of the classic basketry patterns of the Tlingit have been recorded. The upper and lower designs here are known as Tattoo and the inner design is Flying Goose (Paul 1944:63, 65). Note also the diamond-pattern weave in the background, which is created by adding a third strand to the two-strand twining. (LEE)

41

Woods at Creamers
Kesler Woodward
Acrylic on canvas. 121.92 cm ×
152.4 cm. 1996. Purchased, 1996.
UA96:060:001

An Alaska resident since 1977, Kesler Woodward (b. 1951) served as curator of visual arts at the Alaska State Museum and artistic director of the Visual Arts Center of Alaska before moving to Fairbanks in 1981. He currently is a professor of art at the University of Alaska Fairbanks. Solo exhibits include those at the University of Alaska Museum (1985), the Alaska State Museum (1985), the Anchorage Museum of History and Art (1983, 1991), and public and commercial galleries on both coasts of the United States. Juried and invitational exhibitions including his work have ranged from Alaska to Brazil (1982) and Russia (1992). His work is included in all major public art collections in Alaska and in public, corporate, and private collections throughout the United States. He received an Individual Artist Fellowship from the Alaska State Council on the Arts in 1981.

Woodward's work for the past twenty years has explored his relationship to the Northern landscape, from the birch forests of Alaska to the treeless arctic tundra on the shores of Canada's Hudson Bay. *Woods at Creamers,* like *Spring Green* (fig. 95) some dozen years earlier, depicts the Interior Alaskan forest. In this newer work the artist responds to the almost surreal intensity of the brief, bright subarctic fall. (Ingram 1991; Licka 1991; Smith 1992; Soos 1991) (WOODWARD)

Jonaitis: Well, that brings up the cultural biography of artworks and artifacts. Some people think that an artwork that's on the wall has always been there. But before that wall, it had a life. When you are dealing with ethnographic art, you try to discover what it was used for, what it means. You also need to study how it got from its maker to the museum. You need to study what other people have said about it, how it got its name or its value.

Which brings us back to the "Okvik Madonna." It's interesting to reassess that piece, not only in terms of how it was named—the taking of an icon from Western religion and imposing it upon a Native carving—but to analyze "Madonna" as a word used just for women. You could have a feminist read on that.

The cultural biography of an object becomes complicated by the words we use for it, where and how we display it, what people think about it, and what they'll pay for it. All those things become part of what the object truly is. It goes well beyond a particular label, and has a dynamic life of its own.

Lee: This is what Michael Thompson's *Rubbish Theory* is all about. About how things start in the basement, come up to the wall, then go up to the attic. The cultural biography of things is all about how the thing circulates and the various factors that come into play. It's a wonderful book.

Jonaitis: What about Native art and its value?

Chin: Do Native images and art forms belong solely to Natives? Does Jacob Simeonoff have to be Aleut to make an Aleut bentwood hat (fig. 42)? What if a non-Aleut or non-Native begins to work in this tradition?

Simpson: My concern is just truth-in-packaging. If the artists who do the work sign their own names to it, then it's up front—who did it, when, and where. It gets really messy when the piece is misrepresented.

McInnis: As if it's older, or by a different person—

Simpson: Yeah. There's a whole world of artifakes out there. People crank out artifact fakes and sign them with goofy names that sound Native.

Woodward: But suppose Terry here takes up Northwest Coast carving and carves a shaman's mask—

Amason: Here we go . . .

Woodward: —how would you feel about that?

Chin: We're talking about more than geography here. Where's the essence? What makes Native art Native?

Amason: I think you're addressing two things. One is—

Dickey: Let's personalize this. Talk about Aleut art.

Lee: Alutiiq. Got to keep up with the correct usage.

Amason: Let's say you're Tlingit and you see this very nice piece that's been cranked out by some University of Washington student. Say he's a good carver. From a Tlingit's point of view, it's not real yet. No one has put money down on it. It hasn't been brought out at potlatch in some ancestor's name. It doesn't have respect. From the point of view of indigenous people who have been doing this Northwest Coast formline stuff for a long time, it's ownerless. Say you find the same piece in a Seattle gallery. I don't think that would bother Native artists too much. It's up to the connoisseurs to find out who these carvers really are. If they're going to spend a lot of money, and if it's important for them to have an authentic Haida or Tsimshian piece, then they should do their homework. And galleries should be reputable.

As far as commissions go, I think these days people look for the best damn carvers, regardless of ethnicity. If they can handle the knives and do an excellent job, once the piece is presented at potlatch, it's real.

Simpson: Material that's completely alien—feather

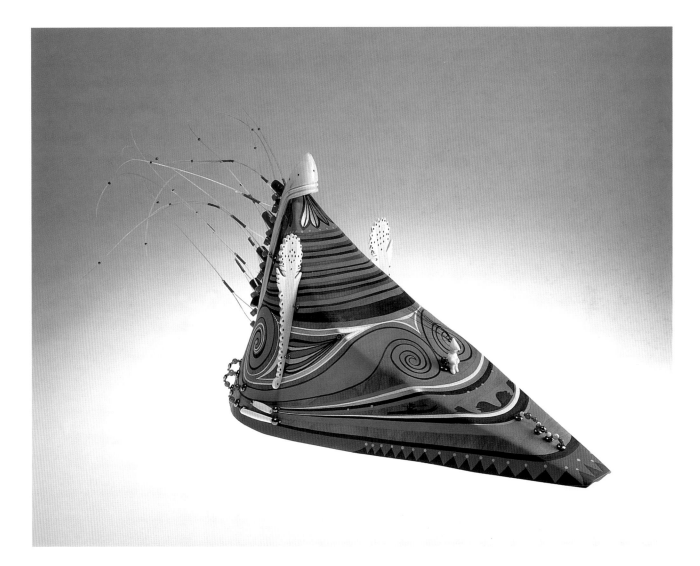

42

Full-crowned hunting hat

Jacob Simeonoff
Cherry wood, walrus ivory, paint,
plastic, leather, beads, simulated sea
lion whiskers. 71 cm. Alutiiq. 1993.
Purchased from artist. Exhibited at
UAM show *Alaska Wet and Wild*, 1995.
ED94-2-3

Jacob Simeonoff's contemporary hunting hat draws its inspiration from historic Aleut headgear, which Lydia Black (1991) has extensively researched. The hat's designs function as a symbolic graphic language: the spirals honor the creator, the circles and dots represent openings through which ancestors and spirits move. Paddles, leaves, and feathers signify new life as well as the ability to travel. Sea lion whiskers convey the wearer's bravery and success in the hunt.

Simeonoff uses an ancient bentwood technique to create these hats. Before he begins work, he sheds any ill thoughts that might offend the creator. Working slowly, carefully, and gently, he first cuts and planes a non-kiln-dried knotless wood plank. Then he carves the wood so that its thinner areas are easier to bend and shape. Although other artists use hot steam, Simeonoff uses the cold-bend method, which takes three days of soaking to soften the wood. Thus softened, the wood can be bent and clamped to a form. Simeonoff has revitalized this ancient technique for re-creating useful, ceremonially significant items.
(CHIN)

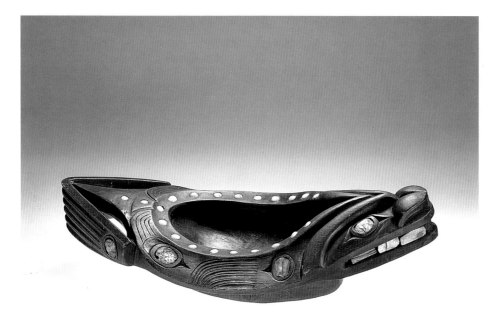

43

Tlingit dish
Anonymous
Wood, abalone, opercula. 42 cm.
Acquired from Lilla W. Davis, 1952.
UA0562-5474

A central feature of Tlingit society is the expression of hereditary rank and status during the complex ceremonial event called the potlatch. At this lavish affair, the host narrates clan legends, displays treasured heirlooms (such as the Chilkat blanket), and feeds the guests sumptuous and rich cuisine. This bowl held seal oil into which guests dipped dried salmon. It assumes the form of a seal, the head of which constitutes one end, as well as that of a canoe, the mode of transportation which bore guests from their villages to the potlatch. (JONAITIS)

capes from Hawaii or something like that—has been incorporated into Southeast clan treasures. It's not unheard of.

Jonaitis: Some of the British Columbia artists I've spoken to really resent white people making Northwest Coast style art. They see it as an economic issue—somebody from the dominant society, in a privileged position in respect to Native people generally, is making money from *their* artistic and cultural traditions.

Lee: It's about hegemony.

Jonaitis: It has to do with money and power. Would this Tlingit bowl (fig. 43) have any value at all if it were made by a white person?

McWayne: What kind of value? Artistic value?

McInnis: Value outside its history and place?

Jonaitis: The answer is in how you interpret the question.

Simpson: I think if it's in an ethnographic collection, that's one thing. If it's bought by somebody who wants something attractive to hang on the wall, that's another question. Educated people don't buy artifakes because they know what they're doing. People who buy souvenirs—where most rip-offs happen—don't care. They're not educated consumers. But the bottom line is that the schlock and junk in souvenir shops isn't competing with quality Native work. I think the response is to do better work and stay ahead of the game. Not to worry about what's happening in the souvenir trade.

Woodward: But now the question sounds suspiciously like the one we addressed a few minutes ago: What happens when that Rembrandt in the Metropolitan Museum suddenly turns out not to be a Rembrandt? Everybody's been in awe of it for a hundred years, but now they have to say, "Oh, this is by the *school* of Rembrandt."

Lee: It's lost its authenticity.

Woodward: "It's not a Rembrandt anymore. Let's get it out of the exhibit." It's lost all its value. Now, it's no less nice a painting. But all of a sudden art historians and critics and everybody else starts saying, "You know, I've always thought that hand was a little clumsy."

So how would that apply to something like this? Let's say these masks (fig. 44), which are really powerful, or this beaded headdress (fig. 45) turn out to have been done by someone who's not Native, not part of that tradition, who didn't make it out of the motivations that we assume are Inupiat for the masks and Yupik for the headdress. Do they lose their power?

Chin: Chinese art has a category for the reputable imitation, and it's respected in its own right. One has to know how to distinguish the imitations from originals—stylistically—brush strokes and composition. It's a different world. Good or bad imitations.

McInnis: Are you talking about respectful quotes, like, "As an artist, I'm going to quote this other famous artist because his work is so splendid"? Or is this "I'll pass myself off as this great painter, and make a lot of money when I sell my forgery"? Or is it both?

Chin: Both. I think even in Okvik times. Even in the future. Human nature has that wide variety. And there probably are several different motivations—respect and spirituality and connectedness and reverence. Or the fast buck, or putting one over.

McInnis: I'm wondering if "good will out"—if the fake, no matter how excellent, will be recognized inevitably, in ten years or a thousand?

McWayne: There's something else, and my medium is a culprit. Photography reproduces images—casually and openly—even with the best intentions.

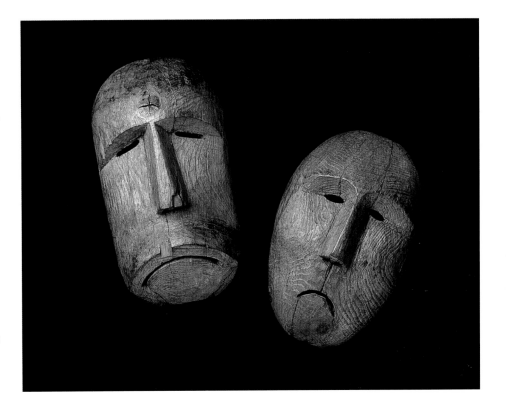

44

Inupiaq male and female masks
Anonymous
Wood. Male mask (*left*) 24.1 cm, female mask (*right*) 21 cm. Little Diomede Island, 1916–18. Donated by Dr. Harold McCracken, 1975. UAM75-49-2AB

Compared to the exuberant Yupik masks from the Bering Sea coast, Inupiaq masks from north of Norton Sound are simple and austere. Usually unpainted, they rely for their aesthetic power on sculptural form and virtuoso faceting. The masks' drama was intensified in the illumination of the oil lamp in the men's house (*qagri*), where ceremonies and secular dance performances were held. The ceremonies usually focused on appeasing the animal world, whereas the dance performances were purely for entertainment. These masks, supposedly representing a woman and a man (they can be differentiated by the male's heavier brow ridge), were donated by Dr. Harold McCracken, an explorer-photographer who first came to Alaska in 1916. Dr. McCracken purchased them from the missionary Arthur Eide, who had acquired the masks on Little Diomede Island (Eide 1952). Masks were sometimes placed on the graves of those who had danced with them (Ray 1967a:54; 1977:12). The University of Alaska Museum is fortunate to own two outstanding examples of rare Little Diomede masks. (LEE)

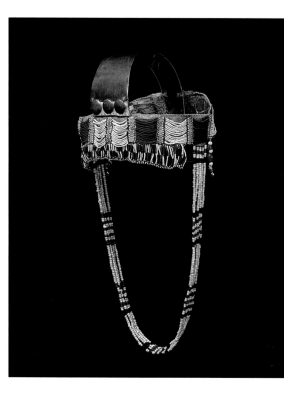

45

Yupik dance headdress

Anonymous

Glass trade beads, seed beads, sealskin, brass. 41 cm (including beads) × 17.5 cm. c. 1900. Collected in Nunapitchuk, 1947; purchased from Frank Waskey, 1947. UAM366-1

Purchased from Frank Waskey along with the white fox mask (fig. 7), this metal-and-bead women's dance headdress *(camataq)* was collected on the lower Kuskokwim River. According to Ann Fienup-Riordan (1996:136), dance headdresses with metal headbands were rare in southwest Alaska, the more common form being a skull cap of beads encircled with long, dangling bead pendants (e.g., Graburn, Lee, and Rousselot 1996:361). The rarity of this example can be judged from the reaction of one elderly woman during the exhibition *The Living Tradition of Yup'ik Masks* at Toksook Bay in January 1996—she returned five times to look at the headdress during the show's three-day venue. (LEE)

With copies all around us, we lose our connection with the original. In the museum, theoretically, anyway, we allow people to stand in contact with the original and its creator. That's why there's such an enormous letdown when a piece is determined not to be the original. It's the loss of contact.

Chin: Do you think that's American, though?

Lee: It's Western.

Jonaitis: Walter Benjamin's essay "The Work of Art in the Age of Mechanical Reproduction" makes the point that when art began to be mechanically reproducible, it lost the "aura" that surrounds the unique object. We feel it in the difference between standing in front of a Tlingit knife in the museum and reading about that knife, or seeing its photograph.

Simpson: Something like this dagger has encoded

cultural information (fig. 46). It's sending me a message from 1875. If you look at the piece just as *art*, an object of beauty, that's one thing. But as an ethnographic document, as a Native work of art, it also has *content*. If it's not authentic, then the content is deceptive. You think you are going to discover something, ferret out some wonderful revelation, and it's not there. You blow the time you've invested. But it's also wonderful to know the symbolism, to figure out all that's contained within the piece. It's more than an object with a surface. Even if one dagger looks like another dagger, they're not equally valuable.

Woodward: So what kind of things are there in this—what kind of encoded information?

Simpson: Daggers often survive because they are portable and durable. They don't rot easily, like baskets do. So quite a number have come down through families. I know of several among the Tahltans, including some coastal daggers, with these formline figures, that were probably taken from the Tlingit in battle. They duked it out on their borders, killed whoever they were fighting with, took their gear, and passed it down through families.

You find these very Asian-looking copper overlays on iron daggers. Where do those come from?

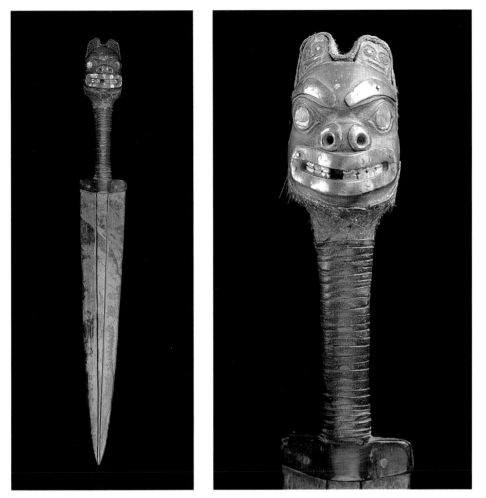

46

Tlingit dagger
Copper, musk-ox horn, abalone,
leather. 56 cm. Haines. Collected
c. 1890 by missionary A. R.
MacKintosh; donated by Donald M.
Feurt, 1965. UA65-039-0039

The Tlingit carried daggers ornamented with a crest animal such
as this bear as emblems of the history, wealth, and status of their
extended family. The early Europeans who first contacted the
Tlingit at the end of the eighteenth century noted that virtually
every man carried a double-bladed knife in a moosehide sheath
around his neck. The earliest such knives were made of slate, and
later ones of copper and iron. As warfare became less frequent,
the image of the crest animal's head, often inlaid with abalone
and decorated with copper, replaced the upper blade (Emmons
and de Laguna 1991). So esteemed were certain knives as clan
heirlooms that they were given honorific names, such as "Ghost
of Courageous Adventurer" (Shotridge 1920). (JONAITIS)

Did that influence come from Japan? The copper
can be tested by spectrometer and a probable source
picked out and you can start looking at trade routes.
Where did this copper come from? How did it get
to wherever it got to? There are a lot of answers in
daggers.

And then there are meanings and clan associa-
tions in the carvings, and their individual histories.
Some valuable clan pieces have titles. There's a
wonderful iron dagger from Haines at the University
Museum in Philadelphia called "Ghost of Coura-

geous Adventurer." The story is that a group of ad-
venturers from Haines went north into the Copper
River area. They acquired Native copper and a piece
of walrus ivory there. On their way back along the
coast they also found a large spike in debris that came
in from Asia on the Japan current. From this spike
they forged the dagger. The hilt is a skull carved from
ivory, and studded with abalone eyes. There's a cop-
per underlay under the wrap that flares down onto
the blade. "Ghost of Courageous Adventurer." It's
a great dagger.

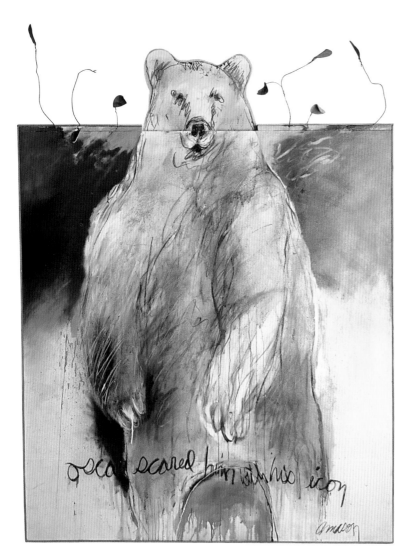

47

Oscar Scared Him with His Icon
Alvin Eli Amason
Oil on canvas, plastic, wire, Masonite.
188.6 cm × 160 cm. Undated.
Purchased, 1985. UA85-3-1

Originally from Kodiak, Alutiiq artist Alvin Amason (b. 1948) received his B.A. and M.A. in art from Central Washington University and his M.F.A. from Arizona State University. He has taught at the University of Alaska Fairbanks, where he heads the Alaska Native Art Center, since 1992. Amason is a nationally recognized artist who has participated in invitational exhibitions in Arizona, Michigan, Oklahoma, Montana, and Washington, D.C. His work is in the collections of the Nodjyllands Kunstmuseum in Denmark, the Indian Arts and Crafts Board, and the U.S. National Collection of Fine Arts. His important public art commissions include mixed media works for the Federal Building in Anchorage and Anchorage International Airport.

Amason has long played an important role in the development of the artistic life of his native state. He has served as a member of the Alaska State Council on the Arts, a board member of the Institute of Alaska Native Arts, and a speaker at Native arts conferences throughout the state.

Teaching both Native art history and studio art at UAF, he has been able to introduce new materials, techniques, and ideas to students while at the same time drawing Native elders and other leading Native artists from throughout Alaska to work in his program.

Amason is one of several contemporary Alaskan artists who have found ambitious, innovative ways to turn their experience in two worlds—the Native and non-Native worlds of the late twentieth century—into compelling and memorable images. With this generation of artists, Alaska Native art has become a current of the mainstream art of our time without losing the identity that makes it unique. (P. Bermingham 1978; Blackman and Hall 1988; Paine 1979; Stadem 1994; K. Woodward 1995)
(WOODWARD)

McInnis: I think that if I were a warrior, I would be empowered by this dagger.

Simpson: Absolutely. This one has a bear on the hilt. In an animistic world, grizzly bears are associated with physical strength. You fight your enemy with the bone of the grizzly bear. Bone from a moose wouldn't have the power of a bear.

Jonaitis: Bears are associated with power throughout the circumpolar region. But this dagger also has copper and abalone, both of which signify tremendous wealth and power. Your status is also embodied in your weapons, and in the images on your weapons, reinforcing the power and wealth that you already have.

Simpson: There are wooden war helmets in southeast Alaska that have lines on them similar to the lines on the flat, woven shaman's hat. So warriors carried with them an association with shaman's powers when they wore a completely unrelated headpiece. When you're up against the opposition and they see some reference to shamanic power, it intimidates them.

McInnis: My people painted themselves blue and ran screaming down the hills at the enemy.

Simpson: Same concept.

Amason: If you look at this with a collector's eye, it has what they call "good age," and it had fur on it that has worn off—

Simpson: Very hard to duplicate that.

Amason: Its physical properties and the material used show that it's an old piece.

Simpson: Apparently, on the Northwest Coast, copper pieces like this were treated with fish oil. It formed a protective film and kept the copper from corroding in the damp environment. They tested it in the 1960s and found that it's a chelate bond—the same high-tech stuff used in paints. The reaction between the fish oil and the metal produces an extremely durable surface. So pieces protected with fish oil have come down without corrosion. As long as some collector hasn't abraded that surface off, it can be several hundred years old and still be solid.

Lee: The emphasis Western culture places on authenticity, uniqueness, individuality, comes right down from the Greeks. It's a distinctly Western value. Non-Western societies, traditional ones, had *object types*. They didn't have the unique works of art. A piece might be better or worse or more wonderful than another, but it wasn't valued for its originality.

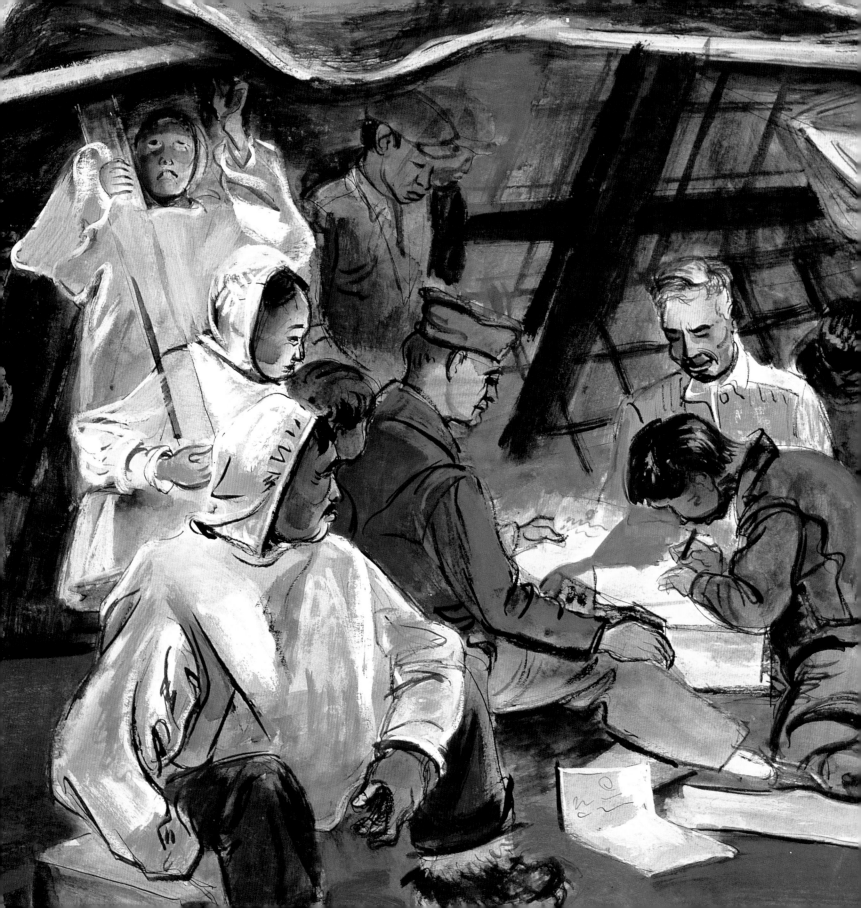

4 Categories

What to Count On

Not one star, not even the half moon
 on the night you were born
Not the flash of salmon
 nor ridges on blue snow
Not the flicker of raven's
 never-still eye
Not breath frozen in fine hairs
 beading the bull moose's nostril
Not one hand under flannel
 warming before reaching
Not burbot at home under Tanana ice
 not burbot pulled up into failing light
Not the knife blade honed, not the leather sheath
Not raw bawling in the dog yard
 when the musher barks *gee*
Not the gnawed ends of wrist-thick sticks
 mounded over beaver dens

Not solar flares scouring the earth over China
Not rime crystals bearding a sleek cheek of snow
Not six minutes more of darkness each day
Not air water food words touch
Not art
Not anything we expect
Not anything we expect to keep
Not anything we expect to keep us alive

Not the center of the sea
Not the birthplace of the waves
Not the compass too close to true north to guide us

Then with no warning
 flukes of three orcas
 rise, arc clear of sea water

Peggy Shumaker

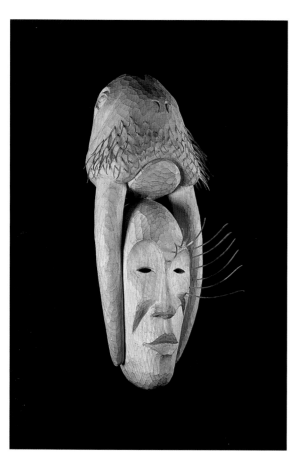

48

Walrus Mask
Lawrence Ullaq Aviaq Ahvakana
Alder wood, walrus whiskers. 48.75
cm × 22.5 cm × 14.375 cm. Inupiaq.
1983. UA84-3-32

Ahvakana's work steadfastly embodies the continuous dynamic
thread of traditional culture and contemporary form. Although
he lives in Seattle now, far away from his birthplace of Barrow, the
spirit of his ancestors streams through his work, whether stone,
wood, or metal. *Walrus Mask* shows the interconnection of hu-
man and animal worlds as a young man's face seems to emerge
to be held between the walrus's powerful tusks. Ahvakana's work
is noted for its deliberately crafted surface texture; methodically
stroked, painterly tool marks shape the craggy walrus skin. Walrus
whiskers bring the artwork to life. (CHIN)

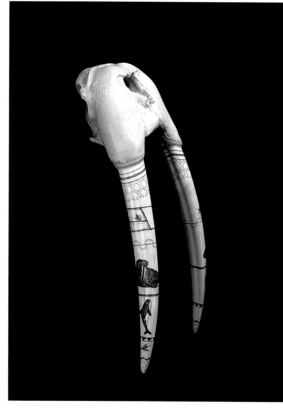

49

**Inupiaq walrus skull
with carved tusks**
Anonymous
Ivory. 57.2 cm. King Island (?),
1918–50. Donated by Rachel Rogers,
1996. UAM96-12-1

At the time this piece was acces-
sioned, Christopher Hyrcko, UAM
curatorial assistant in ethnology, was
doing research on the art of tattoo
and remembered a design practically
identical to the abstract octagonal
motifs nearest the tusks' base. The
design was a common tattoo pat-
tern on King Island around the turn
of the century (Gordon 1906:pl. 11)
and has been used here as a decora-
tive border for the tusk carving. The
engraving style of the tusk, however,
suggests that it was carved some-
what later (Ray 1996:132). (LEE)

Woodward: The categories people assign to visual culture can enhance or detract from a meaningful experience. Those categories themselves tell us a lot about what and how people think. One of the first things that people do is find a slot to put something in. They say, "This is art," or "This is an artifact," or "This is a piece of craft."

Jonaitis: The divisions between art and craft have kept us from seeing how the acts of production are part of the same whole. There are exceptions, but traditionally art has referred to male-dominated activities—painting, sculpture, printmaking. Pottery, basketry, and textiles are traditionally female. The distinction between art and craft, which is hierarchical—art at the top, craft below it—actually signifies a division of labor.

Then we get some interesting hybrids that really challenge any categories—like this Inupiaq walrus skull with engraved tusks (fig. 49). If we insist on conventional classifications, we'd have a little difficulty determining if it's a natural history specimen, a cultural artifact, or a work of art. And then there is this incredible Yupik carrying bag (fig. 51) made from—of all things—plastic supermarket bags. Does its pedestrian origin remove it from the category of "craft," much less "art"? We have lots of dolls here—what about them?

Chin: These dolls are wonderful (figs. 53–55). Coming from a tradition of working with the needle, I can see great precision in the craftsmanship. The artists make that sinew themselves. Have you tried braiding sinew? Have you tried poking a needle through leather?

I'm taken with this work on two levels—both the demands of the craft and the expression of it—the sort of brush stroke these women use in their needlework. I see passion there.

Simpson: Really elaborate dolls have very little relation to kids' dolls. They've entered another realm: the collector's sequence, the series. They've become very specialized, very refined. The doll not as a toy, but as pure consumer item.

Lee: That's absolutely right—that's what happens to them.

Simpson: I like the really direct little dolls that are made for kids to play with, the ones that get dragged around, with the arms ripped off. And I've seen some really nice old dolls with ivory faces passed down through families. But these highly evolved dolls, made for collectors, are a breed apart. They've evolved so far they've lost their origin.

It's like custom knives these days. Nobody would ever use one of those things. You've invested so much in it you're afraid you might scratch it. And you'd probably cut yourself if you tried to use it, because it's not made for a real person's grip. They're ritual objects, not tools.

Lee: "Obsolete technology becomes art," that's what Marshall McLuhan said—which may even be a relevant thought. We acquired this Ethel Washington doll two months ago as I was walking down to my office. A stranger came across the gallery, handed me the doll, and said, "This ought to be in a museum." Not in the playroom.

What's characteristic of Ethel Washington's work is her use of accoutrements. In Inuktituk it's called *nalunaikutanga*, which means their identity mark. Here, the doll holds a spoon and birchbark basket. Washington's figures are almost always doing things. Dolly Spencer's *nalunaikutanga* is the portrait, such as this one of Muktuk Marston.

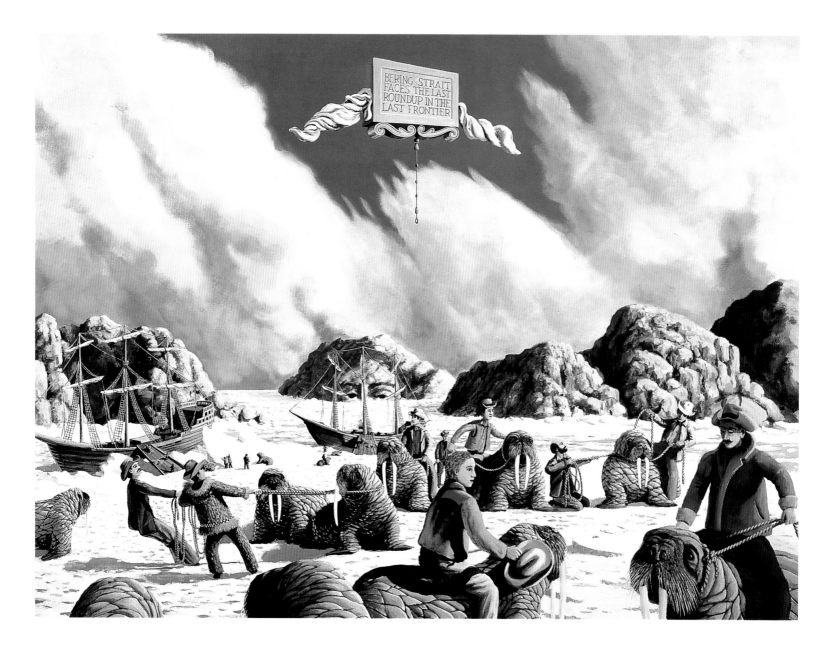

**Bering Strait Faces the Last Roundup
in the Last Frontier**
Daniel DeRoux
Acrylic on canvas. 87.63 cm × 117.48
cm. 1982. Purchased, 1983. UA82-3-21

Juneau-born painter Dan DeRoux (b. 1951) studied at the Nova Scotia College of Art and Design. He is well known throughout Alaska for his surreal combinations of Alaskan and non-Alaskan, historical and contemporary imagery. In the late 1980s DeRoux experimented with a variety of styles and worked closely with artists as a member of Juneau's innovative Arts-R-Us group (Rich 1988). During that period his collaborative work ranged in style from his own well-known fantasy images to darker, neo-Expressionist narratives and even nonrepresentational paintings.

More recently he has completed a series of enigmatic, powerful portraits of Eskimo masks.

One of the first recipients of an Individual Artist Fellowship from the Alaska State Council on the Arts, DeRoux has had work in a number of important regional and national exhibitions, including the First Western States Biennial Art Exhibition in 1979. (P. Bermingham 1978:40–41; Firmin 1979; Harder 1987a; Ingram 1986; Schmitt 1980; K. Woodward 1995; M. B. Woodward 1980) (WOODWARD)

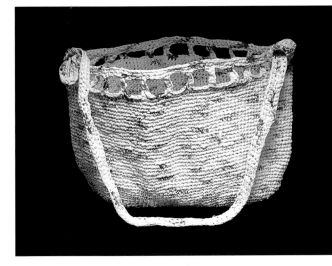

Yupik gathering bags
Lucy Whitman
Recycled plastic. 46 cm long × 32 cm wide. Bethel. Collected by Molly Lee, 1994; donated, 1994. UAM95-18-1

Anonymous
Beach grass. 51 cm long × 33 cm wide. Nunivak Island. Collected by James W. VanStone, 1952; purchased, 1952. UAM554-5446

Open-twined bags made of beach grass were used throughout traditional times by the Yupiit as well as the neighboring Aleut to collect and transport foodstuffs and to store frozen fish. Sometime in the 1980s women began making similar bags out of recycled plastic. Lucy Whitman, a receptionist at radio station KYUK, made the one above from plastic bags used to haul home her groceries from the Alaska Commercial Company store. The bag, which is crocheted instead of twined, replicates the traditional type. An imaginative synthesis of time-honored idea and new material, the bag perfectly illustrates the creativity with which Native people have adapted and updated traditional technology for contemporary purposes. According to Whitman, her sons use bags of this type, which are called "recycles" locally, in their fishing boat. Their durability, compared to the more fragile examples made of grass, is no doubt appealing. (LEE)

52

Untitled

Jane Meyer
Titanium, acrylic, silicone, oil enamel.
44 cm × 85 cm. 1984. Purchased
from artist. Exhibited at UAM show
Panned Art, 1985. UA84-3-127

Since the Gold Rush, Alaska's lands have provided a wealth of minerals, yet artists rarely turned metal into art until the 1980s, when income from oil production funded extensive state construction, which in turn stimulated public art commissions of outdoor metal sculptures designed to withstand harsh winters. Jane Meyer's sculpture displays the adventurous artistic explorations and innovations characteristic of that exciting time. Trained as a painter and jeweler, Meyer received a 1985 Artist Fellowship from the Alaska State Council on the Arts to expand her repertoire to large sculpture. She mixes together a variety of twentieth-century materials: acrylic sheet, enamel paints, and titanium for strength and lightness. To create this multimedia work, Meyer heated and bent the acrylic sheet, flame-polished its edge, and added colors by anodizing the titanium. The iridescent titanium surface allows the color and designs to be perceived differently under varied lighting situations. (CHIN)

53

Inupiaq doll
Ethel Washington
Wood; ground-squirrel, caribou, beaver, and wolf fur; birchbark; red and dark thread; black ink. 27 cm. Kotzebue, c. 1950. Donated by Theresa M. Whitaker, 1996. UAM96-9-1

The term "doll" is used by both Alaskan Eskimos and non-Natives to refer to a broad spectrum of human figurines made and used for toys as well as other purposes. Dolls are known to have existed as early as 300 B.C.E. (see fig. 25) around the Bering Strait (Fair 1982:46). Even as recently as this century they were used in fertility and whaling rituals and to represent members of a community absent during important ceremonies. Dolls also appear to have been broken over the graves of children (Fair 1982). Dolls made by Yupik and Inupiaq women for the tourist trade have enabled outsiders as well as Native people to take delight in the variety of figures and clothing.

Possibly the best-known and most influential of the many Alaskan Eskimo doll makers was Ethel Washington (1889–1967) of Kotzebue. Washington, who began making dolls in the 1930s, is known for the lifelike birchwood heads of her dolls. Her dolls usually carry traditional utensils, such as birchbark baskets and wooden spoons for female dolls, and skin drums and wooden drumsticks or bows and arrows for male dolls. In traditional Eskimo cultures, women usually worked with soft, flexible materials such as fur and skin; thus, it was unusual for a woman to carve wood, as Washington did to make her doll heads. Washington dressed her dolls in the traditional fur clothing of the Kotzebue region (Hedrick and Pickel-Hedrick 1983). (LEE)

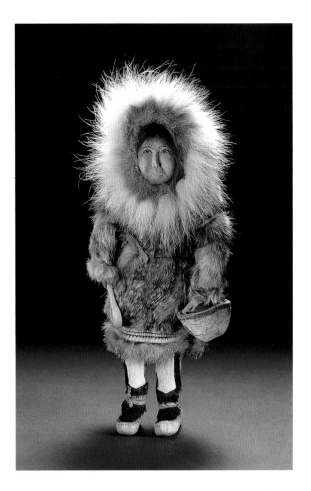

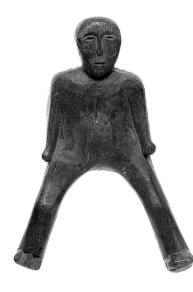

54

Siberian Yupik human figure
Anonymous
Wood. 14 cm. St. Lawrence Island, 1927. Collected for UAM by Otto W. Geist at Gambell, 1927. 1-1927-495

Dolls made of walrus jawbone are a traditional type made on St. Lawrence Island. They were usually carved by fathers or uncles for little girls, who clothed them and carried them on their shoulders inside their parka hoods, as mothers carried real babies (Fair 1982:54). This example is carved from a natural driftwood crook instead of walrus jawbone. (LEE)

55

Inupiaq doll
Dolly Spencer
Alaskan birch, willow bark, muskrat and wolf fur, calfskin, sealskin, caribou sinew, felt. 36.8 cm. Kotzebue, 1982. Purchased from Dolly Spencer, 1982. UAM82-3-48

Like Ethel Washington, Dolly Spencer was born in Kotzebue in 1930. Spencer is outstanding in her ability to innovate, carrying the realistic portrayals of Washington (one of her teachers) one step further. Her doll's faces often represent specific people rather than generic types. This example is a portrait of Major Marvin "Muktuk" Marston, founder of the Alaska Territorial Guard, a U.S. Army unit that enlisted Native Alaskans to protect the remote coastline during World War II. (LEE)

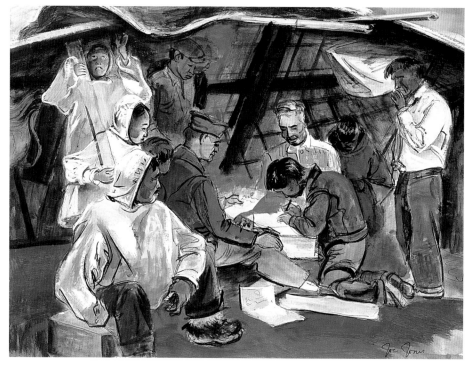

Woodward: Interesting—Marston appears also in Joseph John Jones's painting *Signing Eskimos into the Alaska Territorial Guard* (fig. 56).

Lee: I wonder if the Ethel Washington dolls were portraits of people, too—of people from the village who were familiar to her.

McInnis: Were these dolls always intended as art, never as playthings?

Lee: Right.

Woodward: Art by destination.

Lee: People argued for a long time about whether so-called primitive art was "art." The visual anthropologist Jacques Maquet said, "It's all art. There are just two kinds." He distinguished between art by metamorphosis and art by destination. The former comes from societies that have no word for art. Someone else "transforms" the work by carrying it across the cultural boundary. If it's by destination, it starts out as art—its makers are consciously making something they call "art."

Woodward: The new approach in the museum is to try to break down those barriers between categories, to get beyond sliding things into slots. The idea of "art" cuts both ways. It's something Molly and I argue about a lot, good-naturedly mostly.

On the one hand, when we call something art, we think we are elevating it. When we say that a basket, or a bowl, or an arrowhead is a work of art, we mean that it is beautifully crafted, beautifully designed, has inherent in it extraordinary qualities. We put it on the pedestal of "art." It's an act of elevation.

But then, Molly's going to jump on me in a minute and say that that's *not* elevating things. She'll say we can't understand the basket and the arrowhead if we persist in *stripping* them of their context. It's the *context* that's important.

Lee: What I really say is that we're assigning a Western term to objects from cultures that did not traditionally have words for art. For instance, in Inuktitut, which is the only Eskimo language that I know at all well, the nearest they've been able to come to the term for art is "things that we make." Sometimes putting a Western label on those objects deprives them of the ambiance in which they are created. It can be looked upon as very colonialist.

McInnis: Glen, when we were talking the other day, you said an object has a higher aesthetic through its function—that what it does makes it beautiful. Does that follow what Kes and Molly are saying?

56

Muktuk Marston Signing Eskimos into the Alaska Territorial Guard
Joseph John Jones
Watercolor. 26.67 cm × 36.83 cm.
1943. Purchased, 1982. UA82-3-27

Joe Jones (1909–63) was, like Henry Varnum Poor, a well-known midcentury artist and member of the Army War Unit, which documented the war effort in Alaska in World War II. Most of his time here was spent observing construction of the Alaska Highway, but Jones traveled with Poor to Galena and on to Nome, where they met Major Marvin "Muktuk" Marston. Marston was in charge of the forty-foot boat *Ada,* delivering guns and ammunition to coastal villages as far north as Barrow. In this delightful watercolor, Jones has captured Marston at work signing Eskimos into the Guard. A remarkably lifelike evocation of the activity, Jones's picture takes in the overturned umiak in whose shelter the sign-up is taking place as well as the individual character of

not only the famous Alaskan military leader, but each man on the scene.

Born in 1909 in St. Louis, Jones was largely self-taught but was a prolific and successful artist whose work is included in many major art institutions in the United States. His Alaskan drawings are remarkably similar to those of Poor, who had a much more traditional and extensive academic training. Both artists provide a strikingly personal and intimate glimpse of the character of the war effort, an operation that would herald great changes in the nature of life in Alaska. (Binek 1989; Poor 1945a, 1945b; K. Woodward 1993:109–14) (WOODWARD)

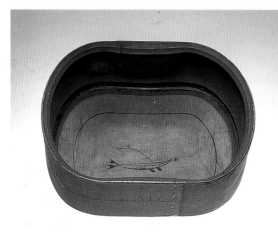

57

Yupik feast bowl
Anonymous
Wood. 23.8 cm high × 48 cm long × 39 cm wide. Hooper Bay, c. 1940. Donated by Sue Bartlett Peterson, 1977. UAM77-12-5

This magnificent feast bowl, which was probably made in the 1930s or 1940s, was acquired by U.S. senator Bob Bartlett (1904–68) of Alaska during his long political career and donated by his daughter, Sue Bartlett Peterson. Wooden dishes painted with geometricized figures of real or imaginary animals are characteristic of southwest Alaska, but examples of such size are rare. The concave rim suggests that this was a woman's dish (men's dishes had flat rims) (Ray 1981:41). Made by a bentwood technique, such bowls have rims that are steamed, molded, and secured with spruce-root line. This bowl has been painted with a wash of alder stain or hematite. The significance of the harpooned seal, depicted in characteristic X-ray view, is probably related to the bowl's association with food. According to Dorothy Jean Ray, such designs usually represented "mythologic animals or grotesque beings in folktales" (Ray 1981:41). (LEE)

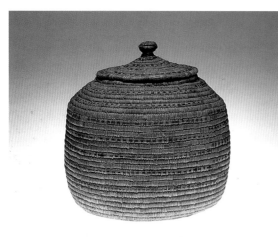

58

Yupik grass basket
Anonymous
Grass, brown root. 21 cm high (with lid) × 19.7 cm diameter. Southwest Alaska, c. 1900. Donated by the estate of William O. McCarthy, 1990. UAM90-10-8

As is often the case with ethnological artifacts, the humble demeanor of this coiled basket belies its historical importance. Among the hundreds of Yupik baskets in the UAM collection, it is perhaps the oldest. It most closely resembles baskets collected by Prof. George Gordon of the University of Pennsylvania along the lower Kuskokwim in 1903. Its cylindrical jar shape and understated decoration of dyed sea mammal intestine suggest that it is of the earliest type made around the Bering Sea. In the Yukon-Kuskokwim delta, unlike on the arctic coast, coiled basket making continued, possibly because Moravian missionaries encouraged the making of arts and crafts to send south and sell for support of their mission work (Lee 1995). (LEE)

Simpson: It's not function, really. What I like in an artifact is the way it reveals belief, or worldview. I like charms that represent animistic ideas or have sufficiently understandable symbols to tell me what they represent. It's sort of a coded message, and the more clues you have, the more amazing the piece becomes. These are the kinds of things that really excite me.

Lee: What happens with the Ipiutak rake (fig. 59)? We don't know anything about what its functions were.

Simpson: Well, we know the function of some other pieces excavated at Ipiutak, and some of their relationships. The Ipiutak ivory chains are related to metal chains used by Siberian shamans. There are ivory chains with loon-head finials among Ipiutak materials, and we know the loon is a shaman's symbol. Put together, the ivory chains and the loon are double shaman symbols. So some of the symbolism is obvious.

Jonaitis: Glen and Molly are pointing to something that the new art historians are just beginning to see—

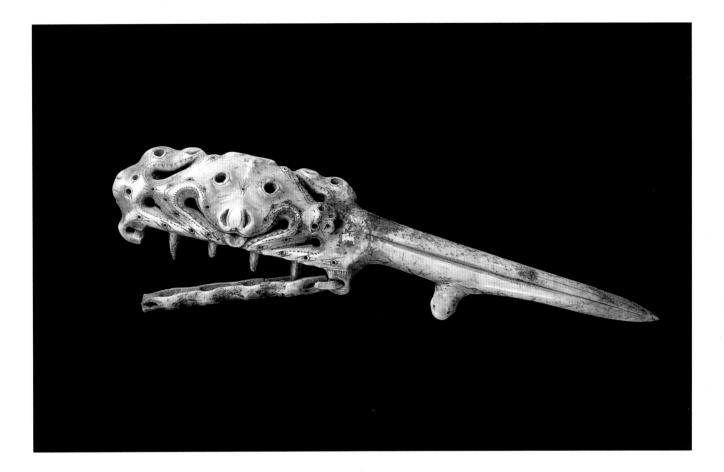

59

Ipiutak-style "rake"

Anonymous

Ivory. 26 cm. Point Spencer, Seward Peninsula, Ipiutak period (C.E. 450–850). Purchased from Froelich Rainey, late 1940s; catalogued, 1972. UA72-049-0001

This extraordinary rakelike implement from Point Spencer, with its elaborately carved zoomorphic heads, resembles in style other artifacts found in 1939 by Helge Larsen, Froelich Rainey, and Louis Giddings at the Ipiutak site of Point Hope. No information exists, however, on exactly where this implement was actually found.

The central figure represents a bear head peering out between its forelegs, surrounded by animal heads (possibly seals), two above the bear facing inward and two beside it. On the handle is another animal head, possibly a seal. By turning the piece upside down, one can see a "hidden" animal or human face carved above the bear. Henry Collins (1987) speculates that the short parallel engravings on the bear's cheeks, the V-shaped design between its eyes, and the single-dot marks on the cheeks of the animal face directly above the main figure all represent tattooing. The central pits representing the animals' eyes may have been inlaid with jet, as on other Ipiutak pieces.

There has been considerable speculation as to the influence of other cultures on Ipiutak. Although its curvilinear designs resemble the Old Bering Sea style, the main bear figure with its head between its paws resembles certain Siberian art, such as the bronze plates, belt clasps, and brooches from the Perm district and Yamal Peninsula in east Russia and Siberia made between C.E. 400 and 700 (Larsen and Rainey 1948). Other possibly Siberian stylistic elements in Ipiutak pieces include pear-shaped bosses, skeleton motives, inlays, and the representation of fantastic and realistic animal heads. Bandi (1969) proposes that Ipiutak style was influenced by the Scytho-Siberia style that extended from the Black Sea to north China from 900 to 100 B.C.E. The function of this piece is unknown. (Bandi 1969:110–14 [illus., 112]; Collins 1987:16–19; Collins et al. 1977:11–13, 24; Dummond 1977:116–17 [illus.]; Gerlach and Mason 1992; Giddings 1967:114–27 [illus., 115]; Larsen and Rainey 1948; Ray 1961:51 [illus.]) (JONAITIS AND YOUNG)

60

Jewelry by Denise Wallace

Basketmaker II *(left)*
Silver, gold, fossil ivory, lace agate, sugilite, black ink, gems. 6.875 cm × 6.875 cm × 1.25 cm. 1995. No. 5 of 5. Purchased from DW Studio, 1995. Exhibited at UAM show *Themes, Dreams, Ideas,* 1995; in long-term exhibit *Art and Craft, Then and Now.* UA95-066-001

Little Girl *(right)*
Silver, gold, fossil ivory, lapis, coral, chrysacholia. 5.625 cm × 3.75 cm × .625 cm. 1995. No. 5 of 5. Purchased from DW Studio, 1995. Exhibited at UAM show *Themes, Dreams, Ideas,* 1995; in long-term exhibit *Art and Craft, Then and Now.* UA95-065-001

Denise Wallace forms groups of jewelry that reflect childhood memories of family and tradition. *Basketmaker II* is one of ten figures created for "The Craftspeople," a series that pays homage to mask makers, doll makers, boat carvers, and ivory carvers. *Little Girl* is one of eighteen figures created for her *Women and Children* belt, inspired by experiences of berry picking with her family. The belt, a design structure fashioned after the South-western concho belt, links separate characters. Each has a pin allowing it to be worn independently. Individual details on the playful figures are not merely decorative, but show Wallace's deep understanding and respect for her surroundings. The seals swimming on *Little Girl* acknowledge the animal as the mainstay of her survival—that which provides oil, heat, and clothing. *Basketmaker II* shows not just the seeds of plants, but of all that wiggles with life. The delicately engraved lines of the beginning coiled baskets embroider the edge of *Basketmaker II*'s dress. Besides the engraved ivory faces and elements, gemstones artistically show Alaska's rich mineral resources, which are a major part of the UAM collection. Wallace's special signature is the surprise of a movable element that makes her work dynamic. *Basketmaker II*'s arm lifts up and the spruce-root coils rotate in her hands. Wallace's pieces of jewelry are symbolic sculptures that transcend personal adornment, bringing art into life. (CHIN)

the importance of context, and that formalism has its limits.

Woodward: That's what now allows us to look at terms like "Okvik Madonna" and say, "Wait a min-ute!" We've been calling this wonderful piece of ivory—one of the most valuable pieces of ivory, one of the most often reproduced, most published pieces of Alaskan art—we've been calling this thing "Okvik Madonna" for years. And we have to step back and ask, *"Madonna?"* What are we saying when we call it a Madonna?

Lee: Right! What are we doing?

Woodward: Because a Madonna is an image that carries an incredible amount of baggage. It's another double-edged sword, like calling something "art." We think we're putting it on a pedestal when we call it the "Okvik Madonna." We're recognizing it as an incredibly important piece. And the Madonna's not alone. Perhaps the most famous prehistoric object in the world is named the *"Venus* of Willendorf," even though it was made many millennia before the in-vention of Venus as a Roman goddess.

In the *Crossroads of Continents* exhibition, one of the most striking, most talked-about pieces was a representation of the head of a woman. On the label, without any commentary, was *"Nefertiti* of the Amur." So we take things from our culture and say, "Oh, this piece is extraordinary. It's like Nefertiti." "This piece is extraordinary, we'll call it Venus." "This piece is extraordinary, it's the Madonna."

With this new approach to art history and an-thropology, and even history, we're able to step back a little and take another look at why we call these things what we do.

McInnis: Once the tag "Okvik Madonna" slides to the status of footnote, what is it about the piece that makes it fabulous?

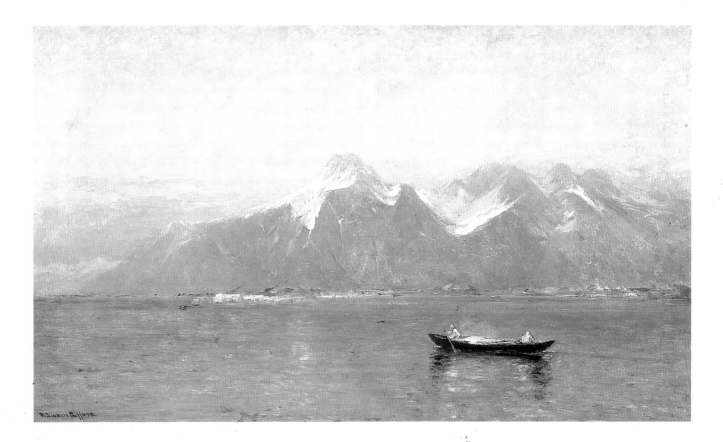

61

Icy Bay, Alaska

Robert Swain Gifford
Oil on canvas. 48.90 cm × 85.1 cm.
1899. Purchased, 1981. Included in the
R. Swain Gifford, 1840–1905 exhibition,
Old Dartmouth Historical Society
Whaling Museum, 1974; Hudson River
Museum, 1974. UA81-3-116

R. Swain Gifford (1840–1905) was one of the many prominent artists and naturalists retained by Edward Harriman for the last great exploring expedition to Alaska, the Harriman Expedition of 1899. Along with artists Frederick Dellenbaugh and Louis Agassiz Fuertes, photographer Edward S. Curtis, and such well-known scientists and naturalists as John Muir and John Burroughs, Gifford traveled up the coast of Alaska and as far as Plover Bay in Siberia. The venture was both an elaborate family vacation for the Harrimans and perhaps the most extraordinary collection of investigating artists and scientists ever to make a journey of exploration to Alaska.

A number of Gifford's paintings are reproduced in the first two volumes of the thirteen-volume account of the expedition (Merriam 1901–14). *Icy Bay, Alaska,* a mist-shrouded scene set in the northern Gulf of Alaska, with the towering St. Elias mountains in the background, is one of Gifford's finest and most ambitious works from the expedition. (Falk 1990; Fielding 1965; Goetzmann and Sloan 1986; Old Dartmouth Historical Society 1974:29 [illus.]; Stenzel 1963) (WOODWARD)

Woodward: I think what Wanda said about her own experience really speaks to that. Until the label is separated from the piece, we really don't begin to see what's there. Categorization should communicate to—or better yet, invite—the viewer.

McInnis: So one quality that makes this piece fabulous is that, across centuries and cultures, something that never touched any part of your hand, your culture, your life, nonetheless touches you?

Chin: Alvin's students tell me they have the same experience in his classes. I have it when I walk with Glen through the galleries. With the "Okvik Madonna," fifteen minutes after Gary asked, "So, what do you see here?" I thought, "Wow, look at the quality of that surface!"

Glen was saying that beyond form and line and composition, there is life. It's not just the perfection of line or the beauty of line that makes that piece what it is, but what lies behind it. It's like the very intellectual process of appreciating the spiritual. I don't really have good words for this, other than to compare it with other spiritual experiences in other cultures, like the tea ceremony.

McWayne: I'm still stuck on this question of naming things. Are we the only society that does this? If you step inside Japanese culture, do they make analogs to their own experiences? And is it an act of arrogance?

McInnis: Or is it irreverence?

Simpson: I think it's just cultural ethnocentricity. We understand foreign things by naming them after what's familiar to us. I don't think it's unexpected. But it is nice to look beyond those categories and not get locked in so tightly.

Lee: Things have to be made meaningful in terms of your own experience.

McWayne: You know, years ago when I came to the museum—and I was new to Alaskan archaeology—I was asked to make photographs of a variety of objects, most of which were labeled only by culture and number. And then out came the "Okvik Madonna." All of a sudden I stopped and looked at it. That title gave me something. I would hate to see the wealth of

62

Tlingit spruce root basket
Anonymous
Spruce root with twine handles.
33.7 cm high. Sitka, c. 1900. Donated
by Henry B. Wolking, 1942.
UAM0236-3985

This pack basket is a prime example of the utilitarian baskets Tlingit women made for their own use (Emmons 1903:250). Although the basket lacks decoration, its tall-sided form, evenness of stitch, and rarity make it an important piece in the UAM collection. Utilitarian baskets such as this, especially if they were stained (as this one is), came to be especially valued during the Indian basket craze of 1905–10 because they were thought to be closer to the lives of the women who made them. Collectors underestimated the worldliness of the Tlingit weavers, some of whom began making replicas of baskets—and sometimes even stained them—several generations later when they learned of the collectors' preferences (Lee: 1998). (LEE)

our collections descend into "Untitled, Number 6, Okvik."

Simpson: There's a lot to be said for approaching something—including the piece we're talking about—as if it were a puzzle, as if it were asking to be discovered.

This conversation reminds me of a silversmith, Charles Loloma. He's gone now. Some of his bracelets are very plain. The most important part, his stone settings, are hidden. Take the bracelet off and look inside. It's just carpeted with stones.

There's a sense of discovery—like opening a box. It's a high note. See a few pieces like that and it teaches you. Maybe the next piece has some hidden aspect and if you look at it carefully enough, you're really going to find something wonderful.

Woodward: Probably one of the most intense museum-going experiences I've ever had was with Glen at the Smithsonian's *Crossroads of Continents* exhibit, just going case by case with him. He would say, "You know, they soak that ivory in urine for a long time before the ammonia makes it pliable enough to bend into that ladle, or into that bucket."

At one point he was standing there looking inside this case at two pieces, and suddenly he said, "They've got that put together wrong. They must have had a bunch of disconnected pieces, and they put them together in what they thought was an obvious way. But look, the back of this polar bear belongs on this other piece, and this piece goes with the front of this other bear." And you know, it was really obvious once he pointed it out, but nobody had noticed that before. Nobody seems to have noticed it since. It went through the rest of its international tour without being corrected, even though he made it known.

But I think, for me, what art comes down to— what museum-going comes down to—is ultimately the encounter between the individual and the object. Labels may help that. Multimedia experiences may help that. Tour guides may help. But fundamentally museum-going is about the opportunity for an individual to encounter that object firsthand. And that's something that a museum can provide that no book or movie or other medium can. And that's what makes museums ultimately important.

Chin: I remember being at the café at the Berkeley Art Museum at the University of California once. That day none of the drawings hanging there caught my eye, so I walked by them and went into the café to have lunch. As I was eating, I overheard a nine-year-old girl talking to her father. She was telling him about these things that were happening in one of the drawings on display. After she left I just *had* to go back to take another look at what caught her attention. Her description—what compelled her— wasn't historical. It wasn't deep. It wasn't an artistic analysis. She brought something fresh—her frame, her context, what *she* saw. This kid taught me— to look again.

5 Images of Natives

Avalanche Lily

Any disturbance, particle
or wave, footfall or

word, can loosen the cornice,
grease the slide, send crashing

breathless snow spume
thunderheads to edge

the sharp-rimmed space
no one ever saw before,

here, where restless
earth releases

at once all urges held back,
magnified, till

pure force carves
a new face

transformation mask opening
to reveal a fresh self

masked and slippery
unstable lily

cradle of absence
rocked by loss.

Peggy Shumaker

Detail of figure 68

63

4th of July at Black River Fishcamp
James H. Barker
Photograph, gelatin silver print.
32 cm × 21 cm. 1982. Purchased,
1983. UAP83:071:001

James Barker, Alaska's most respected ethnographic photographer, spent thirteen years in the hub community of Bethel, where he amassed a large and impressive body of work documenting the lifestyles and activities of Yupiit in the Yukon/Kuskokwim delta. Because he was a longtime member of the community, his friends and neighbors were comfortable with his ever-present camera, and he was free to record tender moments, family interaction, and community highjinks with special sensitivity. Here Bryon Hunter, Elia Charlie, and Oscar Rivers participate in the sort of picnic event seen at many Independence Day celebrations across America. This one happens to be at Black River Fishcamp near Scammon Bay. The University of Alaska Museum owns over forty works by this talented and productive artist.
(MCWAYNE)

McInnis: A great many Alaskan artworks depict Native people. I'm curious about levels of intimacy in such works.

Chin: Barry has pointed out to me differences in the photography of artists-in-community versus visiting artists, such as Jim Barker's series and works by Alex Harris.

McWayne: Jim Barker lived for thirteen years in Bethel and was a long-standing resident of that community, well known by a lot of people, and he always had a camera with him. His camera was welcomed wherever he went. So he was able to make photographs, comfortably, of situations that were interpersonal—families, closed groups. You can see that when you look at his work.

When someone like Alex Harris comes to a village, even if he stays for a while, there's still a distance that you can't help but feel when you look at his images. There isn't the comfort on the part of the photographer or on the part of his subjects.

I think maybe that's something you're alluding to, Wanda. James Everett Stuart kept people at a distance. Maybe that was more comfortable for him. He was a visitor and people were probably just another element in his work.

Woodward: *Indian Town near Sitka* (fig. 66) is an important historical document. James Everett Stuart was a very successful, relatively well-known turn-of-the-century American painter who made several trips to Alaska. His scenes range in quality from quite nice, like this one, to really awful. He's a prime example of someone who painted for the tourist market and, in his desire to meet its demands, dropped not just into formula, but hastiness.

At his best, Stuart made well-crafted, beautifully executed paintings that both chronicle Alaska at a particular time in its settlement by Westerners and depict encounters between Western culture and Native culture. The results are interesting and pretty powerful.

64

Newtok, July 1977
Alex Harris
Photograph, gelatin silver print.
37 cm × 37 cm. 1977. Purchased,
1986. UAP86:052:068

Our largest cohesive group of ethnographic photographs is *The Last and First Eskimos* by Alex Harris, a collection of eighty-seven images. The International Center of Photography in New York City organized an exhibition of these works that traveled the country for three years. The photographs document a culture undergoing intensive change. In the villages Harris photographed, subsistence lifestyles coexist with cash-job economies. Both offer viable options, yet for some families change brought difficulties. Some grandparents could not understand their grandchildren because they spoke a different language. Harris is a thoughtful, perceptive observer—particularly of the individual—and captures on film the fleeting expression and the personal moment.

Although the ICP exhibit never came to Alaska, since the University of Alaska Museum purchased the collection in 1986 it has traveled to rural sites, enabling communities throughout the state to view these images of the changing nature of rural Alaska. (MCWAYNE)

65

Ben Chugaluk Moves a House to Toksook Bay
Don Doll, S.J.
Photograph, gelatin silver print.
20.5 cm × 30.5 cm. 1980. Purchased,
1988. UAP88:014:001

Don Doll shares a special relationship with the people he photographs because he is a Jesuit priest. His documentary style focuses on group activities, personal relationships, and important moments in individual lives. Doll has a long-standing affiliation with the Lakota Sioux, whom he has photographed over many years. His interest in the issues and concerns of Native Americans introduced him to Alaska's Native peoples. He has made several extended visits to the state and created powerful visual essays. Photographs by this gifted artist with a keen eye and a sense of humor have appeared in numerous highly regarded publications, such as *National Geographic* and the "Day in the Life" books. Doll is also a respected educator and has served on the faculty of Creighton University since 1969. (MCWAYNE)

This is an image from just outside present-day downtown Sitka. It was then, and is today, the Native section of town. With its depiction of Tlingit canoes pulled up on the beach, this is both an historical document and a well-painted, strikingly composed image.

Simpson: The canoes are covered to keep them moist, so they don't dry out too rapidly in the sun and crack.

McInnis: What are some of the impressions Stuart sends us about time, place?

Amason: It's low tide.

Simpson: Probably seeking a little bit for the exotic.

Jonaitis: Every person is invisible. Anonymous. No one is close enough to be an individual. Looking at those people walking away on the pathway and then down by the beach, you can't see anything in them.

Intentional or not, it seems to me the artist is reflecting the attitude of the colonists at the time, that Native people were—

Simpson: Invisible.

Jonaitis: Not quite human.

Simpson: Interchangeable.

Jonaitis: Right. Stuart might have had a very great fondness for Native people, but what comes across to me in this painting is a merging of landscape and community. What's the date on this painting, Kes?

Woodward: 1891.

Jonaitis: Particularly at that time the notion was that Native people, not just Native Alaskans or Native Americans, but Native people throughout the world, were closer to nature—meaning that they were less evolved than those who had developed urban civilizations.

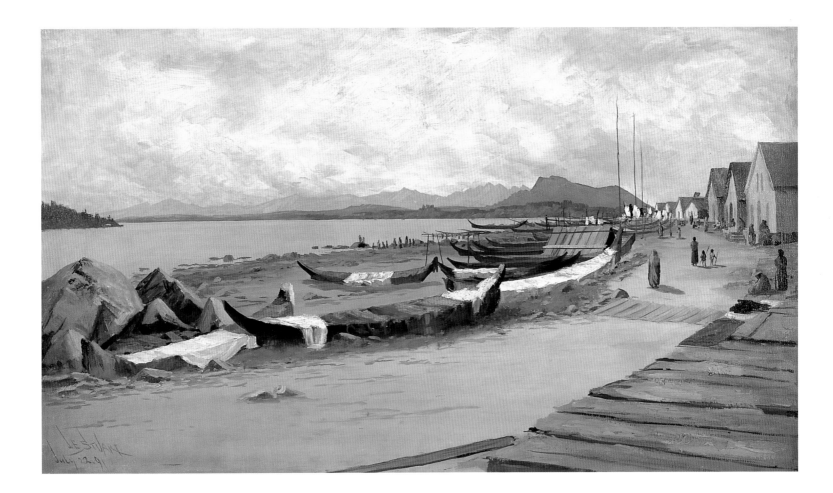

66

Indian Town near Sitka
James Everett Stuart
Oil on canvas. 59.69 cm × 105.41 cm.
1891. Purchased, 1983. UA83-3-28

James Everett Stuart (1852–1941), grandson of the great American portrait painter Gilbert Stuart, was a highly successful artist in his day. Stuart made several trips to Alaska beginning in 1891, and he produced the first really substantial body of Alaska landscape work in oils.

Done in the year of his first visit to Alaska, *Indian Town near Sitka* is representative of the best of Stuart's work. Though many of his later works were done quickly, almost by formula, for what seems to have been a ready market for grand Western landscapes, this painting is executed with the care and delight characteristic of an exceptional artist's first encounter with an awe-inspiring landscape and a still-mysterious Native culture.

The University of Alaska Museum is fortunate to own a substantial collection of sixteen of the artist's Alaskan oils and five watercolors, many of them among his finest Northern work. (Dawdy 1985; DeArmond 1989:8–9; DeRoux 1990:14–15; Falk 1989; Fielding 1965; Hughes 1986; Samuels and Samuels 1985; Stenzel 1963:26; K. Woodward 1993:53–55) (WOODWARD)

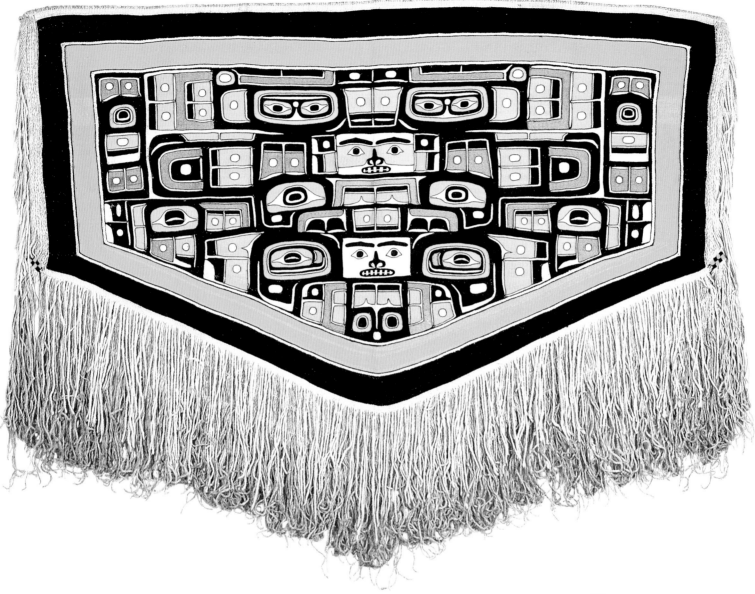

67

Chilkat blanket
Anonymous
Mountain-goat wool, cedar bark,
commercial wool. 95 cm by 160 cm,
excluding fringe. Tlingit. Klukwan,
19th cent. Acquired from Vernon
Humble, 1969. UA69-061-0001

In this painting what you get is the mountains, the sky, the sea, the beach, the people—everything merging into one. The artist communicates a late-nineteenth-century evolutionist attitude about Native people.

Simpson: Cultures fell into Darwinian thinking at that time. It's still pretty pervasive. I've heard people talk about Native people as if they're somewhat childish, as if their cultures are very simple.

Amason: Certain generations talk about themselves that way.

Chin: I think this painting illustrates an idea that Kes writes about in chapter 10—the difference between artist-as-visitor and the artist who lives and makes a living in Alaska. The resident-artist is connected to the land, whereas the visitor, if we go by Stuart's perspective, is kind of disconnected.

Simpson: Interesting. Because this is Tlingit culture, and for the people, the specifics of each individual would be critical. It would be the most important

thing about every interaction. They would know the great-grandfathers of everybody. They would know all the interconnections. They would understand the clan's histories embodied in regalia, like the Chilkat blanket (fig. 67). Each individual would be well known to every other individual. Yet in Stuart's view the people are completely anonymous. There are no faces, no individuals.

Jonaitis: It's interesting to compare this painting to the self-portrait by Tanis Hinsley, a Tlingit woman who studied art at UAF and is now teaching at Western Washington University (fig. 68). A cast of her own face is part of this piece—quite an answer to the anonymity of James Stuart's Tlingit.

Representation of Native people *by* Native artists is another issue that we should at least mention here. George Ahgupuk did this complicated depiction of Eskimo life in a style that combines the graphic tradition seen on that Inupiaq snow beater with a Western-influenced narrative style (figs. 69, 70). That's certainly made from an insider's point of view, no? And this Okvik female figurine (fig. 71) is an ancient Native representation of an anthropomorphic being.

McInnis: Ron Senungetuk has some interesting images of Natives.

Woodward: Ron Senungetuk made *Two Spirits* (fig. 72) for an exhibition that responded to "A People in Peril," the series that the *Anchorage Daily News* did January 10–20, 1988, on alcoholism in contemporary Alaska Native life. He gives us traditionally spiritual symbols: the Eskimo mask and hands with holes in them. But then we've got the pun: images of *alcoholic* spirits. I think he speaks very freely to the conflict that goes on between those two very different kinds of spirits.

Ron grew up in an Inupiaq village but studied in Norway on a Fulbright Fellowship, so you see this

Tlingit noblemen and -women wear Chilkat blankets during major ceremonial occasions such as potlatches and totem pole raisings. The fringe gracefully sways when the wearer dances, thus the name of the textile—"Fringes around the Body." During a funeral the Chilkat blanket of the deceased person is displayed on the wall as an indication of his rank. Women make these elegant textiles from mountain goat wool and shredded cedar bark with a twining technique, copying the designs from a "pattern board" painted by a man.

Like other examples of Tlingit art, Chilkat blankets represent the crest animal that personifies the status, history, and wealth of the owner's lineage. The textile is divided into three panels: the central one depicts the animal's head and body from a frontal position, while the flanking panels represent it in profile. The identity of the animal represented on a Chilkat blanket—one of the most abstract types of Northwest Coast art—cannot be known without information from its maker or wearer (Holm 1982; Samuel 1982). (JONAITIS)

68

Self Portrait

Tanis Hinsley
Handmade paper, mixed media.
78.11 cm × 105.41 cm. 1986.
Purchased, 1986. UA86-3-57

From an early age, Tanis Hinsley was exposed to the artistic traditions of her Tlingit heritage, and that heritage became her artistic foundation. Her mother, Chilkat weaver Maria Miller, taught her to work with traditional Northwest Coast materials and concepts. Like many other Native Alaskan artists of her generation, however, she both built upon that foundation and broadened her sense of possibilities in the more mainstream world of a university art program. While studying art at the University of Alaska Fairbanks, she experimented widely, enrolling in workshops ranging from traditional weaving and Northwest Coast printmaking to papermaking, photo processes, and viscosity printing.

Hinsley's 1987 B.F.A. thesis exhibition synthesized her cultural traditions and her inclination toward aesthetic experimentation.

Handmade paper, bamboo, and mixed-media works similar to *Self Portrait* made direct reference to her heritage while using it as a springboard to abstraction. Bamboo-reinforced paper forms recalled the textures of ancient Tlingit armor. Traditional red iron oxide and teal blue were incorporated in abstract forms in decidedly untraditional ways, and cocoon forms served as a metaphor for artistic transformation.

Since leaving Alaska Hinsley has continued to develop her awareness of herself, her traditions, and the role of the Native artist in contemporary culture. We are fortunate to have this powerful memento from her time of metamorphosis. (Harder 1987b; unpublished B.F.A. thesis report, UAF, 1987) (WOODWARD)

69

Untitled

George Aden Ahgupuk
Pen and ink on hide. 44.45 cm × 88.9 cm. 1936. Donated by Dr. and Mrs. John I. Weston, 1983. UA83-9-13

Perhaps the best-known Alaskan Eskimo graphic artist of this century, George Ahgupuk was born in 1911 in the village of Shishmaref. During a period of convalescence at the Kotzebue Native Health Service in 1934, he took up drawing with pencils and paper provided by a nurse. When he ran out of paper after his return home, he continued to draw on bleached sealskin, a medium that—along with the prepared skins of reindeer, caribou, moose, and various kinds of fish—became his trademark.

Ahgupuk's drawings range from small vignettes of hunting, reindeer herding, and other village scenes to large, elaborate compositions depicting scores of people, animals, and activities.

His skills and originality were recognized as early as 1937 by the artist Rockwell Kent, on whose introduction and recommendation Ahgupuk was elected to full membership in the American Artists Group in New York. That prestigious body not only sent him drawing supplies, but later published Christmas cards featuring his work (K. Woodward 1995:91).

Unpretentious but accomplished, complex without being fussy, Ahgupuk's drawings give us a rare direct, perceptive, and often witty look at the traditional activities of the village life in Alaska with which he grew up. (Mozee 1975; Woods 1957; K. Woodward 1995:91–92) (WOODWARD)

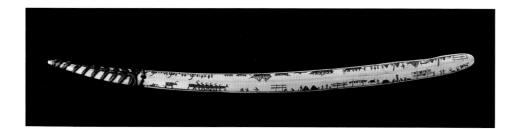

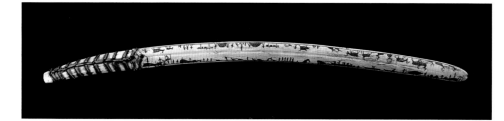

70

Inupiaq snow beater *(front and back)*
Anonymous
Ivory. 47.3 cm. Port Clarence, Seward
Peninsula. Collected by George W.
Klinefelter, 1866; donated by Dorothy
Jean Ray, 1994. UAM94-9-37

Snow beaters were used to whisk off snow from fur clothing
before entering a house. Among the earliest objects with picto-
rial engraving collected by European explorers, they were often
embellished with lively scenes of everyday life. This example
was collected by George W. Klinefelter, a member of the Western
Union Telegraph Expedition to the Bering Strait (1864–67). De-
picted are typical Seward Peninsula Eskimo pursuits, such as
fishing and caribou hunting, as well as Yankee whalers (repre-
sented by a slash on the head for a hat), their ships, and trading
stations. The pictographic style in which the lively scenes are
drawn is typical of the early historic period. It gave way to more
representational styles as contacts with Euro-Americans intensi-
fied. The expressiveness of the design elements and permanence
of color in the bold incisions make this an object of excellent
quality (Ray 1996:103). (LEE)

71

Okvik Eskimo human figure
Anonymous
Ivory. 17 cm. Punuk Island, Okvik
period. Collected by Brian Rookok,
1970; purchased from Rookok, 1971.
UA71-009-0001

The elaborate designs covering the surface of this female figure
include single and double curved lines, sharp long spurs radiat-
ing from circles, and oval designs. It has a long, oval, pointed head
and elongated nose. The linear motifs decorating the cheeks,
nose, and chin may represent tattoos such as those that adorned
the faces of St. Lawrence Island women in historic times; indeed,
Rainey (1941) speculates that tattooing began during this period.
Unique features of this carving include breasts, explicit represen-
tation of the genitalia, and finished legs and feet. (Collins et al.
1973:4–6 [illus., 6]; Burland 1973:10; Dumond 1977:122–23 [illus.];
Rainey 1941:551) (JONAITIS AND YOUNG)

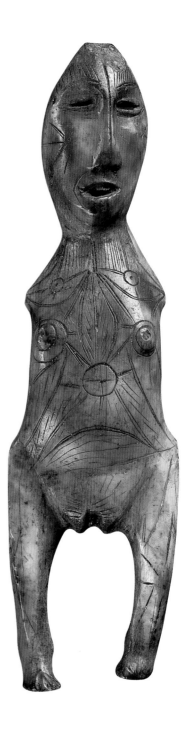

72

Two Spirits
Ronald W. Senungetuk
Wood, paint, aluminum.
72.39 cm × 63.5 cm. 1994.
Purchased, 1994. UA94:004:001

Ron Senungetuk (b. 1933), an Inupiat Eskimo born in the village
of Wales, completed high school in Nome. He received his college
art education at Rochester Institute of Technology, completing a
B.F.A. in 1960 before continuing his training in Oslo as a Fulbright
fellow. Perhaps the most widely exhibited Alaskan artist, Senun-
getuk has exhibited nationally since 1954. From exhibitions at
the Krannert Art Museum and the Museum of Contemporary
Crafts in New York in 1962, to the landmark *Objects U.S.A.* travel-
ing exhibition in 1970, to the Smithsonian Institution's 1982 *Inua:
Spirit World of the Bering Sea Eskimo,* the artist's résumé is replete
with important national and international exhibitions.

Though he retired in 1988 from his position as professor of
art at the University of Alaska Fairbanks, where he was a major
influence on a generation of Alaska Native artists, Senungetuk
continues to exhibit actively today. *Two Spirits* was done in re-
sponse to a series of newspaper articles on alcohol abuse in
Native communities in Alaska. Like all of the artist's work, it
couples immaculate craftsmanship and elegant design with
imagery from the rich tradition of Inupiat culture. But here,
Senungetuk also takes on a contemporary issue with wit and
insight. (Ard 1972; Blackman and Hall 1988; Federoff 1966;
Nordness 1970; Ray 1967a, 1969, 1977; Simpson 1991; Untracht
1982:2, 109, 495; Visual Arts Center of Alaska 1988; K. Woodward,
1993:133–35) (WOODWARD)

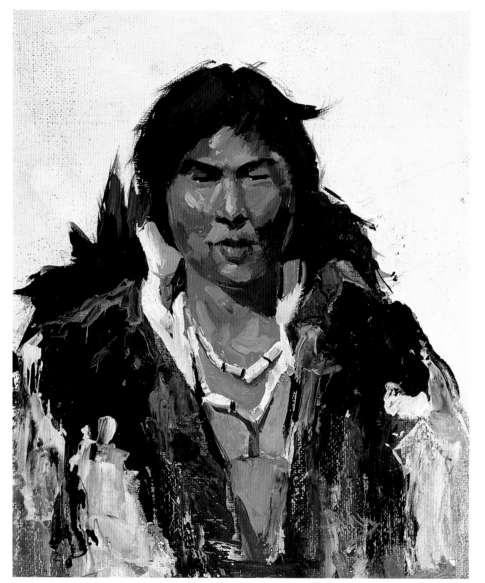

overlay of Scandinavian craftsmanship that is as much a part of the piece as its Inupiaq heritage or the social commentary. Even when he's dealing with a subject that is very hard to talk about, tense, and full of conflict, it's still done with Ron's characteristic precision and very tight craftsmanship.

Simpson: The spirit seems to be wearing a T-shirt. See the arm? The piercings in the hands, I'd guess, are natural knotholes. Still, it's almost closer to the Christian symbolism of crucifixion—

Chin: If you know Ron, you can see his sense of humor in the most incredibly serious things. Like Alvin's. Sometimes when I look at Alvin's work, I think, "Is he for real?" and I think he's putting me on all the time. When you're looking at art sometimes you take it so very seriously that you forget to see the humor.

73

Native Woman
Eustace Paul Ziegler
Oil on Masonite. 29.21 cm × 24.13 cm. Undated. Donated by Gerald FitzGerald, 1970. UA70-306-2

In addition to his landscapes, Eustace Ziegler painted many portraits of the people on the frontier: Native people, priests, miners, trappers, and fishermen. In contrast to the largely symbolic figures that appear in the paintings of Sydney Laurence, Ziegler's people are individuals, whether they are miners or young Native women, engaged in work or posed for portraits. We seldom are given their names, but they are rarely stereotypes, and each portrait seems to offer us a glimpse into the character of the individual.

Though small, loosely painted, and almost a sketch, *Native Woman* is a striking example of Ziegler's ability to fuse an interest in the character of paint for its own sake with sharp, insightful likeness. He was the first resident Alaskan painter to emphasize painterly means and pictorial description in more or less equal portions. (WOODWARD)

Simpson: Ron likes to put little irreverent things in his carvings. He did some panels for the courthouse, I think, in Anchorage, years ago, showing various animals. And, if you looked closely, you could see droppings falling from a caribou.

Lee: Which was often done in the etchings on small snow beaters.

Woodward: Artists who are visitors to Alaska, artists who are residents here, and artists who are Native make very different kinds of art that represent Indians and Eskimos. Eustace Ziegler lived in Cordova, where he interacted with both Native and non-Native Alaskans for a long, long time. It was his community. Ziegler tended to focus on individuals, and even though he painted very broadly in *Native Woman* (fig. 73) and he sometimes represented Natives in ceremonial dress—which kind of exoticized his subjects—the people come through very much as individuals, in contrast to Stuart—

Lee: You mean no visitor ever made a portrait of somebody this close up?

Woodward: Well, we're comparing it with the Stuart painting from several decades earlier, in which the subject was really the Native village and the Tlingit canoes on the beach. Certainly visitors made images of this sort of Native people as well.

I think it's apparent when you look at this work that Ziegler is painting an individual, not a generic Native person painted primarily for the exotic costume or as an example of the culture. This is probably someone he encountered on the street, probably daily, whom he knew well and talked to. Ziegler continued to paint images very much like this long after he left Alaska. This is what Susan was asking about earlier—where something begins as an authentic encounter, but eventually turns into formula. Certainly for Ziegler, his portraits became formulaic,

because he ended up making probably hundreds of paintings of Native people.

Lee: And can you actually tell the difference? I mean, if you were tested? Not on formal grounds, but on the grounds of how well he knew his subjects, whether they were painted early or late?

Woodward: Well—

Lee: While he knew them and after he didn't know them anymore?

Woodward: In many cases, I think one can.

McInnis: Glen, is there a difference for you between what you see in the Stuart and the Ziegler?

Simpson: These are obviously strong individuals. What I see—and it's kind of a peripheral thing—is the cobalt blue in the dress. And that, to me, reeks of Navajo or the Southwest. Of course it's just clothing, but to me it reads as turquoise and I wonder if that's a deliberate use of the color or just coincidental.

McWayne: What about how Lambert paints Eskimos in his *kashim* paintings (fig. 74)? He keeps everybody very vague in them. But Lambert and Ziegler traveled together. They did a trip down the Yukon in 1936. The majority of things I see in our collection from Ziegler are portraits, and yet Lambert has five of these wonderful ceremonial views inside the *kashim*. Very different kind of thing.

McInnis: Yet they must reflect some level of intimacy. Had he not been close enough—trustworthy—would he have been allowed in the *kashim*?

Jonaitis: No, he wouldn't have been. Still and all, Lambert's people are also indistinguishable as individuals, which I think is the result of his painterly style.

There is a Christian element to that figure in the middle. The arms are outstretched, almost crosslike.

There are "God rays" coming through the roof. It seems to me that Lambert is using certain Christian, iconographic metaphors to *enhance* the Native image. I think back to the designation of the "Okvik Madonna." There's a tendency to use religious ideas to elevate Native representations.

Lee: Well, when religion fades from a culture, it leaves a vacuum that's almost always filled in some way. Westerners often read spirituality into Native culture. I think it has something to do with their own emptiness, the lack of resonance, if you will, of Christian religion as the twentieth century has worn on.

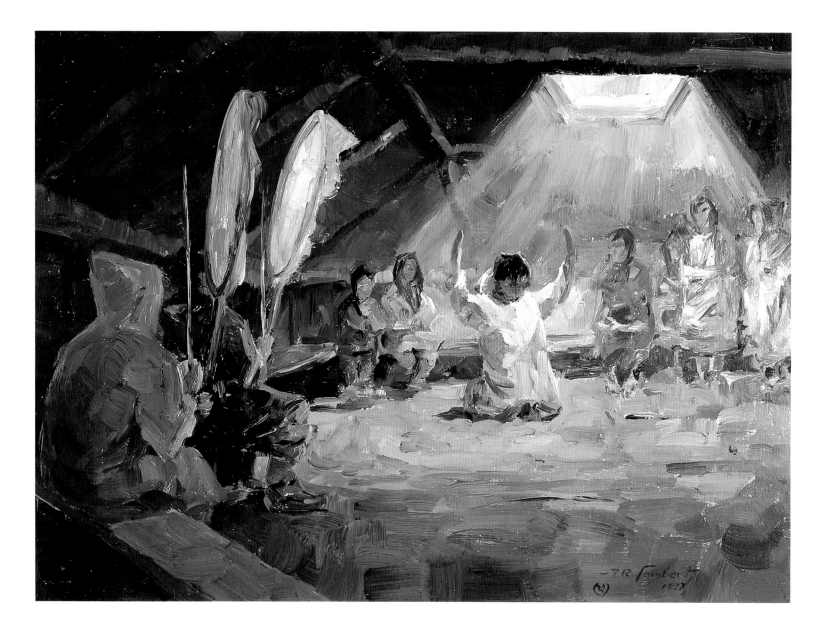

You find, for instance, people who looked at Native baskets—especially around the turn of the twentieth century when this was a big deal—and read Christian symbolism into a completely secular art form. They needed to believe that the basket maker was praying for rain, or thunder.

Jonaitis: The Native-as-more-closely-connected-to-the-land, to nature, to God. They're of a piece. And we haven't gotten out of that viewpoint yet.

Lee: Poldine Carlo spoke to this yesterday when she was down in the Collections Room. I showed her an old chief's jacket to ask where she thought it came from, and she said, "It's so nice to see this old stuff where beadwork is just beadwork. All these new artists are making things and they put the circle here and the dot here and they say this represents God." It clearly made her furious to see Native craftspeople serving the expectations of Western audiences.

Jonaitis: Good point. Some Native art does represent the spirit world. But some does not. We have on

74

Eskimo Dance in the Kashige
Theodore Roosevelt Lambert
Oil on canvas. 31.75 cm × 38.1 cm. 1937. Note on back: "This scene depicts a preliminary dance with the dancer in the movement of 'I have found something.'—T. R. Lambert, Feb., 1937—Bethel." Donated by the Charles Bunnell Estate, 1949. UA903-7

Lambert traveled with Eustace Ziegler down the Chena, Tanana, and Yukon rivers and then across the portage to the Kuskokwim River in the summer of 1936. Staying in Bethel when Ziegler returned to Seattle for the winter, he was able to witness and record expressive ceremonial Yupik dance performances such as this one in the *kashim (kashige)*. (WOODWARD)

75

Gwich'in Athabaskan sled bag
Anonymous
Smoked moosehide, metal, cotton material, seed beads, trade beads, wool. 52.7 cm × 47.6 cm. Fort Yukon or Arctic Village, before 1912. Donated by Rev. Wilder C. Files, 1969. UAM69-54-10

This sled bag was made for Archdeacon Hudson Stuck for use during his dog team travels around the Alaskan Interior during the second decade of the twentieth century. The presence of the cross is probably explained by the bag's purpose, which was to hold prayer books and other religious paraphernalia. According to Duncan (1989:139 and plate 35), it is probably of Gwich'in Athabaskan origin and made either in Arctic Village or Fort Yukon. (LEE)

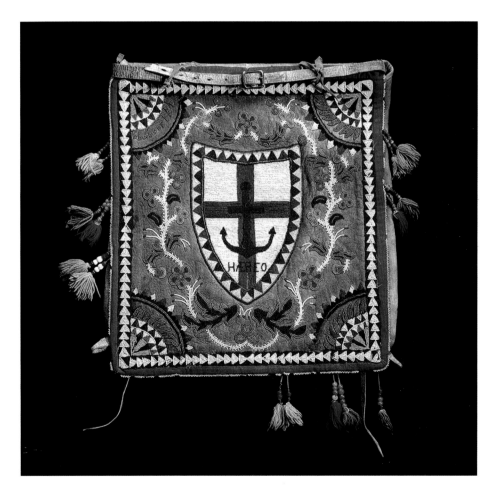

display a lovely Athabaskan beaded sled bag (fig. 75) that has a cross in the center not because it symbolizes some uniquely mystical Indian thing, but because it was made for a priest. I sometimes wonder what those twenty-second visitors make of it.

Chin: In *The Shaman* (fig. 76), Mark Daughhetee manages to bring together cerebralness and spirituality, and a humor that makes fun of himself as well as whatever else he's targeting.

Simpson: I think the willingness to relax with Native art is not something that people outside the group usually feel free to do. They feel like they should be very serious. They don't dare be frivolous.

McInnis: Barry, what's happening here? What do you see?

McWayne: Well, that's a very good question. Mark takes tales and stories that he finds interesting, or jokes or personal experiences, and creates these wonderful images that somehow work on different levels of meaning.

Woodward: It's certainly not coincidental that Mark has been a museum curator. It certainly informs his photographs.

Simpson: This looks like an old-fashioned ethno-logical portrait. To me, the raven's an icon. And the whole thing's a clichéd stage set, a play on any one of the early big museum dioramas.

Chin: What's deceptive here is the craftsmanship. Mark builds very complex sets for each photograph, painstakingly, with the same meticulous, even reverential care Glen puts into a silver piece. He builds it and photographs it and then he tears it all apart and builds a whole new set. When you look at the body of his work and how many sets he's built, it's impressive. This photograph is ponderous, evocative of 1900s East Coast museums. If you look at it cold, without knowing all that, you miss an encyclopedia of knowledge.

Lee: Yeah. It's very Shakespearean.

McInnis: Let's return to the Lambert. Is this piece not possibly just a "snapshot in oils" of a dance?

Lee: But even a snapshot is not a snapshot.

McInnis: Do all those overlays always live with this painting?

Woodward: Well, the overlays are not just inherent in the painting. They're overlays that we bring to the painting. Our feelings about the role of Christianity vis-à-vis Native people make us look for things of that

76

The Shaman
Mark Daughhetee
Photograph, toned gelatin silver print.
45 cm × 58 cm. 1990. Purchased, 1992.
UAP92:006:001

Mark Daughhetee grew up in Los Angeles and happily admits that his art has been influenced by the make-believe world of movie studio back lots; he even relishes the fact. Many of his images derive from elaborate tableau creations fabricated solely for the camera. His intent in these works is complex and varied, and often questions social and cultural norms. *The Shaman* is such a work. Here the artist examines the idea of cultures looking into each other: the Native shaman with his box of light versus the ivory-tower curator with his scientific instruments. Though Daughhetee's work often functions on several levels at once and is filled with rich symbolism and intellectual detail, it always retains a sophisticated aesthetic harmony and vivid visual panache. (MCWAYNE)

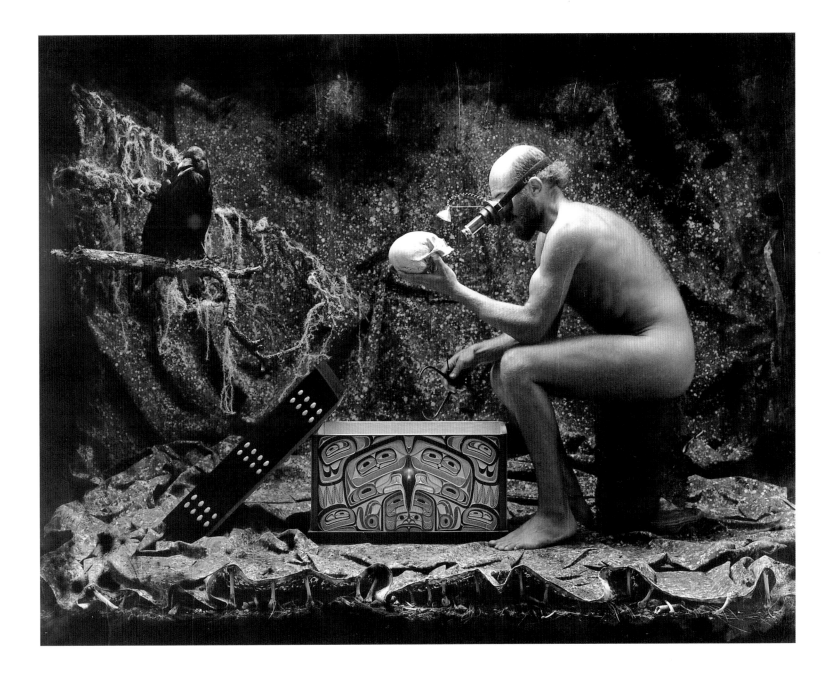

77

Shaman
James Kivetoruk Moses
Watercolor and ink on paper.
29.85 cm × 45.09 cm. Undated.
Purchased, 1972. UA72-20-1

James Kivetoruk Moses (1908–82) was born in Cape Espenberg, fifty miles from Shishmaref on Alaska's Seward Peninsula. As a young man Moses hunted, trapped, traded, hauled mail by dog-sled, and worked as a reindeer herder, but by the age of fourteen he also had produced drawings of interest to buyers. In 1953 he took up drawing as a way to make a living after a severe injury to his knee in an airplane accident made his former occupations impossible.

Moses's work is almost invariably done on paper or board in a variety of media ranging from ink to oil paint, watercolor, and colored pencil. Richly colored and fanciful, his work is quite different from that of other well-known Eskimo artists of his generation, such as George Ahgupuk and Robert Mayokok. Most of his pictures are narrative, ranging from everyday hunting events to fantasies and legends. *Shaman* is one of a number of his images of a shaman conjuring a devil-like spirit, presumably for consultation. (DeRoux 1990:24; Mozee 1978; K. Woodward 1993:92–93) (WOODWARD)

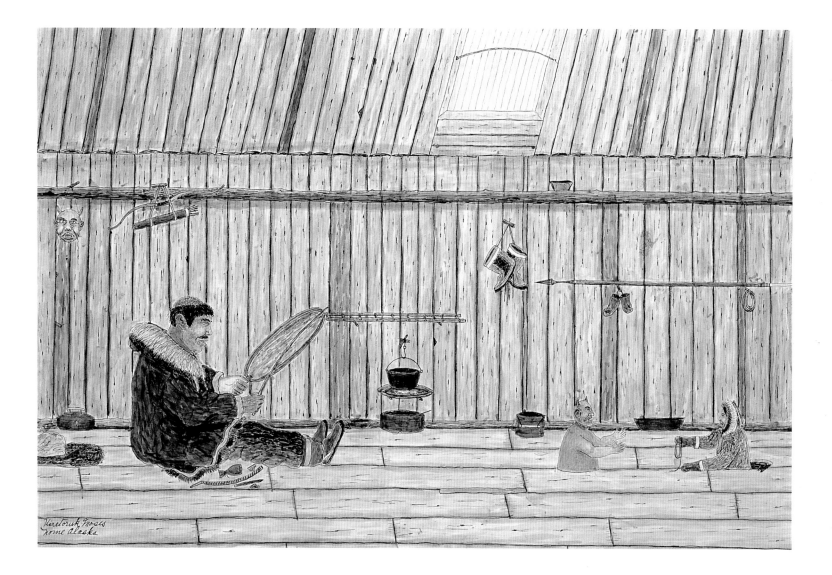

78

Pulling for Port
Sydney Mortimer Laurence
Oil on canvas. 45.72 cm × 60.96 cm.
Undated. Donated by Charles M.
Binkley, 1981. UA81-27-2

Pulling for Port is a fine example of another of Sydney Laurence's trademark images. Certain scenes seemed to etch themselves in the artist's mind, and he returned to them throughout his lengthy career. We are fortunate to have in the UAM collection outstanding examples of virtually all of the subjects for which the artist is best known and most loved.

It is hard to overestimate Laurence's impact on Alaskan landscape painting. Not only has his vision influenced virtually all later depictions of Alaska; it has, more than the work of any other artist, conditioned the way we Alaskans see our own land. (WOODWARD)

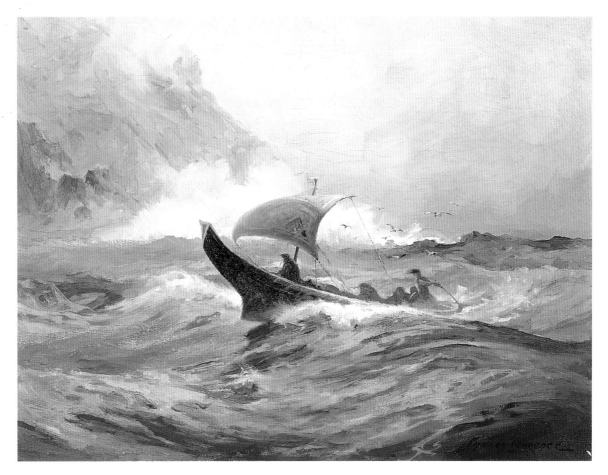

sort. I doubt that Lambert intended any Christian symbolism here. But that's not to say that it doesn't exist, that it wasn't part of his whole way of looking at the world, which came through unconsciously.

It is important, I think, that Aldona looks at it and sees that, because that says something about her relationship to the work. Everything we bring to the painting from our own experience becomes part of the encounter. That's one of the things that great art, or even good art, does. It allows for a lot of interaction. It isn't just a single thing, but engenders a lot of different kinds of encounters.

Dickey: Is that planned or does it just happen?

Woodward: Both. Some of it's planned, and a lot of it just happens.

Lee: Zeitgeist.

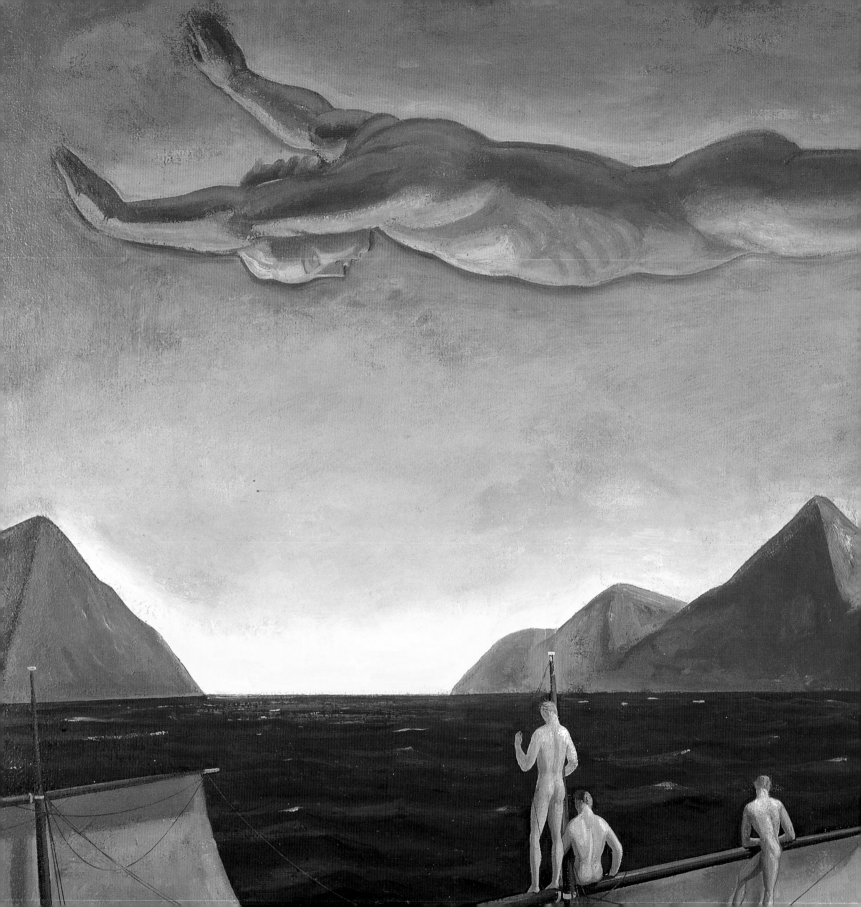

6 Landscape

The Story of Light

Think of the woman who first touched fire
to a hollow stone filled with seal oil,
how she fiddled with wick and flame
until blue shadows before and after her
filled her house, crowded
the underground, then
fled like sky-captains
chasing the aurora's whale tail
green beyond the earth's curve.
Her tenth summer, the elders let her
raise her issum, seal pup orphaned
when hunters brought in her mother,
their grins of plenty
broad, red. The women
slit the hard belly.
Plopped among the ruby innards
steaming on rough-cut planks
blinked a new sea-child
whose first sound
came out a question
in the old language, a question
that in one throaty bark
asked *who*, meaning What family
is this? What comfort
do you provide for guests?
Do you let strangers remain

strangers? The women rinsed the slick pup
in cool water, crafted a pouch
for her to suck. Then the young girl
whose hands held light
even when the room did not
brought this new being
beside her bed, let it scatter
babiche and split birch
gathered for snowshoes, let it
nose the caribou neck hairs
bearding her dance fans. They
held up the fans to their foreheads,
playing white hair, playing old.
In the time when women do not sew
the seal danced at her first potlatch.
And when the lamps burned down,
no one could see
any difference between waves
in rock, waves in sea.
The pup lifted her nose, licked
salt from seven stars, and slipped
light back among silvers and chum
light among the ghostly belugas
swimming far north to offer themselves.

Peggy Shumaker

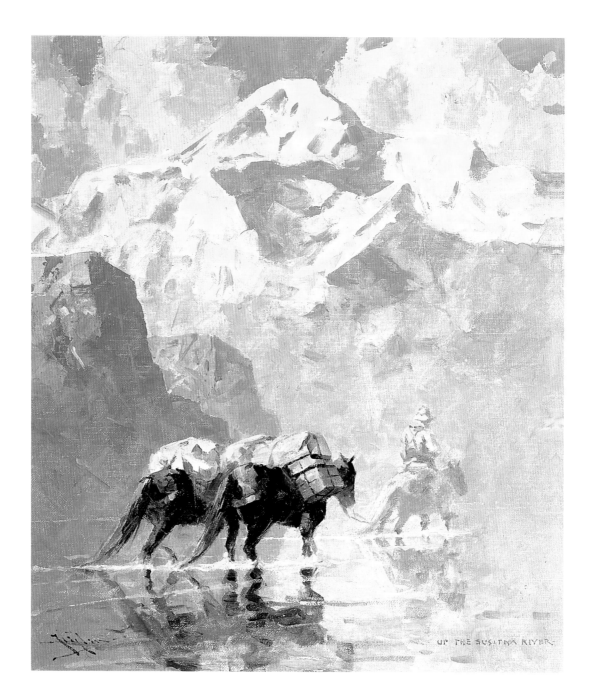

UP THE SUSITNA RIVER

Woodward: Sydney Laurence really defined the Alaskan landscape for early-twentieth-century painters. His image was what I call the "lonely landscape": either unpeopled or with just the smallest signs of human habitation. Very big mountains. Very grand landscape. Very small, symbolic, incidental, puny figures. This perspective influenced not only other painters but other Alaskans for whom the landscape was predominant, separate from human activities.

One of the things that makes Ziegler interesting to a significant minority of people who are interested in Alaskan art is that his view is just the opposite. In *Up the Susitna River* (fig. 79) Mount McKinley is very much in the background. Ziegler's subject is pioneer activity. Elsewhere in his work it's pioneers, Native people, fishermen—so his emphasis is on human activity within this grand landscape.

Lee: Isn't the idea of the small person and the large landscape a fairly diagnostic feature of landscape painting in the nineteenth and early twentieth centuries? I think there's a danger in identifying features as regionally significant when they're actually manifestations of wider trends.

Woodward: Absolutely. I don't mean to suggest that he's doing anything innovative, at least in global terms. Laurence was picking up on something that the Hudson River School, and American landscape painters in general, had begun several generations before him.

But when he started painting here, he did for Alaska what the others had done for the American West. Like a lot of others, he came north seeking the exotic scenery that was disappearing in other parts of America. So it's really a sort of replaying of the American West a couple of generations later.

McInnis: When we move forward in time to Rockwell Kent, his images of people are sometimes almost as big as his mountains (fig. 80). It seems to me he's equating wilderness with wisdom, a wisdom that's bigger than his mountains. I hear him saying, "Come to the mountains. I am bigger through these mountains. I am enlivened here."

Woodward: For Kent it's the human spirit that is large. The figure is really symbolic. This piece was begun right after he left Alaska in 1919 and was completed in 1923. He was reading William Blake and

79

Up the Susitna River
Eustace Paul Ziegler
Oil on canvas. 34.29 cm × 29.21 cm.
Undated. Donated by Charles M.
Binkley, 1981. UA81-27-6

If Sydney Laurence is Alaska's best-known and most loved historical painter, Eustace Ziegler is certainly second. In fact, many Alaskans prefer Ziegler's work, as it focuses less on the landscape itself and more on the character of pioneer Alaskan life. Ziegler's vision was of Alaska as a place of natural beauty, but his emphasis is on the men and women who worked to settle it. His figures are neither heroic nor tragic, but solid, hard-working, and real.

Though Ziegler lived in Alaska for only fifteen years, from 1909 to 1924, he made numerous return visits and painted primarily Alaskan scenes for the remaining forty-five years of his life. His work is widely revered and avidly collected by those who respond to both his lively painterly touch and his keen depiction of the character of the early twentieth-century Alaskan frontier. (C. Barker 1940; Campbell 1974; DeArmond 1978; Hoffman 1969; Shalkop 1977; Wilson 1923) (WOODWARD)

80

Voyagers
Rockwell Kent
Oil on canvas. 69.22 cm × 110.49 cm.
1923. Purchased, 1982. UA82-3-4

Rockwell Kent (1882–1971) came to Alaska in the winter of 1918–19 in search of haven for a troubled spirit and a source of inspiration, and found "a fresh unfolding of the mystery of life" (Kent 1919). The brief stay was an extraordinarily fertile period for his work and his spirit, and it proved pivotal in terms of his future direction and his critical and financial success. The 1920 exhibition of his Alaska work at Knoedler's Gallery in New York was critically acclaimed, and his book about the trip, *Wilderness, A*

Journal of Quiet Adventure in Alaska (Kent 1920), helped establish his reputation and cement his lifelong devotion to the North.

Voyagers is a striking example of Kent's identification of the sublime Northern wilderness with the unfettered potential of the human spirit. Among the best-known paintings from this watershed stage in the great American artist's career, it is one of the museum's most important works of art. (Kent 1919, 1955; Traxel 1980 [illus.]; K. Woodward 1993) (WOODWARD)

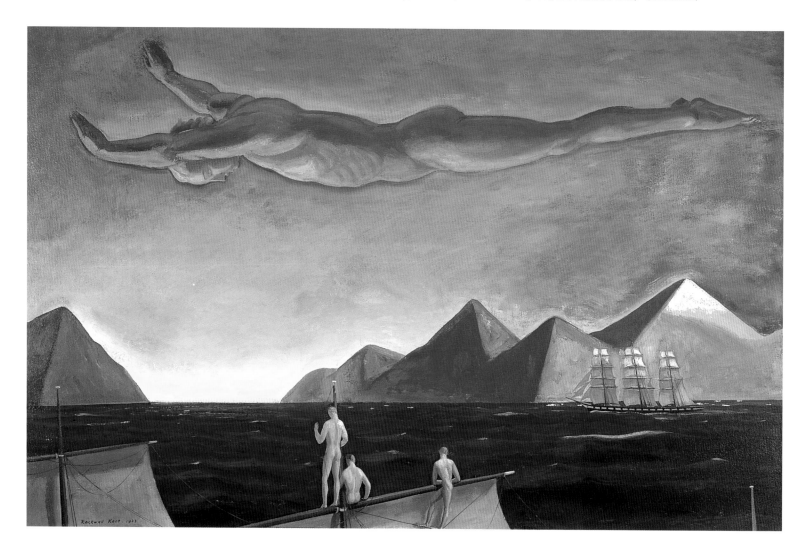

was influenced by his illustrations—and Nietzsche's *Thus Spake Zarathustra*. You can see both in his "man and superman" drawings. He was also inspired during this period by Arthur B. Davies, an American painter who created this type of symbolic, dreamy figure.

So Kent doesn't really participate in the Alaska landscape tradition at all. He comes in as an outsider, spends several months, and then defines Alaska—not the way Laurence or Ziegler and other permanent residents did—but Alaska as part of the "Mystical North," a place he further chronicled in Greenland. Just as he did the "Mystical South" in Tierra del Fuego.

McInnis: Do others of you find either of these paintings provocative or resonant in other ways?

Jonaitis: I view this as such a male painting, I just can't—

Amason: He's damned handsome, isn't he?

Jonaitis: The masculinity of some of these landscape paintings has struck me. The iconography. The boldness of Laurence's Mount McKinley. Ziegler's gold miners. And here you have this Blake-like nude. And the mountains—more like pyramids. It's very Eurocentric. I see nothing in this painting that is Alaskan. He's taken what he saw in Alaska and replied with an invention, a fantasy.

McWayne: You know, Kent uses that same shape of mountain in a lot of his paintings.

Woodward: I see it as a formal device, a simplifying of forms.

Simpson: What year was this?

Woodward: A couple of years after he left Alaska. He had come here in part to avoid World War I. He had a great love for German culture. He was also a really strange guy. Some people had even decided he was

a German spy. He wasn't, but he was very upset by the anti-German feeling in the country, and didn't want to be a part of fighting and killing. It was one of the worst periods of Kent's life. He came to Alaska in part to get away from all that and brought his nine-year-old son, Rockwell Jr., with him.

Amason: Do you know where he went in Alaska?

Woodward: Fox Island in Resurrection Bay, just off Seward. He came up along the coast looking for a place to spend the winter. While he was looking, he and his son went rowing in a little dinghy one day in Resurrection Bay. They ran into a Norwegian who had a fox ranch on a little island there. He towed them over to Fox Island and Kent fell in love with it.

Amason: He never made it out west at all—to the Alaskan Peninsula?

Woodward: No.

Amason: Wow. I get a totally different impression from this painting. I look at this and see the shoreline below Chignik, Castle Cape maybe, heading into False Pass. You have cliffs like this that just jolt out of the ocean, and very swift currents. There's a wind there, and a chop, creating shadows, making the ocean blue on the Pacific side—dark blue. The clipper ships were running back and forth to the canneries back then. Not knowing where Kent was, I'd swear this was down around False Pass, where I've fished commercially. It's barren there, no trees.

Woodward: For him, Alaska was not so much the place that we think about—a place to live or settle—but very pure, theoretical, ideal, far removed from the world of strife and conflict. It was a place to get away from the petty quarreling of human beings, live in isolation with the clear light and pure air of the North, and get back in touch with himself and his human spirit.

Simpson: Were others doing this kind of dreamscape

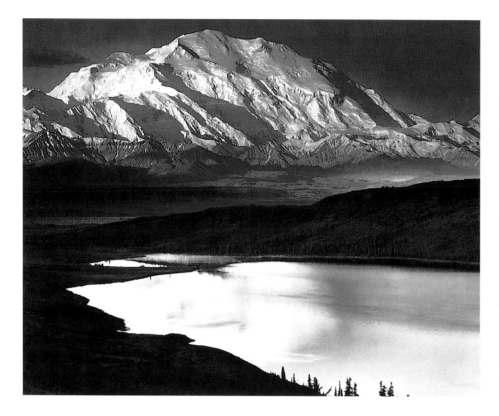

81

Mount McKinley and Wonder Lake
Ansel Adams
Photograph, gelatin silver print.
38 cm × 49 cm. 1947. Purchased,
1986. UAP86:023:001

In 1947 Ansel Adams came to Alaska on a Guggenheim Fellowship to photograph in the national parks. With the assistance of the National Park Service, he spent a week at the Wonder Lake ranger cabin. During that time he had only two cloudless days to photograph. This world-renowned image was made the very first evening, or, more accurately, the next morning just after sunrise—at 1:30 A.M. Amidst swarming, merciless mosquitoes Adams was able to take only a few exposures before the clouds closed in and obscured the mountain. Later in his trip, the film case containing his McKinley photographs fell into shallow water at Glacier Bay. Adams jumped in and retrieved it, but many fine images were ruined. Fortunately, this one survived. (MCWAYNE)

vision at the time? Was that typical? Was it Freudian psychology?

Woodward: Some artists were doing the same sort of thing, like Arthur B. Davies, with his figures and unicorns and horses. But most of the art world had moved on to more formal innovation, toward abstraction, German expressionism, more experimental visual modes.

This was a turning point for Rockwell Kent. The work he did between 1910 and 1920 is the closest he ever came to flirting with abstraction. The forms become much simpler. Some of the landscapes become dreamy and mystical. It's as if he toyed with the idea of leaving representation aside. But after this point, he became much more devoted to the landscape itself, depicting it the way he felt it looked in

essence. So by 1920 he was kind of behind the curve in terms of formal innovation. He related more to the artists from the symbolist and post-symbolist period at the turn of the century.

There are some very superficial similarities to surrealism in some of these images. But surrealists juxtaposed figures in the landscape and used distortions of scale differently. I don't think there's any genuine affinity with surrealism in his work at all. It's a pretty individual vision, married to the idea of the landscape. He really identified with the feel of it, the spirit, and with his feeling as a human being. It is extremely male. In a lot of ways, and on different levels, he followed his maleness around the world.

McInnis: How does photography fit in here? What about Ansel Adams?

McWayne: When Adams first came to Alaska in 1947, he was already a successful photographer of California and the West and was involved with environmental issues. He planned to use the first (of two) Guggenheims to begin documenting the national parks, starting with what he thought was the last and greatest wilderness. It was a good first trip, enriching, and he recorded some strong images, but his pivotal experience came the following year.

He settled in at Glacier Bay National Park for three or four weeks. Often alone—dropped for a day or two on a mountaintop or a remote island—he wanted to experience true wilderness. But it rained continually.

He couldn't work very much at all. You can imagine how frustrating this would be. But it was really wonderful. During the forced period of real isolation he completely recast his thinking. He solidified his ideas about the wilderness.

Surrounded by all that space, Adams dedicated the rest of his life to fighting for the wilderness. From that point on his reference to and reverence for Alaska was heartfelt, genuine, and showed throughout his life in his writings.

It is interesting to see Alaska's effect on Adams and compare it to that on Kent. Adams admitted that he often made the landscape dramatic, because this was how he felt about it. Not for the sake of theater, but because he had such an abiding connection with the land. It just came out in these rather dramatic, sometimes even overdone, representations.

McInnis: Take us to today: Bill Brody, David Mollett, or anywhere you'd want to go. What's inherited, if anything? What's shed? What's traveling?

Woodward: In a lot of ways Mollett and Brody and other contemporary Alaskan landscape painters turn away from Laurence's and Ziegler's vision of Alaska as a place to settle and develop (figs. 83, 84). They turn toward an earlier image—Alaska as a place to visit and be left the way it is. They return to the primacy of the landscape. There are no people in either Mollett's or Brody's work from the Brooks Range. You're aware of the artist being there and seeing, but it's the artist as a "looker," a visitor. Neither artist claims for himself what he sees. They preserve a distance from the land. It's a place that deserves awe and respect on its own.

82

Clockwise from upper left: **Kesler Woodward, Wanda Chin, Glen Simpson, Molly Lee, Alvin Amason, Susan McInnis, Aldona Jonaitis, Terry Dickey**

83

Guardians of the Valley
Arthur William (Bill) Brody
Oil and alkyd on canvas. 111.76 cm
× 175.26 cm. 1993. Purchased, 1993.
UA93:024:001

A longtime professor of art at the University of Alaska Fairbanks, Bill Brody (b. 1943) for many years was known primarily as a figurative painter and printmaker. In recent years, however, he has turned his attention to landscape painting and to computer-assisted works, often combining the two interests in complex images involving layers of manipulation by both the computer and the artist's hand.

In the last several years Brody has joined various Fairbanks artists on trips to the Arctic National Wildlife Refuge (ANWR) and other portions of the Brooks Range (M. B. Michaels 1990b; Mollett 1992; Sharp 1996; Wignall Museum/Gallery 1994). *Guardians of the Valley* was painted on location near the upper Marsh Fork of the Canning River in ANWR. Working in the field under frequently trying conditions, Brody begins with a black-and-white drawing, defining values in carbon pencil and compressed charcoal. After sealing the drawing with an alkyd medium, he uses a combination of transparent glazes and opaque areas to capture the shifting light of his arctic scenes. (P. Bermingham 1978:32–33; M. B. Michaels 1990a; Mollett 1992; Sharp 1996; Warner 1994; Wignall Museum/Gallery 1994; K. Woodward 1995) (WOODWARD)

McWayne: Yes, it's remote. But there's a paradox here. There is something about Brody's landscapes that seems almost human, alive. There may be no people here, but he makes the forms so figurative. The mountains are pregnant with life. There's something alive in those forms. I may just be trying to identify, as a human being, with these kinds of spaces. But I don't feel that people are *not* present and it's mostly because of those forms. I may be just reacting to his former work, which was so totally figurative.

Woodward: I think you're absolutely right. I hadn't thought about it. Brody always was a figurative painter. At one time he did these very surrealistic, introspective, tortured-looking figures in tortured-looking landscapes that came out of his head rather than his observation.

You're right—there's still a lot of figure development in his recent landscapes. I remember Bill saying over and over, "Boy, you'll never catch *me* turning into a landscape painter. The rest of you guys may be landscape painters, but *I'm* not going to be a landscape painter. I'm a figurative painter." Finally he succumbed. But even so, as Barry points out, the figure's still there.

Jonaitis: Am I the only person thinking that we're sitting on the navel of a woman, looking up between her breasts toward her chin?

McWayne: Yeah, but—okay, I'll go with that.

McInnis: That was a quick trip!

McWayne: I'll tell you something. When I saw this painting in his studio, I saw—I don't want to wreck this—but I saw this as a head, and an arm—

McInnis: Oh look!

McWayne: —and a body floating in the sky.

McInnis: Oh yeah!

Jonaitis: Right! It's the guy looking at the woman!

McWayne: Could be!

Woodward: Brody has actually done computer-generated images in which he takes a photograph of his face and a photograph of a range of mountains and morphs the one onto the other, so his face is distorted over the form of the mountains. I think, clearly, he wouldn't have any objection to this sort of reading.

Simpson: There are places—like the Arctic National Wildlife Refuge and Gates of the Arctic National Park—that have been set aside for preservation, in an effort to lessen the impact of human beings. If you come forward from the turn of the century, you see that the boundaries are rapidly moving farther and farther away, to very isolated places. People recognized the need to set some places aside—first it was the American West, then southeast Alaska, then McKinley, then Gates of the Arctic, then ANWR. The borders are constantly retreating, but people go to those places seeking something.

McWayne: Do you think Bill goes to these places to represent them for us in the hope that we won't go there? Do you know the work of Dave Bohn, the photographer? He goes to places like the Katmai, lives there, does extensive photography, and writes very sensitively. His goal is that you experience the place through his writings and photographs, but stay away.

McInnis: Richard Nelson did the same thing in his book *The Island*. He completely disguised its location but still took us to it, so he kept it all to himself while giving it to us. Interesting concept. He said he was harassed for a while by people saying, "Come on, just tell *me* where it is."

Simpson: When people go to very remote places to paint, is it because they can't find similar things close

by? Or is there some sort of ideal in an area that is set aside, or off limits?

Woodward: Well, that's another long, artistic tradition. As the American frontier retreated in the late nineteenth century, a lot of artists went out West. Frederic Church and other Hudson River School painters sought out even more exotic landscapes. Church went to South America. He painted in the Andes and along the Amazon. He chartered a boat to Labrador to paint icebergs and made trips to paint the pyramids and other exotic scenery in Europe and northern Africa. There's a long tradition of searching for ever more exotic scenery.

Jonaitis: What I find interesting about the Brody compared to the Mollett is that these two roughly contemporaneous paintings seem to embody the two major divisions in Western art history: the romantic and the classical. Brody's is a profoundly romantic painting in that it is very emotional. There is a tremendous amount of passion in just the way the brush strokes cover the canvas. The allusions to the female form are also fraught with meaning. Then you go to the Mollett, which is so, to me, incredibly objective. He objectifies and stands back from his subject matter, almost like a scientist looking at the landscape.

This makes sense: The romantic tradition is one of emotion and passion. The classical tradition is one of rationality and distance. The two works are very different, but each artist imposes on the landscape what he has to say about art. For Bill, art is a way to express his passion about the world. David expresses his scientific understanding.

Lee: But can you see anything that tells us these painters have lived here for a long time? Could either of these been painted by an outsider?

Woodward: I would say yes. You don't know from the work that each has a strong, long-lasting connection to the place. They're both more interested in things other than expressing their identification with that place as home. I buy Aldona's distinction pretty completely.

Jonaitis: But we also know these people, so—

Woodward: Look at David Mollett: He just went over to France and did an extensive series of works there. He paints the French landscape exactly the same way he paints the Alaska landscape. He analyzes complex jumbles of form and breaks them down into more stylized, simplified, coherent analyses. He plays with color in equally formal ways.

84

Tanana River
David Mollett
Oil on canvas. 101.6 cm × 127 cm.
1987. Purchased, 1987. UA87-3-55

David Mollett grew up in Fairbanks from the age of ten and went on to study at Reed College in Oregon and the New York Studio School. He is the progenitor of much of the interest in on-location landscape painting among Interior Alaska artists in recent years. Known by the mid-1970s for his Fairbanks cityscapes, Mollett began working in the hills and river valleys around town, moved on to the more dramatic scenery in and around Denali Park, and since 1988 has worked frequently in the Brooks Range and other areas of arctic Alaska.

Mollett breaks complex landscape forms into highly structured shapes of all-but-solid color, stretching them tautly across his well-ordered canvases. In recent years, his simplification of the forms has become more radical and his colors more intense. The strongly outlined forms, bright colors, and tight structuring of his canvases have had a noticeable impact on the work of the increasing number of artists who have accompanied him or followed his lead into the Brooks Range and Arctic National Wildlife Refuge. (Behlke 1989; Harder 1986; M. B. Michaels 1990b; Mollett 1992; Sharp 1996; Wignall Museum/Gallery 1994; K. Woodward 1995) (WOODWARD)

85

Tidal Pool

Gary L. Freeburg

Photograph, gelatin silver print.
9 cm × 12 cm. 1982. Purchased, 1983.
UAP83:020:001

Gary Freeburg was raised in the cultivated farmlands of the Midwest and came to Alaska in 1980 in search of something different to stimulate his art. What he found was a raw landscape, vast in scale and complex in visual elements. Initially, it overwhelmed him and he produced little other than "scenery" images. But after six months of observation he was drawn to the tidal areas of southeast Alaska around Chichagof and Kruzof Islands near Sitka. The natural movement of the ocean and the monumental appearance of rock formations renewed his spirit and invigorated his vision. Influences in Freeburg's tidal work came from experiences with Buddhist rock gardens in Japan, from the color-field paintings of Mark Rothko and Barnett Newman, and from the Edward Weston photographs of Point Lobos, California. *Tidal Pool* is a simple selection of organic shapes, moving lines, and middle grays in its formal presentation. Freeburg has used a condensed tonal palette here to enhance the perception of serenity and quietude, elements that appear often in his work. (MCWAYNE)

That's the way he was trained, and I think that's the way he sees the world. I really do. Because he paints figures that way. He paints the French landscape that way, and urban scenes and mountains. I believe when he gets up in the morning, that's the way the world looks to him.

And Bill's the same. I think you're right. Bill is a very emotional person and there's all this wrought-up feeling in there. Painting is a way to harness it and to get it out.

Jonaitis: All of these paintings are projections of the artists' imaginations, impositions on the landscape itself. One is dreamy, otherworldly, what a lot of people want to see in Alaska. Another is bold, aggressive, wild—another imagined Alaska. Different landscapes meet different expectations. For many art lovers, such landscapes *define* what Alaskan art's all about.

But I find this classification of landscape painting a bit limiting. I'd like to expand this general category to include not only images of the land but of creatures that live on the land. Ecology teaches us that plants and animals interact with their environments in complex ways. This would also enable us to include Native art within this broadened category. Animals appear in ancient Eskimo carvings, on works such as totem poles as well as on baskets (figs. 86, 87). Although almost always they are not contextualized within a landscape, Florence Malewotkuk does situate her *Polar Bears* (fig. 88) within an ice floe. And, if we're really into shattering classifications, we can even include these Yupik masks that look anthropomorphic in a highly stylized way but represent *grasses*—which are certainly an important part of the land (fig. 89).

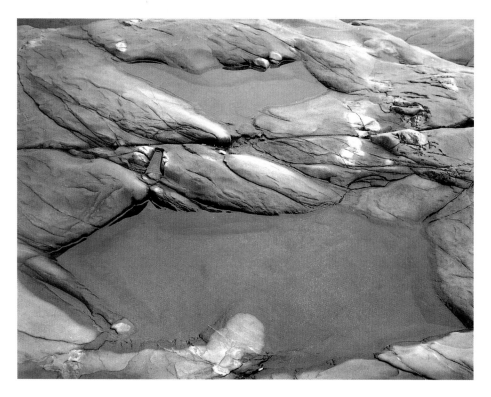

86

Tlingit eagle Kaag Waan Taan totem pole
Nathan Jackson, with apprentices Bert Ryan and Lee Wallace
Cedar. 6.6 m. Carved at UAM, 1988.
UA88-022-0001

Although often considered the quintessential Native American art form of southeast Alaska and coastal British Columbia, totem poles such as this example were the product of encounters between Natives and non-Natives starting at the end of the eighteenth century. Prior to contact, Natives of the region installed posts decorated with clan images in the interiors of their large lineage houses. With the influx of wealth from the fur trade, which inspired chiefs to commission larger and more spectacular monuments that embodied their lineage's position and legacy, and with the use of metal tools, which enabled carvers to work much faster, the large totem pole erected outside houses developed among the Haida in the Queen Charlotte Islands and then spread to the other Northwest Coast groups.

Factors including missionization, population decimation due to disease, and abandonment of traditional villages resulted in a decline in totem pole production by the turn of the century. During the Depression, however, as part of a Native work project, totem poles in southeast Alaska were restored or, if their decay was too extensive, replicated, and erected in Ketchikan, Wrangel, and Klawock. By the 1970s Tlingit carvers were making new poles for their own communities as well as for museums (Jonaitis 1998).

This pole was carved during the summer 1988 UAM exhibit *A Treasured Heritage: Works by Masters and Apprentices* by master artist Nathan Jackson. The crests represent the eagle, wolf, and bear, and the pole honors the wolf clan by representing the clan history of an ancestor who removed a splinter from the mouth of a wolf; to express its gratitude, the wolf bestowed wealth and status upon that man and his clan. The pole was raised in October, in an event planned by elders from the Klukwan and Hoonah eagle wolf clans, the Hoonah bear clan, and the Haines raven clan. (JONAITIS)

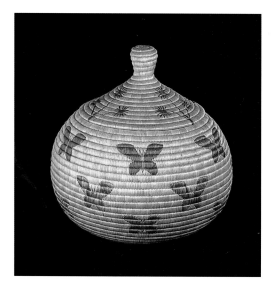

87

Yupik grass basket

Anonymous

34.3 cm high × 35.6 cm diameter at base. Tununak, 1983. Purchased from R. T. Schultz, 1983. UAM83-3-65AB

One of the earliest departures from the geometrically decorated Yupik basket was the innovation of zoomorphic designs. Introduced by the women of Nunivak Island, the idea of decorating a basket with fanciful and realistic animals depicted in bright aniline dyes quickly spread, reaching other Bering Sea villages by the 1930s (Lantis 1950). At first basket collectors, persisting in a misguided belief that geometric designs had symbolic significance, rejected baskets with zoomorphic motifs, which eventually began to sell well during the 1950s. Originally basket makers created designs by substituting colored for plain overwrapping strands. Later, as with the butterflies on this basket, they oversewed a plain basket with a second, colored strand in an embroiderylike process. (LEE)

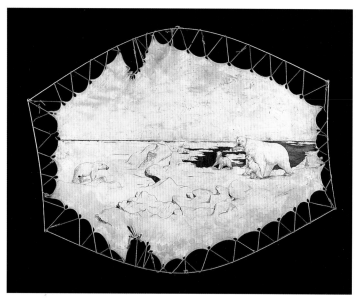

88

Polar Bears

Florence Nupok Malewotkuk

Ink on bleached seal hide. 121.92 cm × 149.86 cm. Undated. Purchased, 1982. UA82-3-49

Florence Nupok Malewotkuk (1906–71), born in the village of Gambell on St. Lawrence Island, developed an interest in drawing at an early age and was already known by the time she was seven as a "picture maker." From the age of nine she sold her drawings to non-Native visitors aboard ships visiting Gambell. She had an intense desire to share her vision of her people's way of life with the world beyond.

Malewotkuk's greatest encouragement in that regard came from collector and archaeologist Otto Geist of the University of Alaska. Recognizing both the artistic and the documentary value of Malewotkuk's skills from the time of his first meeting with her on St. Lawrence in 1926, Geist commissioned her to do thirteen pictures for the University of Alaska Museum. After completing the commissioned work, she produced more than ninety additional drawings, colored with crayon and/or watercolor on 7-by-11-inch tablet paper, which Geist was able to purchase as well.

Malewotkuk worked actively through the 1960s, producing several other bodies of commissioned work and selling drawings on paper and large compositions in ink on sealskin such as *Polar Bears*. Her work is varied and inventive in technique, ranging from flat and schematic to richly shaded and volumetric, but she never wavered from her early goal of telling the story of the people, animals, and way of life on St. Lawrence Island. (Hargraves 1982; Matthews 1973:21; Ray 1977:51–52, 271; K. Woodward 1993:96) (WOODWARD)

89

Yupik masks representing plants
Wood. 18–20 cm. Old Hamilton.
Collected for UAM by Otto Geist, 1934.
UA2002-64-64-11, 64-7-23

When Otto Geist collected these masks, he acquired stories about them from Pauline Kameroff, a schoolteacher who interviewed an old Yupik man and then wrote English summaries of his narratives. According to these accounts, "Out of the earth grass and other growing plants appeared. As they grew out from the earth they would spin a top. Whenever the top would stop spinning they would quarrel among themselves saying that the top had turned towards them." The wearer could open and close the articulated lower jaws on these masks by manipulating a string. (Fienup-Riordan 1996:241 [illus.]) (LEE)

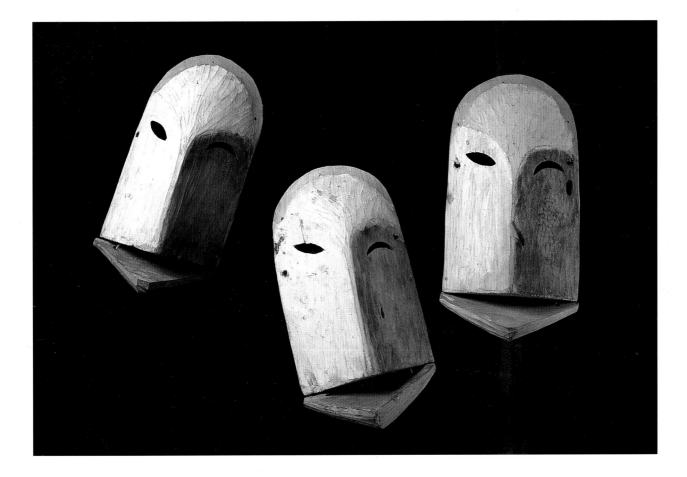

7 A Sense of Place

The Day the Leaves Came

For so long the hillside shone white,
the white of white branches laden, the sky
more white, the river unmoved.

And when the first stirrings started
underneath, the hollowing subtle,
unpredictable, rotten crust gave way—

ice water up to the ankle! She
turned from her work and shook
her wet foot. The buds had broken.

Not the green of birches in full leaf.
Not meadow, tundra, berry patch, tussock.
For this moment only, this green—

the touch of one loved
in secret, a gasp held in,
let go.

Peggy Shumaker
Wings Moist from the Other World

Detail of figure 91

90

American Gothic, 1985
Charles Mason
Photograph, gelatin silver print.
31 cm × 25 cm. 1985. Purchased,
1985. UAP85:106:001

One of Alaska's most versatile and successful photographers, Charles Mason has developed a diverse portfolio ranging from traditional landscapes to candid street photographs to highly stylized portraits. Of his many areas of interest, photographing tourists is surely his favorite. This image of summer visitors and their satellite-dish-equipped motor home was made using unusual equipment for Mason, a new 4 × 5 view camera he was learning to use. The dark arc at the top of the picture is a technical flaw—vignetting—which the artist didn't discover until the film was developed, but he liked the effect. The couple was inside watching TV when Mason knocked on their door and asked if he could photograph them and their traveling home. This image was the last of three exposures he made and the only one in which the subjects look serious. But the effect is just what Mason wanted—a new American Gothic. (MCWAYNE)

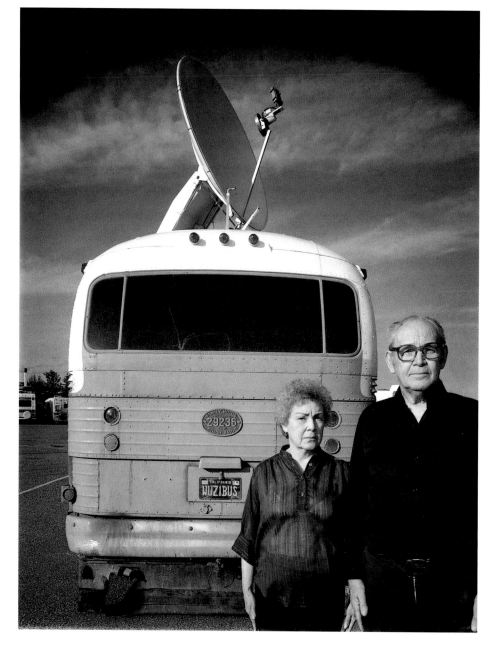

Lee: Is the sense of place we perceive in Alaskan art unique?

Woodward: We're attuned to it because this is our place. But I think it's no different for artists in Minnesota. They're trying to define the place where they live.

Jonaitis: I don't know, I think there's something about Alaska. In the earliest days of Alaska tourism, in the 1880s and '90s, the extraordinary landscape was one of Alaska's attractions. See the glaciers. See the mountains. See the fjords. Alaska's also a special place where Native culture remains especially strong —those early visitors came here to see those cultures and to purchase their art.

Barry, there's a wonderful photo in your collection in which tourists become the subject of art, no?

McWayne: Yes indeed—Charles Mason's "WUZI-BUS," which shows two tourists in Alaska. They were very annoyed, I must tell you.

Lee: They look it.

McWayne: They wanted their license plate to say "WASABUS," but it was already taken. When Charles pronounced it "was*ee*bus," they corrected him. They insisted that it be pronounced "was*uh*bus."

Anyway, the title of this is *American Gothic, 1985,* and I think it sums up succinctly an experience we have all seen in Fairbanks. Charles is, of course, *in love* with tourists. He always photographs them. He has a vast portfolio of this kind of work. This was something of a departure. He used a large camera on a tripod, a very different approach from his normal, candid, capable, thirty-five [millimeter] handheld. And all of the features about the image are very powerful. Even the technical flaw. I might mention this, just for your insight. You see that dark area at the top? This was one of the first times that Charles had used a four-by-five view camera. As he raised the lens in order to see higher, he didn't notice he had gone

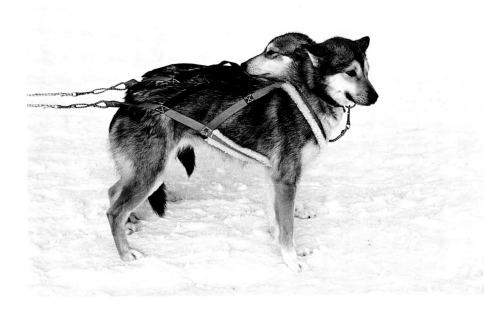

91

Two-Headed Dog
Stephanie Harlan
Photograph, gelatin silver print.
13 cm × 20 cm. 1983. Purchased,
1983. UAP83:093:001

Stephanie Harlan was perhaps the first contemporary Alaskan photographer to look seriously at sled dogs as individuals, as athletes, and as symbols. Many of her photographs catch the dogs in the act of racing, in blurred motion or set off against a totally white ground to isolate and highlight them, allowing their character and anima to surface in a perceptible way. Humans rarely appear in her images, and she makes no attempt to present the dogs as pets. This delightful photograph is at once humorous and telling. It catches the viewer off guard by presenting an impossible creature, yet it depicts the ideal lead dog, one that pays attention to both the trail and the team. (MCWAYNE)

92

Aleut model boat

Anonymous

Sea mammal skin, caribou fur, driftwood, trade cloth, thread and yarn, red and blue pigment. 61 cm × 9 cm × 17 cm. Collected by Capt. Soren Hansen, before 1890; donated, 1957. UAM823-1

Numerous models of Alaska Native ethnographic objects exist in museum collections (Phillips 1989b). In earlier times Alaska Natives most commonly made models as toys for children, for whom they were not only pleasurable but also taught mastery of the surrounding world. Among Eskimo groups, models also were used in religious ceremonies to represent aspects of the natural world or absent members of a community. Along the arctic coast of Alaska and western Canada, models were sometimes left on graves in place of material possessions needed by close living relatives. More recently, miniatures have become popular with tourists because they enable visitors to pack, ship, and display exotic peoples and their way of life more conveniently than would full-size objects. Model boats were among the most commonly miniaturized aspects of Alaska Native culture.

This example, an especially old and fine one, is of a three-hole Aleut *bidarka*. Originally such boats had room for only two hunters, but after the arrival of the Russians, three-hole kayaks became popular because of foreigners' inability to handle the delicate and dangerous watercraft while hunting. Boat models normally include numerous pieces of hunting gear lashed to the model's skin cover. Here we see (fore to aft) a paddle, whaling club, harpoon and float, sealskin float, and wooden quiver. The quiver is indicative of the model's age; very few full-size ones can be found in museum collections, suggesting that they disappeared during the early contact period. (Graburn, Lee, and Rousselot 1996:156, pl. 414) (LEE)

past the edge of the lens's imaging circle. So that is a technical flaw. But he liked the results.

Lee: Oh, yeah—like a nebula.

McWayne: God smiled at him that day. It really tightened up the top.

Chin: I'd like to say something also about the people in this photograph. We have stereotypes of our visitors, of the kind of people they are.

I see people driving by the museum. They stop. They jump out of their car. They run over to the Bernard Posey sculpture, *Totem*, the big black piece outside the museum. And they take a picture. I wonder what they're seeing, what makes them do this. But whatever it is, they appreciate what they see, and it moves them.

Simpson: We don't always give tourists enough credit. There are some amazing people who wander around in funny-looking buses, and we stereotype them all.

Jonaitis: Well, let's return to what draws so many tourists to our gorgeous state—the land.

Certainly the early painters tried to capture that landscape as well as Native culture, and many did so quite successfully. But even today a very important subject of Alaskan art is Alaska's nature—Kes's birch trees, Ansel Adams's Mount McKinley. And this land's animals—Alvin's birds, Stephanie Harlan's sled dogs, the supernatural animals that appear in so much Native art. Isn't there something unique that inspires this genre to stay at the forefront of our art history?

Amason: There's lots of information here.

Jonaitis: What do you mean?

Amason: Well, you paint them and shoot them. You have to know a lot about them to do both. To harvest with respect. It's more than just looking for animals.

93

**Pacific Eskimo (Alutiiq)
spruce root basket**
Anonymous
Spruce root, grass. 13 cm high.
Prince William Sound or Kodiak
Island, before 1920. Lilla W. Davis.
UAM0562-5463

Possibly the most satisfying research project I have undertaken was identifying the Pacific Eskimo basket type as a new species (Lee 1982). At my first museum job as a student intern at the Alaska State Museum in Juneau, my desk in the Collection Room faced a wall of baskets. For a year or more I kept noticing one example shelved with the Tlingit baskets that didn't look right. When I finally looked up its catalog information, I found out why. The basket had been collected at Prince William Sound, which lies in Pacific Eskimo (now called Alutiiq) territory. Eventually, I located enough examples to argue that they had been made by the neighboring Alutiiq peoples rather than the Tlingit. Since then, at least twenty have come to light. This example can be distinguished from Tlingit baskets by its use of inner-layer, matte spruce-root fiber, its coarser weave, simple non-Tlingit decorative motif, and added three-strand twined ridge as a decorative feature. (LEE)

You have to have all this information about the environment, the weather, what you need, what doesn't work, about laws and traditions. Living in Alaska gives you the luxury to immerse yourself in all of this—to saturate yourself in the information of our surroundings. It's a richness.

Some Alaska Native artists have resided Outside for so long—and they may be excellent craftsmen— but their stuff to me is flat. It just doesn't have the nuances. You couldn't really define it, but it's dead to me. Even if it sells really well. There's so much money in mediocrity these days.

Simpson: I look at this bird of Alvin's and see the bird as a character (fig. 94). You look into its eye. You can see it's a mischievous, noisy little beast. It's not just an ornithological study. You really feel a presence. I think that's often what Native people bring— the animistic sense of animals having some kind of spirit, some kind of knowledge.

Lee: Kingfisher-raven.

Simpson: Kingfishers. Complex beasties. They have these big sturdy beaks. At the clay bluffs down by the Tanana River where the swallows nest, the kingfishers will get up there and spear those little babies. They drag them out of their holes and fly off with them. They're real aggressive, sturdy little guys. Noisy and obstreperous.

Amason: Territorial.

The mischief that comes across on the canvas emerges from my own immersion, I think, the comfort I feel with my subject. When you're familiar with the territory, you can throw on a T-shirt, like Ronald Senungetuk does in *Two Spirits*. That's totally off the wall, but it worked so well. Someone from Outside or a generation out might have been too rigid to do that.

Simpson: And there's a willingness to be frivolous and have some fun, to not be uptight about it. You

94

I Could Watch You Until the Stars
Come Out and I Can't See No More
Alvin Eli Amason
Oil on canvas. 152.44 cm ×
137.16 cm. 1983. Purchased, 1983.
UA83-3-63

Alvin Amason's painting, which often incorporates attached
sculptural and mixed-media elements, draws less upon the
traditional imagery of his Native culture than on his affection for
and understanding of the animals that he grew up hunting and
observing with his grandfather, a hunting guide in Kodiak. The
great strength of the artist's work lies in his ability to make his
big, splashy canvases look almost effortlessly thrown together,
while capturing with real insight the character of the animals
he depicts. (P. Bermingham 1978; Blackman and Hall 1988; Paine
1979; Stadem 1994; K. Woodward 1995)　　(WOODWARD)

don't have to be somber and tiptoe around here. It's
okay to have a sense of levity in these things.

Amason: What about Kes's painting of birch trees
(fig. 95)? When was that done?

Woodward: 1983. I did my first image of a birch tree
when I moved to Anchorage from Juneau in 1978.
There was this beautiful birch tree outside the win-
dow. Missy had been away, going to school Outside
learning to blow glass, and I did this portrait-of-a-
birch-tree for her as a "coming back to Alaska"
present. And then I just sort of fell in love with it.

　This is called *Spring Green*, and it's about the
time of year when the leaves first come out. You get
that odd yellowy-green before the birch forest deep-
ens into the blue-green of summer.

Amason: You know, the first time I saw your birch
paintings, I thought, "Hey, I bet this guy can paint
birds!"

Woodward: I paint birch trees partly because I love
them, but also because the image allows me to make
big abstract paintings that people can relate to. When
people ask me what I paint—which is always the
hardest question, I think, for an artist to answer—I
tell them I paint big abstract paintings that happen to
look like birch trees. I was an abstract painter before
I was a landscape painter. My work evolved into land-
scape when I moved out West, particularly after I
came to Alaska.

　With birch trees, I get to do the abstract painting
that I like to do and work with an image that I find
personally intriguing and powerful, continually inter-
esting and different. I make something that normal
people who don't read *Artforum* every month can
relate to. I get to sneak in this abstract painting when
they're not looking.

McInnis: What is it about a birch tree that has that
continual life in you—for you—with you?

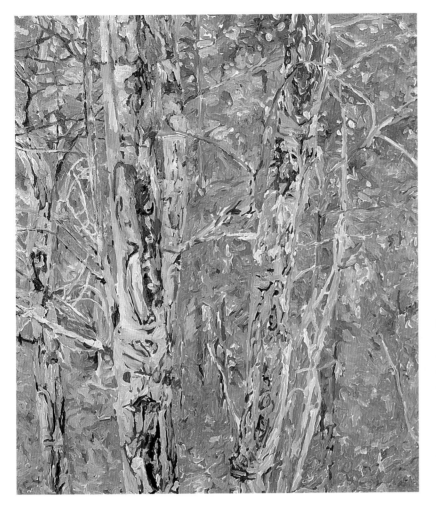

95

Spring Green

Kesler Woodward

Acrylic on canvas. 182.88 cm ×
152.4 cm. 1982. Purchased, 1984.
UA84-3-119

In *Spring Green,* the artist responds
to the joyous profusion and singular
hues of spring in the great subarctic
forest of Alaska. (WOODWARD)

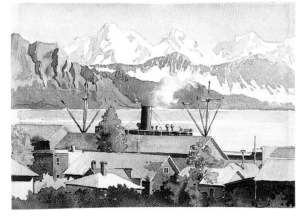

96

Seward Skyline

Joseph W. Kehoe

Watercolor. 24.13 cm × 34.93 cm.
Undated. Donated by Dr. and Mrs.
John I. Weston, 1983. UA83-9-10

Joseph William Kehoe (1890–1959) came to Alaska with the
army in World War I and remained to practice law. Later made a
territorial judge, Kehoe was not a professional artist but was a
highly accomplished watercolorist. He lived in Alaska until 1954
and died in Oregon in 1959. Seven of his watercolors are included
in the UAM collection.

 Judge Kehoe's paintings range from accurate, unromantic
topographic views of Alaskan towns, to deft portraits of settlers
and Native people and images of Alaskan animals. They are
noteworthy for their combination of detailed observation and
fluid, painterly style. (DeRoux 1990:17–18; Hulley 1970:368;
K. Woodward 1993:89, 90) (WOODWARD)

97

Thule Bird
Glen Simpson
Sterling silver, copper. 5 cm ×
2.5 cm. 1982. Purchased from artist,
1982. UA82-3-35

Glen Simpson (b. 1941) integrates an exquisite craftsmanship acquired during his training at the Rochester Institute of Technology, an understanding of historic metalwork traditions, meticulous attention to detail, and a profound knowledge of Native American symbolism.

Flat-bottomed "counters," or game pieces, used in Native Alaskan gambling games inspired this pendant designed to lie flat against its wearer's chest. Players toss such counters onto the ground; how they land determines points in the game. *Thule Bird*'s laminated sheets of copper and sterling silver contribute subtle color variation to its minimalist form. Copper and silver in the links extend those colors throughout the chain. Because of its exquisite balance, Simpson's symbolically meaningful jewelry fits comfortably on the human body. (CHIN)

Woodward: They're so individual. That's why I call a lot of the paintings birch "portraits." No two trees look alike. Pines have a lot more similarity, one to the next, than birches. Birchbark is like the wrinkles on a person's face. You can tell how it grew: what kind of weather it has dealt with, what direction the prevailing winds come from, how fast it has grown. These things make Alaskan birch look different from the same species in northern Minnesota or New England. They grow at a different rate. The bark splits more rapidly because of the long summer days. You get more peeling, more color.

I paint birch trees and paint birch trees until I get sick of painting them. I swear I'm never going to paint another. And I go paint rocks or reflections in rivers for a year or two. The next thing I know, I'm out in the woods and I see this birch tree. And, God, it's the most beautiful thing I've ever seen. I find myself back in the studio painting another birch tree.

McWayne: How do you find your audience? Do they want you to paint birch trees? Do galleries?

Woodward: One of the luxuries of being a college teacher is that you don't have to worry too much about whether the audience is going to be out there to buy your work. It's a different situation from that of James Everett Stuart, who made a living off his paintings. I have the luxury of painting what I feel like painting. If people like them and they sell, that's nice.

I sell a lot more work back East than I do in Alaska. It continually amazes me that people who live where there aren't any birch trees, much less Alaskan mountains, want these Alaskan images.

McWayne: So the market is not driving your choice of topic. Is that true for you, too, Alvin, with your galleries?

98

Yupik game pieces

Anonymous

Ivory. 4.4 cm diameter each. Anvik, lower Yukon. Collected by Lillian Proebstel, 1898–1900; purchased from Rosemary Van Slyke, 1981. UAM81-3-74DEH

The function of these extraordinary carvings, part of a set of eight, is uncertain, but their most likely use was as gaming pieces. The iconography is unusual. The piece on the lower left shows a walrus with its *yua*, or spirit person. The hole at the center of the hand engraved across the flanks of the walrus is a common Yupik motif, denoting a passageway for the animals on which human life depended (Fienup-Riordan 1996:180). The wolf depicted on the piece on the upper right is shown with its *yua* resting between its jaws. The piece on the lower right shows a pair of faces with the hands resting on the sides. These may represent masked dancers; dances were usually done in pairs, and hands often protruded from the sides of the dancers' masks. The fourth piece (upper left) depicts a sea bird and a seal. Its significance is unknown. The carvings were collected by Lillian Proebstel, matron of a missionary girls' school in the Yukon River community of Anvik at the turn of the century. (LEE)

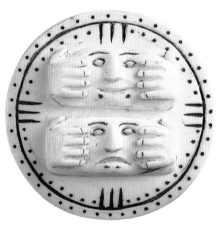

99

Clockwise from upper left: **Aldona Jonaitis, Terry Dickey, Kesler Woodward, Glen Simpson**

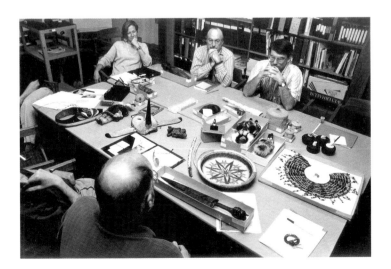

100

Lake George, Chugach Mountains
Myron Wright
Photograph, gelatin silver print.
26 cm × 34 cm. 1975. Purchased,
1983. UAP83-059-001

In November 1975 Myron Wright wanted to show his new bride some of the beauty and grandeur of the Alaskan winter landscape. Even though it was -10°, they flew out to Lake George near Anchorage to have a "picnic" lunch. It had been an early freeze that year and the lake ice was thick enough to support the small Aeronca Champ that Wright had rented. As they circled above, he noticed the ice formations jutting up from the heavy fog that covered part of the lake. Recognizing the potential for a dramatic image, he carefully chose a landing site. Visualizing the scene in his mind, he decided to include the airplane, both for size comparison and to "set" the dark end of the final print's tonal scale. When the Wrights departed the plane, they walked in a broad arc so as not to disturb the foreground with distracting footprints. The negative for this image requires masterful printing because of the extreme brightness range of the scene and the uneven density of the fog near the sun, but the effort results in this mysterious and hauntingly beautiful masterwork. (MCWAYNE)

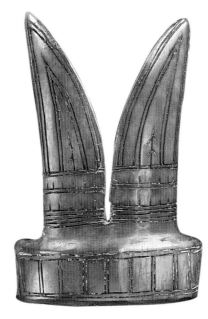

Amason: I make what I feel like making. I know if I did a hundred kingfishers, they would all go. But I'd get tired of making a hundred kingfishers. It's got to be something that kind of pulls at you. I have images like Kes's birches that I'll probably never get tired of painting. But then I need a rest. I find something else that I get that excited about. So when I do go back to this image that I love, it's because I have a new way of looking at it. It's fun again.

Jonaitis: I would like to throw out some possibilities as to why your art sells well here and elsewhere. There's something very magical about the land, the animals, and the people. Not just Native people, but, inclusively, what we think of when we say "Alaskans" and "Alaska." It is the last wilderness, a place of enormous abundance. It has its problems, too, but one of

101

Punuk Eskimo wrist guard
Anonymous
Ivory. 7 cm high. St. Lawrence Island,
Punuk period (C.E. 600–1400).
Donated, 1927. UAM1-1927-0258

This ivory piece was collected from the Mayughaaq site near Gambell on St. Lawrence Island during the Bunnell-Geist Bering Sea Expedition in 1927. Slots drilled at the base for lashing suggest that it was worn on the wrist to prevent the strike of a bowstring. This unique piece, with its outward flanges, resembles wrist guards from the Asian side of the Bering Sea.

The deep, curved, paired lines that outline the extensions, the three oblique spurs attached to the center lines, and the straight base with closely spaced horizontal and vertical lines are characteristic of the Punuk style. The appearance in the archaeological record of wrist guards in association with ivory arrowheads, bow braces, sinew twisters, and plate armor suggests a change in the social and/or physical environment. According to Collins (1973), such elements reflect warfare and indicate a possible advance of hostile groups into Northeastern Siberia or a gradual northward spread of weapons in the Bering Strait. (Bandi 1969:80; Collins 1937:224, 331; Collins et al. 1973:7–9, 32; Geist and Rainey 1936:28–34; Giddings 1973:159; Nelson 1899:161) (JONAITIS AND YOUNG)

102

The Sporting Life of Nome
Tony Rubey
Color lithograph. 63.5 cm × 91.44 cm.
1984. Purchased, 1984. UA84-3-133J

As manager of the printmaking studio area at the Visual Arts Center of Alaska in Anchorage in the early 1980s, Tony Rubey was one of the state's most influential and innovative printmakers. Perhaps his best-known body of work is a suite of twelve original color lithographs produced for the Anchorage Pioneer Home through Alaska's One Percent for Public Art program in 1982. Collectively titled *Camera Obscura,* the prints combine a variety of photographic images largely drawn from the personal collections of elderly residents of the Pioneer Home. The project is widely regarded as one of the most successful public art pieces produced in Alaska.

The University of Alaska Museum is fortunate to own a full set of the prints. *The Sporting Life of Nome,* from the suite, depicts several scenes, including a group of ladies in pre–World War I outfits posing as "The Lightning Strikers—Winner of the Ladies Indoor Baseball League Trophy." Male players in Nome's first (1913) tennis tournament smile from behind a net in an adjoining image. An Eskimo woman in traditional parka holds a bright pennant, and an Eskimo group with dog team peers from a fog of snow and/or time. Like the other images in this beautiful suite, *The Sporting Life* juxtaposes cultures and worldviews in a seemingly casual, but often provocative way. (Alaska State Council on the Arts 1982, 1983; Ingram 1983) (WOODWARD)

the reasons people want images of our landscape is that we still have something that is disappearing elsewhere.

Woodward: Well, what about you, Barry? You show and sell your work. Are you able to make the images you want to make? Or do people expect recognizably Alaskan things from you?

McWayne: The Alaskan landscape has a certain unavoidable cachet. The closer you get to conceptual photography, the less you sell, here or elsewhere. I've done projects just because I wanted to explore a certain idea, knowing there wouldn't be much of a market. But fortunately, I really enjoy photographing landscape.

Chin: You know, *Spring Green* is one of the loosest of Kes's paintings I've ever seen. Having seen the later works, I say, "Wow! I can't believe he was that loose."

Coming from an art school paint-slinger's perspective, what is compelling about an abstract is that it's not immediately recognizable. You can't learn everything about it in twenty seconds. You come back and see something new each and every time. Sometimes you don't have anything recognizable to hang on to. You slide around and lose your grip, and that makes it visually exciting. It's not tiresome. But most people don't have the time—they have only their twenty seconds.

Aldona recently asked me, "Well, do you think that's good or not?" We were standing in front of a piece in the special exhibits gallery.

And I said, "You know, frankly, I don't think I could judge it in ten seconds. I don't know if I could judge it in six weeks."

I haven't really looked at this piece of Kes's in eight years. Now, I look at it anew and discover its loose quality, its abstraction.

Dickey: This discussion calls to mind a pair of

anthropological terms, "emic" and etic." Emic means seeing things from an insider's perspective. Etic refers to the outsider's view. What you've been doing is looking at art "from the inside out." Our visitors want the personal view, the experiences, the artist's connections. They want the artist and the work to speak for themselves, not some anonymous "expert" speaking for them. When Kes and Alvin explain their art, when Wanda talks about what she sees, that's what gives art life, vitality, and interest.

Jonaitis: It's just the opposite of what causes museum fatigue. You're in a museum and after an hour, you're exhausted, but you can be at a theme park all day and not get tired. It's the deadening nature of so many exhibit labels—they're very objective.

Simpson: Labeling has to be really safe, beyond question, bottom line. Place. Materials. Who did it. There's nothing lyrical about it, nothing human. It's flat.

Dickey: Yes, exactly. Our visitors see Alvin's kingfisher, and they don't have any guide to it. They don't know how to connect to its wonder, its excitement, its vitality. But if they come in, see the artwork, and read the artist's words—if the words match their experiences—they may grow along with the artist. It's that kind of connection that I see as possible between the museum and the visitor.

Lee: It just occurred to me to apply the concepts of emic and etic to regional art. And to the way visitor-artists see things differently from people who live in a place. If the theory of emic and etic holds up, it explains a lot about why visiting artists paint differently from resident artists. If you live in a place, you're going to see things differently.

103

Athabaskan willow basket
Anonymous
34.3 cm high × 36.8 cm diameter.
Shageluk, 1920–60. Donated by the
estate of Mayme Wiig-Olsen, 1976.
UAM76-15-5

Recent research into the origin of coiled willow basketry suggests that it moved between 1915 and 1920 from the coastal Eskimos inland to the Athabaskans rather than the reverse, as was previously supposed (Lee 1995: 58–59). Unlike the Yupit, Athabaskan women made baskets primarily for sale to outsiders. Athabaskan willow-root ware is distinguished by its bright, aniline dyes, exclusively geometric patterns, and basket shapes. Most are shallow trays, although many beautiful covered baskets have been made as well. Mayme Wiig-Olsen and her husband, Sig, ran the Ruby Roadhouse during the 1950s and probably purchased the basket during that period. (LEE)

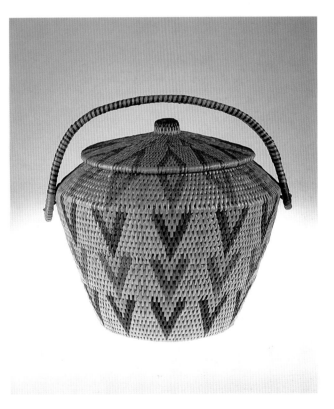

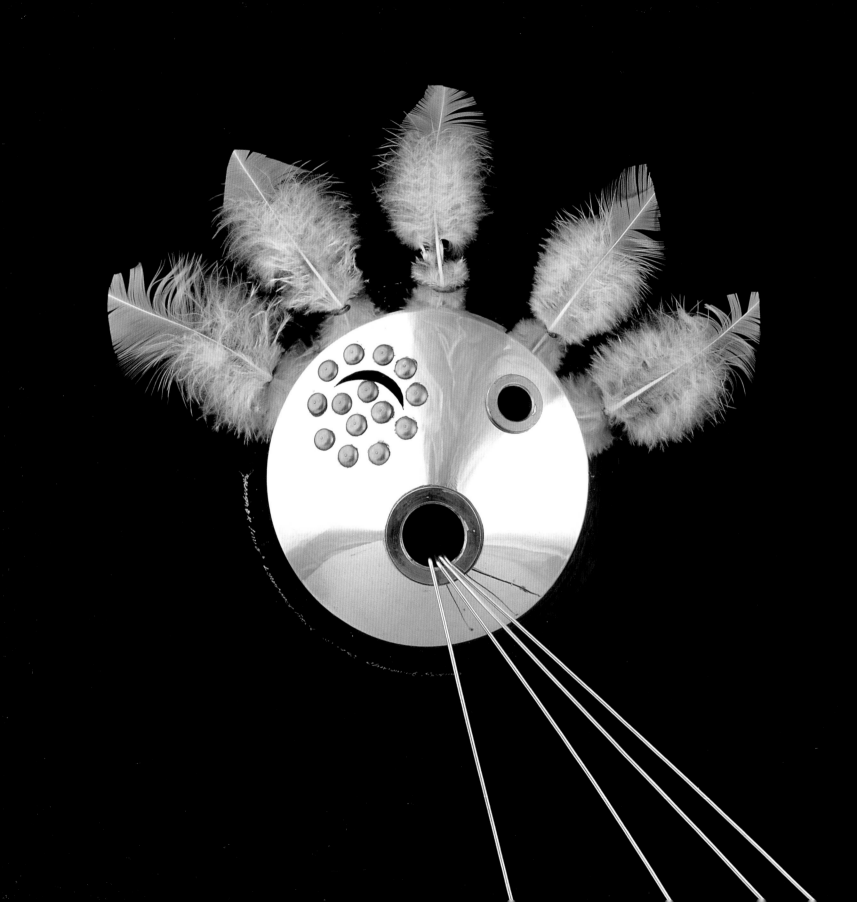

8 Conversations among Alaskan Artists

Wild Lake

After the Widgeon skimmed belly first
 onto lake ripples
after propwash settled and the engine cut
after we pulled on hipwaders and waddled
 supplies to shore
after the silt bottom gave and I listed starboard
after the hipboot filled and I sank like a rock
after I shivered while the fire caught
after clothes dried layer by layer
after the black bear ripped down the boat tarp
after the black bear lingered, left back fur
 clinging to twisted wingnuts
after the bear scratched his back and disappeared
after we hiked to the spring to fill our jug
after the otter tumbled down the creekbank,
 glissando of fur
after the surface of water broke and healed
after bubbles shook free from river weeds
 brushed by the otter tail
after water returned to reflection
after birch startled us with gold so loud
 our bodies flared wild as fireweed gone to seed
after twilight put its slant on the afternoon

after four loons swam twice around the seaplane
after the largest puffed out his chest,
 paddlewalked straight for us
the waning moon echoed the rare light of autumn,
stars borrowed the voices of loons.

Peggy Shumaker

104

Raven: In the Pink
James Schoppert
Wood panels, paint. 100.97 cm ×
165.1 cm × 10.80 cm. 1984.
Purchased, 1984. UA84-3-128

A Tlingit artist born in Juneau, James Schoppert (1947–92) was a leading member of a new generation of university-trained Alaska Native artists. Schoppert received his B.F.A. in art from the University of Alaska Anchorage and his M.F.A. in sculpture and printmaking from the University of Washington. A talented speaker, writer, and teacher as well as a skilled and well-known artist, he taught, lectured, and wrote widely on contemporary Alaska Native art. His work was included in a number of major national exhibitions of contemporary Native American art—at the Philbrook Art Center in Tulsa, the Heard Museum in Phoenix, the Yellowstone Art Center in Billings, and elsewhere—and he completed a number of public art commissions in Alaska and Washington State.

Raven: In the Pink is a particularly ambitious example of the kind of work Schoppert was doing in the decade preceding his untimely death at the age of 42. In his late works, he used the traditional formline designs of his Northwest Coast forebears as strong, complex, but organic structures to play off against expressionistic surface relief, lovely abstract paint, and shifting grids. The interplay of ancient traditional designs and modern methods of composition and surface treatment made his work a bridge between the ancient and modern worlds—almost a metaphor for the life of Alaska's Native people today. (Blackman and Hall 1988:338; Carroll 1979; Institute of Alaska Native Arts 1984; _Institute of Alaska Native Arts Newsletter,_ March–April 1987)
(WOODWARD)

Lee: May I ask a question of the artists in the room? When you follow contemporary art in New York, you see that so much of it is an inside conversation—artists responding to other artists. Is this also true of your art? Are you looking at Ron Senungetuk's stuff or Glen's or Kes's? Or somebody else's? Or your own earlier stuff? And talking about it in some new way, constructing a long conversation of Alaskan art?

Amason: Artist Melvin Olanna once walked into Jim Schoppert's studio, where Schoppert had some of his very large, more or less formline, contemporary painted commissions. They weren't in any order—some were staggered, some were up, and some were down.

Melvin looked at them and said something like, "Gee, these pieces are nice, just the way they are."

Melvin walked in with totally different eyes and changed Schoppert's style.

Simpson: Well, I was influenced by Ron [Senungetuk], because he was my teacher for a time and I went to the school he had gone to and studied with the same professor. So we all had that Danish Modern fastback approach to form—

McInnis: But now, do you look at other Alaskan artists—Native, not Native—and respond to their work? Quote it? Play on it? Play off it in some way in your own work?

Amason: I see that question a little differently. In Alaska, there are indigenous people all over the state, different groups and lots of mixes. The artists, wherever they're from, have something that's not just them—it's in the environment they're from, being familiar with one place for a long time, over generations. I believe that infusion gives them a sense of rhythm. They respond and see things in a certain way. Each area's rhythm is unique—the rhythm the earth has, and the sky, and all the elements, and the rhythm the cosmos has for the people.

If you bring all these people together in one place, like the University, you bring the rhythms together—the Inupiaq looking at the Yupik and the Aleut.

Woodward: I think it's true that Alaskan artists are dealing with an Alaskan context. And I also believe they're dealing with a larger art-world context.

Alvin's work comes out of his experience growing up in Kodiak and being part of Aleut culture, and it's more than that. He wouldn't make those paintings if he never had gotten outside of Kodiak. His is

105

***Tunghak* (Spirit Hand)**
Glen Simpson
Sterling silver, 14 karat gold.
5.6 cm × 3.8 cm. 1986. Purchased.
UA87-3-1

For some Native Alaskan groups, a pierced hand such as this signifies a passageway through which animal souls travel as they leave the spirit world and enter the world of humans to ensure the perpetuation of their species on earth. (CHIN)

the work of a painter who went to art school, who went out and was in an M.F.A. program and learned how contemporary painters throw paint around. It's really a hybrid of influences.

The same is true of Glen. There's a School for American Craftsmen overlay to his work that informs its stylishness and craftsmanship. It's also informed by his own Native roots and awareness of other Native cultural roots.

This gets back to what Molly was asking us: Do we talk to each other? I think we talk to each other literally in our studios—

Lee: That's what I meant.

Woodward: But in our work, we talk to all the artists in history all the time. It's like art historian E. H. Gombrich said—all art is more about other art than about observation. You can't help it. You don't go into your studio and make up the world from scratch.

Chin: This notion is beyond "memory" and "universality." It's like the admiration jazz musicians have for hot licks—surprises—the qualities that other artists appreciate. Admiration of quality—that paint-slinging—reaches out as deeply as anything else.

Amason: There's a term in academia, "the painter's painter." It keeps you in check. It's part of your "craft detection" equipment. People you respect in your craft look at your work and say, "Not bad," or, "That's handsome."

McWayne: "That's a keeper."

Chin: You know what they're really looking at. And you can't fool them.

Amason: If you give a pair of moccasins to a woman at a potlatch, the first thing she does is pick them up, look at them, and smell them—"How's the stitching? How's the tanning?"

106

Athabaskan moccasins
(*clockwise from left*)

Moccasin boots
Anonymous
Smoked moosehide, rabbit fur, beads, satin lining. 24.3 cm × 24.7 cm × 10 cm. Collected by William and Rhoda Thomas; bequested, 1967. UAM67-98-138

Moccasin boots
Anonymous
Smoked moosehide, plucked beaver, felt, beads, porcupine quill, satin lining. 24.5 cm × 10 cm × 10.5 cm. Kutchin Athabaskan. Collected by Mr. and Mrs. Homer Stockdale, Fort Yukon, 1972; donated, 1972. UAM72-36-59

Moccasins
Anonymous
Caribou skin, neonatal seal fur, beads, felt lining. 23 cm × 9 cm × 6 cm. Athabaskan or Northwest Coast (Tahltan? Inland Tlingit?). Collected by George Gasser, 1908–20; donated, 1960. UAM900-8

Among the most visually pleasing beaded Athabaskan objects are the many varieties of moccasins found throughout the historical period and into the present day.

The bottom pair was collected by George Gasser, superintendent of the University of Alaska's Rampart Agricultural Experiment Station from 1908 to 1920. Typologically they most closely resemble examples from the Tahltan or Inland Tlingit groups of northern British Columbia. (Duncan 1989:170–76) (LEE)

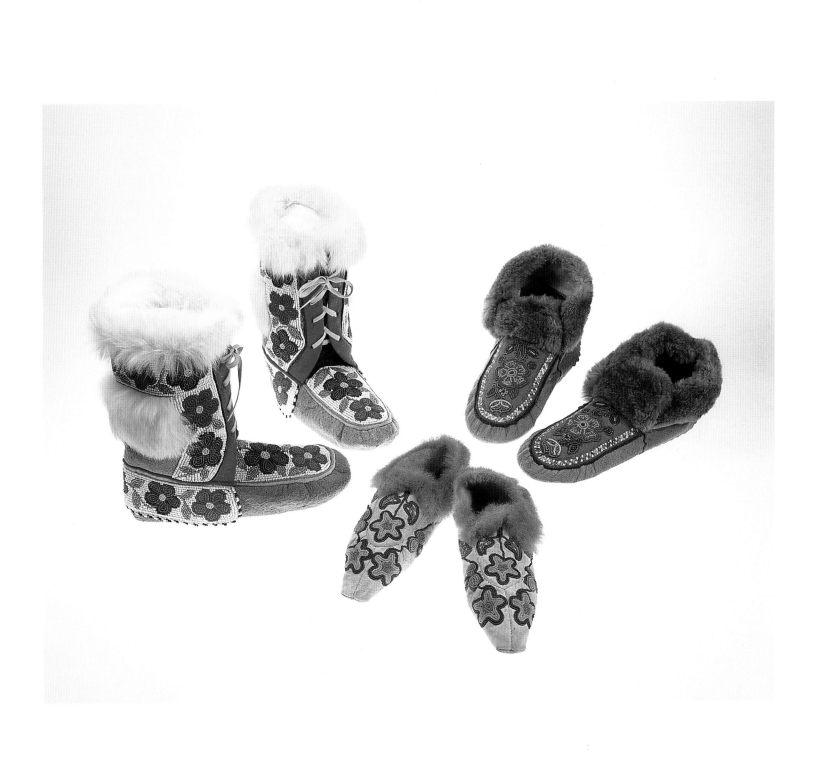

107

Ice Fractures

Malcolm Lockwood

Photograph, Cibachrome print. 18 cm × 23 cm. 1968. Donated by Malcolm Lockwood, 1983. UAP83:030:001

Malcolm Lockwood, one of Alaska's foremost landscape photographers, prefers to use large-format cameras because of the great detail and tonal richness they produce. This image was made on 4-by-5-inch film on an overcast day in March 1968. Lockwood was returning home to Fairbanks from a photography outing to Valdez when he spotted a deeply frozen beaver pond at the base of Rainbow Mountain near Isabel Pass. The ice had attained a washboard appearance over the winter, and strong winds had cleared snow from several large sections. Peering down, he saw this extraordinary sight. The ice had fractured from some great pressure, accentuating the frozen bubbles and the trapped grass. As if a view to some other cosmos, this work is alternately titled *Ice Galaxy* by the photographer. (MCWAYNE)

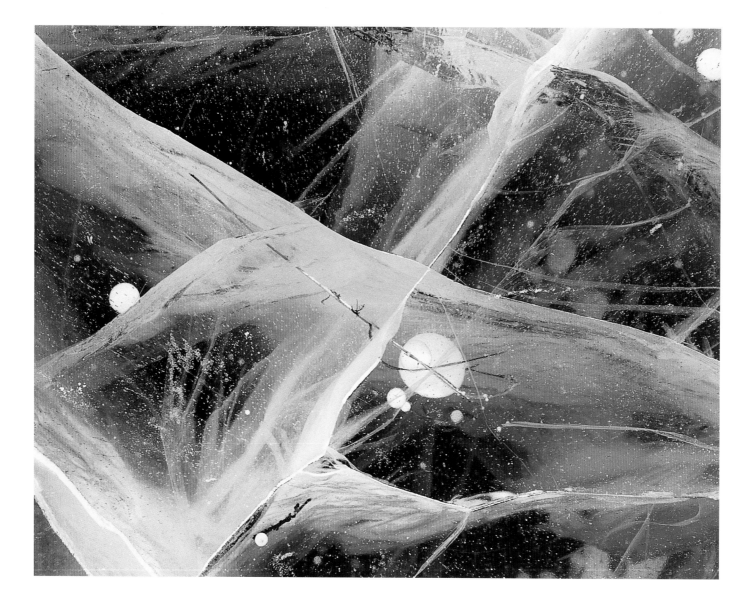

McWayne: I know photographers who won't even look at the tonality of an image. They'll pick it up, tilt it to the light, and search for flaws, because it's so hard to keep the surface clean.

Simpson: Those are insider's judgments that don't transmit to the audience. If you're not involved in the technology, you don't see it, and you don't care about it. And even if you did, it wouldn't make any difference.

McInnis: How about Native artists—how do they, or did they, share artistic ideas?

Jonaitis: We can talk about the intentionality of painters. Is there an equivalent artistic self-consciousness on the part of Eskimo, Athabaskan, Tlingit artists?

Lee: I would say more in contemporary expressions. Just generally, from my perspective, when people go to art school, when they become aware of art history, they become more self-conscious about what they do. They have their grandmothers to factor in, and also people who paint in a way they admire.

Jonaitis: Molly, you've worked for some time on the history of Yupik coiled baskets, which represent a fairly wide geographic area of artists' "conversations," no?

Lee: Otis Mason, who was sort of the turn-of-the-century basket guru, assumed that Athabaskans introduced coiling to the Eskimos. If that were true, I should have been able to find old coiled Athabaskan baskets in museum collections. I searched through early Athabaskan collections, but found none.

108

Yupik grass basket
Anonymous
15.9 cm high. Togiak, before 1941.
Collected by Henry B. Wolking;
donated by his estate, 1942.
UAM236-3958

Henry B. Wolking, a prospector who lived in the Yukon-Kuskokwim Delta on and off beginning in 1909, probably collected this basket shortly before his death in 1941. The bowl shape is a more recent innovation than the basket illustrated in figure 58, though it still uses the modest, dyed sea mammal intestine and dyed grass for decoration. The diamond-shaped patterns and open bowl design were a later innovation. The "open wave" zigzag pattern of the coils toward the upper edge is thought to be one of the surest signs of Moravian influence on Yupik coiled-basket design. It is shared with baskets of the Labrador Inuit, who were taught to weave by the Moravians in the eighteenth century (Goodridge 1979). (LEE)

109

Old Bering Sea winged object

Anonymous

Ivory. 12 cm. Savoonga, St. Lawrence Island. Old Bering Sea period. Donated by Otto Geist, 1964. UA64-021-1012

This richly incised piece contains a square socket at its base. Although part of the right "wing" has broken off, the wings were symmetrically carved.

Numerous such objects have been found in prehistoric Eskimo sites and in Siberia. Archaeologists have speculated since the beginning of the twentieth century on their function. Some suggestions are that a head and tail were attached, transforming the objects into birds or butterflies that ritualists suspended on straps during whaling ceremonies; or that hunters attached the objects at the ends of harpoons that were thrown for practice at a board; or that the objects served as counterweights to stabilize the ivory harpoon head, foreshaft, and socket piece. (Bandi 1969:73–77; Collins 1929:8–9, 48; Collins et al. 1973:5–9, 16–20: Fitzhugh and Crowell 1988:122–23; Fitzhugh and Kaplan 1982:245; Gordon 1906:46–68; Rainey 1941:520–21, 553; Rudenko 1961; Wardell 1986) (JONAITIS AND YOUNG)

Finally, when I did my post-doc at the American Museum of Natural History, I found a letter written in 1932 by the wife of a missionary named John Chapman, commenting on baskets in a collection she had donated to the museum. She had begun to see coiled baskets just fifteen to twenty years earlier, and thought the Athabaskans had learned the technique from the Eskimos.

I think the Inupiaq learned it from the Siberians. Coiling probably came across the Bering Strait, from the Chukchi and other Siberians. The coiling tradition probably wasn't very old when it came to Alaska —compared to twining, which is absolutely established in the archaeological record. Coiling, I think, came from China with the culture of tea. It first traveled north to Siberia, then west across the Bering Strait, and through Alaska along with the Gold Rush trade. Think about the shape of Chinese tea baskets. They're coiled. I made the connection when I found

110

Gulkana basket

Fran Reed

Salmon skin, driftwood, hog gut, dye. 40 cm × 60 cm. 1993. Purchased from artist. Exhibited at UAM show *Working Inspirations*, 1994. UA94-1-1

a coiled birchbark basket from the Yukaghir at the American Museum of Natural History.

Jonaitis: The geography of the world is greater than we may initially see. The view that these basket makers worked in isolation fails to recognize these connections and influences.

Woodward: I wonder about that. I wonder whether the guy who did the archaeological ivory carving "Untitled, number 6, Okvik" wasn't really thinking, "Boy, those other ivory carvers in the village are just going to be knocked out by this—"

Lee: Absolutely.

Woodward: "—and this is just one hell of a work of art. Nobody's done one this good!"

Lee: Nelson Graburn and I found that this was the case with soapstone carvers in Cape Dorset, Pangnirtung, and northern Quebec. They talk to each other, maybe not with the same consciousness of world art, or art beyond their culture. But study after study of art in small-scale societies shows that conversations among artists, about their art, go on all the time—and through time.

Fran Reed's use of fish skin as a medium draws upon a rich heritage of Native use of Alaskan natural resources. For centuries women made waterproof bags, windows, and parkas from the gut inner skins and outer skins of various animals. Reed transforms these natural materials into a range of self-expressive forms, facilely integrating them with contemporary manufactured materials. Once dried into this elegant shape, translucent salmon skins provide no clue to the challenge slippery wet materials present to the artist attempting to shape them into a basket. Reed must purchase hog gut from commercial meat packers because the Marine Mammal Protection Act denies her access to the marine mammal gut traditionally used for gut parkas (see fig. 129). (CHIN)

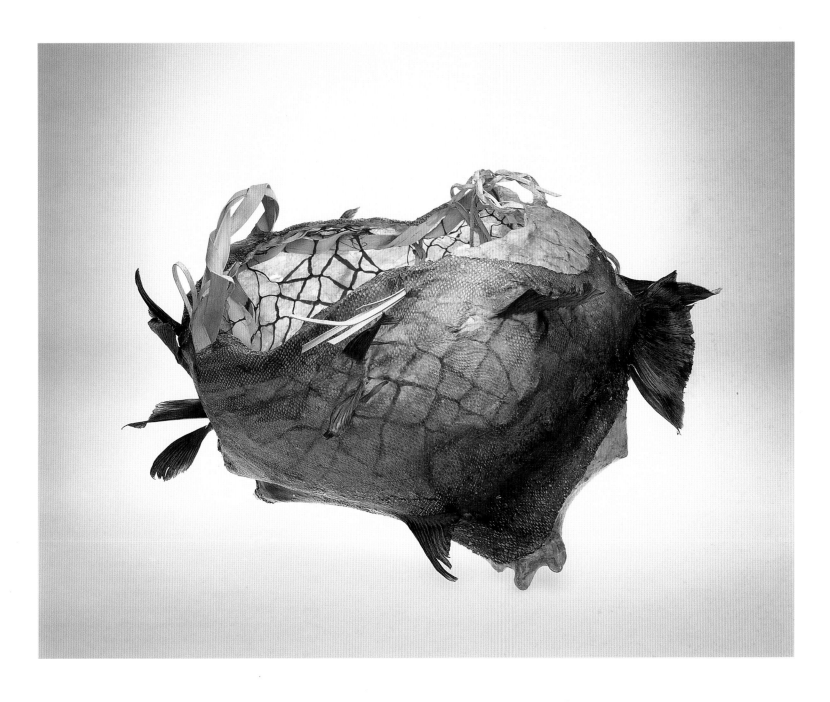

McInnis: Isn't it "world art" no matter where you are, and no matter the relative size of the world? The ivory carver may be competing with, and responding to, the great carver four generations ago who's still spoken of, still respected, right? In this carver's mind, he may be responding to another carver who was and is still known as "the best."

Amason: I've watched my own students, the best ivory carvers in class, pick up an old Bering Sea piece and say, "Damn! How'd they do that?" Just amazed at the tools, knowing what they did and didn't have back then—say, tools made of squirrel teeth or a piece of iron from a Japanese hull— "How could he do stuff like that? It's incredible. What vision!"

McInnis: I'm still interested in this notion of inheritance and transformation. Fran Reed's baskets (fig. 110), for example, come out of much earlier, functional fish baskets (fig. 111). Nathan Jackson's raven headdress (fig. 112) traces its line from his own Tlingit potlatch tradition. Kathleen Carlo, a woman and an Athabaskan, created her art from what was a Yupik man's craft (figs. 113, 114).

Jonaitis: Those "conversations" among artists can go in many different directions and can be conducted over time. Yupik masks, for example, have influenced a good many other artists: Carlo, Larry Beck (fig. 115), Ron Senungetuk, Harry Shavings (fig. 116), the Deg Hit'an (fig. 117). It's even been suggested that some of the Tlingit shamans' masks that have little animals here and there on the face were inspired by the Yupit.

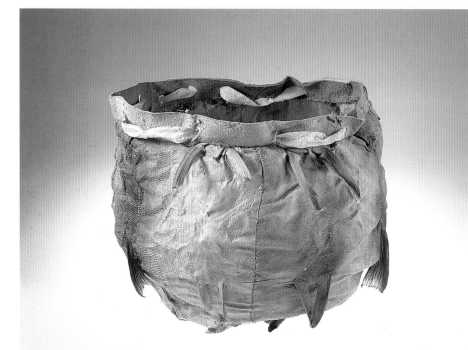

111

Gwich'in Athabaskan fish-skin bag
Leah Roberts
Salmon skin, moosehide, caribou sinew. 29.5 cm high × 33 cm diameter. Fort Yukon, 1979. Purchased, 1979. UAM79-17-1

Alaska Natives are known for their imaginative use of raw materials for producing the articles necessary for daily life. This is as true of the material culture of the interior Athabaskan Indians as it is for the better-known fur and skin objects of Eskimo manufacture. Among the Athabaskans, fish skin is used for making clothing and other items, such as this bag. Many kinds of fish are used, including lamprey, pike, Dolly Varden, numerous types of salmon, halibut, and wolffish. Fish skin is worked while pliable and sewn while wet. (Hickman 1987:11–12) (LEE)

McInnis: Fran Reed took the notion of a fish basket and somehow turned it around inside her own mind and then brought it out again, quite differently, through her hands.

Woodward: As an artist, you keep trying different things until something works. I think that's how Fran got to the fish baskets. She was a really good traditional weaver and took a lot of workshops, played with technique, and experimented with materials. And then one day she tried fish skins. Whammo! She looked at what she had and said, "Now this is more like it!" From there, she's just gone on to different kinds of skins and more elaborate uses of the form.

Amason: You know, you have to be ready. I bet she probably wasn't ready for that leap before she made it. She had to go through these other circles of learning and trying before she stumbled on that one and knew where it could take her.

112

Tlingit raven headdress
Nathan Jackson
Cedar, abalone, copper, sea lion
whiskers. 17 cm × 14 cm. 1984.
Purchased, 1984. UA84-003-0153

The frontlet headdress carved to represent an animal who, in mythic times, interacted in some way with an ancestor is an item of cherished clan regalia. The story of that encounter and the artwork depicting the animal are carefully guarded possessions of the clan; no outsider may tell the story or represent the animal without prior permission. Headdresses such as this often had trains of ermine pelts that flowed down the wearer's back, and were commonly worn with Chilkat blankets. Nathan Jackson, the most accomplished contemporary Tlingit artist, carved this sensitive image of the raven holding on its chest a small "copper," the shield-shaped plate of beaten metal that signifies great wealth to Native groups from southeast Alaska south to Vancouver Island. (JONAITIS)

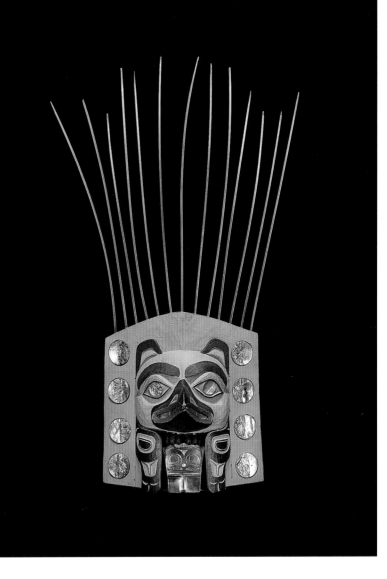

113

***Nokinmaa yiłmaa* (Snowy Owl)**
Kathleen Carlo
Teak, wire, feathers. 62 cm. 1980.
Purchased, exhibited at UAM show
Dinaa Yoo Naaná, 1981. UA81-3-149

In traditional Athabaskan society men did woodwork while women made baskets and sewed hides, decorating them first with quills and later with beads. Kathleen Carlo challenged this tradition when, in the 1970s, she won a scholarship to the University of Alaska Fairbanks to study with Ron Senungetuk at the Native Arts Center, where she began carving wood to represent both her Native heritage and universal human experience. This owl, which Athabaskans believe can foretell a bad omen *(hot łaanee),* has a symmetrical face with deep hollows. Sharp lines meet to form the forehead, and a beak drops into a heart-shaped opening, offsetting the slight rounded rise of the eyes. The transparent ochre finish on one side reveals a complex wood grain that contrasts with the other side's quiet opacity. (CHIN)

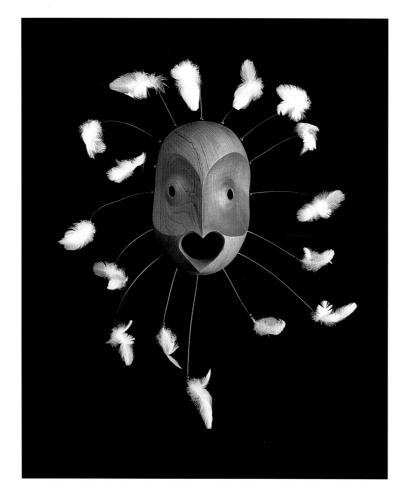

McWayne: She's really locked onto this, too. She's put an enormous amount of effort into the study of fish skins and traditional uses—visiting major collections around the country, informing herself. And her own work became informed by this whole process. It's now very mature.

Simpson: Steffenson refers to the people to the south who have windows made from the skins of codfish—he means burbot. I can envision these gut covers all pieced together—a great surface to see light through. I'd like to do a stained-glass window like that—pieced-together skins of the codfish.

Chin: Working with fish skins is slippery and tedious. Jim Barker (1993:72) writes about Walkie Charles, whose auntie had always cleaned the fish. When she was too old to work, then he had to do it, and he said, "I'll never eat fish again without thinking about all the work these women do."

Later, one day Kathleen Carlo was carving at the museum and her mom, Poldine Carlo, came up to bring dried fish for our lunch. As we ate, I looked at those beautiful strips, almost like a machine had made them. Mine had been so raggedy.

You look at a basket like Fran's, and it seems easy, until you actually handle the material.

Another interesting aspect of Fran's work is that for it to find a larger acceptance and market, and the respect it deserves, it needs to be represented through another art form—photography.

McWayne: Here! Here! Chris Arend's made some beautiful slides of her work.

Simpson: It's the way the piece is set up and the way the light comes through the fish skins. If you had them on display, it would be hard to get that consistent lighting. But when you set it up and take that fabulous slide with just the right light, it makes a striking impression. It really hits you.

114

Yupik bird mask

Anonymous
Wood, feathers. 65 cm. Qissunaq.
Collected by Frank Waskey, 1946;
purchased, 1947. UA314-4353

This mask appeared at the same time during the Inviting-In
festival as the white fox mask (fig. 7). It depicts a bird with a *yua*
face on its back. Typical of some Yupik masks, this example is
surrounded by a hoop made of wood and has six appendages,
four of which hold feathers (one is missing). (Fienup-Riordan
1996:299 [illus.]) (LEE)

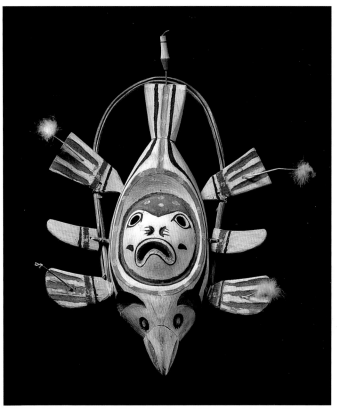

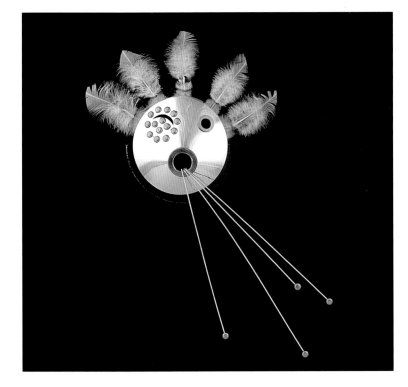

115

***Tunghak Inua* (Spirit Mask)**

Lawrence Beck
Commercial mirror, aluminum,
feathers, rivets. 32.5 cm. 1982.
Purchased. UA82-3-95

Lawrence Beck reminds us that no matter how dramatically life
changes, human needs and traditions remain strikingly constant.
Beck transforms our common daily tools and materials he discov-
ers in a junkyard or purchases from a store into a new version of
the Yupik mask. In this piece, an automobile's chrome rearview
mirror replaces the wooden face of a traditional mask. Copper
rivets replace the traditional dots, and pieces of an antenna
substitute for whiskers. Though his later work became more
monumental in scale, many find Beck's smaller, more intimate
creations especially accessible. (CHIN)

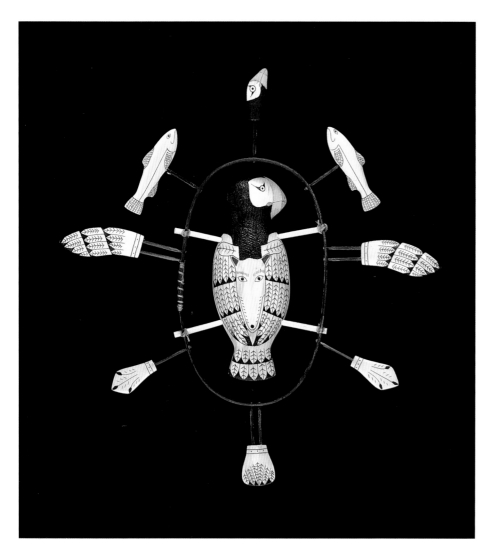

116

Yupik miniature mask
Harry Shavings
Ivory, baleen, sinew, pigments. Outer baleen rim, 20.3 cm × 12.7 cm; flat puffin figure, 16.5 cm × 7 cm; fish, 7.5 cm; wings, 7 cm; webbed feet, 4.4 cm; tail, 3.2 cm; puffin head, 4.1 cm. Mekoryuk, Nunivak Island. Purchased, 1984. UAM84-3-53

The genesis of miniature ivory masks is uncertain, but probably began on Nunivak Island, home of many great modern mask makers. According to Jane Shuldberg, collector and former ethnographic-art-shop owner in Seattle, the idea originated between 1950 and 1960, when a non-Native schoolteacher at Mekoryuk wanted a smaller version of the large, complex wooden masks for which the island is famous (Schuldberg 1996). The earliest maker may have been John Kusowyuuk (Ray 1981:70). This example bears out Schuldberg's opinion that the best makers of ivory masks were also the most accomplished wooden-mask carvers. Harry Shavings (1909–c. 1990), a celebrated carver of large masks, has created this miniature masterpiece in ivory. The central plaque, representing a puffin, is embellished with an animal, possibly a wolf spirit person. The plaque is encircled by a baleen hoop attached with sinew. Pegged into the hoop are ivory extensions representing fish, wings, flippers, and a bird's head. (LEE)

Chin: It's not just lighting or photography. Contemporary artists and craftspeople have to be aware of the media they must use to reach their markets. Fran's baskets became known after the photographs were published. Scholarly books and journals, magazines, and newspapers help you find an audience and be judged.

When we did Glen's show here, I had a sense of urgency that here's this great body of work in Alaska that nobody knows about. Then *American Craft* published Barry's incredible photos that capture the essence of Glen's work.

Works get an extended life through museums and the people who come to see them, but I think contemporary artists must also think about that larger market, and how to get to it.

Jonaitis: This concept of craftsmanship is what Franz Boas called the fundamental essence of art. I think

117

Deg Hit'an (Ingalik Athabaskan) mask
Anonymous
Wood, paint, string, squirrel (?) skin.
49 cm × 13.1 cm. Collected in
Shageluk by Charles Bunnell, 1930s;
donated. UAM64-7-7

Many features of Deg Hit'an Athabaskan culture mirror that of
the Yupik Eskimos, whose territory bordered theirs on the down-
stream side of the Yukon River. For instance, the Deg Hit'an have
more elaborate ceremonies and a more extensive array of masks
than is generally found among other Alaskan Athabaskans. The
masks were used in ceremonies and for secular amusement in
dances that closely paralleled those of the Yupik. The University
of Alaska Museum is fortunate in having a small but choice
collection of rare Deg Hit'an masks. They can be distinguished
from their Yupik counterparts by their long, narrow faces, pro-
nounced brow ridges, and long, narrow noses. Their mouths
often pucker, as is the case here. This example most closely
represents a type de Laguna identifies as the First Cannibal
Woman's Son. (de Laguna 1936:574; fig. 1:2) (LEE)

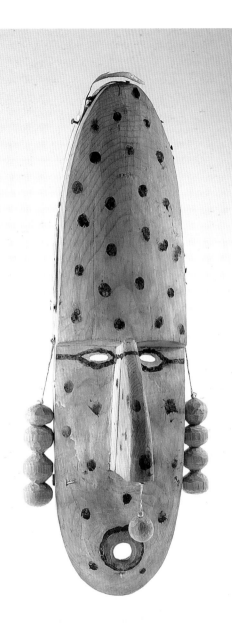

museums have not, for the most part, paid any atten-
tion to that feature of artistic creativity. The public is
denied access to the kind of evaluation of art that
artists talk about among themselves. It's an interest-
ing challenge to try to find some way to educate the
visitor to this level of discussion.

McWayne: Especially if they only have twenty
seconds.

Lee: Maybe the way to do it is to do labels color-
coded to how much time they have. It it's *this*
amount of time, you read *this*, and if you're *more*
interested and have *more* time, you read *this*.

Amason: Some forty-seconders.

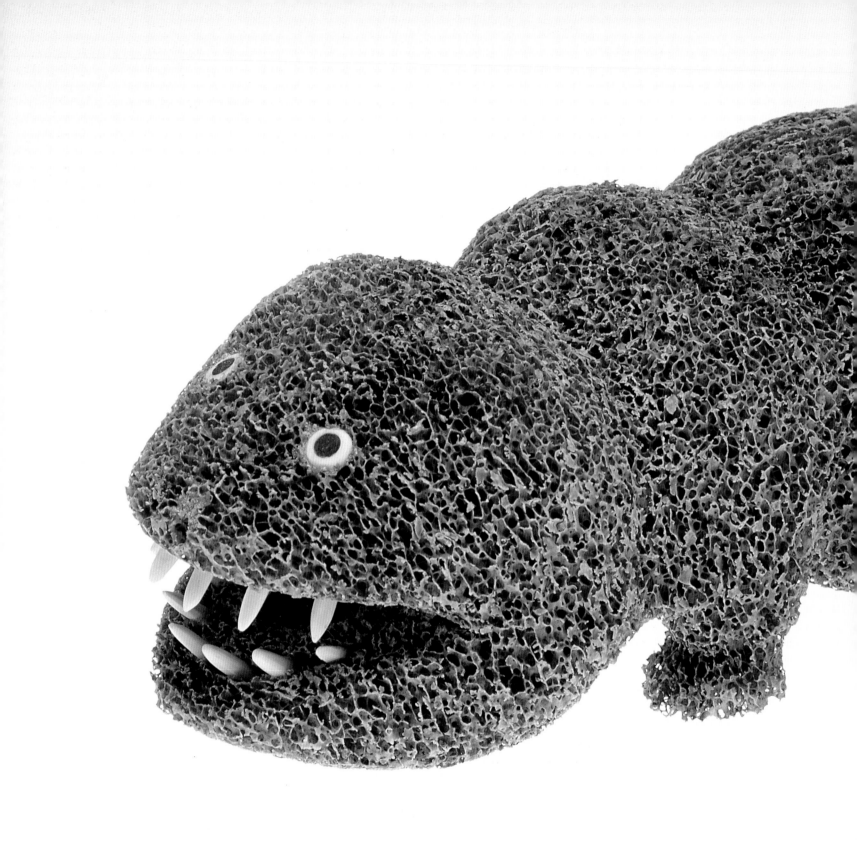

9 Final Thoughts

The Inupiat Christmas Pageant

Under the red Korean banner
spanning the space above the altar
of the Episcopal Church
downtown in Fairbanks,
from way out in the bush
or just up from Two Street,
the faithful and the unfaithful gather.

The choir, like most choirs,
all women. Lining up to march in,
bright cotton calf-length
hooded dresses, silent
caribou foot coverings.

Flat drums, firm beat,
knee bends, grass fans.

Joseph's ermine
and squirrel tail coat,
ruff of hollow wolverine.

Hunters, not shepherds, searching
the night sky, tracing
string webs and stars
to mark a way
across sea ice.

Gifts of the whale captains:
a sealskin, mukluks,
tiny parka for the fur-swaddled child.

Glottal stopped, chopped
"Adeste Fidelis."

Koolaid, Oreos, and
bread born of lowbush cranberries.
Slices of raw turnip
dipped in seal oil.

Kiernan's jovial yank
breaks his mama's string
of blue beads—
we kneel to retrieve them—
shiny Siamese cats' eyes
skipping over dust
under straightbacked pews.

He laughs out loud,
this child conceived
when a sterile syringe let go
the milky rush and one
of millions whipped through
selfless whiteness to unite
with a small orb
traveling imperceptibly
through the lightless season.

<div align="right">

Peggy Shumaker
The Circle of Totems

</div>

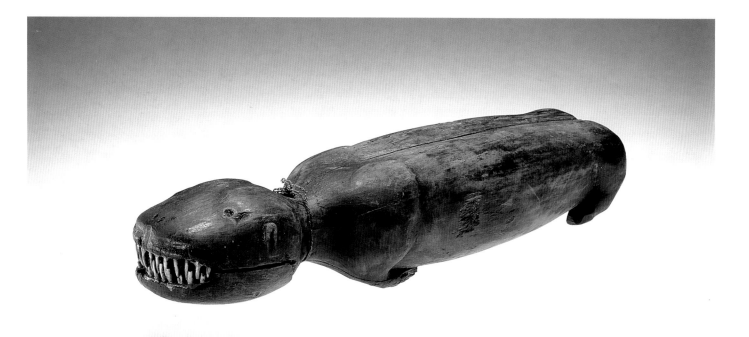

118

Inupiaq *kikituk*

Anonymous

Wood, sinew, fox teeth. 37.5 cm. Point Hope, before 1938. Collected by Nashukruk Nashooklook, 1930s; sold to Froelich G. Rainey, 1939; purchased by UAM, 1940. UAM1-1940-0138

The *kikituk* was a shaman's familiar used in ceremonies for purposes such as punishing offenders and predicting the weather. They appear to have been used only in Point Hope, although a similar type was reported for the Seward Peninsula (Nordenskiold 1882:580). Before using his *kikituk*, a shaman "gave birth" to it by squatting as women did during childbirth. The *kikituk* was then wrapped in fawn skin like a new baby. The effigy was thought to fly by flapping its tail. As is often the case with shaman's familiars, the *kikituk* had both positive and negative powers. Able "to kill a person at short range as easily as a double-barreled shotgun" (Rainey 1947:277), it was equally able to cure illnesses by snapping its jaws at a sick person and to foretell the weather by sinking its teeth into someone's back (Frankson 1980). Today in Point Hope, despite many generations of Christianity, the *kikituk* is remembered in song and story. This one, probably the only traditional example in existence, was excavated from an abandoned sod house at the old village site at Point Hope by Mrs. Nashukruk Nashooklook, who was fond of digging for old things (Giddings 1977:108–9). The *kikituk*, missing its lower jaw, had been stored in a seal poke full of oil. Two seasons later at the same house, Mrs. Nashooklook uncovered a second oil-filled

poke containing the lower jaw. Point Hopers say this method of storage disempowered the *kikituk* and kept it out of mischief. By the time the *kikituk* was unearthed, Point Hope had been missionized, and Lydia Nashookpuk, Mrs. Nashooklook's granddaughter, was allowed to play with it after her grandfather reattached the jaw with pegs. In 1939 Lydia Nashookpuk sold the *kikituk* to archaeologist Froelich Rainey (Tuzroyluk 1996; Rainey 1959:13). In the early 1980s I heard the story in Point Hope from Alec Frankson and from Andrew Tooyak, Sr., whose wife, Irene, is a relative of Lydia Nashookpuk's. The family had lost track of the *kikituk* and wondered where it was. Over the next decade I looked for it in the collections of the American Museum of Natural History and the University of Pennsylvania Museum, the two main U.S. repositories of Rainey's material; neither had any record of it. Shortly after I came to work at UAM in 1995, I opened a drawer and discovered the *kikituk* right here in our own collection. Since then, a number of Point Hopers have come to visit it. Rex Tuzroyluk, Lydia Nashookpuk's son, came with his family in July 1996 and asked us to store its lower jaw separately. We have done so and reunited the two parts only for this photograph. (LEE)

Lee: We haven't talked about the Inupiaq *kikituk* (fig. 118) yet, perhaps intentionally.

Simpson: Nice guy.

Amason: Awesome.

Jonaitis: Hard to talk about.

Simpson: Powerful beast.

Lee: We thought a long time before we put it in, not only because of the NAGPRA issue, but—

Amason: What issue is that?

Lee: The Native American Grave Protection and Repatriation Act.

Jonaitis: I think it's an important issue to talk about.

Lee: The *kikituk* is important, all by itself. This is the only traditional one I know of in captivity, the only one at all, anywhere.

*Kikituk*s fly really well. They clack their jaws when they fly—you can see that the lower jaw articulates—and part of their dynamism in flight comes from this clacking movement. And they have terrible teeth. *Kikituk*s can foretell the weather by biting someone on the back—how the blood runs tells them what the weather will be. They also buzz around graves. The noise they make, gnashing their horrible teeth, throws evil spirits from the grave. They have these wonderful little stubby legs. Maybe the *kikituk* isn't beautiful, but it's pure potency. There aren't any words to describe it, really—an intense, powerful beast from around Point Hope. People are still very much afraid of them up there. There are many, many stories about them.

This one is absolutely unique. There are none at the American Museum of Natural History, where the Siberian collections are the largest in the world. I never saw any, anywhere, from that side of the Bering Strait.

There was good reason he looked like that. He had a lot of work to do. He gnashed his terrible teeth and showed his terrible claws.

McInnis: This is not benign energy, then. Not blessing energy.

Lee: No.

McInnis: This is vengeful. This is—

Lee: I guess you would call it a protector for the shaman and for the people it saw as being within its domain. *Kikituk*s warred—they traveled across the Bering Strait with their shamans and fought other *kikituk*s.

I've seen three versions of another tale. A shaman would perform something like a birth act where the *kikituk* would come out from under his parka. The *kikituk* was often associated with blood, but in this ceremony, when he appeared, he was being born.

Alec Frankson told me a *kikituk* had a song that called forth a fog from his mouth. The song was part of the shaman's protection—as much as the animal itself was.

Amason: Maybe once Christianity came and the shamans lost their position with the people, these were so powerful they couldn't be left loose.

Lee: The people there seemed to feel that way. Those old people up there were scared of them.

Amason: So maybe it was a case of "It's okay to take this, but take it far away."

Lee: Yes, maybe they were glad to get rid of him. It's possible they believed in the *kikituk* enough to consider him dangerous, but since they were Christian they wanted him out of their community. That may be how this one came to Froelich Rainey, and thus to us.

McInnis: And the fate of other *kikituk*s might be—what?

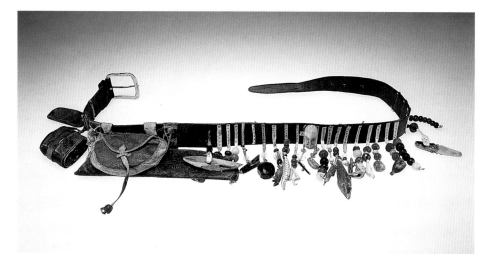

119

Siberian Yupik charm belt
Anonymous
Leather, steel, ivory, trade beads,
whetstone. 94 cm. Savoonga, St.
Lawrence Island, 1927–29. Collected
by Otto W. Geist, 1927–29; bequested
by Geist Estate, 1964. UAM64-21-134

Amateur archaeologist Otto Geist, who had spent enough time on St. Lawrence Island to have been made a member of a local clan, was planning in the late 1920s to take part in a whale hunt. A Siberian cousin of Otiyohok, the boat captain, objected to having a white man along, and pointed specifically to Geist's leather belt. Otiyohok gave Geist his own walrus-hide belt and attached amulets on the advice of a local shaman. The cousin was apparently mollified. Later, Otiyohok added more beads and carvings to show that Geist had taken part in other important events, such as carrying the dead away from the village (Keim 1969:172–73). The Euro-American belt now holding the charms must have been substituted later. (LEE)

Amason: Destroyed.

Lee: Could be, like masks.

McInnis: Broken up or burned, or—?

Lee: Yeah.

Amason: Like charms. When they get foggy in their meaning, you're better off destroying them so they don't mess up your day.

How old is this guy?

Lee: The *kikituk* was collected in 1947 but is much older. Alec Frankson, who is a baleen basket maker, probably in his late eighties now, was the oldest

person I talked to about the *kikituk*. He said that the Reverend Driggs, the first minister in Point Hope, destroyed all the evil. My guess is that Driggs and other preachers effectively neutralized it. The songs weren't powerful anymore. Which is one of the explanations, I guess, for why Christianity caught on as well as it did.

Simpson: Why does the *kikituk* have a dark head?

Lee: I don't know.

Simpson: I was thinking it might be soot. His head, his face, is really much darker than his back. It might have been rubbed with soot.

Lee: Oil or soot.

Simpson: Soot is a spiritual camouflage.

Lee: Oh, really?

Simpson: Whalers' charm kits on the North Slope are coated inside with oil and soot. Athabaskan people burn something in order to convey it to the spirit world. The thing becomes smoke and dissipates into the air. You can burn food, for example, to send it to the spirits. What's left—after you've taken the spiritual essence out and conveyed it elsewhere—what's left is soot, a lifeless element. You can rub that lifeless element over something—your face, your charm kit—and isolate it from the surrounding world. It's protective: a spirit will not be able to discern what's behind the lifeless surface. That's why it's a spiritual camouflage.

McInnis: Which is why the *kikituk* could go anywhere.

Simpson: Could be that his face was coated with soot so he could surprise some other *kikituk*.

Dickey: Like when you go into war you rub soot on your face to distance yourself from the other life forms out there.

Chin: I was thinking about football players.

Simpson: Well, the soot around eyes does cut down on light reflection. So if you're hunting at sea, for example, you might paint circles around your eyes to protect yourself from glare. It has a practical application.

Lee: That would be very useful if you were flying over to Diomede to get another shaman's *kikituk*—

Dickey: —and suddenly decloak.

Lee: —and you wouldn't get bitten.

Simpson: He'd be camouflaged until he actually got his teeth into the opposition.

Chin: That's a great explanation. When I was a girl and I asked my mother why she did things a certain way, she'd just say, "It's just how it's done." Like it was a stupid question.

Simpson: I got the same response when I was a kid. We do this. We do that. But I never got the rationale behind it. You treat this animal a certain way. But no one said why.

Chin: My mother told us about burning food. And I've heard Poldine Carlo talk about burning food for her late husband. The Chinese burn symbolic papers, representing spirits, in huge furnaces. People are burning and burning and burning. It finally makes sense. Access to the otherworld.

Simpson: If you look at the graphics on the snow beater (fig. 70), the featherlike thing represents smoke. I don't think it's just coincidence that it looks like a feather. Feathers are "from the air," from the birds.

Amason: There's a kind of graphic alphabet here— the smoke symbol—

Simpson: Graphic alphabet?

120

Inupiaq umiak seat
Anonymous
Wood, ivory, baleen. 39.4 cm × 24.8 cm. Little Diomede Island, 1928. Collected by Dr. Harold McCracken; donated, 1976. UAM76-23-12

For the Inupiaq and Siberian Yupit who live in whaling villages, the return and harvest of the bowhead whale continues to be the paramount event in the annual cycle. Both practical and spiritual precautions are taken to ensure a successful hunt. The centrality of the whale is especially evident in imagery on hunting equipment. Among the most revered of such artifacts is the helmsman's wooden seat *(ektuRaq)*, positioned in the aft of the large walrus-hide hunting boat (umiak) from which the *umialik* (boat owner) directed the hunt. Harold McCracken traded for this example with a Little Diomeder in 1928 on his expedition to Alaska for the American Museum of Natural History. Engaging in activities such as carving images of whales, which metaphorically lure the prey, makes use of a technique called sympathetic magic. (LEE)

Amason: —like the smoke, or the feather. I've seen that in other pieces.

Chin: You're going to love a book we acquired with the Dorothy Jean Ray collection. It was written by Ruth Ekak in a graphic language. Ray refers to this as picture writing.

Lee: It's all in images—pictographic memory aids for the Old Testament. A number of symbol systems were introduced into the arctic—by missionaries— to aid communication and for teaching the Bible. But these were pictographs invented by the people they came to teach. There were two pictographic

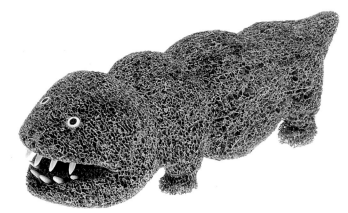

121

Inupiaq *kikituk*

Andrew Tooyak, Sr.

Whalebone, ivory, baleen. 21 cm × 6.4
cm. Point Hope, 1968. Purchased from
Lynn Castle, 1968. UAM68-014-0003

When driftwood was not available
Point Hope carvers used whalebone
as a raw material. Masks were made
of whalebone there, and a few carvers
have made whalebone *kikituk*s.
Master craftsman Andrew Tooyak, Sr.,
carved this one based on what he
had heard in stories, since neither he
nor anyone his age had seen a tradi-
tional *kikituk*. Tooyak has a special
interest in the *kikituk* because of his
wife's family's association with the old
one pictured in figure 118, which he
examined carefully on a recent visit to
the UAM ethnology collection. (LEE)

systems invented by the Yupit and another by the
Inupiat. Apparently they were independent.

Simpson: I've seen a reference to putting soot
around the eyes of young people before the Yupik
Bladder Festival. There are spirits everywhere during
the festival. The soot protects them. Having it around
the eyes is doubly significant—the soot is spiritual
camouflage, and the eyes are passageways to the
individual.

Amason: When shamans from the Kodiak area went
on journeys, you saw a horizontal tracking in the sky,
like a meteor, a shower of sparks. A shaman often
would originate in fire. That was his tunnel into the
flights—a very sooty light.

Simpson: To come back after being completely
consumed by fire was the most powerful form of
resurrection. Being burned really reduced him to an
essence: dissipated into the air, completely lifeless,
except for a few charred bones. This experience with
fire is the most indicative of a shaman's power. Not
just to die, to have no brain activity, but to be totally
consumed and then return intact.

A small thing like the sooty face of a *kikituk*
fascinates me. There are little clues hidden on the
face of things, or tucked inside. Their significance is
seldom apparent. But the search is most intriguing.

You become aware of something and then start
finding more of it as you look around. Sometimes it
takes just that one little thing. You've looked through
collections forever and it just didn't make an impres-
sion. So the inside of the box is black. So what? Then
you see or hear some reference, you put a couple of
things together, and suddenly you start to see it.

McInnis: Speaking of smoke, let's look at these pipes
(fig. 123).

Simpson: Lincoln Blassie of Gambell was pouring
pipes out of pure lead. I think he salvaged it out of
batteries, broke up the plates, and cooked them down
on a Coleman stove—100 percent lead. This same
kind of hot-pour inlay is found in a lot of Asian
materials, Siberian stuff.

When I visited with Albert Kulowiyi in Sa-
voonga, he was using bar solder, which is fifty-fifty—
half tin, half lead. It's brighter than pure lead, which
is quite gray. Albert had great pipe stories. He was
also a very devout Christian, so we would work for a
while and then he'd say, "Now we will stop to pray."
And he would go on at great length praying for
people in Savoonga, and everywhere else where they
might need some help. He had a list of all the infir-
mities in the village—

Lee: That's very Russian Orthodox—

Simpson: He'd pray for all of them, and then we'd go
back to work. One story he told was from the turn of
the century. There was a man being pursued by his
enemies. They were coming after him with knives.
What to do? This man had no weapon, but he had
his faithful pipe in his pocket. Well, he tucked it up
his sleeve, turned around, and pointed the stem at
them. They thought it was a pocket pistol, turned
around, and ran. He was saved by his pipe.

McWayne: By his trusty pipe.

Amason: Good thing he was a smoker.

122

Glen Simpson and Alvin Amason

123

Siberian Yupik pipes

Left

Anonymous

Ivory, sealskin, trade beads, ivory pipe cleaner. 26.7 cm. St. Lawrence Island, c. 1930. Collected by Otto W. Geist; acquired before 1966. UAM90-1-22

Right

Anonymous

Ivory, walnut, lead, brass, leather. 21.6 cm. Gambell, St. Lawrence Island, c. 1930. Collected by Otto W. Geist; acquired before 1966. UAM90-1-24

Tobacco and pipes for smoking it reached the Alaskan Eskimos by way of Siberia some 250 years before the arrival of Europeans. Because of the distance it had to travel, tobacco was highly valued, and smoking paraphernalia such as pipes and tobacco boxes were often greatly elaborated. The characteristic curved stem and cylindrical bowls with wide rims on these pipes probably were borrowed from the Siberian Chukchi.

Ivory pipes, decorated with human and animal figures or more austere design motifs such as the circle-and-dot design on the pipe on the left, were used locally and also sold and traded to outsiders. Both pipes here have small, removable "traps" below the bowl for retrieving nicotine for reuse.

Pipes of walnut (often carved from gun stocks) and cast lead, such as the pipe on the right, were common on St. Lawrence Island and both sides of the Bering Strait. The carved wood was placed in a mold and molten lead poured in to form stems, bowls, and decorative elements (Nelson 1899:281). (LEE)

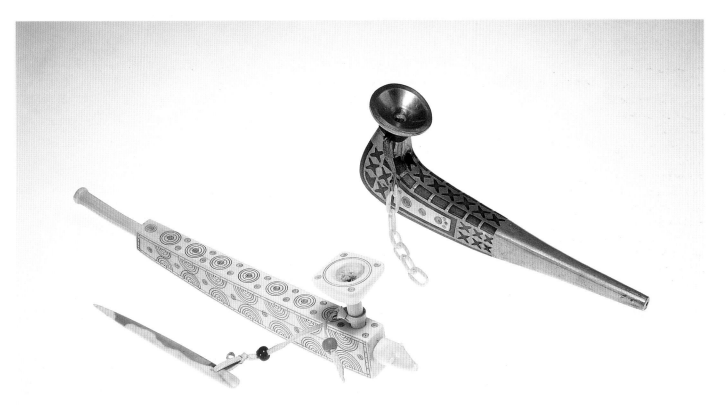

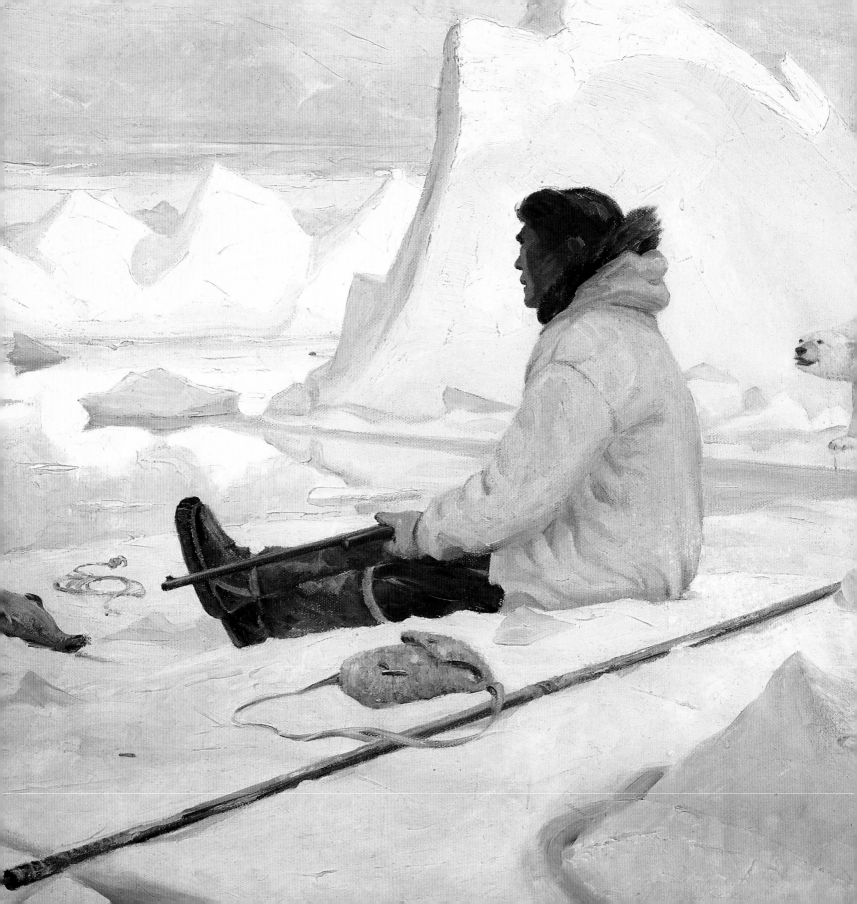

10 A Sense of Wonder *Kesler Woodward*

Exit Glacier

When we got close enough
we could hear

rivers inside the ice
heaving splits

the groaning of a ledge
about to

calve. Strewn in the moraine
fresh moose sign—

tawny oblong pellets
breaking up

sharp black shale. In one breath
ice and air—

history, the record
of breaking—

prophecy, the warning
of what's yet to break

out from under
four stories

of bone-crushing turquoise,
retreating.

Peggy Shumaker
Wings Moist from the Other World

Detail of figure 130

124

Punuk Eskimo turreted object

Anonymous

Ivory. 7 cm. Kukulik, St. Lawrence Island, Punuk period. Excavated by Otto Geist, 1935; received after 1935; catalogued, 1973. UA73-001-0001

Although some have suggested that the socket at the base and the small notch at the upper end of the central projection connect this piece to the small winged objects of Okvik and butterfly-shaped pieces of Old Bering Sea, UAM archaeology curator Craig Gerlach questions such arguments because they are unsupported by data from any source and judges as speculative the suggestion that such turreted objects represent the final and reduced form of the winged object tradition in the Bering Sea area.

Punuk style is characterized by deeply cut uniform lines, occurring mostly in pairs, and oblique spurs and Y figures decorating the object's surface. Some evidence suggests that artists used iron to produce the repetitive and formal engraving of such objects. For example, some carving tools with iron blades from Siberia are at least contemporaneous with, or possibly even earlier than, Punuk on St. Lawrence Island. Some turreted objects have been recovered with fragments of wood in their sockets, suggesting that the pieces might have been mounted on wooden shafts; their function is unknown. (Bandi 1969:73, 76; Collins 1929:9, 19, 49; Collins et al. 1973:7–9, 20 [illus.]; Fitzhugh and Crowell 1988:122–23; Geist and Rainey 1936:190, 306, 316, 322; Giddings 1973:155–322; Rainey 1941:553; Wardwell 1986: 96, 108) (JONAITIS AND YOUNG)

I try in vain to be persuaded that the pole is the
seat of frost and desolation; it ever presents itself
to my imagination as the region of beauty and
delight. There, Margaret, the sun is forever vis-
ible; its broad disk just skirting the horizon, and
diffusing a perpetual splendour . . . there snow
and frost are banished; and sailing over a calm
sea, we may be wafted to a land surpassing in
wonders and in beauty every region hitherto
discovered on the habitable globe.

Mary Shelley
Frankenstein, 1818

If there is a single element that links all Alaskan art—
historical and contemporary, Native and non-Native,
landscape and portrait, and narrative and abstrac-
tion—it is the sense of wonder. Wonder at this land,
its spirits, and its people. We recognize that sense of
marvel at the world of the spirits when we peer at the
two-thousand-year-old "Okvik Madonna" (fig. 25), per-
haps the world's preeminent surviving Eskimo ivory
carving, in its case at the University of Alaska Mu-
seum today. We feel it, too, when we encounter evo-
cations of similar spirits in the work of contemporary
Native Alaskan artists. The cultural strength and con-
tinuity of the Inupiat people are alive in the carved
panels of Eskimo artist Ron Senungetuk, whose im-
maculate craftsmanship in works such as *Two Spirits*
(fig. 72) weds ancient images to modern materials and
pictorial forms.

Glen Simpson pays homage in pieces such as
Thule Bird (fig. 97) not only to his Athabaskan and
Northwest Coast forebears but to the Native artists of
other northern cultures. And Alvin Amason makes
work not overtly about Native Alaskan culture at all
but which speaks at once both humorously and elo-
quently about the animals he learned to hunt and re-
spect as a young Native man. In works such as *I Could
Watch You Until the Stars Come Out and I Can't See*

No More (fig. 94) and *Oscar Scared Him with His Icon*
(fig. 47), Amason's animals, not slavishly rendered but
captured in their essence in a thoroughly contempo-
rary painterly style, are alive in a way that only one
who "grew up with those beasts," as he would say,
could make them.

But the sense of wonder is not limited to Native
Alaskan artists. We see it in the work of those who
came and who continue to come here from every part
of the globe. It's what we respond to in the work of art-
ists who accompanied the first European explorers to
Alaska in the mid-eighteenth century. It's the sense
that they, who were trying their best to do what they
were told—to document without embellishment, to
record what the people, habitations, implements of
daily living, and flora and fauna of the region looked
like—were just knocked out by what they saw and
were trying to deal with the fact that this first contact
with the land and Native people of Alaska had rocked
their view of the world.[1] When that sense of wonder
got into their work, the results were extraordinary.

This gift of wonder is what is shared in the best
art of Alaska—not just that of Native carvers and early
European visitors, but the work of every exceptional
artist who has encountered this landscape and these
cultures. With the gift, however, comes a caution.

When we look at the vast range of Alaskan images around us today, and when we reflect on the historical images from which they have grown, we not only celebrate the ability of artists to evoke wonder but the ability of this place we live in to inspire it. We also see what a dangerous double-edged sword this sense of wonder can be, and how it often robs our art of the very magic that it initially inspires.

To appreciate the best art of Alaska, and to begin to understand the connections between its historical and contemporary manifestations, it is important to examine both the strengths and the limitations of wonder as a motivating factor. For this, we turn to the two themes that have historically dominated Alaskan art—Native Alaska and the land.

Images of Native Alaskans

It is important to acknowledge from the outset that the sense of wonder we see in the first images of Native Alaskans is apparent as far back as the earliest surviving European portrayals of Northern Native people. Even such products of artistic imagination as the representations of Greenland Eskimos on Olaus Magnus's sixteenth-century *Carta Marina*, which provide nothing in the way of real documentary evidence about these people or their way of life, are alive with

125

Salmon Woman
John Hoover
Wood, brass, paint. 45 cm. 1979.
Purchased from Sacred Circle
Gallery. UA82-3-32

John Hoover's work combines his Aleut heritage of storytelling with a deep personal respect for the natural resources of Alaska, which he gained as a working fisherman. Because many Aleut artistic traditions were lost or destroyed, Hoover needed to create a new vocabulary of forms and images. This sculpture contains movable side flanges that open up, transforming a woman's wavy hair into a pair of fish. This alludes to the pervasive belief among many Native Alaskans that beings can pass easily between human and animal domains. Hoover's art is finely crafted, with sinewy slim shapes, surfaces reflecting the knife-blade marks in low relief, and is colored with muted earthy tones. (CHIN)

the power wielded by mere fragmentary reports of exotic people in the far North.[2] If they are failures as ethnographic documentations, they are more successful as art, because they are lasting impressions of a culture still literally and figuratively over-the-horizon for Europeans of the sixteenth century.

The earliest surviving likenesses of Northern Natives drawn from life show the same kind of intense marvel at these unfathomably exotic people. Most such images are of captured Eskimos brought back to Europe for display. Whether a woodcut serving as an advertisement for the exhibition of a Labrador woman and her child who were kidnapped in 1566 by European sailors, or the earliest known painting of Greenland Eskimos—a man, two women, and a girl kidnapped in 1654 near what is now Nuk and taken to Bergen—the images are alive with the evocative power of personal contact with individuals of a wholly exotic culture.[3]

We see that same kind of powerful, personal sense of desire to understand the Other in late-eighteenth- and early-nineteenth-century explorer-artists' images of Native Alaskans, but already there are differences. Watercolors and prints by John Webber of Native Alaskans encountered on Captain James Cook's third expedition are typical of early Alaskan images in their balance of focus among the people themselves, their dwellings, and their artifacts. No longer exotic people encountered by the artist out of cultural context and brought to Europe for show, Native people are seen in images such as these as exemplars of a whole exotic culture, and the focus is not so much on each individual as on their dress, implements, home, and way of life.[4]

Illustrations of this sort by Webber, William Ellis, and others from Cook's expeditions were widely distributed, and for several decades they served as models for artists accompanying other Alaskan expeditions. The same kind of balanced focus on people, artifacts, and dwellings is seen in work by one of the finest artists of the period—Louis Choris. A clear sense of fascinated puzzlement over these new people is evident in the work of Choris, who was only twenty years old when he was chosen to accompany the Russian expedition of Otto von Kotzebue around the world and to the Northwest Coast of Alaska in 1815–17. The watercolors and sketches he made on the trip and the hand-colored lithographs he produced later are striking in their gentle, persistent perceptiveness.[5] He is a keen observer of ethnographic detail, but we can also feel in his pictures a connection with the individuals he portrayed. The Eskimos and Aleuts of Choris are individuals—not really portrayed in their cultural context, but treated with the respect due people who lived in one of the most hostile environments on earth and adapted meager resources to thrive in that place.

We see much the same kind of powerful, sensitive depiction of Alaska Natives in the work of a few other late-eighteenth- and early-nineteenth-century explorer-artists, but other images from this era fall far short of such standards. Some were produced by the artist-observers themselves, out of insensitivity or lack of skill, but most come to us from the hands of engravers and lithographers who, working from the artists' original sketches in the relative comfort of their European studios, produced lithographs and engravings to illustrate published accounts of early voyages. Original observations of great sensitivity and beauty often were turned to caricature and worse by the reworkings of artists and craftsmen remote from the site of inspiration.[6]

What has happened to our original motivating sense of wonder here? In the hands of the explorer-artist who was on the scene, it served as impetus for creation of an often limited but still powerful image of early cultural contact. But by the time most of these images reached the public in published form, they were not only no longer charming or evocative but in many cases patently false.

126

Southeastern Scene

Theodore J. Richardson

Watercolor. 20.3 cm × 30.5 cm. 1886.
Purchased, 1984. UA84-3-139

Between his first visit to Sitka in 1884 and his death in 1914, Minnesota painter Theodore Richardson (1855–1914) became one of southeast Alaska's most faithful, prolific, and accomplished artist-visitors. Richardson made his first trip at the urging of a friend who lent him the money for a ticket, and he visited nearly every summer thereafter. Well liked and respected in Sitka, he was regularly praised in the local papers and taught a watercolor class on at least one occasion.

Richardson's excellent watercolors range from landscape views of the coastal mountains of southeast Alaska, usually shrouded in rain and fog and often painted from an offshore rowboat, to complex scenes of Tlingit house exteriors and interiors. Many of the latter include a wide variety of faithful representations of architectural details and objects of Native manufacture. (Kennedy 1973; Crane 1915; DeRoux 1990; K. Woodward 1995: 50–53) (WOODWARD)

We've made, then, a discovery about the limitations of wonder as a source of art making—that it doesn't travel well. Secondhand wonder is almost never simply less magical and wonderful, but is more likely twisted and subject to reliance on stereotype. The stereotypes range from the idea that "primitive" people must naturally be awed by the magical contrivances of the technologically advanced, to the notion that Native women are invariably bare-breasted, to any number of other more or less subtle misrepresentations. We all see the world through personal and cultural filters, but the filters that compromised the vision of explorer-artists often became blinders in the hands of the distant engraver, blocking out both truth and the original sense of wonder itself.

Already we see that this business of wonder is not quite so simple as my original proposition would have us believe. Wonder is a fine motivator, but a terribly limited tool.

TOURISTS AND TRAVELERS:
THE NATIVE ALASKAN AS SOUVENIR

In the first decades after the purchase of Alaska from Russia by the United States in 1867, boat traffic increased dramatically and visitors began arriving on steamship tours. By the 1880s both tourists and government officials were regular visitors to Alaska's coastal communities, from the southeast to the Bering Sea. Among them were competent artists who chose, on their own initiative, to make images of the still exotic Native people of these coasts. A traveler such as the young Minnesota artist Theodore Richardson could cruise by steamer up the Inside Passage to Sitka, and there visit and paint the Native people and the landscape in leisurely comfort (fig. 126). A photograph from the Minneapolis Public Library shows him contentedly seated in a rowboat on the calm waters of a southeast Alaska fjord, under the shelter of a propped umbrella, at work on a watercolor landscape.[7]

Richardson began by painting the still somewhat exotic Native people of southeast Alaska. His images at first seem very similar to those of the explorer-artists, but there are crucial differences, difficult but important to recognize and define. There is a kind of distance, a picturesqueness, to Richardson's depictions not often seen in the earlier works. The Native people are no longer individuals with whom the artist is trying to make personal contact, no longer even exemplars of a wholly unknown culture that he is trying to fit with some difficulty into his worldview. Instead, they have become just one picturesque aspect of exotic Alaska, something to be rendered and remembered in their exoticism, an aide-mémoire or, to use a more modern term, a souvenir, to be brought back by the artist's brush.[8]

Unlike his eighteenth-century predecessors, Richardson had to seek out and selectively portray scenes in which the Natives' dress, housing, and activities were as traditional and exotic as they had appeared a century before. By the late nineteenth century, traditional Native culture in Alaska was clearly imperiled, having undergone drastic change through acculturation, and a conscious process of selective vision was necessary in order to find and portray the Native Alaskan in such a manner. We see in the work of such artists what we hear in the words of narrators of the period—not the adjective "uncivilized," but "unspoiled."

The difference between these terms is a gulf—one that has as much to do with changes in European and American values between the ends of the eighteenth and nineteenth centuries as with changes in the culture of Native peoples during that era. But for our purposes, we need to look at what that change meant for the artist and his motivating sense of wonder. Clearly what has happened in the first century and a half of contact is that the Native Alaskan, as a subject for the non-Native artist, has gone from being a source of wonder to a source of curiosity, or merely picturesque interest.

127

The Native Camp at Anvik, Alaska
Theodore Roosevelt Lambert
Oil on canvas. 20.96 cm × 27.31 cm.
1936. Donated by Leo Rhode, 1996.
UA96:027:001

Painted on or shortly after Lambert's trip with Eustace Ziegler down the Chena, Tanana, Yukon, and Kuskokwim rivers in the summer of 1936, *The Native Camp at Anvik* is a particularly striking recent addition to the University of Alaska Museum's extensive collection of the artist's work.

A restless, willful, ultimately unhappy man, Lambert finally disappeared in the Levelock area of southwest Alaska in 1960 after years of increasing paranoia and desire to be left alone to paint without interference. He lived in Alaska longer by far than did either Laurence or Ziegler, some thirty-four years, and his work is widely admired for its expressive color and brushstroke and for his obvious firsthand familiarity with the character of pioneer life. Never settling into the easy life of a city dweller reflecting with nostalgia on the rough days of the frontier, he gives us perhaps our most revealing look at both the lure and potential price of that hard life. (WOODWARD)

In late-nineteenth-century images this transition is, I believe, unmistakable, but quite subtle. It is no longer subtle in our own day. In the time between that era and our own, the change has become much more obvious and much more dramatic. Without singling out certain artists, I would simply ask you, the next time you have the opportunity, to examine in this light the images of Native Alaskans you see in contemporary Alaskan gift shops, galleries, coffee-table books, and other sources for traces of the genuine, searching wonder of cultural contact.

I think you will find that it is rare, but evident in the work of a few artists. We see it in the best work of Fairbanks painter Claire Fejes, in paintings such as *Source of Life* (fig. 128), that were done in the years following her first visits to the Eskimo whaling camps of northwest Alaska and show the same kind of unromantic, unpicturesque celebration of the Other that the best explorer-artists incorporated almost two centuries before.

We see it, too, in the work of a few contemporary Alaskan photographers, perhaps most notably in James Barker's perceptive and compelling images of the Yup'ik people of the Yukon-Kuskokwim delta region, images such as *4th of July at Black River Fishcamp* (fig. 63). But such examples are all but drowned in a sea of images of Native Alaskans ranging from stereotyped, to cute, to wholly exploitative.

WHAT HAS GONE WRONG?

Another limitation of wonder as a tool for art making is that it can be dulled or completely worn out, not just by familiarity, overuse, or the sheer weight of imagery already in the mind's eye of the would-be maker of yet another image of the exotic Native, but by an unwillingness to exercise the will to keep the sense of wonder sharp. It is always easier to connect to an existing visual tradition than to find one's own, always easier to rely on stereotype than to refuse to do so.

An Alaska resident since 1946, Claire Fejes (b. 1920) grew up in New York and received her early training at the Art Students League and the Newark Museum. Soon after joining her husband in Alaska, where he had served as a Russian interpreter during World War II, the artist began to draw and paint the Native people of the community. Out of this interest grew her first visit to a remote Eskimo village, the whaling camp of Sheshalik in the Kotzebue area in 1958. On this pivotal trip she found the subject and style she has continued to develop. By 1960 Fejes's work had been shown in solo exhibitions at the Frye Art Museum in Seattle and the Roko Gallery in New York, and in 1966 her first book, *People of the Noatak,* was published by Alfred A. Knopf.

Spending winters in California and summers at work in her studio in downtown Fairbanks, Fejes has continued to be a productive, well-respected figure in Alaskan art into the 1990s. In addition to solo exhibitions in Alaskan museums, the Washington State Capitol Museum, Larcada Gallery in New York, and as far away as Tel Aviv, Fejes was one of only two living artists included in the 1975 Amherst College exhibition *American Painters of the Arctic.* A 1991 retrospective of her work, organized by the University of Alaska Museum, traveled throughout Alaska and the West Coast. (Brunberg 1966; Capps 1991; Fejes 1966, 1969, 1981; Goodwin 1991; Ingram 1992; K. Woodward 1993:127–29, 133) (WOODWARD)

128

Source of Life
Claire Fejes
Oil on canvas. 66.04 cm × 121.92 cm.
Undated. Purchased, 1961. UA1031-1

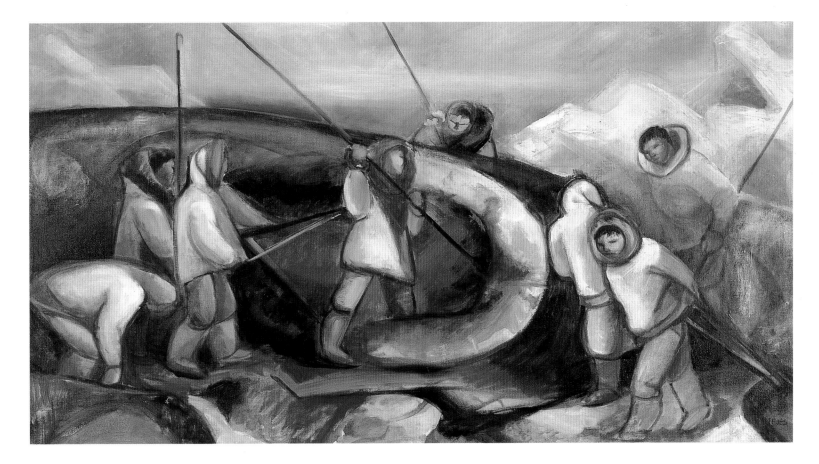

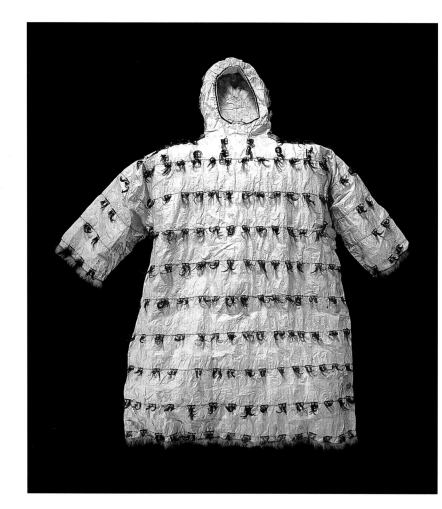

Surely most of the purveyors of cute images of Native Alaskans didn't mean to trivialize their subject. Surely they are not, by and large, cynical exploiters. Certainly most of them do, or at least initially did, feel something much like the same sense of wonder early explorers felt when they first encountered the Native people they portrayed, and they began to make their pictures out of a genuine desire to express that wonder. It is perhaps harder for artists today to find something new, personal, and full of wonder to say about Native Alaskans and their culture than it was for the artists who first encountered these cultures. But if we as contemporary Alaskan artists do not have the ingenuity and the will to do so, then we should change our subject and our means to one for which we do.

The Alaskan Landscape

VISITORS DEPICT THE ALASKAN LAND

Even more than pictures of Native Alaskans, images of the landscape dominate Alaskan art today. In this second major theme, we again find wonder at the source, and we again encounter its limitations. Landscape succeeded Native people as the main subject for Alaskan art in the late nineteenth century. Perhaps most European and American artists had realized that their depictions of Native people were increasingly picturesque and trivial and that they needed to find a subject in which the wonder they felt could be given full rein, but an increasing focus on the landscape itself was typical of artists of the period. The mid–nineteenth century saw the great flowering of the American landscape painting tradition, and energetic, ambitious artists visiting the territory of Alaska were well aware of such developments and eager to adapt these new styles to the Alaskan landscape.

Most of the early landscape painters in the Territory were tourists or travelers who were here for other purposes, such as Henry Wood Elliott, who almost single-handedly saved the fur seal from extinction through his government activism on their behalf. In

129

Siberian Yupik gut parka
Anonymous
Bleached gut, feathers, auklet beaks.
120 cm × 70.5 cm. St. Lawrence Island,
1964. Collected by Otto W. Geist;
bequested 1964 by Geist Estate.
UAM64-21-122

Sometimes known as the Eskimo raincoat (Ray 1959), parkas of sea mammal intestine are made by Aleut and Alaskan Eskimos. They are surely one of the most ingenious of the many creative clothing adaptations of the Western Eskimos to the wetness and cold of their environment. To make a gut parka, a woman cleaned sea mammal intestines, turned them inside out, knotted them at one end, blew them up, and hung them to dry. The intestine was then split and the strips were sewn together with a special waterproofing stitch (Varjola 1990:147). Little is known about whether the different gut-parka styles—for instance, horizontal or vertical stitching—reflect gender, ethnicity, or location of manufacture. In some places gut parkas were used in ceremonies. The auklet crests on this example suggest that it may have served this purpose. (LEE)

130

Eskimo Hunter
Magnus Colcord ("Rusty") Heurlin
Oil on canvas. 49.53 cm × 59.69 cm.
Undated. Donated by Grace Berg
Schaible, 1991. UA91:025:001

One of Alaska's earliest, most beloved, and longest-tenured resident painters, Rusty Heurlin (1895–1986) was a keen observer of the lives of Native people and settlers in northern Alaska. Born in Kristianstad, Sweden, of American parents and trained at the Fenway School of Illustration in Boston, the artist arrived in Valdez in 1916. He left to serve in World War I, but returned to Alaska in 1924 for good. He eventually made his home in Ester, just outside Fairbanks.

Heurlin based his work on the accumulated experience of many years of Alaskan residence. He spent, for instance, four whaling seasons at Barrow in the early days of Eskimo whaling in umiaks under sail—a favorite subject in later years. The artist is best known for several series of large paintings chronicling Alaska's history—*The Great Stampede, The Great Land,* and *Our Heritage*—which illustrate major themes in the history of Alaska's Native and pioneer cultures.

The UAM collection includes more than thirty-five paintings by Heurlin, among them many large canvases. *Eskimo Hunter* is more modest in scale, but is all the more effective for its quiet evocation of a way of life the artist knew well and fervently admired. (Bedford 1986; *Nanook News* 1971; *Tundra Times* 1972; Wold 1973; K. Woodward 1993:89–90) (WOODWARD)

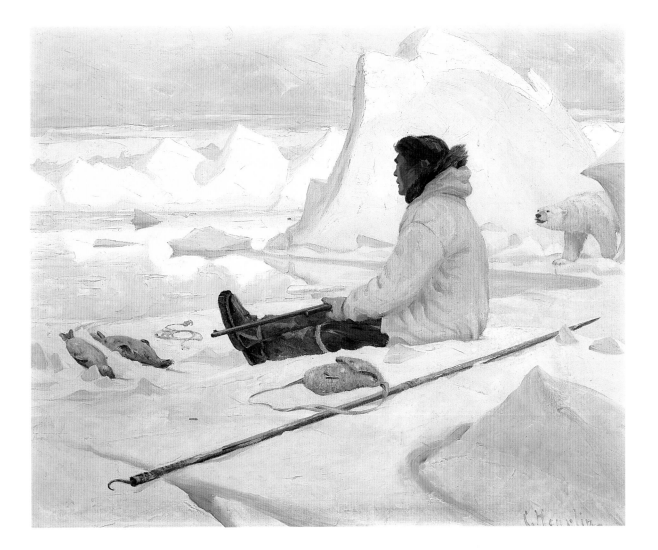

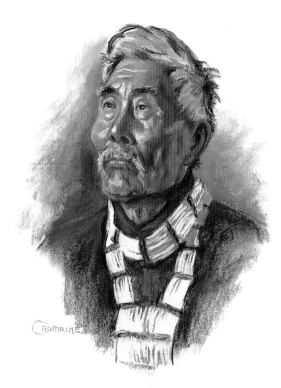

131

Chief Andrew
Nina Crumrine
Oil pastel. 55.3 cm × 43.2 cm.
Undated. Donated by Dr. and Mrs.
Terris Moore, 1953. UA71-69-9

Born in Indiana and trained at the Art Institute of Chicago, Nina Crumrine (1889–1959) came north to live with her uncle, H.V. McGee, in Ketchikan in 1923. She and her daughter Josephine (b. 1917), both known for their work in pastels, were great travelers, visiting every region of Alaska—from Ketchikan to Barrow, Nunivak Island, St. Lawrence Island, and beyond—as well as South America, Africa, Europe, and Asia. Nina made a tour of Canada at the behest of the Canadian Railway, painting both landscapes and portraits of Canada's Native people.

Nina Crumrine eventually settled in Haines, and when her daughter married Robert Liddell, the couple built a house on her property. Josephine became a well-known painter of Alaskan sled dogs. Nina is best known for her portraits of midcentury Native Alaskans, twenty-five beautifully rendered and strikingly perceptive examples of which are included in the UAM collection. (Hulley 1970:367–68; Reed 1945; K. Woodward 1993:124–25) (WOODWARD)

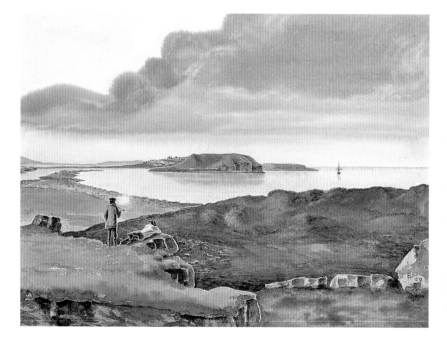

132

Village Cove and Hill
Henry Wood Elliott
Watercolor. 22.86 cm × 30.48 cm.
1872. Donated by Mrs. Harriet
Wetmore Chapell Newcomb, 1948.
UA482-7

A small, contemplative scene encompassing relaxed foreground figures on a promontory, a peaceful bay with a becalmed ship at anchor, and the distant settlement, *Village Cove and Hill* is painted with sure, deft, unpretentious strokes and a minimum of fussy detail. Its small size, almost domestic character, and lack of overt drama stand in stark contrast to the windswept, storm-tossed killing grounds of *Seal Drive Crossing* (fig. 13). (DeRoux 1990:3–5; Elliott 1886; Graburn, Lee, and Rousselot 1996:56–57, 525–42; Shalkop 1982a; Van Nostrand 1963:11–17, 78–80; K. Woodward, 1993:26–28) (WOODWARD)

works such as *Seal Drive Crossing* (fig. 13) and *Village Cove and Hill* (fig. 132), Elliott gave us some of our finest nineteenth-century watercolors of the Aleutian and Pribilof Islands.

In these last decades of the nineteenth century a few artists also began to come to Alaska specifically to paint. This was an era in which adventurous American artists, no longer content with the splendors of the American West, began to roam even farther afield, to Central and South America, to Africa, and also to Alaska in search of ever more dramatic landscape material. Among the first were William Keith and Thomas Hill, perhaps the most highly regarded painters in California at the time and major national figures. Painting along the coast of southeast and southcentral Alaska, both experienced wonder at the Alaskan coastal landscape, and both had the requisite skills to capture that feeling and share it with their viewers. Other, less-skilled artists came as well, some to succeed in modest aims, and some to encounter another limitation of wonder—that the ability to perceive grandeur does not necessarily entail the ability to communicate it.

Paintings of Alaska by visitors reached their zenith in the early years of the twentieth century. In the winter of 1918–19 Rockwell Kent visited Alaska for reasons quite different from any artist who had come before him. Kent and his nine-year-old son spent a winter on Fox Island, in Resurrection Bay, near Seward, in search of something less tangible than exotic scenery. His own words say it best:

> The Northern Wilderness is terrible. There is discomfort, even misery, in being cold. The gloom of the long and lonely winter nights is appalling, and yet do you know I love this misery and court it. Always I have fought and worked and played with a fierce energy and always as a man of flesh and blood and surging spirit. I have burned the candle at both ends, and can only

wonder that there has been left even a slender taper glow for art. And so this sojourn in the wilderness is in no sense an artist's junket in search of picturesque material for brush or pencil, but the flight to freedom of a man who detests the endless petty quarrels and bitterness of the crowded world—the pilgrimage of a philosopher in quest of happiness and peace of mind.[9]

While we may be uncomfortable with the romantic phrasing and the self-aggrandizement, I suspect those are sentiments many of us find resonant with our own reasons for coming to Alaska, and the joy of Rockwell Kent's work is that we see those sentiments as boldly expressed in his art as in his words. From the simple, unpretentious liveliness of his drawings of their cabin, to symbolic personifications of primal elements such as the North Wind, the Fox Island imagery is filled with wonder. In the canvases he produced on the island or soon after his return, such as *Voyagers* (fig. 80), Kent found a way for the first time to get his sense of wonder at not just the natural world, but the human spirit, into his work.

RESIDENT PAINTERS: SYDNEY LAURENCE AND THE LONELY LANDSCAPE

Keith, Hill, and Kent, however successful at portraying the wonders of Alaska, were short-term visitors. The first resident Alaskan painters arrived early in the twentieth century, among them such revered Alaska names as Sydney Laurence, Eustace Ziegler, Ted Lambert, Jules Dahlager, and Rusty Heurlin.

The first professionally trained painter to make Alaska his long-term home was Sydney Laurence, unquestionably Alaska's most beloved historical painter. Still little-known outside Alaska, his name is a household word here, where his paintings are seen not only in museums but in banks, hospitals, offices, private homes of longtime residents, and in countless reproductions.[10]

Laurence's work sheds more light on the question of the power of wonder to motivate and on its limitations. In his early paintings of Mount McKinley, work from the teens and 1920s such as the two *Mt. McKinley* paintings from the museum's collection (figs. 34, 133), we see marvelous, fresh, ambitious attempts to come to grips artistically with North America's highest peak. The mountain in these paintings is already near the center of the canvas, but it often shares the stage with equally dramatic clouds and a sweeping foreground space that speaks as much of the mountain's majesty as does the peak's vertical rise. In much of Laurence's later work, however, the mountain loses its individual-ity and freshness and becomes an icon, something that he painted—and people sought—not because it was a wonderful painting, but because it was recognizably "The Mountain." The foreground wilderness, rather than being a source of wonder itself, becomes an impediment to be hastily brushed aside in the rush to get us, the viewers, to the peak.

By the mid-1930s—a decade after Laurence had quit being a full-time resident of Alaska and was spending his winters making scores of Mount McKinley paintings in his Los Angeles studio for Block's department stores in Illinois, Belle Simpson's Nugget Shop in Juneau, and other steady volume buyers—the

133

Mt. McKinley

Sydney Mortimer Laurence
Oil on canvas. 40.64 cm × 50.8 cm. 1924. Label on back in ink, in Laurence's hand: "Mount McKinley from the Tokacheetna River, Alaska Sydney Laurence Anchorage Alaska 1924." Donated by Dr. and Mrs. John I. Weston, 1983. UA83-9-5

In his long and prolific career Sydney Laurence painted a variety of Alaskan scenes, among them sailing ships and steamships in Alaskan waters, totem poles in southeast Alaska, the dramatic headlands and quiet coves and streams of Cook Inlet, cabins and caches under the northern lights, and Alaska's Natives, miners, and trappers engaged in their often solitary lives in the wilderness. But the image of Mount McKinley from the hills above the rapids of the Tokositna River became his trademark. This image, more than any other, personifies Laurence for his many admirers and collectors in Alaska and beyond.
(WOODWARD)

134

Alaskan Scene

Jules Dahlager
Oil on board. 30.48 cm × 24.13 cm.
1933. Purchased, 1982. UA82-3-28

The work of Jules Dahlager (1884–1952) is often linked with that of Sydney Laurence, Eustace Ziegler, and Ted Lambert as the core of Alaska's romantic artistic inheritance. Dahlager and his wife moved to Cordova in 1921, where he was employed by the *Cordova Daily Times.* Already a cartoonist and longtime newspaperman, he began to paint and soon developed his trademark style of palette-knife work on small canvases that has become a staple of Alaskan art collectors.

Dahlager was encouraged by both Ziegler and Laurence, as well as by the purchase of a number of his paintings by President Hoover and his entourage on a visit to Cordova. Though he continued his newspaper work when he moved to Ketchikan in 1929, he spent much of his time and energy on his art. In addition to landscapes, he painted numerous portraits, among them many of Horse Creek Mary (the well-known Copper River Native woman painted frequently by Eustace Ziegler) and Chief Johnson, a distinguished Tlingit elder in Ketchikan. (Queener-Shaw 1987; Roppel 1977; K. Woodward 1995:86–87) (WOODWARD)

135

Danger Point
David Rosenthal
Oil on canvas. 76.2 cm × 71.12 cm.
1984. Donated by Grace Berg
Schaible, 1995. UA95:062:001

David Rosenthal first visited Cordova in 1977 and has made it his home since 1981. Born, raised, and educated in Maine, he is more widely traveled in the polar regions than is any other Alaskan artist. Rosenthal has painted not only Alaskan landscapes from Cordova to Anaktuvuk Pass, but the high arctic and antarctic as well. As an officially sponsored artist for the U.S. Coast Guard, he was able to paint from polar icebreakers in the vicinity of Greenland and through the Northwest Passage to Kaktovik. He has since painted for several seasons in Antarctica, initially on his own while working construction at McMurdo Sound and more recently as the National Science Foundation Antarctic Artist-in-Residence in 1993–94.

Working almost invariably on a small, almost-square format, Rosenthal makes his images of the polar regions from sketches and memory, inventing methods of representing the colors and forms he has seen and so accurately remembered. He achieves an impression of stark realism while maintaining a light, inventive touch. (Chin 1992; Lockhart 1995; Palmer 1992; K. Woodward 1995) (WOODWARD)

image was almost used up, no longer full of wonder, but an empty commercial husk. We see here another of the limitations of wonder as a tool for making art—its saleability. Wonder successfully captured is highly marketable, but painting for that ready market is not conducive to the genuine search that engenders and nourishes the sense of wonder itself.

While it is important to acknowledge Laurence's limitations, it is equally important to acknowledge his accomplishment and his legacy. Laurence could, in moments of pure wonder, produce throughout his career quiet images that captured as well as anyone ever has the still, chill beauty of this land. They are most often images free of grand gesture, but full of quiet marvel. The best of his many images of the light, land, and water of Cook Inlet are about as evocative of place as paintings get. Moreover, if his images of Mount McKinley, cabins and caches under the northern lights, and other subjects often seem stereotypes today, we must remember that he was the creator, not the imitator, of the stereotype.

But his real contribution, is seems to me, is what I have called the image of "the lonely landscape." For Laurence, Alaska was immeasurably greater than the humans who scrabbled about on it. We see that in his paintings in the diminutive scale of human habitation, its vulnerability among the light and grandeur of the landscape. He produced that image not by eliminating human traces but by juxtaposing them with the landscape in such a way that the dominance of the land over man was made clear. That predominance had been lost in the American West by his time, and in Alaska it was already under siege. But by giving us that powerful image of humans in an earlier, more subordinate relationship to the mountains, the sea, the cold, and the northern lights, he allowed a few more generations to feel the magic of the frontier.

His work also shaped landscape painting in Alaska. In a very real way, every landscape painter in Alaska has had to choose, since his day, whether to follow Laurence's example or reject it, and it is important for us to recognize that the rejection of his image, conscious or unconscious, is as reflective of his importance as the adoption of it. One way of talking about all subsequent Alaskan landscape painting is to define where each painter stands in relation to that divide—choosing to look forward, to look for a new image of this land and our relationship to it, or to look back, to preserve the image of Alaska we inherited from Sydney Laurence.

CONTEMPORARY VIEWS OF THE ALASKAN LANDSCAPE

Many familiar, successful, contemporary landscape painters stand on the conservative side of that divide, acknowledging in their painting, as they do in their own words, that they seek to be the torchbearers half a century later not only of Laurence's image but of his painterly style. But other contemporary Alaskan landscape painters stand on the far side of the divide, insisting in their work that the only true wonder lies in looking ahead. Their work, all influenced by the Alaskan land, is as various in style as in intent.

Fred Machetanz's work has itself become an icon of romantic Alaska imagery, but he forged his strongly individual style not by following the artistic lead of Sydney Laurence, but by developing his own technique and vision. His 1984 painting *Off to the Trapline* (fig. 10) does not reach for grandiose symbol, but captures the everyday excitement of dogs joyfully and powerfully pulling a sled, a pleasure shared by early trappers and modern mushers alike.

Bill Brody's *Guardians of the Valley* (fig. 83), David Mollett's *Tanana River* (fig. 84), and David Rosenthal's *Danger Point* (fig. 135) make it clear their creators are among the growing number of artists who have recently found fresh imagery in the still nearly pristine landscapes from the outskirts of Alaskan communities to the more remote regions of the Arctic National Wildlife Refuge. Their work speaks

136
**Kesler Woodward and
Barry McWayne**
Photograph by Aldona Jonaitis

more to the clear air, wide spaces, and strange optical phenomena that so overwhelm visitors to the unpeopled parts of Alaska than to the look of individual peaks.

Photographic representations of the Alaskan landscape abound, but only a small percentage of the countless published and unpublished photographs escape the picturesque cliché. Included in this publication are many of those that do, drawn from the preeminent collection of contemporary Alaskan photography built over the past two decades by UAM photographer and fine arts coordinator Barry McWayne. The best Alaskan landscape photographs are as varied in visual character and as various in their interpretive visions as the best Alaskan paintings.

The animal life of the Alaskan landscape, a subject even easier prey to stereotype, is one that a few Alaskan artists have taken on with freshness, originality, and new insight as well. Among the UAM collections, Todd Sherman's beautiful but eerie painted meditations on the melding of wolves and forest, fiber artist Fran Reed's use of salmon skins to create elegant organic containers, and Charles Mason's stunning portfolio of reindeer-herding photographs are but a few examples of the diverse ways contemporary Alaskan artists are expressing personal experience with the animal life of the North.

Much excellent contemporary work is difficult to connect specifically to the Alaskan land and its people, but from political and social commentary to color-field abstraction, it is conditioned in part, as are we, by the Alaskan experience. Nevertheless, in the highly abstract carved and painted panels of Jim Schoppert's *Raven: In the Pink* (fig. 104), painter Robby Mohatt's *Traces VI* (fig. 15), and Paul Gardinier's mixed-media *Sounding Board for Joseph Beuys* (fig. 137), Alaskan artists show themselves as aware of national and international modes of expression as they are of local sources.

COMING FULL CIRCLE:
THE ARTIST AS VISITOR

In the best Alaskan contemporary work we see a sense of wonder, not unlike that which we sensed in the work of early explorer-artists—artists struggling to incorporate this still-new image into their view of the world and their place in it. But I think we may see something more specific. I think we may see being born in new Alaskan art an image that in its essence is a rival to Sydney Laurence's image of the frontier and of ourselves as pioneers.

I have said that Sydney Laurence enabled a few more generations of Alaskans to feel the magic of the frontier. But the key word here is "frontier." However small Laurence felt people were in relation to the land, his image was by and large of men and women who came to stay, to settle, to pioneer. The whole notion of pioneering is dependent on the existence of a frontier. Inherent in it also is a sense of identification with the land, and at least collective ownership of it. Sydney Laurence's image of Alaska, I believe, has shaped more than any other artist's the ways we Alaskans see ourselves and our land today. Whether we see the land as something fragile, in need of protection, or as something so much greater than ourselves that it does not need much protection, we identify ourselves as Alaskans, and we feel that we have made this land our own. We still see ourselves, or want to see ourselves, as pioneers—especially the vast majority of us

137

Sounding Board for Joseph Beuys
Paul Gardinier
Spruce, copper, felt, gut, rubber.
56.52 cm × 41.91 cm × 15.88 cm.
1992. Purchased at *Sense of Wonder*
auction, UAM, 1995. UA95:063:001

Paul Gardinier (b. 1956), a curator at the Alaska State Museum
and a member of the Juneau Arts-R-Us group in the late 1980s
(Rich 1988), first became known in Alaska a few years earlier for
watercolors based on Aleut hunting hats and elegantly crafted
three-dimensional stick constructions. His work became better
known statewide through dynamic exhibitions at the Civic
Center Gallery in Fairbanks in 1986 and the Anchorage Museum
in 1989 that dealt with his response as a contemporary artist to
a two-month tour of more than fifty European museums in 1986.
In these exhibitions Gardinier juxtaposed enigmatic, symbolic
forms and large, expressionistic grounds with found and fabri-
cated three-dimensional objects. He was awarded an Alaska
State Council on the Arts Individual Artist Fellowship in 1986.

Like most of Gardinier's recent work, *Sounding Board for
Joseph Beuys* employs a wide range of materials to refer to other
artwork, the nature of culture, and the way in which works of art
are created, displayed, and interpreted in our time. (Ingram 1989;
Mollett 1984; K. Woodward 1989) (WOODWARD)

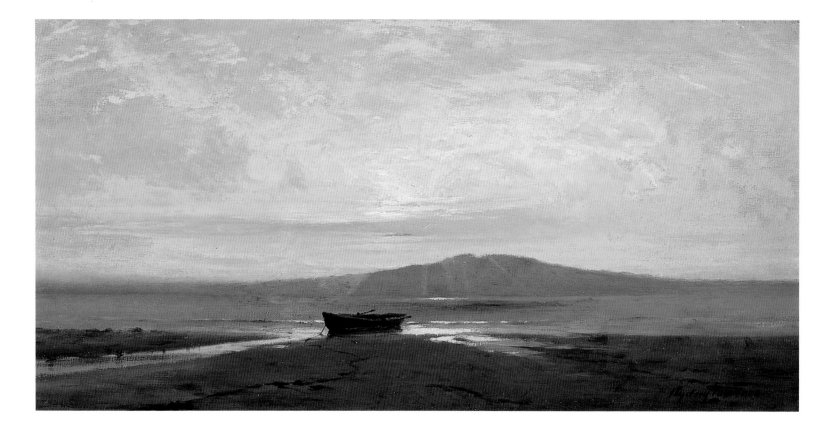

138

Mount Susitna, Cook Inlet, Alaska
Sydney Mortimer Laurence
Oil on canvas. 45.72 cm × 64.77 cm.
Undated. Donated by Dr. and Mrs.
John I. Weston, 1983. UA83-9-7

Laurence's paintings of Mount Susitna, seen from the present
townsite of Anchorage across the water of Cook Inlet, are among
his most striking scenes. These and other strongly horizontal
compositions, most of them Cook Inlet scenes, are consistently
among his finest works.　(WOODWARD)

who made a choice to come here—and most of us take great pride in having a part in the shaping of what we now think of as "our" place.

But it seems to me that in much of the new art of Alaska, the artist has come full circle, has returned to the status of visitor. We are profoundly influenced by and in awe of this land, its spirits, and its cultures. But we are beginning to understand, as we get to know it better, that we cannot "own" it, in the sense that our pioneer forebears believed they could and should. It is no longer "our" land that we depict, but simply "the" land, land that has and will have no owner, and consequently no pioneer. We are not without pride in our status—whether as Natives or explorers. But our pride is in being a part of such a place, not in the prospect of pioneering it, conquering it, taming it. The focus, it seems to me, is changing from Sydney Laurence's image, which put the emphasis on Alaskans as pioneers, to a newly rediscovered image of Alaskans as visitors—in a place of wonder.

Notes

This chapter is adapted from the text for *A Sense of Wonder* (Woodward 1995), the catalog of an exhibition and fund-raising auction in support of expansion of the University of Alaska Museum, held at the Museum in May 1995.

1. See, for example, the instructions given by the Russian Imperial Academy of Arts to explorer-artist Pavel Mikhailov. He was to strive for accuracy, avoid drawing only from memory, and above all to shun embellishment (Shur and Pierce 1978:360).

2. These earliest depictions of Inuit, on a map of Scandinavia, the North Atlantic islands, and Greenland, are widely acknowledged to be the product of the artist's imagination coupled with fragmentary rumors and reports, as neither the people nor their oceangoing vessel have any distinguishable Inuit characteristics. For extensive discussions of these images from an ethnographic point of view, see Lyman (1949), Birket-Smith (1959), Sturtevant (1976), and Oswalt (1979).

3. The woodcut, by an unknown artist, is thoroughly examined in Sturtevant (1980) and Sturtevant and Quinn (1987). See my discussion of the painting, which is now in the National Museum of Denmark, in K. Woodward (1993:18).

4. Illustrations by Webber and other explorer-artists mentioned in this essay are discussed in more detail in Henry (1984) and K. Woodward (1993:18–26). These Alaskan pictures are of course not the earliest examples of such a focus. Similar illustrations of implements, dwellings, and customs abound in the literature of exploration of the central and eastern arctic in the centuries between the making of the prints of captured Eskimos described above and the onset of contact in Alaska.

5. See Choris (1822). Two copies of this rare and extraordinarily beautiful volume are in the collection of the Rasmuson Library at the University of Alaska Fairbanks, along with first and later editions of virtually every published account by early Alaskan explorers.

6. For a particularly striking example of such a dramatic change between firsthand representation and published print, see the discussion of the work of Gaspard Duché de Vancy, official artist of the 1785–88 Le Perouse expedition, in Henry (1984:146–47) and K. Woodward (1993:21–23).

7. Kennedy (1973:35).

8. For examples of such works by Richardson and an extensive discussion of this issue, as well as more information on the artist himself, see K. Woodward (1993:50–53) and M. Kennedy (1973).

9. Kent (1919, unpaginated).

10. For more on Laurence's life and work, see K. Woodward (1990a).

Bibliography

Adams, Anne J.
1994 "Competing Communities in the 'Great Bog of Europe':
 Identity and Seventeenth-Century Dutch Landscape."
 In W. J. T. Mitchell, ed., *Landscape and Power,* 35–76.
 Chicago: University of Chicago Press.

Adler, Kathleen, and Marcia Pointon, eds.
1993 *The Body Imagined: The Human Form and Visual Culture
 Since the Renaissance.* Cambridge: Cambridge University
 Press.

Alaska Life: The Territorial Magazine
1941 "Northern Lights." 4(12):29, cover.
1942 "Ted Lambert, Alaskan." 5(6):2, cover.

Alaska State Council on the Arts
1982 *Annual Report.* Anchorage: Department of Education,
 State of Alaska.
1983 *Annual Report.* Anchorage: Department of Education,
 State of Alaska.

Alexei, Maxie
1996 Telephone interview with Molly Lee, July.

Ames, Michael
1992 *Cannibal Tours and Glass Boxes: The Anthropology of
 Museums.* Vancouver: University of British Columbia
 Press.

Appadurai, Arjun
1986 "Introduction: Commodities and the Politics of Value."
 In Arjun Appadurai, ed., *The Social Life of Things,* 3–63.
 Cambridge: Cambridge University Press.

Ard, Saradell
1972 "Alaskan Eskimo Art Today." *Alaska Journal* 2(4):30–41.

Association of Art Museum Directors
1992 *Different Voices: A Social, Cultural, and Historical Frame-
 work for Change in the American Art Museum.* New York:
 Association of Art Museum Directors.

Bal, Mieke
1996 *Double Exposures: The Subject of Cultural Analysis.* New
 York: Routledge.

Bandi, Hans-Georg
1969 *Eskimo Prehistory.* Seattle: University of Washington
 Press.

Barker, Charles
1940 "Philosopher on Canvas." *Alaska Life* 5 (7):5, 24

Barker, James H., with Robin Barker
1993 *Always Getting Ready,* Upterrlainarluta: *Yup'ik Eskimo*

Subsistence in Southwest Alaska. Seattle: University of
 Washington Press.

Barrell, John
1980 *The Dark Side of Landscape.* Cambridge: Cambridge
 University Press.
1986 *The Political Theory of Painting from Reynolds to Hazlitt.*
 New Haven: Yale University Press.
1992 *The Birth of Pandora and the Division of Knowledge.*
 Philadelphia: University of Pennsylvania Press.

Bateman, Robert
1984 *The Robert Bateman Naturalist's Diary—1985.* New York:
 Holt, Rinehart and Winston.
1985 *The Robert Bateman Naturalist's Diary—1986.* New York
 and Toronto: Random House/Madison Press.
1986 *The Robert Bateman Naturalist's Diary—1987.* New York:
 Holt, Rinehart and Winston.

Baxendall, Michael
1985 *Patterns of Intention.* New Haven: Yale University Press.
1995 *Shadows and Enlightenment.* New Haven: Yale University
 Press.

Bedford, Jimmy
1986 "The Long Journey of Rusty Heurlin." *Fairbanks Daily
 News-Miner,* March 16, D1.

Behlke, James
1989 *David Mollett.* Anchorage: Anchorage Museum of
 History and Art.

Belk, Russell W.
1995 *Collecting in a Consumer Society.* New York: Routledge.

Belting, Hans
1987 *The End of the History of Art?* Trans. Christopher S. Wood.
 Chicago: University of Chicago Press.

Benjamin, Walter
1968 "The Work of Art in the Age of Mechanical Reproduc-
 tion." In Hannah Arendt, ed., *Illuminations,* 219–23. (Orig.
 pub. 1936) New York: Harcourt, Brace.

Bennett, Tony
1995 *The Birth of the Museum.* New York: Routledge.
1996 "The Exhibitionery Complex." In Greenberg et al.
 1996:81–112.

Berger, Maurice
1992 *How Art Becomes History: Essays on Art, Society, and
 Culture in Post–New Deal America.* New York: Harper
 Collins.

Berkhofer, Robert

1979　*The White Man's Indian: Images of the American Indian from Columbus to the Present.* New York: Vintage.

Berlo, Janet Catherine, and Ruth B. Phillips

1992　"'Vitalizing the Things of the Past': Museum Representations of Native North American Art in the 1990s." *Museum Anthropology* 16:29–43.

Bermingham, Ann

1986　*Landscape and Ideology: The English Rustic Tradition, 1740–1860.* Berkeley: University of California Press.

Bermingham, Peter

1978　*Contemporary Art from Alaska.* Washington, D.C.: Smithsonian Institution Press.

Binek, Lynn

1989　*Drawing the Lines of Battle: Military Art of World War II Alaska.* Anchorage: Anchorage Museum of History and Art.

Bird, S. Elizabeth, ed.

1996　*Dressing in Feathers: The Construction of the Indian in American Popular Culture.* Boulder: Westview Press.

Birket-Smith, Kaj

1959　"The Earliest Eskimo Portraits." *Folk* 1:5–14.

Black, Lydia

1991　*Glory Remembered: Wooden Headgear of Alaska Sea Hunters.* Juneau: Alaska State Museum.

Blackman, Margaret, and Edwin S. Hall

1988　"Alaska Native Arts in the Twentieth Century." In William Fitzhugh and Aron Crowell, eds., *Crossroads of Continents: Cultures of Siberia and Alaska,* 326–40. Washington, D.C.: Smithsonian Institution Press.

Boniface, Priscilla, and Peter Fowler

1993　*Heritage and Tourism in the "Global Village."* New York: Routledge.

Bonnell, Raymond

1986　"An Artist on the Trail: Edmond James FitzGerald and the U.S. Geological Survey." *Alaska Journal* 16:55–60.

Bourdieu, Pierre, and Alain Darbel

1990　*The Love of Art: European Art Museums and Their Public.* Trans. B. Beattie and N. Merriman. Stanford: Stanford University Press.

Bright, Brenda Jo, and Liza Bakewell, eds.

1995　*Looking High and Low: Art and Cultural Identity.* Tucson: University of Arizona Press.

Broude, Norma, and Mary Garrard, eds.

1982　*Feminism and Art History: Questioning the Litany.* New York: Harper and Row.

1992　*The Expanding Discourse: Feminism and Art History.* New York: Harper and Row.

Brunberg, Janet

1966　"Claire Fejes, Artist." *Alaska Review* 2(2).

Bryson, Norman

1995　"Philostratus and the Imaginary Museum." In Melville and Readings 1995:174–94.

Burland, Cottie

1973　*Eskimo Art.* London: Hamlyn.

Butler, Judith

1990　*Gender Trouble: Feminism and the Subversion of Identity.* London: Routledge.

Campbell, Nola H.

1974　*Talkeetna Cronies.* Anchorage: Color Art Printing.

Canclini, Nestor Garcia

1995　*Hybrid Cultures.* Minneapolis: University of Minnesota Press.

Capps, Kris

1991　"Claire Fejes: Capturing Northern Life on Canvas." *Fairbanks Daily News-Miner, Heartland* magazine, November, H8–13.

Carlo, Jean Flanagan, and Rose Atuk Fosdick

1988　*A Treasured Heritage.* Fairbanks: University of Alaska Museum and the Institute of Alaska Native Arts.

Carroll, Patricia

1979　"Jim Schoppert, Minimal Sculptor." *Alaska Journal* (Spring):88–91.

Chin, Wanda

1992　*David Rosenthal.* Anchorage: Anchorage Museum of History and Art.

Choris, Louis

1822　*Voyages Pittoresques autour du Monde.* Paris.

Clark, Kenneth

1976　*Landscape into Art.* (Orig. pub. 1949) New York: Harper and Row.

Clark, T. J.

1973　*Image of the People: Gustave Courbet and the 1848 Revolution.* Princeton: Princeton University Press.

Clifford, James

1988　*The Predicament of Culture: Twentieth-Century*

Ethnography, Literature, and Art. Cambridge: Harvard University Press.

1990 "Four Northwest Coast Museums: Travel Reflections." In Karp and Lavine 1990:212–54.

1992 "Traveling Cultures." In Lawrence Grossberg, Cary Nelson, and Paula A. Treichler, eds., *Cultural Studies,* 96–112. New York: Routledge.

1997 *Routes: Travel and Translation in the Late Twentieth Century.* Cambridge, Mass.: Harvard University Press.

Collins, Henry
1929 "Prehistoric Art of the Alaskan Eskimo." *Smithsonian Miscellaneous Collections* 14.

1937 "The Archeology of St. Lawrence Island." *Smithsonian Miscellaneous Collections* 96 (1).

1969/70 "The Okvik Figurine: Madonna or Bear Mother?" *Folk, Dansk Etnografisk Tidsskrift* 11–12:85–114.

———, Frederica de Laguna, Edmund Carpenter, and Peter Stone
1973 *The Far North: 2000 Years of American Eskimo and Indian Art.* Washington, D.C.: National Gallery of Art.

Cooke, Lynne, and Peter Wollen
1995 *Visual Display: Culture Beyond Appearances.* Seattle: Bay Press.

Coombes, Annie
1994 *Reinventing Africa: Museums, Material Culture, and Popular Imagination in Late Victorian and Edwardian England.* New Haven: Yale University Press.

Crane, Frank
1915 "Who Is Who in Minnesota Art Annals: The Story of a Pioneer." *Minnesotan* 1 (5):19–21.

Crimp, Douglas
1993 *On the Museum's Ruins.* Cambridge: Harvard University Press.

Dawdy, Doris Ostrander
1985 *Artists of the American West.* Vol. 3. Athens, Oh.: Swallow Press.

DeArmond, Robert
1978 "Ziegler in Black and White." *Alaska Journal* 8 (2):162–69.

1989 "Graphic Artists in Sitka, 1867–1897." Paper presented at annual meeting of the Alaska Historical Society, Sitka.

de Laguna, Frederica
1936 "Indian Masks from the Lower Yukon." *American Anthropologist* 38:569–85.

DeRoux, Kenneth
1990 *The Gentle Craft: Watercolor Views of Alaska 1778–1974 from the Collection of the Alaska State Museum, Juneau, Alaska.* Juneau: Alaska State Museum.

Derry, Ramsay
1981 *The Art of Robert Bateman.* Intro. by Roger Tory Peterson. New York: Viking.

1985 *The World of Robert Bateman.* New York: Random House/ Madison Press; Toronto: Viking/Madison Press.

Diffily, John
1980 "Introduction." In Sara Machetanz, *The Oil Paintings of Fred Machetanz,* 7–14. Leigh-on-Sea, U.K.: F. Lewis Publishers.

DiMaggio, Paul
1991 "Cultural Entrepreneurship in Nineteenth-Century Boston: The Creation of an Organizational Base for High Culture in America." In Chandra Mukerji and Michael Schudson, eds., *Rethinking Popular Culture,* 374–97. Berkeley: University of California Press.

Doherty, M. Stephen
1981 "The American Artist Collection, 1981 Selection, Fred Machetanz." *American Artist* (Nov.):50–55, cover.

Dumond, Don E.
1977 *The Eskimos and Aleuts.* Boulder: Westview Press.

Duncan, Carol
1995 *Civilizing Rituals: Inside Public Art Museums.* New York: Routledge.

———, and Amei Wallach
1980 "The Universal Survey Museum." *Art History* 3:448–69.

Duncan, Kate
1989 *Northern Athapaskan Art.* Seattle: University of Washington Press.

Eide, Arthur H.
1952 *Drums of Diomede.* Hollywood, Calif.: Home-Warner.

Elliott, Henry Wood
1886 *Our Arctic Province: Alaska and the Seal Islands.* New York: Charles Scribner's Sons.

Elsner, John, and Roger Cardinal, eds.
1994 *The Cultures of Collecting.* Cambridge, Mass.: Harvard University Press.

Emmons, George T.
1903 "Basketry of the Tlingit." *Memoirs of the American Museum of Natural History, Anthropology Series* 2:229–77.

1907 "The Chilkat Dancing Blanket." *Memoirs of the American Museum of Natural History, Anthropology Series* 3:229–77.

————, and Frederica de Laguna
1991 *The Tlingit Indians.* New York and Seattle: American Museum of Natural History and University of Washington Press.

Even, Yael
1989 "Lorenzo Ghiberti's Quest for Professional Autonomy." *Kunsthistorisk Tidskrift* 58: 1–6.

Fabian, Johannes
1983 *Time and the Other: How Anthropology Makes Its Object.* New York: Columbia University Press.

Fair, Susan
1982 "Eskimo Dolls." In Suzy Jones, ed., *Eskimo Dolls,* 46–74. Anchorage: Alaska State Council on the Arts.

Falk, Peter Hastings, ed.
1990 *The Annual Exhibition Record of the Art Institute of Chicago, 1888–1950.* Seattle: Sound View Press.

Federoff, George W.
1966 "Alaska." *Smoke Signals* (Indian Arts and Crafts Board) (50–51):10–17, 20–21.

Fejes, Claire
1966 *People of the Noatak.* New York: Alfred A. Knopf.

1969 *Enuk, My Son.* New York: Pantheon Books.

1981 *Villagers: Athabaskan Life Along the Yukon River.* New York: Random House.

Fermie, Eric
1995 "Introduction: A History of Methods." In Eric Fermie, ed., *Art History and Its Methods,* 10–21. London: Phaidon.

Fielding, Mantle
1965 *Dictionary of American Painters, Sculptors, and Engravers.* New York: James F. Carr.

Fienup-Riordan, Ann
1986 *The Artists Behind the Works: Life Histories of Nick Charles, Sr., Frances Demientiff, Lena Sours and Jennie Thlunaut.* Fairbanks: University of Alaska Museum.

1996 *The Living Tradition of Yup'ik Masks.* Seattle: University of Washington Press.

Firmin, Margaret
1979 "Only Painting What He Sees." *Alaska Advocate* (Feb. 1–7):4.

First National Bank of Fairbanks
1986 *A Salute to a Hometown Artist: T. R. Lambert, 1905–1960.* Fairbanks.

Fitzhugh, William, and Aron Crowell, eds.
1988 *Crossroads of Continents: Cultures of Siberia and Alaska.* Washington, D.C.: Smithsonian Institution Press.

Fitzhugh, William, and Susan Kaplan
1982 *Inua: Spirit World of the Bering Sea Eskimo.* Washington, D.C.: Smithsonian Institution Press.

Frankson, Alec
1980 Personal communication with Molly Lee, Anchorage, June.

Fyfe, Gordon
1996 "A Trojan Horse at the Tate: Theorizing Museums as Agency and Structure." In MacDonald and Fyfe 1996:203–28.

Geist, Otto, and Froelich Rainey
1936 "Archeological Excavations as Kukulik, St. Lawrence Island, Alaska." *Miscellaneous Papers, University of Alaska* 2.

Gerlach, Craig, and Owen Mason
1992 "Calibrated Radiocarbon Dates and Cultural Interaction in the Western Arctic." *Arctic Anthropology* 29 (1):54–81.

Getty Center for Education in the Arts
1991 *Arts, Museums, Visitors, Attitudes, Expectations: A Focus Group Experiment.* Los Angeles: Getty Center.

Giddings, James
1967 *Ancient Men of the Arctic.* New York: Random House.

Gifford, Don
1993 "The Touch of Landscape." In Salim Kemal and Ivan Gaskell, eds., *Landscape, Natural Beauty and the Arts,* 127–38. Cambridge: Cambridge University Press.

Glaser, J. R., and A. A. Zenetou
1994 *Gender Perspectives: Essays on Women in Museums.* Washington, D.C.: Smithsonian Institution Press.

Goetzmann, William H., and Kay Sloan
1982 *Looking Far North: The Harriman Expedition to Alaska, 1899.* New York: Viking Press.

Goodridge, Edythe
1979 *Grass Work of Labrador.* St. Johns, Newfoundland: Memorial University Art Gallery.

Goodwin, Mary
1991 *Claire Fejes Retrospective.* Fairbanks: University of Alaska Museum.

Gordon, George

1906 "Notes on the Western Eskimo." *Transactions of the Department of Archeology, Free Museum of Science and Art* 2:69–101.

Graburn, Nelson, ed.

1976 *Ethnic and Tourist Art: Cultural Expressions from the Fourth World.* Berkeley: University of California Press.

———, Molly Lee, and Jean-Loup Rousselot

1996 *Catalogue Raisonné of the Alaska Commercial Company Collection.* Berkeley: University of California Press.

Greenberg, Reesa, Bruce Ferguson, and Sandy Nairne

1994 *Thinking About Exhibitions.* New York: Routledge.

Harder, Mary Beth

1986 "Mollett Uses Solid Forms to Capture Surroundings." *Fairbanks Daily News-Miner,* Oct. 23.

1987a "Fanciful Images Fly Through His Art." *Fairbanks Daily News-Miner,* April 10.

1987b "Handmade Paper Crux of This Show." *Fairbanks Daily News-Miner,* April 10.

Hargraves, Darrell

1982 "Florence Malewotuk" [*sic*]. *Alaskafest* (May):34–41.

Harvey, David

1989 *The Condition of Postmodernity.* Cambridge: Basil Blackwell.

Harvey, P.

1996 *Hybrids of Modernity: Anthropology, the Nation-State and the Universal Exhibition.* New York: Routledge.

Hedrick, Basil, and Susan Pickel-Hedrick

1983 "Ethel Washington: The Life and Times of an Eskimo Doll Maker." *Alaska Historical Commission Studies in History* 31.

Heinrich, Albert C.

1950 "Some Present Day Acculturative Features in a Non-Literate Society." *American Anthropologist* 52:235–42.

Helsinger, Elizabeth

1996 *Rural Scenes and the Representation of Britain 1815–1850.* Princeton: Princeton University Press.

Henry, John F.

1984 *Early Maritime Artists of the Pacific Northwest Coast, 1741–1841.* Seattle: University of Washington Press.

Hickman, Pat

1987 *Innerskins Outerskins: Gut and Fishskin.* San Francisco: San Francisco Craft and Folk Art Museum.

Higgonet, Anne

1994 "A New Center: The National Museum of Women in the Arts." In Sherman and Rogoff 1994:250–64.

Hines, Diane Casella

1983 "The Living Legends of American Watercolor—Edmond J. FitzGerald." *American Artist* (Feb.):70.

Hoffman, Fergus

1969 "The Active Life of Eustace Ziegler." *Seattle Post-Intelligencer, Northwest Today,* Jan. 19, 10–13.

Hoffman, Walter

1897 "The Graphic Art of the Eskimo." *Annual Report of the United States National Museum for 1895.*

Holm, Bill

1965 *Northwest Coast Indian Art: An Analysis of Form.* Seattle: University of Washington Press.

1982 "A Wooling Mantle Neatly Wrought: The Early Historic Records of Northwest Coast Pattern-Twined Textiles, 1774–1850." *American Indian Art Magazine* 34–47.

———, and Bill Reid

1975 *Form and Freedom: A Dialogue on Northwest Coast Indian Art.* Houston: Institute for the Arts, Rice University. Reprinted under the title *Indian Art of the Northwest Coast: A Dialogue on Craftsmanship and Aesthetics,* 1976.

Hooper-Greenhill, Eilean

1992 *Museums and the Shaping of Knowledge.* New York: Routledge.

1995 *Museum, Media, Message.* New York: Routledge.

Hudson, Raymond

1987 "Designs in Aleut Basketry." In Peter Corey, ed., *Faces Voices Dreams,* 63–93. Juneau: Division of Alaska State Museums and Friends of the Alaska State Museum.

Hughes, Edan Milton

1986 *Artists in California, 1786–1940.* San Francisco: Hughes Publishing.

Hulley, Clarence C.

1970 *Alaska, Past and Present.* 2nd ed. Portland, Ore.: Binford and Mort.

Ingram, Jan

1983 "Little New at Visual Arts Center Show." *Anchorage Daily News,* Oct. 30, D-4.

1986 "Artists' Risk-Taking Freshens Exhibits." *Anchorage Daily News,* Nov. 30.

1989 "New Emotional Content to Painting." *Anchorage Daily News,* Jan. 1, F4.

1991 "Concern for Relationship of Man to Environment Demonstrated in Exhibit." *Anchorage Daily News,* Dec. 15.

1992 "Exhibit Honors Art of a True Original." *Anchorage Daily News,* Mar. 1, H-6.

Institute of Alaska Native Arts and the University of Alaska Museum

1984 *New Traditions: An Exhibition of Alaska Native Sculpture.* Fairbanks: Institute of Alaska Native Arts and the University of Alaska Museum.

1993 *Bending Tradition.* Fairbanks: Institute of Alaska Native Arts and the University of Alaska Museum.

Jackson, John B.

1984 *Discovering the Vernacular Landscape.* New Haven: Yale University Press.

1994 *A Sense of Place, A Sense of Time.* New Haven: Yale University Press.

Jencks, C.

1995 *Visual Culture.* New York: Routledge.

Jencks, Charles

1996 *What Is Post-Modernism?* London: Agency Group Ltd.

———, ed.

1992 *The Post-Modern Reader.* New York: St. Martin's Press.

Jonaitis, Aldona

1981 "Creations of Mystics and Philosophers: The White Man's Perception of Northwest Coast Indian Art from the 1930s to the Present." *American Indian Culture and Research Journal* 5:1–48.

1986 *Art of the Northern Tlingit.* Seattle: University of Washington Press.

1988 *From the Land of the Totem Poles: The Northwest Coast Indian Art Collection at the American Museum of Natural History.* New York and Seattle: American Museum of Natural History and University of Washington Press.

1992 "Franz Boas, John Swanton, and the New Haida Sculpture at the American Museum of Natural History." In Janet Berlo, ed., *The Early Years of Native American Art History: The Politics of Scholarship and Collecting,* 20–62. Seattle: University of Washington Press.

1993 "Traders of Tradition: Haida Art from Argillite Masters to Robert Davidson." In Ian Thom, ed., *Robert Davidson: Eagle of the Dawn.* Vancouver, B.C.: Vancouver Art Gallery.

1998 "Totem Poles." In R. Phillips and C. Steiner, eds., *Art and Commodities: The Authenticity of the Object in Colonial and Post-Colonial Worlds.* Berkeley: University of California Press.

———, ed.

1991 *Chiefly Feasts: The Enduring Kwakiutl Potlatch.* Seattle and New York: University of Washington Press and the American Museum of Natural History.

Karp, Ivan, and Steven D. Lavine, eds.

1991 *Exhibiting Cultures: The Poetics and Politics of Museum Display.* Washington, D.C.: Smithsonian Institution Press.

Keim, Charles

1969 *Aghvook, White Eskimo: Otto Geist and Alaskan Archaeology.* Seattle: University of Washington Press.

Kemal, Salim, and Ivan Gaskell

1993 "Nature, Fine Arts, and Aesthetics." In Salim Kemal and Ivan Gaskell, eds., *Landscape, Natural Beauty and the Arts,* 1–42. Cambridge: Cambridge University Press.

Kennedy, Kay J.

1939 "Sourdough Artist." *Alaska Life: The Territorial Magazine* (Nov.):5, 24.

Kennedy, Michael

1973 "Alaska's Artists: Theodore J. Richardson." *Alaska Journal* 1:31–40.

Kent, Rockwell

1919 *Alaska Drawings by Rockwell Kent, with a Letter from Rockwell Kent to Christian Brinton.* New York: M. Knoedler and Co.

1920 *Wilderness: A Journal of Quiet Adventure in Alaska.* New York: G. P. Putnam's Sons.

1955 *It's Me, O Lord: The Autobiography of Rockwell Kent.* New York: Dodd, Mead, and Company.

Kollar, Allan

1993 *Edmond James FitzGerald, N.A., A.W.S.: American 1912–1989.* Seattle: Kollar and Davidson Gallery.

Kopytoff, Igor

1986 "The Cultural Biography of Things." In Arjun Appadurai, ed., *The Social Life of Things,* 64–94. Cambridge, Mass.: Cambridge University Press.

Lantis, Margaret

1950 "Mme. Eskimo Proves Herself an Artist." *Natural History* 59 (2):68–71.

Larsen, Helge, and Froelich Rainey

1948 "Ipiutak and the Arctic Whale Hunting Culture." *Anthro-
 pological Papers of the American Museum of Natural
 History* 42.

Lawton, Joseph

1965 "Fred and Sara Machetanz." *Alaska Review* 2 (1):55–66.

Lee, Molly

1981 "Pacific Eskimo Spruce Root Baskets." *American Indian
 Art* 6 (2):55–73.

1983 *Baleen Basketry of the North Alaskan Eskimo.* Barrow:
 North Slope Borough Commission on History and
 Culture.

1991 "Appropriating the Primitive: Turn-of-the-Century
 Collection and Display of Native Alaskan Art." *Arctic
 Anthropology* 28:6–15.

1995 "Siberian Sources of Alaskan Eskimo Coiled Basketry:
 Types and Prototypes." *American Indian Art* 20 (4):56–69.

1998 "Tourists and Taste Cultures: Art Collecting in Turn-of-
 the-Century Alaska." In Phillips and Steiner 1998.

Leppert, Richard

1996 *Art and the Committed Eye: The Cultural Functions of
 Imagery.* Boulder: Westview Press.

Licka, C. E.

1991 *Inscapes and Poethics: The James Bay Paintings.* Anchor-
 age: University of Alaska Anchorage Art Gallery.

Lockhart, Tammy

1995 "Aura of Antarctica Captured by Artist." *Bangor Daily
 News,* Aug. 16, C1, C3.

Lubin, David

1994 *"Picturing a Nation: Art and Social Change in Nineteenth-
 Century America.* New Haven: Yale University Press.

Luevano, Jen

1995 "Crossing the Boundaries of Space and Memory in the
 Paintings of Robby Mohatt." *Fairbanks Arts* (Jan./Feb.):
 6–7.

Lumley, R., ed.

1988 *The Museum Time-Machine: Putting Cultures on Display.*
 New York: Routledge.

Lynam, Edward

1949 *The Carta Marina of Olaus Magnus, Venice 1539 and Rome
 1572.* Jenkintown, Pa.: Tall Tree Library.

MacCannell, Dean

1989 *The Tourist: A New Theory of the Leisure Class.* New York:
 Schocken Books.

MacDonald, Sharon, and Gordon Fyfe, eds.

1996 *Theorizing Museums.* Oxford: Blackwell Publishers.

Macnair, Peter, and Alan Hoover

1984 *Magic Leaves: A History of Argillite Carving.* Victoria: Royal
 British Columbia Museum.

Maquet, Jacques

1979 *Introduction to Aesthetic Anthropology.* Malibu, Calif.:
 Udena Publications.

Marcus, George

1995 "The Modernist Sensibility in Recent Ethnographic
 Writings and the Cinematic Metaphor of Montage."
 In L. Devereux and R. Hillman, eds., *Fields of Vision: Essays
 in Film Studies, Visual Anthropology, and Photography,*
 35–55. Berkeley: University of California Press.

———, and Fred Myers, eds.

1995 *The Traffic in Culture: Refiguring Art and Anthropology.*
 Berkeley: University of California Press.

Mason, Otis T.

1904 "Aboriginal American Basketry: Studies in a Textile Art
 Without Machinery." *U.S. National Museum Annual
 Report for 1902,* 171–548.

Mathews, Mildred

1973 "Florence Lives." *Alaska Magazine* (Oct.):20–21, 59–61.

McCollom, Pat

1974 "Artist Machetanz." *Alaska Journal* 4 (1):6–11.

1976 "Ted Lambert, Alaska's Sourdough Artist." *Alaska Journal*
 6 (3):184–91.

Melville, Stephen, and Bill Readings

1995 *Vision and Textuality.* Durham: Duke University Press.

Merriam, C. Hart, ed.

1901–14 *Harriman Alaska Expedition.* 13 vols. New York and
 Washington, D.C.: Doubleday, Page, and Co. and
 Smithsonian Institution.

Michaels, Eric

1994 *Bad Aboriginal Art.* Minneapolis: University of Minnesota
 Press.

Michaels, Mary Beth

1990a "Local Artist Likes to Push the Limitations." *All-Alaska
 Weekly* (Aug. 24):5.

1990b "Artists Paint in the Plain Air of the Arctic Refuge."
 All-Alaska Weekly (Sept. 7):5–6.

Mitchell, W. J. T.

1994a "Imperial Landscape." In W. J. T. Mitchell, ed., *Landscape and Power,* 5–34. Chicago: University of Chicago Press.

1994b *Picture Theory: Essays on Verbal and Visual Representation.* Chicago: University of Chicago Press.

Mollett, Nina

1984 "'Stick Drawing' Sculptures Create Airy Exhibit." *Fairbanks Daily News-Miner,* Feb. 23, 10.

1992 "Brushing Up on ANWAR: Expansive Vistas and Multi-Hued Geology Make the Arctic National Wildlife Refuge an Inspiration for Artists." *Alaska Magazine* (Jan.):29–31.

Morris, Rosalind

1994 *New Worlds from Fragments: Film, Ethnography and the Presentation of Northwest Coast Cultures.* Boulder: Westview Press.

Mozee, Yvonne

1975 "George Ahgupuk." *Alaska Journal* 5 (3):140–43.

1978 "A Conversation with Eskimo Artist Kivetoruk Moses." *Alaska Journal* 8 (2):102–9.

Murdoch, John

1892 "Ethnological Results of the Point Barrow Expedition." *9th Annual Report of the Bureau of American Ethnology for the Years 1887–1888,* 19–441.

Nanook News

1971 "Honorary Degrees Go to Three." May 14, 6.

Nelson, Edward

1899 "The Eskimo Around Bering Strait." *Bureau of American Ethnology Report* 18 (1).

Nemerov, Alexander

1995 *Frederic Remington and Turn-of-the-Century America.* New Haven: Yale University Press.

Nicholson, Marjorie Hope

1997 *Mountain Gloom and Mountain Glory.* Seattle: University of Washington Press.

Nochlin, Linda

1988 *Women, Art, Power and Other Essays.* New York: Harper and Row.

Nordenskiold, A. E.

1882 *The Voyage of the Vega Round Asia and Europe.* A. Leslie, trans. New York: Macmillan.

Nordness, Lee

1970 *Objects: USA.* New York: Viking Press.

O'Barr, William

1994 *Culture and the Ad: Exploring Otherness in the World of Advertising.* Boulder: Westview Press.

Old Dartmouth Historical Society

1974 *R. Swain Gifford 1840–1905.* New Bedford, Mass.: Old Dartmouth Historical Society.

Orvell, Miles

1995 *After the Machine: Visual Arts and the Erasing of Cultural Boundaries.* Jackson: University Press of Mississippi.

Oswalt, Wendell H.

1979 *Eskimos and Explorers.* Novato, Calif.: Chandler and Sharp.

Paine, Jocelyn

1979 "Alvin Eli Amason." *Alaska Journal* (Summer):6–12.

Palmer, Susan

1992 "Isolated Landscapes Fascinate Painter." *Anchorage Daily News,* May 3, H3.

Parker, Roszika, and Griselda Pollack, eds.

1981 *Old Mistresses: Women, Art and Ideology.* New York: Routledge.

1987 *Framing Feminism.* London: Pandora.

Paul, Frances

1944 *Spruce Root Basketry of the Alaska Tlingit.* Washington, D.C.: U.S. Department of the Interior, Bureau of Indian Affairs.

Pearce, Susan

1992 *Museum Objects and Collections: A Cultural Study.* London: Leicester University Press.

———, ed.

1990 *Objects of Knowledge.* London: Athlone.

1994 *Museums and the Appropriation of Culture.* London: Athlone.

Phillips, Ruth

1989a "What Is 'Huron Art'? Native American Art and the New Art History." *Canadian Journal of Native Studies* 9:167–91.

1989b "Souvenirs from North America: The Miniature as Image of Woodlands Indian Life." *American Indian Art Magazine* 14 (2):52–63, 78–79.

1995 "Why Not Tourist Art? Significant Silences in Native American Museum Representations." In Prakesh 1995: 98–128.

———, and Christopher Steiner, eds.

1998 *Art and Commodities: The Authenticity of the Object in*

Colonial and Post-Colonial Worlds. Berkeley: University of California Press.

Pointon, M., ed.
1994 *Art Apart: Museums in North America and Britain Since 1800.* Manchester: Manchester University Press.

Pollack, Griselda
1988 *Vision and Difference: Femininity, Feminism and the Histories of Art.* New York: Routledge.

1993 *Avant-Garde Gambits: 1888–1893: Gender and the Color of Art History.* London: Thames and Hudson.

Poor, Henry Varnum
1945a *An Artist Sees Alaska.* New York: Viking Press.

1945b *The Cruise of the Ada.* Alaska: Henry Varnum Poor.

Prakesh, Gyan, ed.
1995 *After Colonialism: Imperial Histories and Post-Colonial Displacements.* Princeton: Princeton University Press.

Preziosi, Donald
1989 *Rethinking Art History.* New Haven: Yale University Press.

Pugh, Simon, ed.
1990 *Reading Landscape: Country-City-Capital.* Manchester: University of Manchester Press.

Queener-Shaw, Janice
1987 "The Alaska Four." *Western Art Digest* (Jan./Feb.):34–41.

Rainey, Froelich
1941 "Eskimo Prehistory: The Okvik Site on the Punuk Islands." *Anthropological Papers of the American Museum of Natural History* 37 (4).

1947 "The Whale Hunters of Tigara." *Anthropological Papers of the American Museum of Natural History* 41.

1959 "Vanishing Art of the Arctic." *Expedition* 1 (2) (Winter): 3–13.

Ray, Dorothy Jean
1959 "The Eskimo Raincoat." *Alaska Sportsman* 26 (1): 13, 44.

1961 *Artists of the Tundra and the Sea.* Seattle: University of Washington Press.

1967a *Eskimo Masks: Art and Ceremony.* Seattle: University of Washington Press.

1967b "Alaskan Eskimo Arts and Crafts." *Beaver* (Autumn): 80–91.

1969 *Graphic Arts of the Alaskan Eskimo.* Washington, D.C.: Indian Arts and Crafts Board.

1977 *Eskimo Art: Tradition and Innovation in North Alaska.* Seattle: University of Washington Press.

1981 *Aleut and Eskimo Art: Tradition and Innovation in South Alaska.* Seattle: University of Washington Press.

1996 *A Legacy of Arctic Art.* Seattle and Fairbanks: University of Washington Press and the University of Alaska Museum.

Reed, Don
1945 "The Crumrines, Painters of Alaska." *Alaska Life* (Dec.):53–56.

Rich, Kim
1988 "A Show for the Fun of It." *Anchorage Daily News,* Nov. 6, G1–2.

Root, Deborah
1996 *Cannibal Culture: Art, Appropriation and the Commodification of Difference.* Boulder: Westview Press.

Roppel, Pat
1977 "Jules Dahlager." *Alaska Journal* 7 (3):188–91.

Rudenko, S. I.
1961 "The Ancient Culture of the Bering Sea and the Eskimo Problem." *Anthropology of the North: Translations from Russian Sources* 1.

Samuel, Cheryl
1982 *The Chilkat Dancing Blanket.* Seattle: Pacific Search Press.

Samuels, Peggy, and Harold Samuels
1985 *Samuels' Encyclopedia of Artists of the American West.* Secaucus, N.J.: Book Sales, Inc., Castle.

Schmitt, Nancy Cain
1980 "DeRoux Likes to Whimsy While He Works." *Anchorage Times,* Feb. 17, G1.

Schuldberg, Jane
1996 Personal communication with Molly Lee.

Shalkop, Robert L.
1975 *Sydney Laurence (1865–1940): An Alaskan Impressionist.* Anchorage: Anchorage Historical and Fine Arts Museum.

1977 *Eustace Ziegler: A Retrospective Exhibition.* Anchorage: Anchorage Historical and Fine Arts Museum.

1982a *Henry Wood Elliott, 1846–1930: A Retrospective Exhibition.* Anchorage: Anchorage Historical and Fine Arts Museum.

1982b *Sydney Laurence: His Life and Work. The Collection of the Anchorage Historical and Fine Arts Museum.* Anchorage: Anchorage Historical and Fine Arts Museum.

Shapsnikoff, Anfesia, and Raymond Hudson
1974 "Aleut Basketry." *Anthropological Papers of the University of Alaska* 16:41–69.

Sharp, Anne

1996 "The Artists of ANWAR." *Anchorage Press*, Feb. 22–28, 1, 12.

Sherman, Daniel, and Irit Rogoff, eds.

1994 *Museum Culture: Histories, Discourses, Spectacles.* Minneapolis: University of Minnesota Press.

Shetler, Stanwyn G.

1987 *Portraits of Nature: Paintings by Robert Bateman.* Washington, D.C.: Smithsonian Institution Press.

Shotridge, Louis

1920 "Ghost of Courageous Adventurer." *Museum Journal* 11 (1):11–26.

Shumaker, Peggy

1988 *The Circle of Totems.* Pittsburgh: University of Pittsburgh Press.

1994 *Wings Moist from Another World.* Pittsburgh: University of Pittsburgh Press.

Shur, Leonid, and R. A. Pierce

1978 "Pavel Mikhailov, Artist in Russian America." *Alaska Journal* 8.

Simpson, Glen

1991 *Ron Senungetuk.* Anchorage: Anchorage Museum of History and Art.

Smedley, Audrey

1993 *Race in North America: Origin and Evolution of a World View.* Boulder: Westview Press.

Smith, Shaw

1992 *The Endurance of Wonder: Kes Woodward's Paintings.* Charlotte, N.C.: Jerald Melberg Gallery.

Soos, Frank

1991 *Kes Woodward.* Anchorage: Anchorage Museum of History and Art.

Stadem, Catherine

1994 "Welcome to My World." *Alaska Magazine* (July):40–47, cover.

Staniszewski, Mary Anne

1995 *Believing Is Seeing: Creating the Culture of Art.* New York: Penguin.

Stenzel, Franz R.

1963 *An Art Perspective of the Historic Pacific Northwest.* Helena: Montana Historical Society.

Stocking, George, ed.

1985 *Objects and Others: Essays on Museums and Material Culture.* Madison: University of Wisconsin Press.

Stone, P., and B. Molyneux, eds.

1994 *The Presented Past: Heritage, Museums and Education.* New York: Routledge.

Sturtevant, William

1976 "First Visual Images of Native America." In F. Chiappelli, ed., *First Images of America,* vol. 1:417–54. Berkeley: University of California Press.

1980 "The First Inuit Depiction by Europeans." *Études/Inuit Studies* 4:47–49.

————, and David Beers Quinn

1987 "The New Prey: Eskimos in Europe in 1567, 1576, and 1577." In Christian F. Feest, ed., *Indians and Europe: An Interdisciplinary Collection of Essays,* 61–140. Aachen: Edition Herodot, Rader-Verlag.

Tagg, John

1992 *Grounds of Dispute: Art History, Cultural Politics and the Discursive Field.* Minneapolis: University of Minnesota Press.

Thompson, Michael

1979 *Rubbish Theory.* New York: Oxford University Press.

Traxel, David

1980 *An American Saga: The Life and Times of Rockwell Kent.* New York: Harper and Row.

Tuan, Yi-Fu

1993 "Desert and Ice: Ambivalent Aesthetics." In Salim Kemal and Ivan Gaskell, eds., *Landscape, Natural Beauty and the Arts,* 139–57. Cambridge, Mass.: Cambridge University Press.

Tucker, Marcia

1992 "'Who's on First?' Issues of Cultural Equity in Today's Museums." In Association of Art Museum Directors 1993:9–16.

Tundra Times

1972 "Artist to Depict Development of Eskimo from Stone Age." Nov. 22:7.

Tuzroyluk, Rex

1996 Personal communication with Molly Lee, Fairbanks.

Untracht, Oppi

1982 *Jewelry Concepts and Technology.* Garden City, N.Y.: Doubleday and Co., Inc.

Van Nostrand, Jeanne

1963 "The Seals Are About Gone." *American Heritage* (June):11–17, 78–80.

Varjola, Pirjo

1990 *The Etholen Collection: The Ethnographic Alaskan
 Collection of Adolf Etholen and His Contemporaries in
 the National Museum of Finland.* Helsinki: National
 Board of Antiquities of Finland.

Varnedoe, Kirk, and Adam Gopnik, eds.

1990 *Modern Art and Popular Culture: Readings in High and
 Low.* New York: Museum of Modern Art.

Vergo, Peter, ed.

1989 *The New Museology.* London: Reaktion Press.

Visual Arts Center of Alaska

1988 *Artists Respond: A People in Peril.* Anchorage: Visual Arts
 Center of Alaska.

Wallen, Lynn Ager

1990 *Bending Traditions.* Fairbanks: University of Alaska Mu-
 seum and the Institute of Alaska Native Arts.

Walsh, Kevin

1992 *The Representation of the Past: Museums and Heritage in
 the Post-Modern World.* New York: Routledge.

Wardwell, Allen

1986 *Ancient Eskimo Ivories of the Bering Strait.* New York:
 Hudson Hills Press.

Warner, Sheree

1994 "Fairbanks Summer." *Fairbanks Daily News-Miner,* June
 16, C1, C3.

Weil, Stephen

1995 *A Cabinet of Curiosities: An Inquiry into Museums and
 Their Practices.* Washington, D.C.: Smithsonian Institution
 Press.

Wignall Museum/Gallery

1994 *Alaskan Landscapes: Views of the Arctic National Wildlife
 Refuge.* Rancho Cucamonga, Calif.: Wignall Museum/
 Gallery, Chaffey College.

Willemen, Paul

1995 "The National." In Leslie Devereux and Roger Hillman,
 eds., *Fields of Vision: Essays in Film Studies, Visual Anthro-
 pology, and Photography,* 21–34. Berkeley: University of
 California Press.

Wilson, Katherine

1923 *Copper-Tints: A Book of Cordova Sketches.* Cordova,
 Alaska: Cordova Daily Times Press.

Winter, Irene

1992 "Change in the American Art Museum: The (An) Art

Historian's Voice." In Association of Art Museum Direc-
tors 1992:9–16.

Wold, Jo Anne

1973 "Art Collectors Loan Paintings for Tea." *Fairbanks Daily
 News-Miner,* May 3.

Wolff, Janet

1992 "Excess and Inhibition: Interdisciplinarity in the Study
 of Art." In Laurence Grossberg, Cary Nelson, and Paula
 Treichler, eds., *Cultural Studies,* 706–27. New York:
 Routledge.

Woods, Anne

1957 "Artist of Shishmaref." *Alaska Sportsman* (Oct.):16–17,
 41–43.

Woodward, Kesler

1989 *Paul Gardinier.* Anchorage: Anchorage Museum of
 History and Art.

1990a *Sydney Laurence: Painter of the North.* Anchorage:
 Anchorage Museum of History and Art.

1990b "Sydney Laurence." *Southwest Art* (Dec.):72–79.

1993 *Painting in the North: Alaskan Art in the Anchorage
 Museum of History and Art.* Anchorage: Anchorage
 Museum of History and Art.

1995 *A Sense of Wonder.* Fairbanks: University of Alaska
 Museum.

Woodward, Marianna B.

1980 "Dan DeRoux, Juneau Buckaroo." *Alaska Journal*
 (Winter):5–11.

Wright, Robin

1991 *A Time of Gathering: Native Heritage in Washington State.*
 Seattle: University of Washington Press and the Burke
 Museum.

Yost, Harry

1970 "Machetanz—Alaska's Great Artist." *This Alaska*
 (Feb.):13–16, 31.

Zolberg, Vera

1992 "Barrier or Leveler? The Case of the Art Museum." In
 Michele Lamont and Marcel Fournier, eds., *Cultivating
 Differences: Symbolic Boundaries and the Making of
 Inequality,* 187–209. Chicago: University of Chicago
 Press.

1994 "'An Elite Experience for Everyone': Art Museums, the
 Public, and Cultural Literacy." In Sherman and Rogoff
 1994:49–65.

Contributors

Alvin Amason

Assistant professor of art and director of the Native Arts Program at UAF. An Alutiiq from Kodiak Island and a member of the UAF faculty since 1992, Amason is a painter and printmaker.

Wanda Chin

Exhibits coordinator at UAM. A member of the staff since 1979, Chin is responsible for all long-term and special exhibits, as well as the graphic design of all UAM publications. She has several public art commissions in Alaska.

Terry Dickey

Education coordinator at UAM. A member of the staff since 1977, Dickey is responsible for all education programs including the docent program, summer interpretation programs, lecture and film series, and public outreach events.

Aldona Jonaitis

Museum director and professor of anthropology. A member of the UAM staff since 1993, Jonaitis is a scholar of Northwest Coast Native art.

Molly Lee

Curator of ethnology at UAM and assistant professor of anthropology. A member of the UAF staff since 1995, Lee is responsible for all ethnographic and historical collections. She is a well-known scholar of Alaskan Eskimo art and has published widely on that topic.

Susan McInnis

News and public affairs producer at KUAC radio and television. A member of the UAF staff since 1983, McInnis is a radio and television interviewer as well as a writer.

Barry McWayne

Fine arts coordinator at UAM. A member of the staff since 1970, McWayne is responsible for the fine arts and photography collections and is the Museum photographer as well as a fine art photographer in his own right.

Peggy Shumaker

Professor of English at UAF. A member of the staff since 1990, Shumaker is an award-winning poet.

Glen Simpson

Professor of art at UAF. A Tahltan metalsmith, Simpson has been a member of the staff since 1985.

Kesler Woodward

Professor of art and UAM fine arts affiliate. A member of the faculty since 1981, Woodward has advised the Museum extensively on its fine arts collection. He is a well-respected painter, seasoned curator, and author of several books on Alaskan art.

Index

Italic numbers refer to illustrations.

Adams, Ansel, 122–23; *Mount McKinley and Wonder Lake, 122*

Ahgupuk, George Aden, 36, 103, 105; drawing, *105*

Ahvakana, Lawrence Ullaq Aviaq, 82; *Walrus Mask, 82*

Alaska Native art, 34–36, 92

Alaska Natives in art, 33–34, 98–115, 174–80

Aleut: baskets, *46, 47;* grass wallets, 68, *68;* headgear, 73; model boat, 136, *136*

Alexei, Max, 56

Allen, Brian, 27, 29; *Pizza Hut, 29*

Alutiiq, basket, 137, *137*

Amason, Alvin Eli, 36, 78, 137, 138, 143, 145, 149–50, 173; *I Could Watch You Until the Stars Come Out and I Can't See No More, 138; Oscar Scared Him with his Icon, 78*

Art: authenticity of, 70–79; classification and categorization of, 39–42, 89–95; collecting, 56

Art history, 20–23

Art market, 65–76, 140

Artists influencing other artists, 149–61

Athabaskan: Deg Hit'an mask, 156, *161;* Gwich'in fish-skin basket by Leah Roberts, 156, *156;* Gwich'in sled bag, 111–22, *111;* moccasins, 150, *151;* Hannah Netro, beaded baby belt, 60, *60;* willow basket, 145, *145*

Bailey, Cheryl A., 39; *Fusion Pattern #1, 39*

Barker, James H., 33–34, 98–99, 178; *4th of July at Black River Fishcamp, 98*

Baskets, 65, 153–54: Aleut, *46, 47,* 65–66; Alutiiq, 137, *137;* Athabaskan, willow 145, *145;* Gwich'in Athabaskan fish-skin by Leah Roberts, 156, *156;* Inupiat baleen, 47–49, *49;* Tlingit spruce root, *54,* 55, 70, *70,* 94, *94;* Yupik, *40,* 41, 90, *90,* 128, 130, *130, 153, *154

Bateman, Robert, 50; *Polar Bear Profile, 50*

Beadwork: Athabaskan, Hannah Netro, beaded baby belt, 60, *60;* Athabaskan moccasins, 150, *151;* Gwich'in Athabaskan sled bag, 111–22, *111;* Yupik or Athabaskan, Bedusa Derendy, *44,* 56–58, *57*

Beck, Lawrence, 156, 159; *Tunghak Inua (Spirit Mask), 146* (detail), *159*

Blassie, Lincoln, 168

Bohn, Dave, 125

Brody, Arthur William (Bill), 25, 123–28, 186; *Guardians of the Valley, 124*

Brown, Xcenia, 47; basket, *46*

Carlo, Kathleen, 156, 158; *Nokinmaa yiłmaa (Snowy Owl), 158*

Carlo, Poldine, 34–35, 56, 60, 111, 158, 167

Chemigak, Lizzie, 41; basket, *40*

Choris, Louis, 175

Choy, Terrence, 19; *Alaska Go Pan, 19*

Collecting art, 56

Crumrine, Nina, 182; *Chief Andrew, 182*

Dahlager, Jules, 183, 185; *Alaskan Scene, 185*

Daughhetee, Mark, 112; *The Shaman, 113*

Davis, Irene and Richard, 41

Deacon, Belle, 66

Deg Hit'an. *See* Athabaskan

Dellenbaugh, Frederick S., 27; *Pier at Orca, 27*

Derendy, Bedusa, 56–58; beaded collar, Yupik or Athabaskan, *44* (detail), *57*

DeRoux, Daniel, 85; *Bering Strait Faces the Last Roundup in the Last Frontier, 2* (detail), *84*

Doll, Don, S.J., 100; *Ben Chugaluk Moves a House to Toksook Bay, 100*

Dolls, 82–83, 87–89: Siberian Yupik, 87, *87;* Dolly Spencer, 83, 88, *88;* Ethel Washington, *87,* 89

Ekak, Ruth, 167–68

Elliott, Henry Wood, 29–30, 180, 182–83; *Seal Drive Crossing, 31; Village Cove and Hill, 182*

Eskimo. *See* Inupiaq; Siberian Yupik; Yupik

Eskimo, archaeological. *See* Ipiutak culture; Okvik culture; Old Bering Sea culture; Punuk culture

Fejes, Claire, 178–79; *Source of Life, 179*

FitzGerald, Edmond James, 66; *Lining through the Riffle, 8* (detail), *66*

Frankson, Alec, 165–66

Freeburg, Gary L., 128; *Tidal Pool, 128*

Fur clothing, 15; Inupiat, *14;* Siberian Yupik, *14;* Yupik, *14*

Gardinier, Paul, 188–89; *Sounding Board for Joseph Beuys, 189*

Geist, Otto, 9, 130, 166

Gifford, Robert Swain, 93; *Icy Bay, Alaska, 93*

Gwich'in. *See* Athabaskan

Haida, argillite carvings, 69, *69*

Happy Jack (Angokwazhuk), 27, 30; incised tusk, *30*

Harlan, Stephanie, 135; *Two-Headed Dog, 132* (detail), *135*

Harriman Expedition, 27, 93

Harris, Alex, 99; *Newtok, July 1977, 99*

Heurlin, Magnus Colcord ("Rusty"), 181, 183; *Eskimo Hunter, 170* (detail), *181*

Hinsley, Tanis, 103–4; *Self Portrait, 96* (detail), *104*

Holm, Bill, and Bill Reid, *Form and Freedom,* 18–19

Hoover, John, 174; *Salmon Woman, 174*

Hudson, Sally, 59

Inupiaq: baleen baskets, 47–49, *49;* doll by Dolly Spencer, 83, 88, *88;* doll by Ethel Washington, *87,* 89; fur parka by Helen Seveck, 20, *21;* incised tusk by Happy Jack (Angokwazhuk), 27, 30, *30; kikituk* 164–68, *164;* masks, 75, *75;* mukluks, *14,* 15; Simon Paneak Nunamiut dipper, 24–25, *25;* snow beater, 106, *106,* 167; umiak seat, 167, *167;* walrus skull with carved tusks, 82, *82*

Ipiutak culture, 90–91; "rake," *91*

Jackson, Mrs., 15; parka, *14*

Jackson, Nathan, 128–29, 156–57; Tlingit eagle Kaag Waan Taan totem pole, *129;* Tlingit raven headdress, *157*

James, Robert, 48–49; baleen basket, *49*

Janda, Charles, 52; *Alluvial Fan, Adams Inlet, 52*

John, Theresa, 58–59

Jones, Joseph John, 38, 89; *Muktuk Marston Signing Eskimos into the Alaska Territorial Guard, 80* (detail), *88*

Joshua, Lola, 41; basket, *40*

Kehoe, Joseph W., 139; *Seward Skyline, 139*

Kent, Rockwell, 27, 119–23, 183; *Voyagers, 116* (detail), *120*

Kikituk, 164–68, *164*

Kulowiyi, Albert, 168

Lambert, Theodore Roosevelt, 34, 109–12, 115, 178, 183; *Eskimo Dance in the Kashige, 110; The Native Camp at Anvik, Alaska, 178; A Tundra Town at Breakup, 34*

Landscape, 25–33, 118–31, 180–91

Laurence, Sydney Mortimer, 38, 65, 115, 119, 183–84, 186, 188; *Mt. McKinley* (1919), *64; Mt. McKinley* (1924), *184; Mount Susitna, Cook Inlet, Alaska, 190; Pulling for Port, 115*

Lockwood, Malcolm, 152; *Ice Fractures, 152*

Loloma, Charles, 95

Machetanz, Fred, 27–28, 186; *Off to the Trapline, 12, 28* (detail)

Malewotkuk, Florence Nupok, 128, 130; *Polar Bears, 130*

Marston, Muktuk, 83, 88–89

Masks: Lawrence Ullaq Aviaq Ahvakana, 82; Athabaskan (Deg Hit'an), 156, *161;* Lawrence Beck, 156, *159;* Kathleen Carlo, 156, *158;* Inupiaq, 75, *75; Nokinmaa yiłmaa* (Snowy Owl), *158; Tunghak Inua* (Spirit Mask), *146* (detail), *159; Walrus Mask,*

82; Yupik bird, 156, *159;* Yupik fox, 22, *22;* Yupik plants, 128, 131, *131;* Yupik, Harry Shavings miniature mask, 156, 160, *160*

Mason, Charles, 38, 134–36, 188; *American Gothic, 1985, 134*

Mathais, Neva, 41; basket, *40*

Meyer, Jane, 86; sculpture, *86*

Mizrahi, Isaac, 56

Mohatt, Robby, 35–36, 188; *Traces VI, 35*

Mollett, David, 25, 123, 126–28, 186; *Tanana River, 127*

Moses, James Kivetoruk, 114; *Shaman, 114*

Museums, 23–24; education in, 53–56, 144–45

Nashooklook, Nashukruk, 164

Nashookpuk, Lydia, 164

Native Alaskans. *See* Alaska Native art; Alaska Natives in art; Aleut; Alutiiq; Athabaskan; Inupiaq; Siberian Yupik; Tlingit; Yupik

Native American Grave Protection and Repatriation Act (NAGPRA), 10, 165

Nelson, Richard, 125

Netro, Hannah, beaded baby belt, 60, *60*

Nevak, Julia, parka, 58–59, *59*

Nunamiut. *See* Paneak, Simon

Okvik culture, 16, 50, 106; carved animal head, *16;* figure, *51, 106*

"Okvik Madonna," 9, 22–23, 48, 50, *51,* 72, 92, 94–95, 173

Old Bering Sea culture, 48, 154; toggle harpoon, *48;* winged object, *154*

Paneak, Simon, 24–25; Nunamiut dipper, *25*

Parka: Inupiaq fur by Helen Seveck, 20, *21;* Siberian Yupik gut, 180, *180;* Yupik by Julia Nevak, 59, *59*

Paul, Lilly, 15; fur cap *14*

Pete, Elena Derendy, 56

Poor, Henry Varnum, 38; *American Soldiers Pulling a Dead Russian from Chena Slough, 38*

Punuk culture, 143, 172; turreted object, *172;* wrist guard, *143*

Ray, Dorothy Jean, 11, 30, 167

Reed, Fran, 154–58, 188; Gulkana basket, *155*

Regionalism, 136–45

Reid, Bill, and Bill Holm, *Form and Freedom,* 18–19

Richardson, Theodore J., 176–77; *Southeastern Scene, 176*

Roberts, Leah, 156; Athabaskan fish-skin bag, *156*

Root, Margie, 52–53; *My Mother Always Ran the Show, 53*

Rosenthal, David, 186–88; *Danger Point, 187*

Rubey, Tony, 144; *The Sporting Life of Nome, 144*

Ryan, Bert, 129

Schneider, Shelley, 67; *Construction Laborers in Clearwell, Eklutna Water Project, 67*

Schoppert, James, 148–49, 188; *Raven: In the Pink, 148*

Senungetuk, Ronald W., 103, 107–9, 137, 173; *Two Spirits, 107*

Seveck, Helen, 20; Inupiaq parka, *21*

Shavings, Harry, 156, 160; Yupik miniature mask, *160*

Sherman, Todd, 188

Siberian Yupik: belt and pouch, *14, 15*; charm belt, 166, *166;* doll, 87, *87;* gut parka, 180, *180;* pipes, 168–69, *169. See also* Yupik

Simeonoff, Jacob, 72–73; hunting hat, *73*

Simpson, Glen, 36, 140, 149–50, 160, 173; *Thule Bird, 140; Tunghak (Spirit Hand), 149*

Solomon, Hannah, 56

Spencer, Dolly, 83, 88; doll, *88*

Stuart, James Everett, 33, 99–103, 109; *Indian Town near Sitka, 101*

Tlingit, 72–74; Chilkat blanket, 102–3, *102;* dagger, 76–79, *77;* dish, 74, *74;* eagle Kaag Waan Taan totem pole, *129;* Nathan Jackson, 128–29, 156–57; raven headdress, *157;* spruce root baskets, *54, 55,* 70, *70,* 94, *94*

Tooyak, Andrew, Sr., 164, 168; *kikituk, 162* (detail), *168*

Tourists and tourism, 36–39, 134–36, 177–78

Tuzroyluk, Rex, 164

Wallace, Denise, 92; jewelry, *92*

Wallace, Lee, 129

Washington, Ethel, 87, 89; doll, *87*

Webber, John, 65–66, 175

Webster, Gloria Cranmer, 60

Weston, Brett, 16; *Mendenhall Glacier, Alaska, 17*

Whitman, Lucy, 85; gathering bag, *85*

Woodward, Kesler, 70, 138–40, 144–45; *Spring Green, 139; Woods at Creamers, 62* (detail), *71*

Wright, Myron, 143; *Lake George, Chugach Mountains, 142*

Yupik: baskets, *40,* 41, 90, *90,* 128, 130, *130, 153,* 154; cap by Lilly Paul, *14, 15*; carved tusk, 37, *37;* feast bowl, 90, *90;* game pieces, 141, *141;* gathering bags, 85, *85;* headdress, 75–76, *76;* mask, bird, 156, *159;* mask, fox, 22, *22;* mask, plants, 128, 131, *131;* miniature mask by Harry Shavings, 156, 160, *160;* Julia Nevak parka, 59, *59. See also* Siberian Yupik

Ziegler, Eustace Paul, 33, 61, 108–9, 119, 183; *Native Woman, 108; Tanana Woman and Dog, 61; Up the Susitna River, 118*